The Pluralist Era

The Pluralist Era

American Art 1968–1981

Corinne Robins

ICON EDITIONS

1817

HARPER & ROW, PUBLISHERS, New York
Cambridge, Philadelphia, San Francisco, London
Mexico City, São Paulo, Singapore, Sydney

To my mother,
Mrs. Lillie Robins

FIRST EDITION

Designed by Abigail Sturges

Library of Congress Cataloging in Publication Data

Robins, Corinne.
 The pluralist era.

 (Icon editions)
 Includes index.
 1. Art, American. 2. Art, Modern—20th century—
United States. I. Title.
N6512.R52 1984 700'.973 83-48817
ISBN 0-06-438448-9 84 85 86 87 88 10 9 8 7 6 5 4 3 2 1
ISBN 0-06-430137-0 (pbk.) 84 85 86 87 88 10 9 8 7 6 5 4 3 2 1

CONTENTS

A section of color photographs follows page 134

LIST OF ILLUSTRATIONS

The numbers in *italics* refer to the pages on which the illustrations appear.

A section of color plates follows page 134.

PREFACE and ACKNOWLEDGMENTS

I hope some of the excitement of living and working as a professional art critic during the 1970s has found its way into *The Pluralist Era: American Art 1968–1981.* In this book, I have tried to describe some of the main movements and most important artists both in terms of the media and of everyday art life of the era. I have omitted many artists from the 1960s who continued to develop their ideas through the next decade partly because of reasons of space, but also in order to be able to pinpoint what made the seventies such a unique moment in and of itself.

I would like to thank first and foremost Dr. Joan Marter, who read this manuscript chapter by chapter and whose suggestions helped clarify many of the main points of the book. I'm grateful also to Tim Druckery of the School of Visual Arts for his initial suggestions and for reading the finished photography portion of the work. In terms of research, I want to thank J. N. Herlin for providing valuable material, which I always asked for "at the very last minute," along with Steve Jacobson, Carlo La Magna, Elaine Reichek, and Erika and Bill Shank of Shank Design. The cooperation of Paula Cooper of the Paula Cooper Gallery and of the Leo Castelli, Max Hutchinson, David McKee, Holly Solomon, Pace, and Robert Miller galleries was also invaluable. I would also like to mention here my two research assistants, Teresa Salazar and Beatriz Hernandez, and my students at both Pratt Institute and the School of Visual Arts, on whom I tried out many of the ideas in the book. And lastly, I want to thank, as a group, my book's heroes and heroines, the artists who have contributed their works to my pages.

1

SoHo and the Seventies

In 1969, New York's Museum of Modern Art turned forty. Simultaneously, the modernist movement from which it takes its name, having been around since 1904, suddenly seemed like past history. As Harold Rosenberg wrote in his essay "The Old Age of Modernism," "Regardless of semantics, modern art is art of the past, a period style with its masterpieces, heros and legends. In the museum, modern art is no longer a process of realizing new possibilities; it is the province of historians and curators engaged in the classification and preservation of artifacts."[1] Pop Art and Minimalism, the dominant styles of the late sixties, also belonged to the tail end of modernism, while the elevation of Conceptual Art as art's end signaled rather the beginnings of the seventies and the Pluralism of the seventies, which effectively did away with the idea of dominant styles for at least a decade. Pluralism, with its non-successive, non-heroic populist stance, is, of course, the very opposite of modernism, and it seems to have arrived almost by default. From a 1979 vantage point, the critic Kim Levin wrote, "The 1970s has not been just another decade. Something did happen, something so momentous that it was ignored in disbelief: modernity had gone out of style."[2] And this passing of modernism took with it the idea of successive major visions, and of art history itself as any kind of sequential stylistic story. Moreover, the seventies as the first post-modernist decade, a captive of its own mixed political and social currents, was itself slow to acknowledge its own wholly Pluralist impulses.

By the end of the seventies, terms such as "post-modernism" and "Pluralism" were being used interchangeably. (The term "post-modern," in fact, came from the book on architecture by Charles Jencks which attacked the International [Bauhaus] school and modernist tradition in architecture and argued for a personal, more eclectic approach.[3]) It was at this time that critics discovered that modernism in fact had lost its critical nerve, that the movement which "sought liberation from history

and began by craving the new, the daring and the destruction of the orderly . . . by cutting off history and tradition had brought us a nice case of alienation and angst," as David Klass wrote in his 1980 editorial in *The New Art Examiner*.[4] From being anti-establishment, modernism had become the establishment, and a good target for artists and critics to attack. But it still, of course, had its loyal champions. "What makes modern art 'progressive' then is its capacity for doing infinite things with limited means," Suzi Gablik explains in her 1977 book, *Progress in Art*. Gablik's modernist position (with some philosophic underpinnings from the French thinker Jean Piaget) is that Don Judd's work, for example, represents perceptual progress over the canvases of Renaissance painters, Picasso, and so on. Thus, Gablik was championing the modernism which had begun back in the 1860s with the Impressionists and for a hundred years had advocated breaking with all academic tradition in the name of progress.[5] The post-modernists, meanwhile, had set off "to cure the angst by reconnecting with some grander spiritual force, and were busily riffling through art history. To a limited group of Conceptual artists and architects, post-modern was seen to be above all an eclectic art of ironic quotation. But in fact, most of the seventies art of this first post-modernist period, while more personal, autobiographical, and social than earlier, modernist art, was nevertheless in deadly earnest. This earnestness, however, was about different things: it was Pluralist—concerning artists' personal lives, the fate of the earth, one's sex, the idea of individual and natural perceptual changes, and the making of technology into a tool of vision. For the era of the seventies, unlike the painter Ad Reinhardt's prescription "Art is art," art in fact was everything else. And thus the Conceptual post-modernists were in fact only a small, vociferous group among a number of such groups, each contributing its vision to the Pluralist spirit of the decade.

From the start, this Pluralism had a quasi-political character. The radicalism prevalent in the 1960s had reached the American art world late. It was in Paris during the 1968 student riots that artists' graffiti announced, "To be free is to participate" and "We have opted for surrealism in the streets." While of course individual artists in America were active locally in the peace movement all through the period, it wasn't until 1970, after the bombing of Cambodia and the Kent State University killings, that artists became mobilized as a large group. It was on May 18, 1970, at a meeting of over fifteen hundred New York artists, writers, and art dealers at New York University's Loeb Student Center, that the New York Art Strike was born. From this initial meeting came a series of actions: ten days later over five hundred people participated in artist-staged sit-ins on the steps of the Metropolitan Museum and inside the Whitney and Guggenheim museums. A series of exhibitions for peace were held where artists donated their works and, on occasion, dealers contributed their gallery space as part of their political action. But, as proved true throughout America in the early seventies, this first wave was followed by a splitting into populist groups, with femi-

nists, blacks, and Puerto Ricans organizing their own spaces to fight for greater recognition.

While that struggle was going on inside the art world, artists were also working to take their art outside, making Earthworks and Conceptual books and pieces, and trying to create a non-collectible art that could exist apart from the gallery/museum system. At the start of the seventies, these second-generation Minimalists were concerned with Process and anti-object works, with *arte povera* (meaning art specifically made from non-fine art materials) on the one hand, and with words on the wall on the other. The ruling idea of this post-Minimal, quasi-Conceptual art—an art that now still seems close to Minimalism—was summed up in Eva Hesse's stated aim: "to go beyond what I know and what I can know."[6] Meanwhile, alongside this conceptual process work another kind of art was being created, an art rooted in social categories and bent on investigating the current ecological situation on the one hand, and on the other, the personal meaning of being a woman or a black or being both, as the case might be. All this new work, as well as new conditions, gave rise to a new kind of exhibition space uptown, downtown, and in SoHo.

New York's SoHo is the perfect paradigm of seventies Pluralism. The SoHo area (South of Houston Street) in downtown Manhattan began to attract artists from a variety of schools and had become an artists' neighborhood by the end of the sixties. Less than five years later, by the mid-seventies, SoHo had become an acknowledged art center, and today includes galleries, and artists and dealers from all parts of the world; every school of contemporary art is shown there sooner or later. In 1969, though, the area was a quasi-derelict manufacturing neighborhood which offered painters, sculptors, and filmmakers unused, inexpensive manufacturing spaces that could easily be converted into studios. Three years before (in 1966), thanks to the efforts of a local artists' tenants organization, "living in manufacturing lofts" had been made legal for artists under New York City housing laws with certain provisos such as "No more than two A.I.R. [artist-in-residence] premises to be occupied in each building." In 1970, the city's Department of Cultural Affairs established more complex loft legalization procedures, giving artists certain building rules to follow in order to achieve a legal conversion of their lofts into studios for both living and working. For the most part, artists did the renovations themselves, subsequently forming groups known as coops (cooperatives) to buy up their buildings. Thus, due to the shortage and high expense of urban spaces, the seventies saw a growing number of artists become owner-entrepreneurs. What ensured the popularity of the SoHo area itself was an organization formed in 1969 called Friends of Cast Iron Architecture, which mobilized to prevent the area's historic cast-iron buildings from falling into the hands of urban redevelopers. By 1973, Friends of Cast Iron Architecture had succeeded in having SoHo rezoned from Manufacturing to City Landmark status, which effectively closed off the neighborhood to high-rise construction. The artist-residents

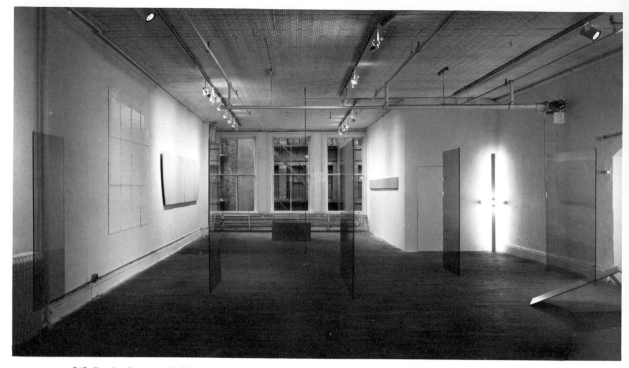

[1] Paula Cooper Gallery, New York City, opening exhibition, October 1968. Installation view, with work by Robert Ryman, Robert Mangold, Donald Judd, Robert Huot, Dan Flavin, Robert Murray, David Lee.

and the gallery owners who followed them into the area worked hard to preserve SoHo as a coherent neighborhood.

Paula Cooper, one of SoHo's earliest art dealers, opened her gallery at 98-100 Prince Street in 1968 [1]. Its third-floor exhibition space was created by putting two manufacturing lofts together to total over 5,000 square feet and, according to Cooper, the gallery space "was beautiful, funky and raw." When 98-100 Prince Street was sold and the building turned into a cooperative, Cooper relocated to SoHo's Wooster Street, where, in the early seventies, her gallery was described as "showing abstract art with a catholic orientation."[7] Another early SoHo settler, the O.K. Harris Gallery, which opened in 1969 at 465 West Broadway, boasted 7,000 square feet, which its owner, Ivan Karp, turned into three separate showing spaces. While O.K. Harris began by featuring a handful of prominent Photo-Realist artists, from the very beginning Ivan Karp espoused a changing, multiple-style stance. Abstract, representational, and numerous *trompe l'oeil* realists to this day make up Karp's shifting gallery roster. Meanwhile, by late 1972, various artist-owned cooperative galleries of feminist, realist, and abstract persuasion had opened their doors. Each of these groups was militant in its stylistic position while exhibiting the work as a challenge to the SoHo art world. In 1973, a group of prestigious dealers (including Leo Castelli and André Emmerich, who had made international reputations exhibiting American Pop, Mini-

mal, and Color Field art) united to buy and remodel the building at 420 West Broadway as their downtown gallery space. It was late in 1974 that Holly Solomon, who was to promote and sponsor a raft of decorative artists and champion a very different kind of art, opened her gallery in the next block of West Broadway. Thus, unlike New York's Tenth Street in the 1950s or Paris's Montmartre (Ecole de Paris) at the beginning of the century, New York's SoHo never achieved or aspired to a single aesthetic. From its inception, the area was Pluralist both in style and subject matter. Even the boutiques that began to open and eventually came to dominate SoHo's streets were eclectic, first offering antique clothing, then African jewelry and Italian designer sportswear as the area became increasingly international. It was only at the very end of the seventies, though—actually, in 1980 and 1981—that other nations' styles and approaches to art-making became an integral part of America's aesthetic Pluralism.

If SoHo was a new kind of art neighborhood, the surrounding "alternative spaces" were a new kind of exhibition space. They were "public" in the sense that most of them had public funding, and yet they were from the art world. They were "created for artists who wanted to make art beyond the object, beyond the gallery, beyond the audience," Mary Delahoyd wrote in "Seven Alternative Spaces" (published in the New Museum catalog for the 1981 exhibition "Alternatives in Retrospect: 1969–1975). At the start, these alternative spaces looked like a continuation of the sixties, specifically of the "Nine Evenings of Art and Technology" staged at the New York Armory in 1968. Certainly some of the same artists exhibited in them. Nevertheless, there were immediate differences. The advent of video, the shift from the notion of Happening to Performance, and the creation of the term "Performance artist" indicated the changing, non-material Conceptual approach. The Kitchen (so named because it began in a kitchen space on Mercer Street in 1971) is a Conceptual space which moved to SoHo in 1974, where it remains committed to showing works by composers, dancers, and video and Performance artists, while its opposite number, Global Village (in SoHo since 1968), functions primarily as a broadcast, production, and video screening center.

In the early seventies, museum policy became more cautious and conservative as mounting exhibitions became a more expensive affair. Hence, the alternative spaces proliferated to fill the gap between the growing number of young artists entering the art world and the decreasing number of places for them to show. Also, it was in the early seventies that for the first time substantial amounts of government funding became available for the arts. It was, in fact, the discovery that state money for the visual arts was available if a nonprofit conduit could be organized that led Irving Sandler and Trudie Grace to organize a Committee for the Visual Arts. In 1973, the Committee held a series of meetings with the New York art community to arrive at the most efficient way of going about funding exhibitions of new work. It was decided

to set up a permanent gallery, and Artists Space at 155 Wooster Street opened in 1973. Artists Space is dedicated to giving individual artists their first shows. When it began, though, its first artist exhibitors were chosen mostly through recommendations by older artists. It took another year (1974) for the Artists Space Unaffiliated Artists file to be set up (in 1974 representing more than one thousand young artists), and the file has become a pool from which subsequent Artist Space committees and new directors make their selections. Today, Artists Space continues its showing policy from its new Hudson Street location, receiving the greater part of its maintenance from private foundations.

After 1975, places such as Studio Watts in Los Angeles, 10 Bleecker Street, The Kitchen, and Artists Space either disappeared or became institutions in their own right. The space known as 10 Bleecker Street metamorphosed into the Institute for Art and Urban Resources, with its own four-story building of studios and exhibition areas (known as P.S. 1) in Long Island City and its top-floor Clock Tower gallery in downtown Manhattan, both spaces under the direction of its founder, Alanna Heiss, whose aim in founding this alternative-space empire was "to make the city an easier place for the artist."[8] Meanwhile, the Studio Museum, devoted to showing work by black artists, established permanent headquarters in Harlem, while the Puerto Rican community has used El Barrio Museo building on 104th Street and Fifth Avenue to serve the needs of Puerto Rican artists.

Besides those mentioned above, there are today other places specializing in showing a certain kind of work or aesthetic approach. The Drawing Center, 137 Greene St., which opened in 1977 under the direction of Martha Beck, a former curator at The Museum of Modern Art, was funded by the New York State Council on the Arts and the National Endowment for the Arts as "a nonprofit center for the exhibition, research and study of contemporary drawing." During the first year of its existence, the Center exhibited drawings by the famous Spanish architect Antonio Gaudí and works by various well-known artists from the Sonnabend and Castelli galleries. Since then, it has concentrated on mounting group shows of younger, unrepresented artists. A similar policy is followed by the SoHo Center for Visual Artists on Prince Street, which also specializes in exhibiting painting and sculpture by unknown, younger artists. In contrast to the last two, the Franklin Furnace and Printed Matter spaces are dedicated to keeping on view work by contemporary artists, exhibiting artists' books (with emphasis on books made by artists, rather than books about artists), and sponsoring Performance works and poetry readings. Franklin Furnace also functions as an archive, registering and keeping records of the existence of all such work.

The problem in the seventies was to keep up with the proliferating art. In order to fill the gap between the alternative spaces and museums such as The Whitney Museum of American Art and The Museum of Modern Art, in 1977 Marcia Tucker,

a former senior curator at the Whitney, opened her New Museum on Fifth Avenue and Thirteenth Street. According to Tucker, the museum is not an alternative space. "The museum is not artist-run. We're a group of art historians. Almost every person on our staff has at least a master's degree. We do the catalogs we set out to do and an educational program both for adults and children. We function in a very museological way," she explains.[9] In its first six years, the New Museum mounted a number of important exhibitions. It put on the now historic " 'Bad' Painting" show, and offered such contemporary historical surveys as the "Alternatives in Retrospective" exhibition, Ree Morton and John Baldessari retrospectives, and surveys of early work by such artists as Lynda Benglis, Joan Brown, Gary Stephan, and Lawrence Weiner —all supplying important documentation of recent art. The New Museum, which for six years existed in borrowed space at the New School for Social Research, moved to its own premises, in SoHo, during the 1983–84 season.

Pluralist, alternative: the seventies created a new art world, larger, more populous, and more prosperous than the Minimalists had ever dreamed of—an art world where Claes Oldenburg's Pop monuments seemed just about the "right size." Seventies art didn't replace Pop Art and Minimalism, but instead offered a host of alternatives——offered the idea that art could be many things and many spirits. Thus, even while many of its creations have become part of permanent collections, the era remains a problem for all its would-be historians. And, by today, artist-created SoHo has become the very last place a young artist can afford to live. It is an area populated by art dealers, entrepreneurs, and collectors, along with its few, now middle-aged, first settlers. Young galleries, cooperatives, and alternative spaces today operate only at its edges. Despite this, the seventies and SoHo itself have become historic by making art more widespread than ever and by aiding in the creation of the wide variety of art which will be described in the succeeding chapters.

NOTES:
SOHO AND THE SEVENTIES

1. Harold Rosenberg, "The Old Age of Modernism," in *Art on the Edge* (New York: Macmillan, 1975), p. 287.
2. Kim Levin, "Farewell to Modernism," *Arts Magazine,* Oct. 1979, p. 90.
3. Charles Jencks, *The Language of Post-Modern Architecture* (New York: Rizzoli, 1977).
4. David Klass, "Editorial," *The New Art Examiner,* Jan. 1980, p. 1.
5. Suzi Gablik, "Stages in the Development of Art," in *Progress in Art* (New York: Rizzoli, 1977), p. 46.
6. Eva Hesse, in Germano Celant, *Arte Povera* (New York: Praeger, 1969), p. 56.
7. Helen Zucker Seeman and Alanna Siegfried, *SoHo* (Neal-Schuman, 1978), p. 53.
8. Phil Patton, "Other Voices, Other Rooms: The Rise of the Alternative Space," *Art in America,* July/Aug. 1977, p. 82.
9. Julia A. Fenton, "Interview: Marcia Tucker," *Art Papers,* Jan.–Feb. 1982, p. 11.

2
Process and Conceptual Art

By 1967, Minimal Art had achieved world-wide renown and was being acknowledged along with Pop Art as one of the two definitive American art movements of the 1960s. For the most part, Pop Art dealt with painting (with the major exception of Claes Oldenburg), while the Minimalists (excepting Frank Stella and Robert Ryman) addressed themselves to the problems of sculpture. Thus, in 1967 the popularity of the primary structure in steel, plastic, and brick, and the stripped-down all-white and pin-striped paintings exemplifying the concept of "What you see is what you get" was at its height. It was in the summer of that year in Aspen, Colorado, that Robert Morris, a leading Minimal sculptor, began making felt pieces loosely tacked to the wall, hanging sculptures whose shapes were deliberately left loose and unsupported. Meanwhile, in New York City the same June, Richard Serra, a younger, then unknown artist, started working with rubber. "I discovered there seemed to be a lot of rubber lying around Canal Street, and found more in the rubber than in anything else —a sort of private language going on—and I felt if you could only get that language, you could reinforce your art by using it," he later reported.[1] And it was then that Serra began making his vulcanized rubber pieces of sloping circles in harness shapes, which were to hang from nails on the wall the following year at the Noah Goldowsky Gallery.

Richard Serra's seeking to find the strength of "rubber's private language" was soon to be paralleled by Lynda Benglis's insistence on her own body as physical source; by Barry Le Va's strewing of his "distributional sculpture," which by its simple occupation of the floor was intended to provoke a visceral reaction in the viewer; and by Dorothea Rockburne's coloring by means of seeping sheets of oil into cardboard surfaces. Around all these younger artists lay the cool, the machine-made, the idea of the artist as super-designer who was, in Andy Warhol's phrase, "to be

famous for five minutes." Pop Art had turned the gallery into a store full of witty objects, while Minimal sculpture, deliberately disconnected from human beings, became the apotheosis of the factory culture. In reaction, a new generation of artists rejected this dehumanization of art by their fathers and looked back to the mystical grandfather presences of the Abstract Expressionist painters and sculptors. Mark Rothko, Ad Reinhardt, and Barnett Newman became their teachers if not literally then by example. The American art world in the sixties had become very different— it was a world market selling Pop and Minimal Art to everyone. And the Process and Conceptual artists deliberately rejected the commercial aspect, meaning to restore to the artist the position of shaman and mystery-maker in the culture. Rubber, oil, wood —non-pretty, unfinished, unglazed materials that made up the real structure of the objects around the artists—became important. Process Art set out to strip art of its glamour and restore to it the pared-down directness of nature. As in Abstract Expressionism, the action, the making of the work, was to reveal life's mystery to the artist and the viewer: in the making of a work lay the finding of its meaning.

In April 1968, Robert Morris's seminal "Anti Form" article, a Process manifesto, appeared in *Artforum* magazine, announcing: "The process of making itself has hardly been examined. . . . Of the Abstract Expressionists only Pollock was able to recover process and hold on to it as part of the end form of the work. Pollock's recovery of process involved a profound re-thinking of the role of both materials and tools in making. The stick which drips paint is a tool which acknowledges the nature of the fluidity of paint. Like any other tool, it is still one that controls and transforms matter. But unlike the brush, it is in far greater sympathy with matter because it acknowledges the inherent tendencies and properties of that matter."[2] Robert Morris's essay argues for incorporating the process, the way of working, into the art as part of its end product; in a similar spirit, Richard Serra argues his preference for using cuts as a device for shaping his rubber, rather than point-to-point drawing, "as being a less self-conscious, less arbitrary means, allowing for a certain amount of change and spontaneity."[3] Thus Serra and Morris both advocated finding form through the use of processes natural to their chosen materials, at the same time deliberately choosing softer materials as part of this move away from structure. Process Art, as it was soon to be called, became a seeking to find and express new forms and/or feeling primarily through the use of soft, industrial materials.

Eva Hesse began to discover the possibilities for art in rope, fabric, and latex and other plastics in 1964. Then a twenty-four-year-old American artist living for a year in Germany, Hesse found such materials to be a good solution for literally transferring her drawings into painting. She began working in relief, translating her lines via cords and ropes and then incorporating papier-mâché and three-dimensional boards. Hesse and her husband returned to New York in 1965, and in the spring of 1966 she was one of the participants in the artist-organized "Abstract Inflationism and Stuffed

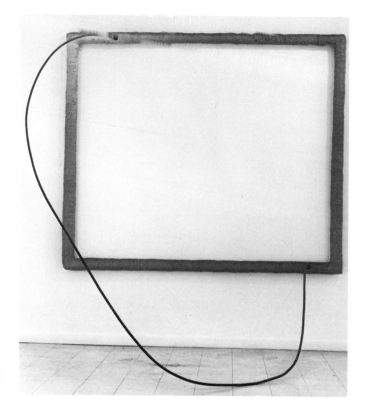

[2] Eva Hesse. *Hang-up.*
1965–66. Collection Mr. and
Mrs. Victor W. Ganz.

Expressionism" show that took place at the Graham Gallery. The exhibition was
utterly out of keeping with the stringently serious Minimal approach of the time,
including its announcement, which, according to the critic Robert Pincus-Witten,
"was a toy balloon surprinted with the gallery particulars emphasizing in this way an
air of comedy." At the time, he reviewed one of Hesse's two works—called *Long Life*
—as follows: "a slapstick ball and chain that might easily pass for an anarchist's bomb
designed by a color-blind obsessive-compulsive."[4] Hesse's other work in the show was
her now well-known *Hang Up* sculpture [2], which Hesse has described "as a frame,
ostensibly, and it sits on the wall with a very thin, strong but easily bent rod that comes
out of it. The frame . . . all cord and rope . . . tied up like a hospital bandage as if
someone broke an arm."[5] From the top of the frame of *Hang Up,* the bent rod
extended some eleven feet out to the center of the room before bending back to the
bottom edge of the frame. In a later interview, Hesse proudly reported, "It was after
seeing this piece that Richard Serra called up and congratulated me." Later the same
year, a more formally organized show of many of the same artists was held at the
Fishbach Gallery, with the critic Lucy Lippard as curator; called "Eccentric Abstrac-
tion," it also included the sculptors Bruce Nauman and Keith Sonnier. In the accom-
panying essay Lucy Lippard explained that "the work was connected both with the
idea of procedure (process art) and ideation," and that the artists in the show were
making "works that were at once both non-sculptural and presented indirect affinities

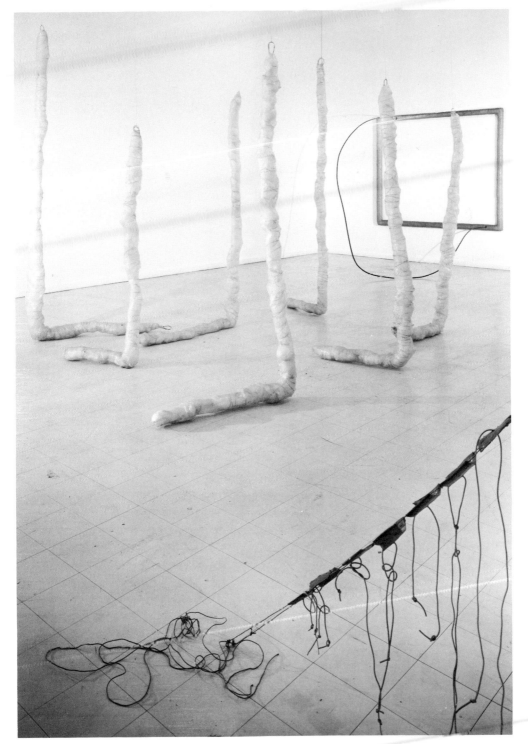

[3] Eva Hesse. Installation, School of Visual Arts. 1970.

with the incongruity and often sexual content of surrealism." After this, Hesse was invited to participate in the series of Process group exhibitions that followed; among them were "9 at Castelli," the "Anti-Illusion" exhibition at The Whitney Museum, and "Process Art IV" at the Finch College Museum. If, during this period, Hesse was somewhat influenced by Minimalists and other Process artists, she herself has pinpointed the difference in her approach (which the *Village Voice* critic John Perreault called "Serial Surrealism"): "If something is meaningful, maybe it's more meaningful said ten times. It's not just an esthetic choice. If something is absurd, it's much more absurd if it's repeated. . . . I don't think I always do it, but repetition does enlarge or increase or exaggerate an idea or purpose in a statement."[6]

In the same interview, with the feminist editor Cindy Nemser, Eva Hesse described her life and her art as being one of extreme positions; her death that year (1970) from a brain tumor, at the age of thirty-three, seems now very much in keeping with this statement. Throughout her short life, it seemed Eva Hesse had to move very fast. After escaping from Germany in 1939 (her parents were German Jews), Hesse attended New York City's Pratt Institute at the age of seventeen, went on to earn a Master's degree from Yale University in 1959, and returned to Germany in late 1963, when her husband had a year's artist-in-residence stipend there. From 1965 to 1970, Hesse's work was widely exhibited and reviewed. In 1970, she was given a survey exhibition at the School of Visual Arts [3] and had a posthumous retrospective exhibition at The Guggenheim Museum. In the years 1966 to 1970, when she produced all her major pieces—most of which had a unique flair—what Hesse was doing with such materials as rope, latex, rubberized cheesecloth, clay, metal, and wire mesh was very much in keeping with the substance if not always the spirit of Process Art.

The group exhibition titled "9 in a Warehouse" and later called "9 at Castelli" opened at the art dealer's warehouse on West 108th Street in December 1968. It was organized by Robert Morris, followed by the sculptor's own exhibition of felt pieces at the Castelli Gallery, and certainly seemed to exemplify many of the premises Morris had put forth in his "Anti Form" article. Indeed, that essay could have served as the show's exhibition catalog, with its explanation of what was at stake in Process Art. "In object type art," Morris wrote, "process is not visible. Materials often are. . . . A direct investigation of the properties of these materials is in progress. . . . Considerations of gravity become as important as those of space. The focus on matter and gravity as means results in forms which were not projected in advance. Considerations of orderings are necessarily casual and imprecise. Random piling, loose stacking, hanging give passing form to the material. Chance is accepted and indeterminacy is implied."[7] It turned out that only seven of the nine artists announced actually took part in the exhibition, since the pieces by the two Italian artists Anselmo and Zorio never arrived. Besides Eva Hesse, the other artists Robert Morris chose and whose

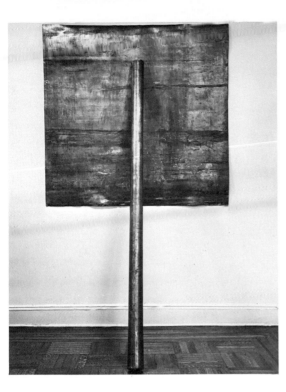

[4] Richard Serra. *Prop.* 1968.

works were actually in the show were William Bollinger, William Kaltenbach, Bruce
Nauman, Alan Saret, Richard Serra, and Keith Sonnier. It was Richard Serra's lead
sculptures that were acclaimed as the strongest and the most radical works in the
exhibition. In a very long article in the *New York Times,* Philip Leider described one
Serra piece as "consisting of a heavy quantity of silver paint splashed along the bottom
of the gallery wall as well as on the floor, with the meeting of wall and floor, a quiet
and passive encounter in everyday life, here made violent. . . . But the main point is
that the material—the silver paint—has assumed no form other than one entirely
natural to its own fluid, formless properties."[8] If this splashed piece was Serra's most
dramatic statement, another piece, entitled *Prop,* proved more significant historically.
Prop consisted of a square of thickly rolled lead pinned in place on the wall by a heavy
steel pipe, coming up from the floor and propped against it; the angling of the heavy
pipe, with the help of gravity, secured the lead square to the wall. In Philip Leider's
words, "The pipe relates the lead square to the floor, the square relates the pipe to
the wall; gravity and gravity alone provides both 'the passing form' which the piece
possesses as well as the suggestion that at any given moment, its action could com-
pletely alter it."[9] *Prop* [4] was included in a Whitney Museum sculpture survey in 1969
—the same year Serra made his even more dramatic *Ten Ton Prop (House of Cards)*
piece, consisting of four lead sheets, each weighing four hundred pounds, placed at
a slight incline so that each sheet corner wedged (balanced) the next in place. *Ten Ton
Prop* has come to be considered an icon, or symbol, of the anti gravity aspect of

Process Art. In 1968, Serra collaborated on a three-minute film, "Hand Catching Lead," which is a film of Serra's own hand catching and missing lead tossings. Around this time, he also wrote out the following working list of art acts, or processes, for making sculpture: "To roll/to crease/to fold/to store/to bend/to shorten/ to twist/to dapple/to crumple/to shave/to tear/to chip/to split/to cut/to sever/to drop."[10] Then, in 1970, Serra wrote his own manifesto of sorts, entitled "Play It Again, Sam," explaining that, for him, "The perception of the work in its state of suspended animation, of arrested motion does not give one calculable truths like geometry, but a sense of presence, an isolated time." Here he also puts himself on record as not being interested in welding or the idea of such kinds of attaching, which stop rather than interrupt a material's action. "There is," he wrote, "a difference between definite literal fixed relationships, i.e., joints, clips, gluing, welding etc. and those which are provisional, non-fixed, elastic. The former seem unneccessary and irrelevant. . . ."[11] Nevertheless, as Rosalind Krauss has pointed out, the "cut" is a preoccupation of Serra's which is already present in the rubber pieces, the torn lead pieces of 1968, and the cutting pieces of 1969. "Like the cut in the film," Krauss explains, "Serra's cut connects materials at the same time that it physically divides them."[12]

Born in San Francisco in 1939, Richard Serra attended the University of California at Berkeley, and earned the M.F.A. degree from Yale in 1964 (five years after Eva Hesse). Explaining his preoccupation with his material, he has said, "As a kid when I was fifteen, I was in a ballbearing factory; when I was 16, in a steel mill, 17, a steel mill," adding he went on to put himself through college by working with a rivet gang at Bethlehem Steel. It wasn't until the mid-seventies that Serra began doing permanent steel pieces (the earlier works were all temporary installations)—pieces that relate very much to the 1972–73 sheets which were propped up to come out from gallery walls and divide exhibition spaces into strange corners by their odd angling.

According to the *New York Times* review, Keith Sonnier's work in the "9 at Castelli" exhibition seemed "almost shocking in its evocation of pictorial space and atmosphere."[13] One Sonnier piece, titled *Rat Tail Exercise,* connected two strings from floor to wall. *Mustee #2,* Sonnier's more complex color work, consisted of a thin sheet of adhesive latex mounted on the wall and covered with "flocking" (colored powdered rayon), which modified the color and shape of the latex rectangle vis-à-vis the wall's own color, making the wall the ground in a figure-ground relationship. Sonnier is one of the few Process artists (together with Dorothea Rockburne and Lynda Benglis) to deal with painting problems and be actively concerned with color. Born in Louisiana (as was Lynda Benglis), Keith Sonnier went from the University of Southwest Louisiana to France in 1963, where he spent the next two years painting semi-erotic pictures. In 1966, he applied for and received a teaching assistantship in the Douglass College Art Department, of Rutgers University, in New Brunswick, New Jersey, where he began exchanging ideas with Robert Morris and Gary Kuehn,

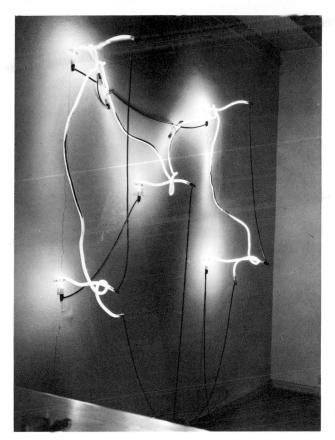

[5] Keith Sonnier. *Untitled.* 1969. Collection Dr. Peter Ludwig.

also on the faculty there at that time. That same year, Sonnier shifted from paint to vinyl and other prefabricated plastics, and was included in Lucy Lippard's "Eccentric Abstraction" show. About 1969, in place of rubber latex and cheesecloth, Sonnier began to use thick sheets of glass shaped in circles and squares in combination with neon tubes [5]; this approach also characterized his work in the 1969 "Anti-Illusion: Procedures/Materials" exhibition that year at The Whitney Museum.

Bruce Nauman, like Keith Sonnier, has used a variety of materials (which included neon tubing) in his work, but his emphasis has always been more on concept rather than material substance. From the beginning, Nauman very consciously took the great French Dadaist Marcel Duchamp as the model of an artist moving art further out from conventional materials. In 1965, the California-born Nauman announced that he intended "to create forms never before seen, made of substances and colors in ways equally unknown."[14] From 1965 to 1967, he made soft sculptures of colored rubber latex with neon templates supported by the wall and floor; he was included, with Sonnier, in Lippard's "Eccentric Abstraction" show. After this, Nauman seemed to start over, taking his own body as a starting point; the piece entitled *Hand to Mouth,* done in 1967, consists of a wax casting of himself, representing his right hand, arm, shoulder, jaw, and lips. For his solo exhibition at the Castelli Gallery

in 1968, Nauman made a series of holograms—photographs made with laser beams that project seemingly three-dimensional images—holograms of himself viewed from below in multiple crouched and fetal positions. His piece in the Whitney Museum "Anti-Illusion" show consisted of a long narrow passageway that one walked through only to discover a video camera at work at the end, so that the passageway was made to be experienced as a scene for the tape.

The "Anti-Illusion: Procedures/Materials" show, organized by James Monte and Marcia Tucker, included a broad mix of Minimal sculptors with Process artists and composers in an attempt to document the mood of the time. The twenty-two-artist roster included a number of important Process artists not represented in the "9 at Castelli" exhibition; among them were the sculptors Barry Le Va, Richard Tuttle, and Lynda Benglis. In different ways, the work of all four of these artists seemed to address issues raised by their Abstract Expressionist predecessors. Barry Le Va, from California like Bruce Nauman, while attending the Otis Art Institute in Los Angeles had decided to be a painter along the lines of Jackson Pollock and Barnett Newman. By his last year in school, though, Le Va had decided he "wanted to reduce art to my terms and then rebuild it—my terms with nobody else's influence."[15] Between 1966 and 1967, Le Va made ten plexiglass trays filled with pieces of felt "in order to have something to show at the graduate exhibition." The Otis Institute had first refused to show the felt pieces or to consider them art unless they were affixed in some way to bases, but these works, though not of interest to Le Va's fellow students, did attract the attention of several art critics. In 1968, Barbara Rose reproduced a photograph of Le Va's *No. 10 1967* [6], with a caption which read in part, "Sculpture of wood, felt, chrome and ball bearings arranged on the floor in a binary system of opposing polarities," in her February/March *Art in America* article, "Gallery Without Walls"; the following month Le Va was included in an *Artforum* article on new Los Angeles artists. Meanwhile, Le Va took a teaching job at the Minneapolis Art Institute, where in 1969 he had his first solo exhibition, which consisted of two consecutive installations, the first being of chalk, mineral oil, and paper toweling, and the second of just chalk. His work in the "Anti-Illusion" show, a piece called *Omitted Section of a Section Omitted 1968–9,* consisted of a fine layer of flour in an irregular shape. Le Va had decided on using materials without much substance as a way to reduce his involvement with materials in general, but subsequently he abandoned the chalk/powder floor works as being too seductive visually. Critics began to refer to Le Va's pieces as "distributional sculpture," reflecting the sculptor's statement that his arrangements were intended to induce a physical experience for an audience participating in walking around these areas. For his first New York exhibition at the Bykert Gallery in 1973, Le Va did an installation entitled *Twelve Lengths, Three Areas* on the gallery floor. Describing a later floor work, Le Va wrote: "Floor space is broken up into two or three isolated areas of differing arrangements consisting of small rectangular pieces

and lengths of wood. . . . Because the located areas are a product of an underlying network of organization which may very loosely be defined as a system does not mean that the work is about that system, nor of any other system. The work is a specific perceptual construction within and about a space, which breaks down creating the individually separate spatial areas which are not visibly defined and become apparent when discovered through experience."[16] Le Va's work, like that of several other Process artists, emphasizes temporality by its focus on impermanent materials and situations. Early on, Le Va stated he was not necessarily concerned with the specific language of certain materials, but rather with materials as the language of a specific idea or concept; the subsequent drawings, floor plans, and installations of his "distributions" or "distributional sculpture," Le Va says, are "attempts to provide viewers with something they do not already know, to establish a dialogue, an exchange between art and audience. What you give the work, it gives you. I am trying to make the audience an active part of the time structure from beginning to end, part of the past, the present and the eventuality."[17]

Thus, the Process artists' approach to materials was even more puritanical and stringent than that of the previous Minimal generation's fabrication of industrial-like objects. Minimal art focused on experiencing the object, on its explicit presence, while Process artists like Barry Le Va and, perhaps even more, Richard Tuttle set out to

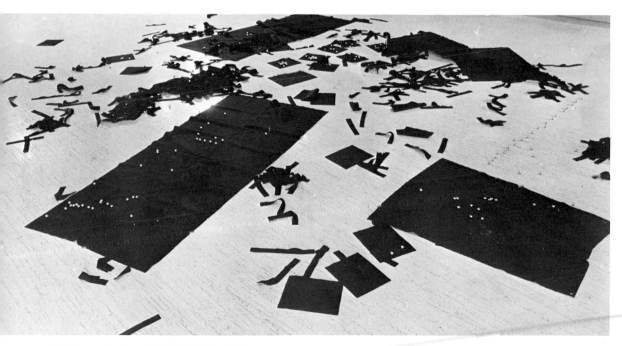

[6] Barry Le Va. *Untitled #10.* 1967.

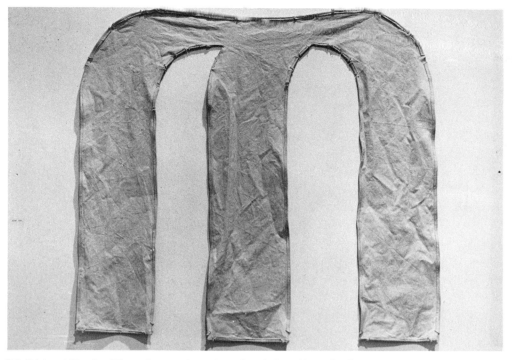

[7] Richard Tuttle. *Three Orange Bars Joined with Free-Form Sculpture.*

evoke the implicit, to create something that only through the viewer's participation would evoke an experience of the art.

Richard Tuttle's *Octagons* in the "Anti-Illusion" show at the Whitney consisted of ten dyed, unstretched, unironed canvas shapes hung on the wall and placed on the floor, which Tuttle described as "drawings for three-dimensional structures in space."[18] The work was an immediate subject for controversy, with John Perreault writing in the *SoHo Weekly News* of "Cloth Octagonals." "As paintings, they abolish the support; they make color integral; they make texture the result of a non-painterly process. As sculpture, they make cloth as a material as valid as bronze or clay." This work and others included in Tuttle's Whitney retrospective some years later provoked the *New York Times* critic Hilton Kramer to complain, "In Mr. Tuttle's work, less . . . is, indeed, remorselessly and irredeemably less. It establishes new standards of lessness, and fairly basks in the void of lessness. One is tempted to say that, so far as art is concerned, less has never been as less as this"[19] [7].

Richard Tuttle, born in 1941 in Rahway, New Jersey, attended Trinity College in Connecticut and came to New York in 1963, where he studied art for a year at Cooper Union. He was given his first one-person show at the Betty Parsons Gallery in 1965, and his work from the start has been, according to some critics, "overly dependent upon its setting for its effect." Rather than being object-oriented, the work was meant as a translation into objects of a kind of interior space. One installation in his 1975 Whitney Museum retrospective was entitled *Ten Kinds of Memory and*

[8] Lynda Benglis. *Bounce.* 1969.

Memory Itself. This work consisted of eleven string pieces on the floor, each piece predicated on the choreographed movements of a single body—for example, Tuttle wrapped the string around his body while crouching down and then cut off the string to that particular length and shape. Also included in this exhibition were Tuttle's wire pieces from 1971 through 1974. These were "drawings done with thin wire and executed by placing nails in the wall according to a brown paper pattern on which their location was marked and then stretching the wire from nail to nail." While the wire pieces seem more deliberate, the making process is an equally integral part of the work. Part of each piece is the evidence, in terms of pencil markings and so on, of how it was made, and thus to some extent Richard Tuttle's work has always had to do with process, often embodying in subtle ways the physical imprint of the artist's gesture.

Lynda Benglis was among the artists selected for the Whitney Museum's "Anti-Illusion" exhibition, but at the last minute, because of a curatorial disagreement, her floor piece was not included in the exhibition. (Someone at the museum had told Benglis she would have to attach her poured rubber pieces to the wall, which the artist refused to do.) In the same year as the Whitney exhibition, 1969, Lynda Benglis participated in a group show at the Bykert Gallery, exhibiting a latex floor piece which she made "by spilling liquid rubber in a free flowing mass directly on the floor of the exhibition space." The spill, called *Bounce* [8], was a mix of "fluorescent oranges, chartreuses, day-glo pinks, greens and blues that made a kind of painting . . . entirely

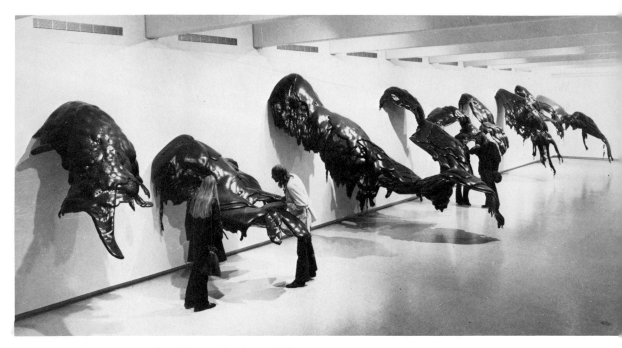

[9] Lynda Benglis. *Adhesive Products.* 1971.

free from an auxiliary ground," which became, according to the critic Robert Pincus-Witten, "a free gesture gelled in space."[20]

Born in New Orleans, Benglis made her first connection with art at Newcomb College there, where she simultaneously realized "art could be a thinking situation" and was attracted to the works of the older American Abstract Expressionists, such as Mark Rothko and Jackson Pollock. When Benglis came to New York in 1964, her response to the cool esthetic around her was "to want to make something very tactile, something that related to the body."[21] She began making narrow wax paintings the length of her arm. Jackson Pollock's interest in his last years in fluorescent paint also became a point of departure as Benglis began pouring her polyurethane pieces, while still making the melted wax paintings (which were very much concerned with the artist's gesture). "I was interested in process," she later explained. "When I learned what the material could do, then I could control it, allowing it to do so much within the parameters that were set up. So the material could and would dictate its own form, in essence."[22]

As Robert Pincus-Witten has pointed out, "Like Richard Serra and Keith Sonnier (and also Richard Tuttle), Lynda Benglis was transposing the easel tradition questioned in abstract expressionism into an actual environmental enterprise." In the years from 1969 through 1971, Benglis's works moved from being single free-standing

objects on the floor to rows of flying configurations adhering to the wall. These wall works were made by pouring pigmented polyurethane over a chicken-wire armature covered with polyethylene sheeting; the armature was removed when the piece was finished. Benglis showed these works at the Paula Cooper Gallery in SoHo, the Walker Art Center in Minneapolis, and at Vassar College in Poughkeepsie. From this series developed the "knot" pieces of the late seventies. According to one critic, Benglis's work through the mid-seventies "was a process art concerned with making soft things hard while preserving their insouciant memories of softness . . . of living out the romantic concept of the artist as a force of nature (that Jackson Pollock exemplified). As nature can change states," he concluded, "freeze water, melt rocks, Benglis too congeals or liquefies matter"[23] [9].

Richard Serra, Lynda Benglis, Barry Le Va, and Richard Tuttle were all concerned with making forms shaped by acts in time—by dripping, pouring, cutting, hardening, or scattering. All of them were concerned with process, and used materials in a highly intuitive, non-schematic way. Dorothea Rockburne, however, inhabits an in-between state. Rockburne shares with the others an interest in materials and the experience of materials in time, but she also has a conceptual approach—her use of mathematical set theory as a means by which to structure her art. She sees her work as inhabiting the gray area between painting and sculpture, but coming closer to painting, since it always touches the wall. Dorothea Rockburne first studied painting in the late 1950s at Black Mountain College, where she discovered she "didn't want to do a painting that involved stretcher bars and canvas because the stretcher bars never seemed to have a function other than to represent external elements in a way you weren't supposed to see."[24] From the start, the visual presence of her processes was all-important, causing her to shy away from objects, which by definition must contain hidden underpinnings. In the mid-sixties, when Rockburne decided to use mathematical set theory as a working premise, she chose paper, grease, oil, graphite, and chipboard as the materials to encompass a room in which each element could interact. One of the physical qualities defining such materials is of course their impermanence. But Rockburne's interest was in immediate physical presence; her work with colors is in the form of industrial paints and oils as physical layers, expressions of depth and dimension. Colors are never mixed, but rather applied as separate sheets. Even using mathematical set theory—a discovery in math, Rockburne points out, that was made about the same time that Karl Marx was writing—is a relational device, a process with which to get at her own feelings. "When I read about theoretical analyses," she says, "an instant visualization takes place. When I read about mathematical disjunction, I visualized disjunction in terms of crude oil, in terms of the absorption of crude oil and crude oil itself as a liquid sheet." In such works, memory—her own and the viewer's—becomes important as one moves from one element to the next in a room. Such pieces as *Leveling* and *Disjunction/Or* [10], made

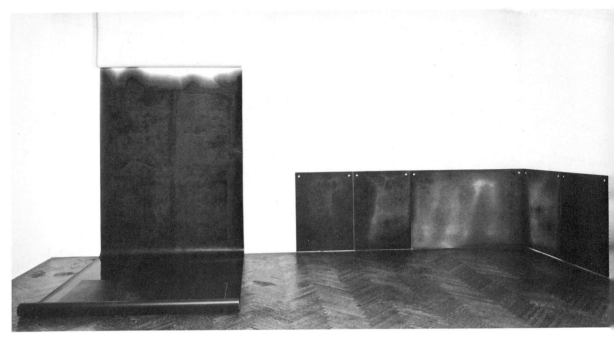

[10] Dorothea Rockburne. *Disjunction/Or.* 1970.

of paper, chipboard, and oil, are works of set membership meant to express growth and change as the eye moves up and down from the oil-soaked geometric rectangles against the wall, which by means of a material-soaking process seem to move gently forward and backward in the room. In the early seventies, Rockburne made a series of paper works with folded paper and ink entitled *Drawing That Makes Itself.* The artist returned to painting—or, anyway, to the use of gesso on sized linen in her *Golden Section Paintings* done in 1975, which were a continuation of Rockburne's attempts to express mathematical concepts in terms of material proportions. (The Golden Section is a term coined by the ancient Greeks to describe the ideal proportions for a rectangle.) "When I focus my seeing, my peripheral vision does not frame itself into a rectangle; it therefore became necessary to consider the rectangle generating through itself and with this in mind, I chose to use the Golden Section," Rockburne wrote in her statement for the Museum of Modern Art catalog for the 1975 "Eight Contemporary Artists" exhibition [11]. The effect of this new work, knife-sharp elbowing pieces attached to the wall, according to one writer, was to make the use of the golden section seem "camouflage in a game whose stakes are Rockburne's need for an image that will hold her identity . . . an image drenched in historical nostalgia about balance and order. Or maybe it's the other way around, and Rockburne's game concerns a logical orderly hunt for chaos, for primal creative matter."[25]

[11] Dorothea Rockburne. *Golden Section Painting: Rectangle and Square.* 1974.

The latter would seem to me a fitting description for most of the Process artists' varied approaches to art at the beginning of the 1970s.

Conceptual Art

Conceptual Art, "impossible art"—the art of words, of ideas, of the non-physical—is in many ways a child of Minimal Art, and as a formal movement was first named and championed by the Minimal artist Sol LeWitt. In 1966, after the "Primary Structures" exhibition at The Jewish Museum in New York City, Sol LeWitt's importance as a first-ranking Minimal artist was well established. His white, baked enamel pieces, based on the permutations of a cube, were adopted as the ideal visual icon of the new cool art; in Gregory Battcock's seminal anthology, *Minimal Art,* Mel Bochner describes LeWitt's sculptures in that show as "complex multipart structures, the consequence of a rigid system of logic that excludes individual personality factors as much as possible,"[26] claiming that with LeWitt's work, the "new art is attempting to make the non-visual (mathematics) visible."[27] And indeed, it is inarguable that the focus of LeWitt's work was the most conceptual aspect of Minimal Art, a focus that immediately set him apart from artists such as Don Judd, Robert Morris, and Ronald

Bladen, who were in the same exhibition and all of whom were concerned with making sculpture as an object to be seen and apprehended in a single glance. Only Carl Andre, whose piece in that show was a series of fire bricks connecting the doorways of two rooms, shared LeWitt's interest in sculpture as spatial definition; thus it seems logical now that Sol LeWitt and Carl Andre both became frequent participants in the Conceptual Art exhibitions that soon took place.

In 1967, the year after the "Primary Structures" show, a series of pages by Sol LeWitt entitled "Paragraphs on Conceptual Art" appeared in *Artforum* magazine and immediately became an unofficial manifesto of the new movement. LeWitt began by announcing, "I will refer to the kind of art I am interested in making as Conceptual Art," and then went on to define and describe this new type of art. "In Conceptual Art," he wrote, "the idea concept is the most important aspect of the work. . . . The idea becomes a machine that makes the art. . . . What the work of art looks like isn't too important."[28] LeWitt then went on to describe the form this new work will take. "This kind of art," he wrote, "should be stated with the greatest economy of means. Any idea that is better stated in two dimensions should not be in three dimensions. Ideas may also be stated with numbers, photographs or words, or any way the artist chooses, the form being unimportant."

Soon after this, LeWitt adopted drawing as his major expression and made his first graphic wall piece—a drawing rendered directly on the wall of the Paula Cooper Gallery. The work, entitled *Project 1968,* or *Fours,* included written instructions for its making in the form of a label which read: "Lines in four directions (horizontal, vertical, diagonal left and diagonal right) covering the entire surface of the wall. Note: the lines are drawn with hard graphite (8H or 9H) as close together as possible ($\frac{1}{16}''$ apart approximately) and are straight."[29] For LeWitt, from the very beginning, such instructions were an integral part of his Conceptual Art. "If I do a wall drawing," he explained, "I have to have the plan written on the wall or the label because it aids the understanding of the idea. If I just had lines on the wall, no one would know that there are ten thousand lines within a certain space, so I have two kinds of form—the lines and the explanation of the lines. . . . The labels not only explain but they contain the meaning by which a wall drawing multiplies and transforms itself."[30]

In 1969, for a show at the Dwan Gallery, LeWitt used the walls of the main room to express one idea about the nature of drawing (limiting himself to a series of four absolute lines in fifteen combinations) by putting the viewer in the center, surrounded by the drawing, while in the next room he made drawings attached to supports which the viewer walked around, thus experiencing the reverse idea. By this time, Minimal Art had dispensed with the myth of the artist's touch, and LeWitt was employing several assistants for his various projects, which included not just wall pieces but models, artist books, prints, and drawing pieces, all involved with investigations of permutations of shape and number. If the wall drawings remain some of the artist's

[12] Sol LeWitt. *Wall Drawing.* 1970.

most famous works, perhaps this is because, according to the art historian Robert Rosenblum, in them, "the perceptual whole is more than its conceptual parts"[31] [12]. In any case, from 1968 well into the eighties, Sol LeWitt's walls seem to expand like webs of thought covering various museum and gallery walls. Photographs can only suggest the work's original effect as art environments which demanded the viewer's active physical and mental response.

In 1969, LeWitt published what might be taken as a second manifesto, his "Sentences on Conceptual Art," which appeared simultaneously in the publication *0..9* edited by Vito Acconci in New York and in a special number of the journal *Art & Language* issued in England. This, together with LeWitt's 1967 "Paragraphs," pretty well established the perimeters of Conceptual Art not only for LeWitt himself but for the majority of the younger Conceptual artists. In the light of future develop-

ments, however, one statement from the earlier manifesto seems overly limiting. LeWitt's 1967 pronouncement that "Conceptual Art doesn't really have much to do with mathematics, philosophy or any other mental discipline" could be taken as a refutation of the future works of Mel Bochner (based on mathematics theory) or as a denial of the already existing pieces by Joseph Kosuth and the Art & Language Group.

The Art & Language Group, based and publishing in England, consisted of the artists Terry Atkinson, David Brainbridge, Michael Baldwin, and Harold Hurrel, who shared an interest in linguistics and the belief that the chief importance of Conceptual Art lay in investigations into the nature of language and the relationship between art and philosophy.

Mel Bochner, who had majored in philosophy at Northwestern University before settling in New York in 1965, from 1966 through 1971 wrote a considerable amount of art criticism about Minimal and Process Art. During this time, he also made a number of works based on numerical systems and, in 1971, did a project installation at The Museum of Modern Art entitled *Three Ideas and Seven Procedures, ostensibly concerned with describing seven methods, beginning, adding, repeating, exhausting, reversing, cancelling and stopping.* [32] This work consisted of a sequence of spaces painted white and connected by a length of masking tape running from room to room. On the tape was recorded a counting sequence from left to right in black, and superimposed on that was a countersequence in red that ran right to left keyed to the area sizes covered by the tape.

In 1965, two years before LeWitt published "Paragraphs on Conceptual Art," Joseph Kosuth made the sculpture *One and Three Chairs,* which was later included in the "Information" exhibition organized by The Museum of Modern Art in 1970. *One and Three Chairs* consisted of a real chair; a large, lifesize photograph of a chair; and a dictionary definition of the word "chair" printed on a placard and affixed to the wall. The work is Kosuth's most formal and perhaps most graphic statement of the artist's conceptual preoccupation with language [13]. In his statement in the "Information" exhibition catalog, Kosuth provided a definition of Conceptual Art quite different from Sol LeWitt's. "Fundamental to this idea of art," Kosuth wrote, "is the understanding of the linguistic nature of all art propositions be they past or present, and regardless of the elements in their construction. . . . This concept of American 'conceptual art,' " he added, "is I admit here defined by my own characterization and, understandably, is one that is related to my own work of the past few years." [33] In 1969, Joseph Kosuth had written his own Conceptual manifesto, entitled "Art After Philosophy, I and II," leading off his "art section" with a quotation from the philosopher Ludwig Wittgenstein: "The meaning is the use." This article by Kosuth, like LeWitt's, was published by the Art & Language Group in England.

Joseph Kosuth, born in Toledo, Ohio, had studied at the Toledo Museum School of Design and the Cleveland Art Institute before moving to New York in 1965, where

he attended the School of Visual Arts. In 1965, at the age of twenty, Kosuth had decided that "organic and geometric shapes were used up." He began experimenting with formless and ephemeral material. After making the chair piece, he followed it in 1966 with a series of photostatted definitions of water and of hydrogen compounds. The same year, he organized visiting-artist programs at the School of Visual Arts, founded and became director of a "Museum of Normal Art," and wrote reviews of other artists' exhibitions. By the time he met Lawrence Weiner in 1968, Kosuth had become convinced that "art had moved beyond visual-formal considerations and indeed that abstraction was a philosophical linguistical problem."[34]

Lawrence Weiner, a native of New York City, who had moved to California in the early sixties and done a series of Earthworks, by 1968 had resolved that his art should exist primarily in the form of proposals in his notebook. This became easier to do publicly after Weiner met the young New York art dealer Seth Siegelaub. Weiner in turn introduced Kosuth to Siegelaub, who added both men to his stable of artists, and later even went so far as to make himself responsible for Kosuth's financial support. In 1968 Siegelaub began to concentrate on Weiner, Kosuth, and two former Minimal artists who had turned Conceptualists—Robert Barry and Douglas Huebler. Siegelaub organized two important exhibitions, one at Bradford Junior

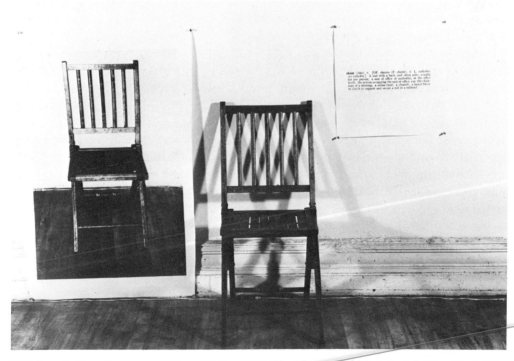

[13] Joseph Kosuth. *One and Three Chairs.* 1965. The Museum of Modern Art, New York City.

College in Bradford, Massachusetts, in February 1968 and the second at Windsor College in Putney, Vermont, in March of the same year. Both exhibitions included artist symposiums. The first show, an indoor exhibition, included Lawrence Weiner, Robert Barry, and Carl Andre. For the second, held outdoors, the artists made works that were not transportable and that would not affect the environment. Lawrence Weiner made a string piece for the outdoor exhibition, the string serving as an indicator of place, but after some students from the college cut the markers, Weiner discovered that the piece itself did not have to exist and that its effect lay in the idea, in the proposal for its existence. Siegelaub published a book of Weiner's "Statements," *The Xerox Book,* which consisted of several artists' proposals, and then decided it was time to mount a New York show for his group. He rented rooms in an office building on Fifty-seventh Street and set about to work closely with Lawrence Weiner, Robert Barry, Joseph Kosuth, and Douglas Huebler. "As an organizer," Siegelaub explained, "I believe in giving every man the same situation, same money, same pages in a catalog, and the same physical space. I asked them how they wanted to show their work—that's how it was done—and discussions continued for one and a half to two months. We decided on the catalog format: four pages for each man, two pages each of photographs, one page statement, and one page listing the works shown. There was also a presentation on the walls of two works by each artist. But in my mind the show existed quite completely in the catalog."[35] This show, which Siegelaub called "January 5–31, 1969," was followed with a "March 1969" show wholly in catalog form, and subsequent Siegelaub catalog exhibitions that year included a "July/August/September 1969" show in three languages, with Conceptual works by Carl Andre, Robert Barry, Daniel Buren, Jan Dibbets, Douglas Huebler, Richard Long, the N.E. Thing Company, Robert Smithson, Lawrence Weiner, and Sol LeWitt.[36] It was no accident that Siegelaub published the work in three languages; Conceptual Art was one of the only seventies movements to begin simultaneously in Europe and North America, and it remains international to this day. The English Art & Language Group; the Dutch artist Jan Dibbets, who made photographs showing the transition from morning to night; the German artist Hanne Darboven, who exhibited pages of her writing of a mysterious numerical system; the French artist Daniel Buren; the Englishman Richard Long; and the Canadian N.E. Thing Company all participated in dozens of catalog, book, and gallery exhibitions with United States Conceptualists. Germano Celant's book *Arte Povera* discussed almost all of these same artists under the heading "impoverished art." As Harold Rosenberg explained, this "*Arte Povera* does not associate itself with the needy, but asserts its alienation from the art market and its opposition to the present order of art. . . . It suggests the presence of a Puritanism that conceives of the artist as a member of a mendicant order, independent of the community and disciplined against succumbing to its cultural goods. . . . It sees the function of art in our time as not to please the senses, but to provide a fundamental

investigation of art and reality."[37] Indeed, Celant's *Arte Povera* category proved inclusive enough to encompass Process artists, Performance artists, Minimalists, and Earthwork and Site sculptors, along with the Conceptualists represented in its pages; indeed throughout the 1970s distinctions among these various groups of artists came and went. In a similar fashion, Lucy Lippard's book *Six Years: The Dematerialization of the Art Object*[38] offers an invaluable if highly idiosyncratic group of catalog listings of numerous Conceptual Art pieces, Bodyworks, performances, Earthworks, and political art Happenings from various countries which took place from 1966 through 1972.

Sentence No. 16 of Sol LeWitt's 1969 "Sentences on Conceptual Art" says, "If words are used and they proceed from ideas about art then they are art and not literature; numbers are not mathematics," which would seem to be a good argument for Kosuth's and Weiner's Conceptual approach. LeWitt, who appears with them in various Siegelaub publications, went on to found (with Lucy Lippard) Printed Matter, an organization devoted to the publication and distribution of artists' books. Nevertheless, LeWitt's position on the use of words as art remains equivocal: sentence No. 35, the final sentence of LeWitt's 1969 series, reads, "These sentences comment on art, but are not art," which, implicitly, raises the question whether Weiner's and Kosuth's presentations of booklets of words are art or words about art. Both Weiner and Kosuth, however, make the point that their words themselves have no aesthetic significance except as clothing of the idea. Kosuth invented the slogan for himself, "Art as Idea as Idea," after an exhibition of his reading/thinking area complete with the artist's own desk, articles, and books.

Weiner's approach—he makes and exhibits wall statements—seems to be very close to Kosuth's. Weiner believes in the inherently democratic nature of Conceptual Art. "Art that imposes conditions human or otherwise on the receiver for its aesthetic appreciation in my eyes constitutes aesthetic fascism," he argues. Furthermore, "Once you know about a work of mine, you own it. There's no way I can climb into someone's head and remove it."[39] Still, Weiner's argument becomes a little ambiguous when he states that the subject of his art "is material, but the reason for the work is to go beyond materials to something else, that something else being art."[40] During the seventies Weiner had several one-person shows of his Conceptual statements at the Leo Castelli Gallery [14], and his "drawing" in the Museum of Modern Art's 1975 mammoth "Drawing Now" exhibition consisted of the following printed on the wall:[41]

IN RELATION TO AN INCREASE IN QUANTITY
REGARDLESS OF QUALITY:

HAVING BEEN PLACED UPON A PLANE
() UPON A PLANE
HAVING BEEN PLACED ()

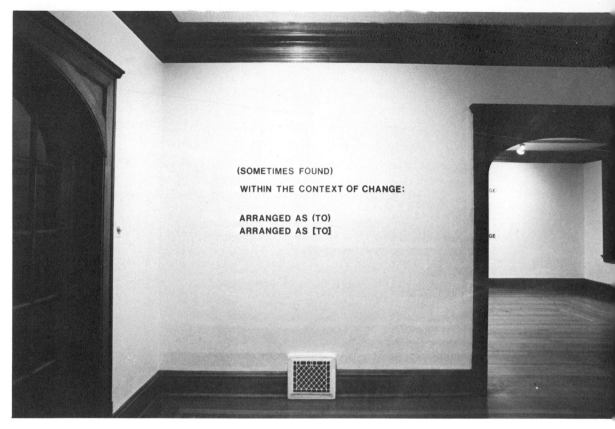

(SOMETIMES FOUND)

WITHIN THE CONTEXT OF CHANGE:

ARRANGED AS (TO)
ARRANGED AS [TO]

[14] Lawrence Weiner. *(Sometimes Found).* 1974.

For Weiner, such texts are art, and all other visual material, by definition, becomes extraneous.

From the beginning, Robert Barry's Conceptual approach seemed less verbal than either Weiner's or Kosuth's. Barry was a Systemic painter in the sixties, who, after participating in Siegelaub's Bradford, Massachusetts, exhibition, came to the same conclusion as Lawrence Weiner, that his works did not actually have to exist, that what mattered was the idea and the cataloging of the idea. It was word and photograph used as an indicator of the invisible that interested Barry when he began making works which had to do with various kinds of energy existing "outside the narrow arbitrary limits of our own senses." In an interview in Ursula Meyer's *Conceptual Art,* Barry explains that his father was an electrical engineer, and that he himself worked with carrier waves and radio transmitters since he was a child. To Barry, carrier waves have several beautiful qualities: "they travel through space at the speed of light, and yet can be enclosed in a room." Barry's invisible art works for Seth Siegelaub included a number of such carrier-wave pieces, one entitled *88mc Carrier Wave (FM).* [42] And since it was impossible to photograph such works, Barry photographed instead the place where the carrier waves had existed. Similarly, the Conceptual work by Barry that Celant included in his *Arte Povera* anthology consists of a

series of photographs of the empty room where two carrier waves of a citizen band radio had filled the space. The following statement was Barry's work for the Museum of Modern Art's "Information" show:

ART WORK, 1970
It is always changing.
It has order.
It doesn't have a specific place.
Its boundaries are not fixed.
It affects other things.
It may be accessible but go unnoticed.
Part of it may also be part of something else.
 Some of it is familiar.
 Some of it is strange.
 Knowing of it changes it.[43]

Thus, for Barry, Conceptual Art exists in the mind; it is visible only to the mind's eye.

Douglas Huebler, born in Michigan in 1942, had been a Minimal painter and sculptor before 1967–68, when he began to question the importance of his art's physical existence. In 1968, Huebler began making Site sculptures in the form of small, innocuous markings at real locations too spatially disparate to be perceivable by the eye. Huebler documented the locations of these markings by words, maps, diagrams, and photographs, all of which supplied proof of their physical if unperceivable reality. The photographs themselves are not intended to be art, but are rather part of the artist's documentation process. Huebler's projects use philosophical concepts of time and space in an aesthetic way. One such piece, in Seth Siegelaub's "November" catalog of Huebler works, specifies "that all geographical, temporal and process lines of demarcation limit only the conceptual boundaries of a piece." In an earlier work, *Duration Piece #2,* the artist presented a series of photographs of tire impressions created by automobiles running over a fine sand line across a highway. The camera here, as in all Huebler's works, serves as a "dumb copying device" documenting whatever phenomenon appears before it. "That other people make the photographs makes no difference," Huebler insists.[44] And thus, a depersonalization of process as well as a dematerialization of the art object takes place in Conceptual work, where the thought rather than the thing or deed is the essential element.

Huebler's art always addresses itself to time, and is usually predicated on an event existing for a specific space or length of time. Take, for example, a work called *Duration Piece #13.* This piece listed one hundred single-dollar bills by serial number; the bills were then put into circulation throughout the world, with the idea that their numbers would be reprinted in an art magazine twenty-five years later (in 1994), at which time each bill holder would receive a $1,000 reward. Just as the tire tracks were recorded during a specific time interval, and the bills have a twenty-five-year

duration, so Huebler's *Location Piece #28* for the Museum of Modern Art's "Information" show set forth the following conditions, which add up to a picture of a particular time interval:

LOCATION PIECE #28 New England, December 1969

On December 11, 1969, a photograph was made of the driver of an automobile or truck who looked at the occupants of the car that was, at the moment, passing his, or her, vehicle. The camera was located in the "passing car." The "moments" represent the following rates of speed: 5; 10; 15; 20; 25; 30; 35; 40; 45; 50; 55; 60; 65; 70; 75 miles per hour.

Fifteen photographs, none "keyed" to a specific rate of speed, join with this statement to constitute the form of this piece.[45]

In 1970, Seth Siegelaub ceased representing the Conceptualists, and Douglas Huebler, Joseph Kosuth, Robert Barry, and Lawrence Weiner went on to have Conceptual shows with the Leo Castelli Gallery throughout the 1970s.

In 1971, the California-born artist John Baldessari made a lithograph consisting of a single sentence written over and over which read, "I will not make any more boring art." Another work by Baldessari consisted of a white canvas with the single word "beauty" painted on it. And there is a videotape entitled "Baldessari Sings LeWitt," on which Baldessari sings LeWitt's "Sentences on Conceptual Art" to various popular song melodies. For a time when he was in college, John Baldessari thought he might want to be an art critic, and he was most attracted to those artists throughout history who were concerned with ideas. But he graduated from the University of California at Berkeley in 1954 resolved on being a painter, and moved to Los Angeles, where he worked as a technical illustrator and taught art in ghetto schools before being invited to teach at the University of California at San Diego. In San Diego in 1968, instead of teaching painting Baldessari changed the course to "Post-Studio Art," because he felt by then that he had already made too many paintings and was now more interested in ideas as art situations. Baldessari's works from this time include canvases with such messages, painted in acrylic, as "A Work With Only One Property" and

A PAINTING THAT IS ITS OWN DOCUMENTATION

JUNE 19, 1968 IDEA CONCEIVED AT 10:25 A.M.

NATIONAL CITY, CALIF. BY JOHN BALDESSARI

JULY 30, CANVAS BUILT AND PREPARED
JULY 31, TEXT PREPARED AND EDITED
AUGUST 1, PAINTING COMMISSIONED
AUGUST 3, PAINTING COMPLETED
OCTOBER 6, FIRST SHOWING MOLLY
BARNES GALLERY, LOS ANGELES . . .[46]

Baldessari had a solo show of these paintings in Los Angeles before coming to New York, where the art dealer Richard Bellamy suggested Baldessari might be interested in meeting Robert Barry, Joseph Kosuth, and Douglas Huebler, and Baldessari's work was soon included in the other artists' subsequent international Conceptual shows and catalogs. One difference between Baldessari and the other Conceptualists is in Baldessari's wider philosophical approach. For example, on the one hand, Baldessari shares with Kosuth an interest in the ideas and writings of the philosopher Ludwig Wittgenstein; on the other, he is equally interested in and has been influenced by the writings of the French Structuralists Claude Lévi-Strauss and Roland Barthes, as well as by "gnomic expressions"—proverbs and adages from his childhood. Baldessari has often told interviewers that what he likes to do the most is read all day. Reading shapes his thinking, which shapes his art, which is all about thinking—in a visual context. Baldessari's eclectic reading is the other side of a visual sense of play which employs the painted word, commercial postcard, made-up documentary, and "real" photographs, and combinations of written and sequential images. "Video," he explains, "is just one more tool in the artist's tool box."[47] Unlike Douglas Huebler or the German-born Conceptualist Hans Haacke, Baldessari has established a highly equivocal relationship with the notion of photographic documentation. One of his photo essays, titled "Throwing 4 Balls in the Air to Get a Straight Line (Best of 36 Tries) 1972–73," is what its title says, but is also a four-part work of sequential visual composition. As in many other Baldessari pieces, what you see is only half of what the artist means to give. His interest in chance is the interest of one who likes to look at the space between things, of someone who wants to make things difficult in order to get at the hidden and, consequently, the new. One must look to art history to find a similar approach—to the Dadaists and especially Marcel Duchamp, their original genius, who protested he was tired of the expression "dumb like a painter" and claimed he wanted to make art of intellectual weight, of verbal import.

In 1981, the New Museum in New York organized a retrospective of fourteen years of Baldessari's work, which traveled to Ohio and Texas. The show consisted of fifty-five works mounted on the wall, twelve films, seven video tapes (including the 1972 thirteen-minute "Baldessari Sings LeWitt" tape), and works in a variety of mediums, all aimed at putting verbal content back into art.

Hans Haacke has been equally concerned with bringing new content to art but, from the beginning, words themselves have been only adjuncts to his aim of going beyond the object. The pages on Haacke in Celant's *Arte Povera* begin with a paragraph which reads in part: "A 'sculpture' that physically reacts to its environment and/or affects its surroundings is no longer to be regarded as an object. The range of outside factors influencing it, as well as its own radius of action, reach beyond the space it materially occupies. It thus merges with the environment in a relationship that is better understood as a 'system' of interdependent processes. These processes—transfers of energy, matter or information—evolve without the viewer's empathy. In

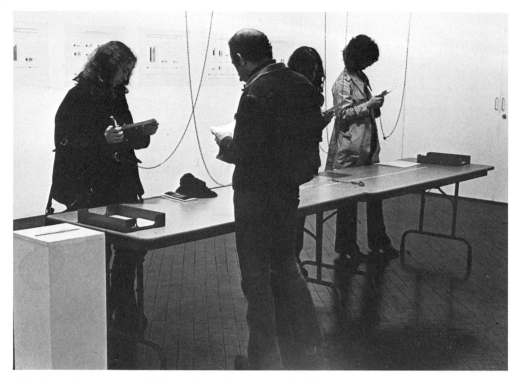

[15] Hans Haacke. *John Weber Gallery Visitors' Profile #2.*

works conceived for audience participation the viewer might be the source of the energy, or his mere presence might be required. There are also 'sculpture' systems which function when there is no viewer at all. . . . A system is not imagined; it is real." Succeeding pages in Celant's book include photographs of Haacke's work with natural systems, such as *Cast Ice Disk in Frozen Environment, December 16, 1968*; *Live Airborne System, 1964*; and *Grass,* which he did in 1967. In a 1971 interview with Jeanne Siegel, Haacke explained that a single thread runs through his works, from the early nature-based pieces to the political information series of 1970, and this is his interest in systems showing change. In 1965, Haacke had already set for himself the following program: ". . . make something which experiences, reacts to its environment, changes, is non-stable . . . make something indeterminate, which always looks different, the shape of which cannot be predicted precisely . . . make something which cannot 'perform' without the assistance of its environment . . . make something which lives in time and makes the 'spectator' experience time . . . articulate something Natural . . . (Hans Haacke, Köln, Jan. 1965)."[48]

Haacke's going from works about ice forming and grass growing to computing voters' opinions indicates a shift of emphasis rather than of aesthetic. His interest in the processing of information by computer is a continued interest in "real" time situations. His work in the "Information" exhibition at The Museum of Modern Art consisted of the following question posed to museum visitors, accompanied by transparent ballot boxes which were provided to hold their answers: "Would the fact that

Governor Rockefeller has not denounced President Nixon's Indochina policy be a reason for you not to vote for him in November?" The question was particularly disquieting, as journalist Emily Genauer pointed out,[49] in the context of a museum which Nelson Rockefeller's mother had founded and of which the governor was a principal trustee. The results of this poll, which Haacke complained the museum did not follow through on accurately, were nevertheless that the museum visitors voted two to one against the governor. Another such system work by Haacke, titled *Gallery Goers' Residence Profile*, set out to document the addresses of people who visited one of his exhibitions at the John Weber Gallery in SoHo [15] to see whether art viewers lived in their own kind of ghetto (as proved to be the case), coming from certain neighborhoods in Manhattan as opposed, say, to Harlem or neighborhoods in Brooklyn and Queens. "An artist," Haacke told Siegel, "is not an isolated system but must constantly interact with the world around him." And it is here that Haacke's work links up with other Conceptualists, his time systems paralleling, for example, Douglas Huebler's documentations of real objects in geographical locations outside traditional art areas.

On April 1, 1971, Thomas Messer, the director of The Solomon R. Guggenheim Museum in New York City, canceled the projected Haacke exhibition at the Guggenheim scheduled to open on April 30, on the grounds that "the documentary works included dealt with specific social considerations not considered art,"[50] and Edward Fry, the Guggenheim curator of the exhibition, resigned in protest. The piece by Haacke that the museum objected to was one that documented, in the form of photographs of actual buildings, the slum real-estate holdings of various Guggenheim Museum trustees. With this particular work, the artist had brought the "real" world and a "real" time situation with a vengeance to the art world proper.

This, of course, took place in 1971, at the height of the anti-war movement in America, and after the invasion of Cambodia and the deaths at Kent State University were making the seventies a time of increasing political involvement for everyone. In Hans Haacke's case, as proved to be the case for many feminist artists, political and aesthetic subject matter became one and the same. But even while artist groups were uniting in their concern for racial, sexual, and economic equality, and political issues suddenly took center stage in the American art world, the question of art work having political content remained a matter of controversy. Many of the most vigilant supporters of the Art Workers Coalition, the Black Arts Movement, and various feminist art groupings did not think that their art had political content. And Sol LeWitt spoke for many people in 1968 when he said, "I don't think that I know of any art of painting or sculpture that has any kind of real significance in terms of political content," he said, "and when it does try to have that, the result is pretty embarrassing."[51] Nevertheless, as will be documented in the next chapter, questions about political content and political activities by artists were very soon to reshape the American art world, bringing to prominence in the seventies new artists, movements, and galleries.

NOTES:
PROCESS AND CONCEPTUAL ART

1. Corinne Robins, "The Circle in Orbit," *Art in America,* Nov./Dec. 1968, p. 66.
2. Robert Morris, "Anti Form," *Artforum,* Apr. 1968, p. 35.
3. Corinne Robins, *op. cit.,* p. 66.
4. Robert Pincus-Witten, *Artforum,* May 1966, p. 54, as cited in "Eva Hesse," in Pincus-Witten, *Postminimalism* (New York: Out of London Press, 1977), p. 47.
5. Cindy Nemser, "Eva Hesse," *Art Talk: Conversations with 12 Women Artists* (New York: Charles Scribner's Sons, 1975), p. 208.
6. Robert Pincus-Witten, "Eva Hesse: More Light on the Transition from Post-Minimalism to the Sublime," *Postminimalism,* p. 51.
7. Cindy Nemser, *op. cit.,* p. 211.
8. Philip Leider, " 'The Properties of Materials': In the Shadow of Robert Morris," *New York Times,* Dec. 22, 1968, p. D 31.
9. *Ibid.*
10. Gregoire Muller, *The New Avant-Garde* (New York: Praeger, 1973), unpaged.
11. Richard Serra, "Play It Again, Sam," *Arts Magazine,* Feb. 1970, p. 27.
12. Rosalind Krauss, "Richard Serra: Sculpture Redrawn," *Artforum,* May 1972, p. 39.
13. Philip Leider, *op. cit.,* p. D 31.
14. Robert Pincus-Witten, "Bruce Nauman: Another Kind of Reasoning," *Postminimalism,* p. 73.
15. Robert Pincus-Witten, "Barry Le Va," *Postminimalism,* p. 121.
16. Barry Le Va statement in Robert Pincus-Witten, "Barry Le Va: The Invisibility of Content," *Arts Magazine,* Oct. 1975, p. 66.
17. *Barry Le Va, Four Consecutive Installations & Drawings, 1967–1978,* exhibition catalog, New Museum, New York, 1978, p. 27.
18. Marcia Tucker, *Richard Tuttle,* exhibition catalog, The Whitney Museum of American Art, New York, 1975, p. 6.
19. Both reviews reprinted in *ibid.,* pp. 75 and 74, respectively.
20. Robert Pincus-Witten, "Lynda Benglis: The Frozen Gesture," *Postminimalism,* p. 149.
21. Lynn Gumpert, Ned Rifkin, Marcia Tucker, *Early Work: Lynda Benglis/Joan Brown/Luis Jimenez/Gary Stephan,* exhibition catalog, New Museum, New York, 1982, p. 8.
22. *Ibid.,* p. 11.
23. Tom Hess, "Review," *New York Magazine,* Dec. 6, 1975, p. 114.
24. Most of the material in the paragraph that follows also is in "Dorothea Rockburne, an Interview by Marcia Tucker," in *Early Work by Five Contemporary Artists,* exhibition catalog, New Museum, New York, 1977, unpaged.
25. Tom Hess, "Rules of the Game, Part II: Marden and Rockburne," *New York Magazine,* Nov. 11, 1974, p. 102.
26. Mel Bochner, "Primary Structures," *Arts Magazine,* June 1966, p. 34.
27. Mel Bochner, "Serial Art, Systems, Solipsism," in Gregory Battcock, *Minimal Art: A Critical Anthology* (New York: Dutton, 1968), p. 101.
28. Sol LeWitt, "Paragraphs on Conceptual Art," reprinted from *Artforum,* June 1967, in Alicia Legg, ed., *Sol LeWitt,* exhibition catalog, The Museum of Modern Art, New York, 1978, pp. 166–67.
29. Bernice Rose, "Sol LeWitt and Drawing," *ibid.,* p. 32.
30. Lucy R. Lippard, "The Structures, The Structures and the Wall Drawings, The Structures and the Wall Drawings and the Books," *ibid.,* p. 32.
31. Robert Rosenblum, "Notes on Sol LeWitt," *ibid.,* p.17.
32. Robert Pincus-Witten, "Bochner at MoMa: Three Ideas and Seven Procedures," *Postminimalism,* p. 90.
33. Kynaston L. McShine, *Information,* exhibition catalog, The Museum of Modern Art, New York, 1970, p. 69.
34. Jack Burnham, *Great Western Salt Works* (New York: George Braziller, 1974), p. 50.
35. *Ibid.*
36. As listed in catalog published by Seth Siegelaub, New York, 1969.
37. Harold Rosenberg, *The De-Definition of Art* (New York: Horizon Press, 1972), p. 35.
38. New York: Praeger, 1973.
39. "Lawrence Weiner, October 12, 1969" in Ursula Meyer, *Conceptual Art* (New York: Dutton, 1972), pp. 217–18.
40. Gregory Battcock, "Lawrence Weiner," in *Idea Art* (New York: Dutton, 1973), p. 149.
41. Bernice Rose, *Drawing Now,* exhibition catalog, The Museum of Modern Art, New York, 1976, p. 80.
42. Ursula Meyer, *op.cit.,* p. 36.
43. Kynaston McShine, *op. cit.,* p. 18.
44. Jack Burnham, *op. cit.,* p. 56.
45. Kynaston McShine, *op. cit,* p. 63.
46. *John Baldessari,* exhibition catalog, New Museum, New York, 1981, p. 8.
47. *Ibid.,* p. 17.
48. Jeanne Siegel, "An Interview with Hans Haacke," *Arts Magazine,* May 1971, p. 18.
49. *Ibid.,* p. 20.
50. Lucy Lippard, *Six Years: The Dematerialization of the Art Object* (New York: Praeger, 1973), p. 227.
51. Lucy R. Lippard, in *Sol LeWitt, op. cit.,* p. 28.

3
Art and Politics

The Advent of the "Artworker," the Black Artist,
and Women Artists in the Seventies

Integration became a way of life for much of the United States, north and south, in the sixties, while the country of American art in New York remained apart, artists seeing themselves as existing in a separate place. It wasn't until 1969 that artists stopped being separatists and recognized that they too existed in a national context, and that in the museums—as well as in the marketplace of collector/dealer/and magazine—racism and sexism were unspoken, everyday facts of life. Three events in 1969 set the tone for the artist protest movements of the seventies. They were the Metropolitan Museum of Art's black cultural extravaganza, "Harlem on My Mind," which gave rise to organized black art protest groups, such as the Black Emergency Cultural Coalition; the Museum of Modern Art's installation of a kinetic work by the sculptor Takis, which Takis and his friends removed, becoming in the process an artist protest group; and the Whitney Museum of American Art's 1969 Annual, which opened in December 1969, with the exhibition list of 143 artists containing 8 women, or exactly 15 percent, and which led to the formation of the first feminist group of artists, known as W.A.R. (Women Artists in Revolution), who by the end of the show were issuing demands that the museum change its policies regarding women artists.

On January 5, 1969, two days after removing his kinetic *Tele-Sculpture 1960* from "The Machine" exhibition at The Museum of Modern Art, the sculptor Takis and his friends issued the following public "Statement of January 5, 1969," which protested against the following: "1. The exhibition of works by living artists against their express consent. 2. The degree of control exercised by museums, galleries and private collectors over the work of living artists. 3. The lack of consultation between museum authorities and artist, particularly with regard to the maintenance and installation of their work, and 4. The unauthorized use of photographs and other material for publicity purposes."[1] An article published in the *East Village Other* on

January 24, 1969, gave an amended list of proposals by the Takis group then picketing The Museum of Modern Art on a fairly regular basis.[2] Only the first of these additional proposals actually became museum policy: this was that The Museum of Modern Art should be open free of charge to the general public on at least one day a week. The other nine included such items as a request that a registry of artists be compiled by the museum to form the basis for random shows of artists' works (this registry idea and way of mounting shows four years later became the basic policy of the Artists Space Gallery); that known and unknown artists be appointed to the board of directors; that provisions be made for shows of environmental works and for shows by unknown artists; and that there be a direct relationship between the artist and museum without the dealer acting as intermediary. Later requests, in letter form to the director of The Museum of Modern Art, Bates Lowry, included a permanent "Black wing for black and Puerto Rican artists and a permanent wing for unknown artists."[3] By this time, not only artists but art critics, such as John Perreault, Gregory Battcock, and Lucy Lippard, had become involved, and joined the sit-ins at the museum. On March 14, Bates Lowry issued a press release announcing he was recommending to the museum's Board of Trustees that "a Special Committee on Artists' Relations be appointed." Throughout the spring of 1969, the Artworkers group staged various demonstrations at museums, and on April 10, in an "official public hearing," "Artworkers coalition changed their name to the Artists Coalition because artists are not workers; because all persons who regard themselves as artists are artists, no matter what their activities; because this organization does not reflect the interests of all persons who have some connection with art, but rather identifies with those who call themselves artists."[4] The report went on to explain that the purpose of the Coalition was to create alternatives to present institutions, to reform existing institutions, to establish the rights of black and Puerto Rican artists, and so on. The newly named Coalition (which, unofficially at least, continued to be known as the Artworkers Coalition, or A.W.C.) went on to work with various artist peace groups who were attacking the trustees of the Modern and the Metropolitan museums for financing the war in Vietnam. In 1969–70, the Coalition held weekly meetings, which from "sixty to one hundred artists attended."[5] According to the critic Lucy Lippard, "The most controversial aspect of the A.W.C. among artists and the establishment has been its politicization of art, a term usually used to cover the black and women's programs as well as the demands that the museums speak out against racism, war and repression."[6] In most cases, this "politicization of art" was kept separate from art-making by many artists who rejected the idea of turning their art into a propaganda tool to effect political change. Also, while these coalition meetings addressed themselves to various forms of political repression, in true sixties style the question of sexism and sexual repression simply didn't find its way to the agenda. And so, after a time, the women artists decided to hold their own meetings, following those of the Coalition (on the same premises), during which the question of discrimination against women

artists not only by existing institutions but by many of their fellow members of the Coalition was discussed. And indeed, while the problems of black, Puerto Rican, and finally even women artists received a certain amount of Coalition support, the minority artists soon felt it essential that they organize to act separately for their own interests while joining in to lend support to larger umbrella movements like the Artworkers Coalition in 1969 and the New York Art Strike in 1970.

The New York Art Strike for a brief time did encompass the whole art world. Created in a meeting called by the sculptor Robert Morris, who had canceled his own solo Whitney Museum exhibition as a protest against the war, the strike itself began as a mass meeting on May 18, 1970, in New York University's Loeb Student Center, attended by artists, gallery dealers, critics, and museum people. Over 1,500 members of the art world met to express their reaction to the news of the deaths at Kent State University and the United States government's invasion of Cambodia, and voted to pass a resolution that would create an emergency cultural government to sever all collaboration with the federal government. At a second meeting, the group adopted as its official name "The New York Art Strike Against War, Racism, Fascism, Sexism and Repression," and set about organizing a series of demonstrations.[7] It chose May 23, 1970, as the date for a one-day closing of the Metropolitan, the Modern, the Jewish, and the Guggenheim museums in protest against the Vietnam War, and on May 23, over five hundred artists staged a sit-in on the steps of the Metropolitan Museum to ensure its closing. The media turned out and covered the event, as it did the Art Strike's "Alternative Venice Biennale," organized to raise funds to help stop the war. From May through October 1970, strike activities were at their highest and then, slowly, while lending support to other anti-war movements, each of the protest groups organized to fight against repression on their own grounds.

Some Black Art and Artists

In 1967, before "Harlem on My Mind" was thought of by Thomas Hoving and his advisers at The Metropolitan Museum, a group of black artists joined together to improve Harlem by creating their own city walls, and attack with black abstract art the urban decay around them. Deciding to function collectively, the group took the name Smokehouse Associates, with the result that in 1969, when both The Jewish Museum and The Museum of Modern Art decided to put on exhibitions of city wall art, the walls done by the Smokehouse group were labeled "Harlem Walls by amateur artists." The fact was that the Smokehouse group (almost all of whom were college-trained artists) included the painter William T. Williams, who had just graduated from Yale, and the sculptor Melvin Edwards, a graduate from the University of Southern California at San Diego, who today is a professor of art at Rutgers University. It was specifically this type of continuing misunderstanding by well-meaning

people who meant to encourage black artists that led to the formation of organizations like the Black Emergency Cultural Coalition. That Coalition, as was noted, was begun in protest against the Metropolitan Museum's "Harlem On My Mind" exhibition, which the group felt concentrated on black memorabilia and all but ignored the work of black artists. According to Benny Andrews, after the protests at The Metropolitan Museum—"The B.E.C.C. was formed by a group of black artists for the purpose of making sure there would be no more Harlem On My Mind exhibitions foisted on the public both black and white"—the Coalition opened talks with The Whitney Museum, which resulted in the Whitney agreeing to the following: 1) the Museum would stage a major exhibition of black art; 2) it would establish a fund to buy more works by black artists; 3) it would put on at least five annual one-man exhibits of black artists in the small gallery off the lobby; 4) have more black artists represented in the Whitney Annuals; and 5) consult with black art experts.[8] What actually happened to all these agreements was the following: from 1969 through 1975, The Whitney Museum did give a series of one-person shows to black artists, amounting to a total of approximately twelve shows of three to six weeks' duration each, and in 1971 it did mount a show entitled "Contemporary Black Artists in America," which in its turn became the subject of picketing and protests by the BECC. According to Andrews, instead of the museum consulting with black experts as had been agreed upon, the show was selected solely by the white curator Robert M. Doty, who "had subjected our fellow artists across the nation to such humiliating experiences as entering their studios and demanding to see only this or that piece of which he had heard." Grace Glueck, in her *New York Times* article on the controversy, noted that while Andrews and other artists withdrew their work, "a spot check of artists around the country known to be involved in the show reveals ambivalence on the part of most, both towards the Whitney and the BECC," and that the problem was simple for the black art experts who had been snubbed, but less simple for young black artists who, "though they question the idea of a black show are glad for the chance to make a museum appearance."[9] Glueck quoted one black artist as saying, "While I have mixed feelings about anyone being cubbyholed in a show of black art, I don't like someone telling me to withdraw my stuff when I've had so little exposure."[10]

But before the Whitney show, in the spring of 1970 the Museum of the National Center of Afro-American Artists and the Boston Museum of Fine Arts together put on the largest exhibition of Afro-American art to date. This show, "Afro American Artists: Boston and New York," organized together with black advisers, was reviewed by the art critic Hilton Kramer in the *New York Times* on May 22, 1970. A paragraph in this review, which Benny Andrews took exception to in his own response to the Boston/New York show (also printed in the *New York Times*) highlights the problem, the double bind black artists were up against in the seventies: "The exhibition itself brings together a wide variety of visual styles, from the most elegantly executed color

abstraction to the most crudely conceived social realism. Behind this stylistic variety, however, there is one basic line of division in the exhibition—the division separating works of art that are conceived as an esthetic end in themselves and those that are conceived as a medium of social and political action. There are works of compelling interest on each side of this basic division in artistic outlook, but for the most part —in my view, at least—the real quality of the exhibition is to be found in a handful of paintings and sculptures that belong to the so-called 'mainstream' of modern art."[11] The problem for blacks and whites alike in the seventies was not, however, only *which* art, but *who* made it. Around this time, the sculptor Melvin Edwards was invited by the Whitney Museum curator Robert Doty to write a statement on black art for his big 1971 exhibition of black artists, which Doty then declined to use and Edwards printed in his 1978 Studio Museum catalog. The following excerpt, I believe, sums up another viewpoint on the issue: "To talk of Black Art in America is to talk of the African American people. Black Art is works made by Black people that are in some way functional in dealing with our lives here in America. Since the most important thing is our dealing with our oppression by White America, our most logical works are those forms of social protest and those which build our self-confidence and self-reliance. Most African American artists either deal directly with their own famil- iar subject matter and symbols or they indirectly title abstractions with the names of friends, heros, relatives, harlems, musicians, foods, etc. There is no Black artist who has not thought about his condition in America. As soon as Blacks know that a work was made by a Black person then it becomes functional."[12]

Besides the Whitney and the Boston/New York exhibitions, from 1968 through 1971 there were many independently organized shows of black artists nationwide. In 1968, there was a show titled "Ten Afro-American Artists" at Mount Holyoke College in Massachusetts and, the same year, an exhibition titled "30 Contemporary Black Artists," which originated at the Minneapolis Institute of Arts and toured the Midwest. In 1970, a large group show titled "Dimensions of Black Art" began at La Jolla Museum and traveled through colleges down the coast of California.

Then, in 1971, acknowledging the increasing visibility of Afro-American artists, The Museum of Modern Art mounted a full-scale dual exhibition of the works of the painter Romare Bearden and the sculptor Richard Hunt, black artists who were already famous by the mid-sixties. The *New York Times* review of the Bearden/Hunt exhibition carried the headline "Have the Walls Come Tumbling Down?"[13] And the show reviews were of course highly favorable, since Romare Bearden's collages of black figures in semi-cubist space, his reputation as an accomplished and celebrated abstract painter (who was exhibited by the prestigious Kootz Gallery in the fifties), and his 1964 "Projection" series of photomontages of Harlem streets and black figures with such titles as *The Block, Evening 9:10 461 Lenox Avenue, The Street* [16], and *Mysteries* were immediately acceptable to all strata of the black arts movement and the white art establishment; he had long been acknowledged as a "dean of black

[16] Romare Bearden. *The Street.* 1964.

artists." Bearden's show, titled "The Prevalence of Ritual," encompassed over forty years of the artist's work, his own "journeying thing." On the one hand there was Bearden's own odyssey through modern art, and on the other, wrote Hilton Kramer, there was the artist's use of "the morphology of certain forms that derive originally from African art, then passed into modern art by way of cubism and are now being employed to evoke a mode of Afro-American experience."[14] The Chicago-born Richard Hunt, a much younger artist, was given a forty-piece retrospective exhibition in tandem with Bearden's. Hunt's welded steel sculpture from sheet metal and found objects had first been shown by The Museum of Modern Art in the 1950s, when Hunt was only twenty years old. The artist received a Guggenheim Foundation fellowship in 1962, and his subsequent work, which incorporated junk fragments into his welded steel sculpture, and his "drawing in space" (which relates to certain works of David Smith) in terms of its figurative connotations, and especially the pieces with subtle allusions to the animal and insect world, were immensely popular. Although Hunt has contributed pieces to a number of black artists' shows, he has gone on record as objecting to the category of black art, saying he rejects such categorization and "is intent on being the best artist [he is] capable of becoming."[15] No walls fell, and for the black art community, the exhibition proved to be a culmination rather than a harbinger of things to come.

Between 1969 and 1975, The Whitney Museum gave one-person shows in the small gallery on its first floor to approximately twelve black artists, Alvin Loving, Melvin Edwards, Frederick Eversley, Marvin Hardin, James Hampton, and Betye Saar among them. The last such show was for the artist Mina Evans, from July 7 through August 3, 1975. These shows proved to be educational on a number of levels. They quickly brought home to both the black and white art world the fact that a black artist, whether making black art, folk art, or doing mainstream abstraction, in terms of available museum and gallery space, was fortunate simply to be given a chance to show his work. On a more positive note, the Whitney series demonstrated the existence of a number of major black artists whose works proved to be a distinct contribution to the art of the time.

For his one-person Whitney exhibition, Melvin Edwards made two large-scale environmental works using barbed wire and linked chains. These pieces were an interim development. In the sixties, Edwards made a series of small pieces containing gears, knife sheaths, and bolts of unpainted steel that came out from the wall like obscure devices and which he called *Lynch Fragments.* Edwards settled in New York in 1967; he worked on environmental pieces with the Smokehouse group and in 1970, following his Whitney exhibition, he began using large semi-circular steel shapes in a series of "rocker" sculptures. His 1979–81 works incorporate some of the earlier imagery, and yet the free-standing sculptures seem to have undergone further metamorphosis [17]. The art critic for *Time* magazine, Robert Hughes, described Mel Edwards's work in a show at P.S. 1 in Long Island City as "alluding to the once

[17] Melvin Edwards. *Homage to the Poet Leon Gontran Damas.* 1978–80.

common practice of bricolage in West African tribal art whereby mixed scraps of junk (nails, tin cartridge cases and so forth) were incorporated into carved masks and figures. Junk sculpture has been a Western convention for decades (and Melvin Edwards's relation to the work of both David Smith and Anthony Caro here, to this writer, would seem worth mentioning), but Edwards invests it with a rough, sinewy power, and his larger piece in the show, 'Homage to the poet Leon Gontran Damas 1978,' has an almost majestic aura of open declamation."[16] Thus, it was thanks to The Whitney Museum, the Studio Museum's artist-in-mid-career series, and the P.S. 1 "Afro-American Abstraction" exhibition that one was able to follow the development of artists such as Melvin Edwards, Edward Clark, Al Loving, Alma Thomas, and Betye Saar in the seventies.

The details from artist to artist differ. Ed Clark's part in the black art movement of the seventies, for example, is that of an American artist with a long exhibition history. A gestural painter of the Abstract Expressionist second generation, Ed Clark made sweeping geometric paintings even before the seventies had made their own unique color statement. In her introduction to Clark's retrospective exhibition, Mary Campbell Schmidt describes him in the context of the second generation of Abstract Expressionists: "If the artists are familiar, so too are the communities they formed and the favored places they frequented: The Five Spot, the Cedar Bar, The Club, Betty Parsons Gallery, the Kootz Gallery, and later, the Tenth Street Cooperative galleries. The story is familiar; the settings have been explored over and over again. But always the presence of Black American artists has been ignored. Norman Lewis at The Club, Romare Bearden at the Kootz Gallery, and Ed Clark at Brata, a Tenth Street Cooperative. These artists were known, their art was known."[17]

Clark's background includes studies at The Art Institute in Chicago and at the Académie de la Grande Chaumière in the early fifties in Paris, where he had his first solo show, at Galerie Creuze in 1955. After his return to New York, in the late fifties, he became one of the founder-members of the Tenth Street Brata Gallery. Clark participated in a number of group shows and had a one-person exhibition at the Brata Gallery in 1958. It was at that time Clark made a painting that literally broke the bounds of the rectangular canvas. He then began moving in the direction of greater control of his gestural brush. By 1963, Clark had begun to divide his canvas into three parts, and he then arrived at the process of making his paintings on the floor and began to use push brooms guided by wooden tracks to increase the speed and scope of his horizontal stroke; as always, the emphasis was on energy and speed. In the mid-sixties Clark left New York for Paris and for a second show at Galerie Creuze. In 1969, the artist arrived at the oval shape as the most natural way of seeing—"it follows the form of the eye and gives a more accurate portrayal of the peripheries of vision"—and began making twelve- and thirteen-foot oval paintings which seemed to float between the floor and ceiling. The problem of controlling the color of the wall against which

[18] Edward Clark. *Mainstream One.* 1974–75.

the canvases were hung became a major preoccupation, one that Clark finally solved by putting the oval form in a rectangular field. A trip to Nigeria in 1974 resulted in the artist's series of *Ife* paintings, done that year: *Homage to the Sands of Ife, Ife Rose,* and *African Sienna.* These were twelve- and fourteen-foot horizontal canvases whose colors of umber, tan, and terra-cotta red, soft rather than sharp, move against a few scattered bands of blue giving a feeling of density, of shedding of light. Clark's work was included in the spate of Afro-American shows of the early seventies, and an *Ife* painting was included in "Afro-American Abstraction" at P.S. 1. In 1975, in an exhibition at the James Yu Gallery in SoHo, Clark showed a series of paintings based on a trip to Greece; the largest one was *Mainstream One* [18], containing "a large white oval that seemed to portray the whole world, the earth in space drawn out to look less round hanging between the blue top and bottom of the painting; a few narrow brown edges flecking the central white band to sound the work's one warm note."[18] Clark's various travels notwithstanding, he remains a major American modernist, the strength of whose color and brush stroke is paralleled by few other contemporary artists.

The work of David Hammons and Barbara Chase-Riboud in the P.S. 1 show did have specific references to the black experience, but—in the case of Chase-Riboud— even that depends on the writer you talk to. Barbara Chase-Riboud dedicated the sculpture in her first one-woman show at the Bertha Schaefer Gallery in New York in 1970 to the memory of Malcolm X. There were also many black political references in the show's exhibition catalog, but Chase-Riboud's sculptures of bronze and silk and wool cording were themselves abstract, totemic works. Born in Philadelphia, Chase-Riboud studied at the Tyler School of Art there and got the Master's degree from Yale University before settling in Paris in the early sixties. From the seventies on Chase-Riboud has been an artist who works "with opposites, feeling the need to join opposing forces, male/female, black/white."[19] Imamu Amiri Baraka criticized Chase-Riboud's pieces, claiming, "They do not actually exist in the black world at all. They are within the tradition of white art, blackface or not."[20] For myself, however, Barbara Chase-Riboud's work at P.S. 1, a nine-foot-high polished bronze and synthetic cord piece entitled *All That Rises Must Converge,* was that show's most tribal work because of its hanging braids and cords and mysterious joinings. David Hammons's environmental room, *Victory over Sin,* in contrast, seemed both more urban and American. *Victory over Sin,* under the light of a yellowish ceiling lamp, consisted of three gray-purple walls covered with the motif of two kidney shapes, each with a pair of fuzzy dots that turned out to be black human hair. Hammons had covered the floor with wands and reeds and more sproutings of the same hair, which made it an empty Harlem room, a poor American black space, and a ritual site.[21]

The Studio Museum has exhibited most of the black artists discussed above. Its 1980–81 retrospective for Edward Clark was part of a series documenting the work of outstanding black American artists. At times during the seventies, the Studio Museum exhibitions dovetailed with those at the Whitney; at other times, in the case of black women artists, the Whitney Museum solo exhibitions anticipated theirs.

The museum began in an old studio loft above a luncheonette and a liquor store on West 125th Street in September 1968, with a statement of purpose: "to provide a space for good black artists to exhibit where black people can see them work. But more than that, we want to be a ground where the black and white art worlds can really meet."[22] The museum, under director Edward Spriggs, was almost immediately confronted with the problem whether mainstream art, even when done by black artists, was of interest to the black community, and during its first five years the museum barred abstraction and concentrated on community-related art. Today, past its fifteenth year of existence, the Studio Museum occupies a five-story building at 125th Street and offers an impressive range of educational services, including studio workshops for artists, archives of the work of black filmmakers, and an impressive array of catalogs both introducing young talent and documenting historically impor-

tant shows. The Studio Museum's current director, Mary Campbell Schmidt, has pointed out that no New York museum has given a one-person show to a black artist since 1976, and as of this writing only two New York alternative spaces, the Just Above Midtown/Downtown Gallery and the Alternative Museum, put on racially integrated shows with any regularity.

Meanwhile, the problem for the black woman artist—even at the Studio Museum until just recently—has been one with even more pitfalls. Betye Saar's one-person show in the Whitney series took place in 1975, and she was included in the Douglass College series of exhibitions of women painters in 1976, but it wasn't until 1980 that she was finally given an exhibition at the Studio Museum. At the beginning of the seventies, one black woman artist told me she went to the Studio Museum in 1969 and 1970 and hung around until she was told she would have a long wait, "that there were all these black male artists who would have to get their chance first."[23] And it seems hardly coincidental that Amiri Baraka's attack was on Barbara Chase-Riboud's non-relevant work rather than on that of, say, Edward Clark or Melvin Edwards.

In the late sixties, Betye Saar's work was full of political content. The California-born artist, who received a B.A. degree from California State University and raised three children before going back to school and earning teaching credentials, was very much influenced in the late sixties by a show of Joseph Cornell's boxes in Pasadena. Saar began building her own boxes; this early work was full of images of racial stereotypes, and dealt specifically with the clichés whites foisted on the black person. A 1972 work titled *The Liberation of Aunt Jemima* was a box with "Mammy" pictures papering its walls and a "Mammy" doll with shotguns. A 1974 work concerned the jazz singer Bessie Smith [19]. That same year Betye Saar began her own personal exploration of fetishism and African voodoo imagery, and began to seek to introduce a unique kind of "spiritual" expression into work. According to the Studio Museum catalog for her exhibition, Saar's piece *Spirit Catcher,* done in 1976–77, "though containing references to voodoo with its feathers and beaded amulets, is structurally reminiscent of Simon Rodia's Watts Towers"[24]—near which Saar grew up in Los Angeles. The 1980 environment *Secrets and Revelations* was built specifically for the Studio Museum exhibition, with Saar setting out to collect its elements in California and then recycling them. In *Secrets and Revelations* her small printer's blocks line up like pews in front of a wall papered with relief images of birds and brooms, next to a central table and mysterious standing figure because, according to Saar, "everywhere there are secrets and everywhere revelations—this piece is about both."[25] Saar's obsessive rituals differ from those in David Hammons's environment piece, but the sense of urgency, of an immanent spirit and brooding force, is strong in both artists' work.

In 1983, Alma Thomas finally received a long-overdue show at the Studio Mu-

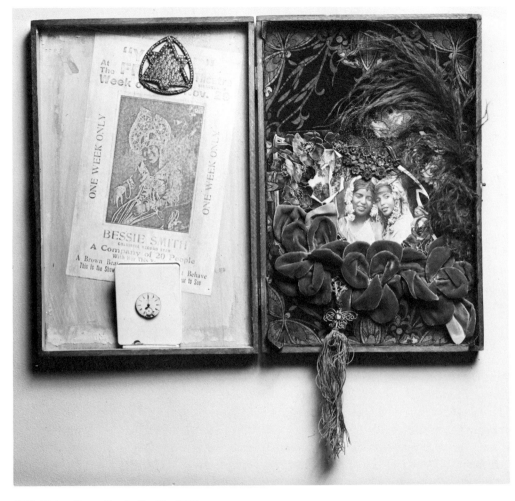

[19] Betye Saar. *Bessie Smith*. 1974.

seum. Thomas, whose mosaic abstractions are unlike anyone else's, was an outstand-
ing artist whose work from the mid-sixties until her death in 1978 belonged to the
so-called Washington School (which also included, at different times, the works of
Gene Davis and Morris Louis). Thomas was a special case in that she didn't begin
doing her own kind of painting until after she had retired from a lifetime of teaching
art, and that her one-person show at The Whitney Museum in 1972 and at the
Corcoran Gallery of Art was unique recognition, outside the regular channels availa-
ble to black or women artists. Thomas was also given a solo exhibition at the National
Museum of American Art, Smithsonian Institution, with the title "A Life in Art:
Alma Thomas 1891–1978." This was in part because, as the catalog essay relates,[26]

besides being an extraordinary artist Alma Thomas was a unique personality in the Washington art world.

A black woman artist like Alma Thomas who takes up abstract painting at the end of her life is of course far more easily assimilated than a black woman artist who takes up the causes of racism and sexism. Faith Ringgold, born and raised in Harlem, completed a Master's degree at City College in New York, studying with Robert Gwathmey and Yasuo Kuniyoshi; in 1967, focusing on direct political subject matter, she began making paintings based on the American flag—"the only truly subversive and revolutionary abstraction one can paint."[27] She took part in the People's Flag Show at the Judson Memorial Church in New York in November 1970, and one of her 1967 oil paintings, *The Flag Is Bleeding,* depicts a white woman, a white man, and a black man with a knife within the American flag, which is the painting's bleeding background. In 1970, Ringgold organized Women Students and Artists for Black Art Liberation (WSABAL), and began working on a series of political landscape paintings. She started using acrylics and then, in 1973, began making soft, doll-like sculptures, and in 1976 masks and heads decorated with beads in geometric designs. Ringgold's work is both a feminist and a black commentary on American society and "daring to be unpopular";[28] her art remains unexpected and disturbing.

The California Feminists:
Judy Chicago and Miriam Schapiro

In 1970, while members of Women Artists in Revolution were demanding from the Whitney Museum better female representation and were staging their first feminist show, "Mod Donn," at the Public Theatre on Lafayette Street, on May 2, 1970,[29] at California's Fresno State College a woman painter was setting up the first feminist art course. The same year, this artist, who had been known as Judy Gerowitz, took on a new name. On a wall of her one-person show at California State University at Fullerton, she had put up the following statement: "Judy Gerowitz hereby divests herself of all names imposed upon her through male social dominance and freely chooses her own name, Judy Chicago."[30] Judy Chicago was disappointed when the critics and the public failed to react to her announcement or recognize the female sexual connotations that to her were so apparent in her sprayed paintings consisting of geometric shapes with central, vagina-like openings. Chicago restricted her first class at Fresno State College to women students, selecting them on the basis of whether or not they wanted to be artists, and deliberately chose to hold the class in a studio away from the school as less restrictive and inhibiting for the students. Chicago invited Miriam Schapiro, a successful woman painter then teaching at the University of California at Fresno, to talk to her students. It was after this lecture that

Chicago and Schapiro discovered that they had both, independently, arrived in their paintings at the same sort of female central imagery. The next year, Miriam Schapiro invited Judy Chicago to help set up a feminist art program with her at the California Institute of the Arts, where they began teaching as a team in 1971. This was also the year, according to Schapiro, that the "seeds of womanspace were sown . . . the weekend of October 9–10 in the home of painter Ms. Max Cole when a group of twelve women who were artists from the Los Angeles area gathered together to conduct a marathon session devoted to continuous discussion of their art. As the women showed slides of their work, I had the impression they were uncovering hidden material."[31] This group became the nucleus for the Womanspace Gallery, a community art gallery which opened in the Women's Building in Los Angeles in 1973. The Women's Building itself grew out of the efforts of these women, the Feminist Art Program, plus a group known as the Los Angeles Council of Women Artists formed in the spring of 1971 specifically to attack the Los Angeles County Museum's "Art and Technology" exhibition, which did not include a single woman artist, and also to attack the museum's ten-year-old policy of not giving one-person shows to women.

Before Womanspace and the Women's Building, in 1972 the Feminist Art Program at the University of California, for a student project, put on an exhibition entitled "Womanhouse." At the suggestion of Paula Harper and under the direction of Judy Chicago and Miriam Schapiro, the students rented a run-down mansion in Los Angeles which they renovated and then converted into a series of rooms structured on women's experiences. For example, the entrance to Womanhouse was shrouded in a spider-like hanging that enveloped the viewer. The "Nurturant Kitchen" sported a fleshy pink paint skin covering the walls, floor, ceilings, and all the objects and appliances; a sheet closet held a closeted female manikin by Sandra Orgel. A "Menstruation Bathroom," done by Chicago herself, was "very sterile, all white," and offered "under a shelf of all the paraphernalia with which this culture 'cleans up' menstruation, a garbage can filled with the unmistakable marks of our animality so conspicuously absent from the rest of the house."[32] During the three-month exhibition, "Womanhouse" was a scene of numerous performance happenings by Judy Chicago and the students, which drew an audience of both women and men from all parts of Los Angeles. Thus, while very much a statement of the Feminist Program at the University of California, "Womanhouse" also served as a focal point for women's groups in the Los Angeles community, who the next year joined together to open the Women's Building. The opening of the Women's Building, on January 27, 1973, featured an exhibition (in Womanspace Gallery) of a cross section of works by the female art community; lectures by art historians on the first Women's Building, the women's craft center of the 1893 Chicago World's Fair; plus a slide show of the work of three women photographers. While the *Womanspace Journal* lasted only three issues, the Women's Building as an institution, which moved from its original

location at 743 Grand Avenue in 1975 to 1727 North Spring Street, Los Angeles, remains now in its tenth year a continuing center for women's culture, "offering a two-year college and graduate level program for women in the arts."[33]

To trace, even briefly, the development of Judy Chicago's and Miriam Schapiro's very different art from 1972 through 1977 is to become aware of stylistic divergencies in both West Coast and/or women's art. Indeed, the emphasis implicit in the term "women's art" shifts radically with geographical location--which is true also in the general art and culture. For example, California and the West Coast have a strong crafts and pottery tradition in both men's and women's art. In New York, the emphasis is more on drawing, and on formal painting and sculpture. By 1972, the women on both coasts were aware of the geographical gap and, in an effort to keep lines of communication open, established W.E.B. (West-East Bag), a newsletter that for a few issues was alternately edited in New York and California. As of this writing, W.E.B. originates from and is being circulated by the Ad Hoc Women's Committee in New York City.

Judy Chicago and Miriam Schapiro are both formally trained artists: Chicago at the Art Institute of Chicago, and Schapiro at Hunter College in New York and at the State University of Iowa. While Chicago in her early years moved easily from painting to sculpture, Miriam Schapiro's work has almost exclusively been concerned with painting; she had a series of solo shows at the André Emmerich Gallery in New York in the sixties, which established her reputation as an abstract painter.

By 1972, Judy Chicago had completed a series of whirling ray, or petal, paintings with bright circular centers; and in an effort to make her work at once more specific and more connected with other women, she began the series of *Great Ladies* paintings, in which she tried to make "my form, language and color reveal something really specific about a particular woman in history."[34] The "Great Ladies" were all queens in history, but even though on one level the paintings were quite literal, Chicago began to be dissatisfied with the limits of abstract formal language. "I wanted to combine the process of working and the thoughts I had about all these women I was reading about, to force the viewer to see the images in specific context and content. So I began to write." After first writing on the drawings and then incorporating her written thoughts into the actual paintings, Chicago found it "fantastic when people told me it made them feel like they were right there with me making the work."[35] Chicago feels the summation of these works is her "Reincarnation Triptych, where 'each five-foot canvas is an inside square in relation to an outside square named after a woman whose work I really identify with. . . .'" This work became the direct ancestor of Chicago's *The Dinner Party. The Dinner Party,* a project the artist began in 1974 and finished four years later with the help of an industrial designer named Ken Gilliam and over a hundred women working in "a Needlework loft" and "a pottery workshop," consists of "an equilateral triangle, 48 feet on a side, which holds some 390 separate pieces

[20] Judy Chicago. *The Dinner Party.* 1979.

including 39 plates, each with its own chalice, flatware runner and napkin, and also includes a tile floor which comes in 144 sections."[36] Chicago designed each of the plates and place settings to represent thirty-nine mythic and historical women whose spirits are to sit at this table. The only live person among them, the painter Georgia O'Keeffe, expressed some resentment at seeing her imagery and name used in Chicago's table settings. The other thirty-eight range from Sojourner Truth, the black abolitionist and feminist, to Emily Dickinson, each represented by a symbolically colored and molded vagina-form plate. *The Dinner Party* [20] was exhibited in the San Francisco Museum in 1978 and, traveling across the country, arrived at The Brooklyn Museum in 1980. The work sums up Chicago's belief in women's crafts as a true art form and in imagery of the vagina, which she is determined to portray as an active rather than passive organ: "It can fly, and bend, and twist, and push and thrust"; her aim, she says, "is to make the feminine holy."[37] In 1980, Chicago said that the women's art movement was successful in that "more women are showing," but added, "female art is still resisted."

Meanwhile, Chicago's definition of "female art" and her insistence upon vaginal imagery has met with mixed reactions from feminist artists, especially on the Eastern Seaboard. (The question whether female characteristics as such exist in art is one that was hotly debated throughout the seventies, and never agreed upon by any two women artists or critics together.[38]) For many, Chicago's *Dinner Party* remains a media rather than an art event which, if it helped women identify with the feminist movement, they consider acceptable propaganda. For many women, art and propaganda are separate entities, and subjects chosen in terms of political rhetoric meet with strong objections. Others, who believe feminist content and political subject matter to be valid in their own work, and to be an important element in contemporary art, still reject the notion of vaginal imagery being used to represent women. Lucy Lippard, Judy Chicago's and *The Dinner Party*'s strongest New York supporter, in an essay entitled "The Pink Glass Swan,"[39] argues that it is the duty of women artists today to make work that is accessible to Third World women, and that art and the elitist art world in which women now exist must be changed not only in terms of more equitable representation but in terms of making art that will be of social use rather than be merely an expression of their own time and conditions. *The Dinner Party,* with its accompanying book explaining who the thirty-nine famous women figures are and what Chicago's symbols mean, does, in these terms, qualify as instructional art.

Miriam Schapiro's description of her experience in helping form the feminist art movement in California differs somewhat from Judy Chicago's in what Schapiro chooses to emphasize. For example, what was especially moving for Schapiro at the time she began working with central (vaginal) imagery was "the discovery that there were all these other women artists isolated, working alone."[40] "Lawrence Alloway and others think Judy and I influenced women. We didn't. The women were making

[21] Miriam Schapiro. *Pandora's Box*. 1973. Collection Zora's.

images the same time we were, and all we did was bring it out in the open. Lecture after lecture, we showed slides, and women would say I did this, I did that. It was all about covert art. . . . I don't want to put down the vaginal iconography issue. I want to keep it alive, but I don't want it to take precedence over other issues."[41]

Miriam Schapiro, as was said earlier, was a mature and well-established artist when she and her husband, Paul Brach, moved to California in 1967. In 1969, when Brach became dean at the California Institute of Arts in Valencia, Schapiro was working on a series of computer paintings and drawings and, by 1970, the open central forms in these paintings were becoming fairly explicit. From 1971 through 1973 Schapiro didn't paint at all. She worked with Chicago on the feminist art program at the California Institute of the Arts and traveled widely, talking to other artists across California and trying to gain as much attention and understanding for the Womanhouse project as possible. Schapiro's own contribution to Womanhouse was a dollhouse she made in collaboration with Sherry Brody. At the end of the exhibition, she took the dollhouse home, realizing "it was a pivotal expression in [her] life,"[42] and the motif of woman artist/the house soon became central in Schapiro's work. But it is not only the house, it is the women's materials, the fabrics that go into making the home that dominated Schapiro's 1973 painting series, which include the fabric-filled *Personal Appearance #3,* with its pieces of fabric going in and out of the window-like inside painted structure, the floating rectangles within the rectangle which are the inner ground for Schapiro's floating fabric. In 1973–74 Schapiro developed a new style: a combination of fabric collage and acrylic painting, abstract decorative imagery, pattern and feminist imagery combined within an architectural framework. The theme of the materials that make up women's lives, of the decorations with which they try to embellish them, and—for Schapiro—a very real new admiration for her mother informed all these works, to which Schapiro gave the name *Femmage,* as they were collages concerned specifically with female imagery. In 1973, the feminist art program came under Schapiro's exclusive direction, and the same year she had a one-person exhibition of many of her new feminist-inspired paintings at the André Emmerich Gallery in New York **[21]**. In 1974, Schapiro and the feminist art program produced the book *Anonymous Was a Woman,* which contained a section of seventy-one letters addressed to young women artists. Miriam Schapiro then went to New York to meet with the painter Robert Zakanitch and they formed the Pattern and Decoration Group of New York City artists and held an unofficial first meeting. In 1976, after an eight-year stay in California, Schapiro moved back to New York, where she remains active in the New York feminist movement and is also a member of the group of male and female artists concerned with pattern painting. Schapiro's house-shaped paintings (some containing painted heart shapes) of the late seventies led to large-scale fan- and kimono-shaped works, all of which express a feminist and a decorative sensibility.

The Women's Caucus

In November 1971, Judy Chicago, Miriam Schapiro, and Paula Harper, on behalf of a woman's group of the California Institute of the Arts, contacted Ann Sutherland Harris about the possibility of a meeting for women members at the College Art Association's annual convention, which was to be held in San Francisco in January 1972. Ann Sutherland Harris sent out questionnaires to about sixty women, whose response "was uniformly positive" and, when that first meeting of women members of the College Art Association was held on January 28, 1972, the room reserved for it proved to be far too small. "Some two hundred women crowded in, sitting on the floor, listening through doorways; others gave up in despair, but contacted the organizers afterward. Clearly, there was a real need for an organized pressure group working to eliminate discrimination against women artists, museum staff and art historians," Harris, who was elected chairperson of the Women's Caucus, wrote later.[43] Her first report, as chairperson, included a summary of government statistics on the number of women faculty members—full professors, associate professors, and instructors—regularly employed in colleges and universities. It was found that women constituted as little as 11 percent of the total art history faculties and were less than 2 percent of the studio faculties of art departments across the country. In its first year the caucus submitted a number of resolutions to the College Art Association, recommending a 40/60-percent faculty ratio of women to men teachers, that statistics on admission of women to graduate programs be watched to ensure fair treatment, and that more nominations and elections be made of women College Art Association members to the College Art Association board. The Women's Caucus succeeded in convincing the board to pass, on January 24, 1973, "a resolution urging its members both individual and institutional to cooperate with campus Affirmative Action Plans intended to increase the numbers of women in colleges and universities at all levels."[44] The caucus won 50-percent representation for women on the board of the College Art Association and, by 1976, had a placement service for women artists and art historians, which annually received over one hundred job listings from various institutions.

In 1974, the College Art Association informed the Women's Caucus that "it must consider itself a separate organization on the grounds that if it continued to call itself the Women's Caucus of the College Art Association, the C.A.A. would then be legally responsible for its actions, a responsibility it wished to divest itself of." Thus, in 1974, the caucus became a separate, non-profit organization known as the Women's Caucus for Art while continuing to hold its sessions in conjunction with those of the College Art Association. Two books on women's art stem directly from panels held by the Women's Caucus. *Woman as Sex Object: Studies in Erotic Art 1730–1970,* edited by Thomas B. Hess and Linda Nochlin (New York: Newsweek, 1973), was based on papers presented at Linda Nochlin's session at the College Art Association meeting

of 1972; *Feminism and Art History: Questioning the Litany,* edited by Norma Broude and Mary D. Garrard (New York: Harper & Row, 1982), consisted of essays for the most part drawn from papers given at the Women's Caucus meeting held in New York in 1978.

In 1976, the Women's Caucus for Art sponsored a works on paper show at the Women's Building in Los Angeles to complement with "a broad show of contemporary women artists" the large-scale historical exhibition "Women Artists: 1550–1950" scheduled to open in December 1976 at the Los Angeles County Museum. The Women's Caucus invited thirty-seven women art historians, critics, and curators to choose the works. They selected contemporary works by a total of 160 women artists to supplement Linda Nochlin's and Ann Sutherland Harris's historical survey, which was meant as a corrective to all those pre-1970 art history texts of two- to fifty-thousand-year surveys of world art that failed to mention the work of a single woman. "Women Artists: 1550–1950" was also an addendum to Linda Nochlin's now famous essay, "Why Have There Been No Great Women Artists?" which was originally published in the November 1971 issue of *Art News* magazine; the entire *Art News* "woman" issue was later brought out as a book titled *Art and Sexual Politics* (New York: Macmillan, 1973),[45] which in its turn proved a cornerstone for the publication of serious art history studies of women artists. The "Women Artists: 1550–1950" exhibition traveled from California to Texas, and then to The Brooklyn Museum in October 1977. The catalog, by Harris and Nochlin, has since become a text for women's art history courses in colleges throughout the country. Meanwhile, the Women's Caucus for Art continues to sponsor exhibitions, puts out a national newsletter, holds regular meetings in conjunction with those of the College Art Association, and through its twenty-four local chapters continues to represent women artists, art historians, museum and gallery administrators, art collectors, and students.

New York Women Artists:
Feminist Pluralism

From the beginning, feminism among New York women artists was pluralistic. The Women Artists in Revolution group wrote their protests to The Museum of Modern Art and to The Whitney Museum of American Art in May and June 1970,[46] Lucy Lippard's Ad Hoc Committee of the Art Workers Coalition began its actions against the Whitney in September 1970, and Faith Ringgold and Women Students and Artists for Black Art Liberation followed with its own demands of the Whitney in October. On June 18, 1970, the Whitney Museum administrator Stephen Weil wrote Dolores Holmes of W.A.R. that the museum had scheduled a Georgia O'Keeffe retrospective, had planned two other one-person exhibitions of women artists, and was planning

"from November 9th through December 14 to show a large group of recently acquired works by Louise Nevelson." These exhibitions had long been planned, Weil explained, and added, "after meeting with you, it has been decided the Museum's holding of works by women artists could serve as a basis for an exhibition of contemporary women's art."[47] Weil sent the same response to Lippard and Ringgold in October; the concession was not acceptable either to the W.A.R. or the Ad Hoc women, who demanded more immediate recognition, in the form of 50-percent representation by women artists in the upcoming Whitney Sculpture Annual. In a letter published in the January *Art Gallery Guide,* Nancy Spero of W.A.R. rejected the Whitney's offer of a token exhibition of women artists selected from their permanent collection and reviewed the history of the museum's relationship to women artists in the period 1965–1969; it is important to remember that 1965–1969 was the period when the women's movement entered the national consciousness. It was in 1963 that Betty Friedan published her book *The Feminine Mystique,* and by 1966 Friedan had joined with other women to organize the National Organization for Women, pledged "to confront with concrete action the conditions which now prevent women from enjoying the equality of opportunity and freedom of choice which is their right as individual Americans, and as human beings."[48] In 1967, the movement to legalize abortion began in earnest in many sections of the country, culminating in a partial victory in 1970, with the New York State legislature passing a law "permitting the termination of pregnancies resulting from rape or incest, as well as those threatening the physical or mental health of the mother."[49] In cities across the United States, on August 26, 1970, tens of thousands of women marched to celebrate the fiftieth anniversary of the passing of the Nineteenth Amendment—the women's suffrage amendment—and to demand passage of an Equal Rights Amendment, which would guarantee equal rights for women.

The women's movement arrived late to the art world, and it was only after marching as part of the larger movement that women artists began to look around at what was happening in their professional world. The fact that The Whitney Museum was ready with a Louise Nevelson show was seen as a skillful public relations maneuver, and in December the Ad Hoc Committee, Women Artists in Revolution, and Women Students and Artists for Black Art Liberation staged a series of demonstrations culminating on December 11, 1970, the opening night of the Whitney Sculpture Annual. Actually, the museum had to some extent responded to the pressure brought by the women; as Grace Glueck reported: "It was noted last evening, however, that the current annual contains a far larger proportion of work by women —22 per cent—than any of the previous annuals. Of the 103 exhibitors from all parts of the country 22 are women. In previous years the representation of women ran between 5½ to 10 per cent. . . . Last year it was 8 women to 143 men. Museum officials concede somewhat reluctantly that pressure from the women's groups was effective."[50] The women artists, however, took this response as merely a better brand of tokenism.

In 1971, the Ad Hoc Committee's Women's Slide Registry contained slides of the work of over six hundred women artists, and other women's groups, while continuing to attack the male art establishment, were also beginning to think in terms of creating alternative spaces for themselves. The same women who took part in consciousness-raising sessions at the end of the sixties, in the seventies began to apply what they had learned to their professional lives. Women in the Arts was organized in April 1971 with "a handful of women artists and writers to explore solutions to end discrimination against women in the art world." Women in the Arts, which from the start included dancers, filmmakers, and writers as well as visual artists, by 1972 was staging large-scale demonstrations in front of the Modern and the Whitney museums. In 1972, it also wrote an open letter to The Brooklyn Museum, The New York Cultural Center, The Metropolitan Museum of Art, The Museum of Modern Art, The Solomon R. Guggenheim Museum, and The Whitney Museum of American Art, in which it announced itself "as an organization of more than 300 members. . . . We believe an expanding art audience deserves to see the work of an expanding community of artists. Therefore, we propose the exhibition 'Women Choose Women,' to be selected by the membership of Women in the Arts to include the largest number of known and unknown talents."[51] The letter went on to suggest that six museums organize a joint exhibition of women's art. On receipt of his letter, the new director of The New York Cultural Center, Mario Amaya, accepted the proposal for his space and on January 19, 1973, "Women Choose Women"—with 109 artists selected by three members of Women in the Arts, together with the critics and art historians Linda Nochlin and Elizabeth C. Baker, and the Cultural Center's coordinator Laura Adler—opened at The New York Cultural Center. "Women Choose Women" was the largest all-women show to be held in a major museum in New York, and the 109 works by 109 artists seemed, in general, no better and no worse than the work in the Whitney Annuals. Some of the art was outstanding; some looked "as if it had been in the closet too long."[52] But the fact that their art was finally being exhibited in a public space was to spark many of these artists to develop amazing work within a very few years. And the number of currently well known names of artists who participated in the 1973 "Women Choose Women" exhibition seems extraordinary.

In 1972, the same year that "Women Choose Women" was being organized, two sculptors, Barbara Zucker and Susan Williams, after attending several Ad Hoc Committee meetings, decided they would start their own cooperative gallery and "go the whole way and make it a woman's gallery."[53] They contacted Anne Healy, another sculptor, and Mary Grigoriadis, a woman painter whose work they liked, and asked the critic Lucy Lippard for the names of some other women artists. Lippard proposed Dotty Attie, Maude Boltz, and Nancy Spero, and then these artists, using the Ad Hoc Slide Registry, after going through the slides of 650 women artists and visiting 55 studios, chose the additional members of the gallery. On March 17, 1972, the twenty women held their first gallery meeting, named the cooperative gallery A.I.R. (an

acronym standing for artist in residence), which they set up on a dues-paying, non-profit structure. They found a machine shop full of rusted pipes on Wooster Street, and spent the summer renovating it. In the early spring, an A.I.R. press release, written by Nancy Spero, announced, "The gallery is being planned with a strong feeling of optimism. There is mutual confidence in each other's work, and there is the knowledge that we are letting fresh air into the current scene."[54] Another artist recounted that the members had acquired between them a long history of gallery and museum exposure. And indeed, from its opening day on September 17, 1972, "A.I.R. was a success. People overflowing from the gallery filled the street. A photographer from the new women's magazine *Ms.* rounded up the members for a group portrait. The male art world turned out in large numbers, one man telling Barbara Zucker, 'Okay, you did it: you found 20 good women artists, but that's about it' "[55]—which by itself says something about the anti-women-artist feeling prevalent at the time. Half the gallery—ten artists chosen by lot—made up the opening group show, exhibiting drawings, sculptures, and wall pieces; the work included artists who worked with rope, pencil, Plexiglas, and paper, along with one woman painter, Mary Grigoriadis, whose heavy, Byzantine-like geometric canvases were later recognized and identified as being part of the Decorative movement. In its first years, the gallery membership included a Conceptual artist, Agnes Denes; a Process artist, Loretta Dunkleman; and a number of women using material such as cloth, and sewing stitches and human hair, who were making a unique kind of personal work which soon became characteristic of mid-seventies art. Drawing and works on paper done in a new manner also became a major expression. Judith Bernstein's gestural charcoal drawing of a huge, hairy screw in the opening show was a sharp contrast to Dotty Attie's sequential copies of Ingres—drawings burned and stained by the artist herself. In the same show a piece by Nancy Spero called *Codex Artaud,* a word and image gouache collage based on the poems of the French Surrealist Antonin Artaud, was simultaneously intimate and cinematic. The content of all the work could be classified as both feminist and post-modern, being about art and about the women themselves. In general, erotic content in the work of women artists in, and outside, the A.I.R. Gallery seemed omnipresent. For example, the sculptor Hannah Wilke began making her vaginal sculptures in the late sixties, and with the advent of the women's movement began doing nude performances based on calendar-girl art, using herself as a centerpiece. Meanwhile, Judith Bernstein's hairy screws and Sylvia Sleigh's portraits of nude young males could be taken to represent women's views of the other sex, or meant to balance out, for example, such art as John Kacere's rather sexist portraits focusing on female bottoms in frilly underpants. Personal expression in the form of heavy erotic content in men's and women's art in what Tom Wolfe dubbed "The Me Decade" was at an all-time high. And being personal and/or erotic also was something the feminist movement had given women permission to be.

Almost from its inception, A.I.R. ran a Monday-night program devoted to feminist issues and addressed to women outside the gallery. A series of panel discussions on women art critics, filmmakers, dancers, and performance people, as well as on the problems of the individual artist, were held on a regular basis and, in its second year, the A.I.R. members had an evening devoted specifically to giving advice to other women wanting to start a cooperative gallery. By 1975 a group of women artists more figurative than those in A.I.R. had opened a feminist gallery named SoHo 20; the Women's Interart Gallery of the Women's Interart Center was functioning on a full-time basis; and, in Brooklyn, the Atlantic Gallery had opened its doors. Meanwhile, in Chicago there were the A.R.C. and the Artemesia galleries, the Hera Women's Cooperative in Rhode Island, and the Women Series at Douglass College in New Jersey, all exhibiting women artists' work on a regular basis. For a few years, then, in the mid-seventies, art by women suddenly became accessible to interested gallery-goers.

It was no accident that the Women's Caucus chose to mount a show of works on paper by contemporary women artists in conjunction with the historical show at the Los Angeles Museum or that the painter Joan Semmel, assigned the same task in Brooklyn, mounted a "Consciousness and Content" contemporary women's art exhibition focused on sexual imagery so that her exhibition "wouldn't just be another works on paper show."[56] In the seventies, it seemed to me, the majority of women artists were either making works on paper or doing outright sculpture, much of which contained feminist content. And in both kinds of work, the erotic element was strongly present.

Both Nancy Spero and Dotty Attie's series of works on paper over the last ten years have dealt with a good deal of sexual imagery. In Attie's work such imagery is used as a means of referring to the covert, the unseen. In Spero's art, the body image as often as not is used as a symbol of political and social anguish; her long paper scrolls are generally built on a social theme. Their work also depends on a great deal of verbal text: in Spero's case, it is collated from historic and poetic sources, while in Attie's work, it is created by the artist herself.

Dotty Attie, a Philadelphia-born artist, graduated from the Philadelphia College of Art before moving to New York and attending the Brooklyn Museum school. In the sixties, she was a Photo-Realist painter and had a show of big-figure paintings at the Castagno Gallery in 1966. In 1970, after painting for eleven years, the artist felt she "was tired" of what she was doing, and decided what she really loved was drawing, which turned out to be more suited to her purposes.[57] "I do personal work couched in impersonal terms," she explains. "Everything is taken from some source that didn't originate from me and yet everything I do emanates from my whole life. When I started making small drawings an internal fantasy started coming out . . . a taboo erotic fantasy. I like sexuality as a theme because it's not something I talk about. It

[22] Dotty Attie. *A Dream of Love.* 1973.

seems to come from a purer part of me."[58] Attie's early works, for her first show at A.I.R., consisted of drawing sequences such as those in *A Literary Illusion,* where the artist's pencil copy of a Granet painting disappears drawing by drawing as if burned away, and the *Seven Deadly Sins* series, where pencil copies of famous paintings are destroyed by anger (pencil scribbles), gluttony (jam stains), and so on. A major work from 1973, entitled *A Dream of Love* [22], consisted of 144 drawings 2 × 2″ each. The wordless images here ranged from a copy of the head of Gainsborough's *Blue Boy* to a boot to a headless nude, cigarette smoke, a stabbed man, and a manacled woman's wrist following each other across the room. In 1974–75, the artist began making up

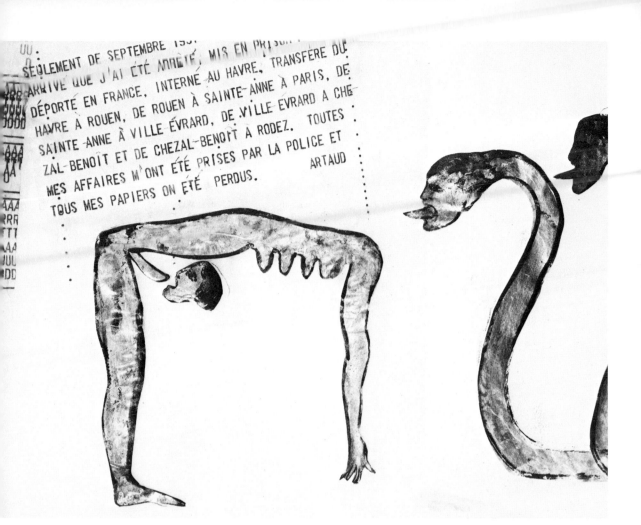

[23] Nancy Spero. *Codex Artaud VI,* detail. 1971.

her own texts; the narrative pieces that followed, such as *Pierre and Lady Holland* and *A Carriage Ride,* all made from visual quotations of parts of eighteenth- and nineteenth-century paintings, created a story in the interstices of Attie's words and images and were concerned with the unknown, the erotic, and the forbidden. Indirectness is part of the Attie wit, but the work is difficult to pinpoint; as one watches in a Texas museum, at the O.K. Harris Gallery, or at A.I.R., the lines of viewers move slowly from one image to the next, reading the text and experiencing Dotty Attie's transformation of the erotic world of another time into a new form of contemporary art.

Nancy Spero's collages deal with both visual and verbal quotations. For her first exhibition at A.I.R., Spero selected scrolls from her *Codex Artaud* series, which take the most irrational sentences from the writings of Antonin Artaud and combine them with such images as a headless body with four pendulous breasts, the head of a man

extending a penis-like tongue, the pattern of a primitive Aztec death game, and columns of typewriter markings. All these were pasted on sheets of paper—some vertical, others horizontal—extending across the gallery walls [23].

Nancy Spero, a Chicago-born artist, graduated from The Chicago Art Institute, got married, and in the sixties set to work making heavy dark paintings of almost invisible figures before abandoning painting for a series of anti-bomb *War Drawings.* After the Artaud series, all Spero's works have been built on a theme, sometimes political and almost always feminist. The titles of her solo exhibitions include *Torture in Chile, Licit Exp., Torture of Women,* and *Notes in Time on Women.* The 1976 *Torture of Women* contained quotations from Amnesty International's reports on the torture of women in Uruguay and Chile, with an excerpt from an ancient Sumerian creation myth. The imagery included a three-headed monster with a single wing trying to fly away from the words of a torture case history while small, exquisitely painted figures ran and danced in the truncated blank spaces of the 221-foot-long scroll, which wrapped around the gallery walls. The effect was to summon up the world of an ancient Egyptian frieze, transferred to paper—except that, in place of solidly massed hierarchical Egyptian figures, Spero presented a world of flying forms, a fragmented world whose sources in art history and literary references heighten the contemporary sense of alienation, by being couched in specifically political terms.

Anne Healy, Elaine Reichek, Pat Lasch, and Howardena Pindell, all of whom have been members of the A.I.R. Gallery,[59] are among the large number of women artists in the seventies using specifically feminist materials in their sculptures and wall pieces.[60] Anne Healy, a Site sculptor,[61] for her first show at A.I.R. was confronted with the problem of bringing her work inside at a period when she was involved with exploring feminine mythology in terms of archetypes. Healy's draped works consisted of free-falling cloth that was shaped by a hidden aluminum structure. On the floor beneath one piece, the artist placed a lit electric bulb to increase further its mystery. In both her *Black Hecate* (12 × 8') and *White Goddess* (12 × 10'), the shadows created by the sculptures became secondary works in themselves; shadow and cloth together suggested a ghostly continuum. The artist thinks of these as "very heavy pieces, heavy in at least psychological content."[62] On the one hand they expressed her interest in witchcraft as a carryover from the older religions dealing with the mother goddess, and on the other, her interest in Robert Graves's "White Goddess" of poetry. After these works, Healy began using more intimate materials—chiffon and silk organzas in dark greens, browns, and pinks in a 1975 show at the Zabriskie Gallery, where most people "couldn't get past the works' heavy sexual content." But for Anne Healy, aside from the feminist connotations of these semi-transparent materials, one of the main reasons for her use of them was to deal with the way they catch and hold light.

For Elaine Reichek, the choice of materials has almost always been part of her

feminist statement, part of a way for her to express being both a female and an artist. Reichek was born in Brooklyn and trained as a formalist as a student of Ad Reinhardt's at Brooklyn College, and then attended the Yale School of Art. Her interest from the beginning has been dealing with formalist problems in the context of feminism. In 1976, the artist made a series of black organdy pieces she placed in 13 × 14″ frames, each with its geometric shape created by the layering and folding of the organdy. The works were hung around the room at eye level, confronting the viewer as a series of severe, black, Minimal sculpture shapes with all the lightness of chiffon handkerchiefs—and the same exquisiteness. Reichek took this concept even further in her 1978 show at the Parson-Dreyfus gallery, which contained work made of pink and white organdy thread and paper placed in Plexiglas panels. As the art historian Joan Marter wrote of this show, "Materials employed by the artist—mesh, organdy in various shades, colored silk threads and metallic threads of various weights—are rich with associations. The visual distraction which might have been caused by the sensuousness of the materials and the skillfully hand-crafted details is avoided by the logical and austere structures in which the works are placed."[63]

Pat Lasch's early work also involved the grid and a Minimalist approach to such materials as muslin and gold and silver needlework. A student of both Richard Serra's and Richard Miller's at Queens College, Lasch began using the stitch as a mark in her paintings in 1969. Building from the idea of art as information, Lasch from her earliest work limited the information to strictly personal matters: name, birth date, and the network of time relations in the immediate generations that touched her life. In exhibitions after 1969, on unbleached muslin canvases, stitched gold and silver grids and radiating circles and drawn graphs were used to express her family history from grandmother to great-granddaughter. Two years later, Lasch's work expressed even more direct personal concerns when the artist went through her family album and gathered pictures of people that were part of her fantasy world—"for example, my mother as a young and beautiful girl"[64]— and began making paintings with them as a center. Around the photographs, Lasch, using cake-frosting tubes, began to paint decorative borders, memorializing her subjects in pastel, icing-like rows of paint.

Howardena Pindell's approach to materials is in many ways more detached than that of Elaine Reichek's or Pat Lasch's. In 1969, Pindell consciously selected the ¼″ point and made templates by punching holes in paper through which color was sprayed. She saved these punchings and four years later used them to make drawings. "To distinguish one point from the other, each was numbered. I equate numbers with distance, size, and mass, quantity and identification," she explained.[65] The artist, who graduated from the Yale School of Art and Architecture in 1967, and was one of the early members of the A.I.R. Gallery, brought her own sensibility to Process Art. By 1973, her pieces included pen and ink, thread, spray adhesive, and paper on board —a mixture of materials whose complexity exceeded the notion of simple process. It

[24] Howardena Pindell. *Untitled.* 1977.

was accretion—the thickness of the material, the layering of first numbers on a two-dimensional grid, and later the building of canvas by sewing pieces together in which were embedded paint, colored dots, and even talcum powder—that rendered Pindell's work into a physical presence. The artist took this even further in the summer of 1975, when she began to make her own paper, using mulberry paper as a base. The semi-transparent paper was exhibited away from the wall—so that you could see both sides of the transparent skin, in which Pindell had embedded drops of ink to make a two-way, all-over drawing suggesting the shifting cellular life one sees under a microscope.

In the seventies, Pindell moved between the black world and the white world of art. Her work was included in the Whitney Museum's "Contemporary Black Artists" show in 1971, and in the Whitney's feminist "Four Americans in Paris" exhibition in 1975. After leaving A.I.R. in 1976, she had one-person shows at such uptown New York spaces as the Rosa Esman and Lerner-Heller galleries, and in 1981 her large acrylic punched, painted, and printed paper collage canvas was included in the "Afro-American Abstraction" show at P.S. 1 [24].

Jackie Winsor and Jennifer Bartlett, two other women artists working more directly in the mainstream, brought their unique contributions to Process and Conceptual Art in the seventies. Winsor had her first one-person show at the Paula Cooper Gallery in 1973, approximately six years after getting a Master's degree from Rutgers University, where she studied all forms of art except sculpture. In the fewer than forty works of art she has made in the decade from 1973 to 1983, she has used the processes of wrapping and binding for some sculptures, and direct construction and building in others. Her interest, she says, has been in making pieces "with a quietness to them; pieces which have their own energy. You relate to them the way you might relate to a sleeping person, to the potential energy that is manifested in a dormant state."[66] The wrapping began with her early rope works, such as the 1970 *Dark Bound Circle,* whose double coils are wrapped and formed by hand from lengths of used rope. Other wrapping pieces include the wrapped wood series *Bound Square,* in which 72-inch-long logs are joined at the corners with twine to form a large wood square; thus a frame form becomes an atavistic object. There are, finally, the 1976 sculptures, *#1 Rope* and *#2 Copper* [25], in which three balls of hemp in one work and two balls of copper in the other are bound in rows around upright wooden sticks to make a square "rope" sculpture of 7 × 7″ and a square copper work of 6 × 6″ standing sticks. In 1974, Winsor started working with plywood, and the piece *Fifty-Fifty* is a marked departure from the earlier wrapped works. "When I started working with rope, I would never work with plywood," Winsor recalls. "But after the personality of plywood became clear to me—how it could come together, then I could sit on the floor and begin laminating it."[67] New materials to this Canadian-born artist mean

[25] Jackie Winsor. *#2 Copper.* 1976.

learning a new kind of identity: "You have to find out what they can bring to you and what you can bring to them," she says.[68] Most of the plywood works have been boxes. One was constructed from ¾″ pine rods stacked log-cabin style and then precisely nailed together to form a lattice-like cube. A later work, *Burnt Piece,* with the same basic cube structure, began with alternating bands of rough wood and sections of concrete. In order to void the inside and create one continuous surface, Winsor set the piece on fire and burned the core from within. Thus, through the seventies Jackie Winsor has been adding new processes and, more slowly, new materials to make sculptures whose "contained energy" creates an art presence, as demonstrated by the ten years' work in the Museum of Modern Art exhibition of 1979.

 In 1965, by the time Jennifer Bartlett received her M.F.A. degree from Yale University, she had rejected the decision-making in art and was using chance methods to select her paint colors. Around the same time, Bartlett began using steel plates because she "wanted to work on a surface of a constant size that would be flat and

[26] Jennifer Bartlett. *Rhapsody.* 1975–76.

adhere to the wall." By 1974, the artist produced her first steel plate for a show at the Paula Cooper Gallery, and by 1976, she had completed *Rhapsody* [26], a large environmental painting made up of 988 square steel plates that was 7 feet high and took up approximately 154 feet of Cooper's gallery wall space. "Bartlett has described *Rhapsody* as 'a conversation, where you start with a thought, bring in another idea to explain it, then drop it.' The work had a total of twelve themes, including four kinds of lines, three shapes, four archetypal images (mountain, house, tree and ocean) and . . . 25 colors of the kind commonly used in plastic model kits."[69] The scope of the piece won for Bartlett almost immediate recognition. " 'Rhapsody' rakes through the basic elements of figuration. It does that in terms of four archetypal subjects, all of them charged with emotional content. They are (i) a house, (ii) a tree, (iii) a mountain, (iv) the ocean. Each of these takes the front of the stage . . . 'Rhapsody' in its figurative aspects has reserves of feeling which have nothing to do with system or alphabet. It examines for example the role played in our lives by kitsch, and by visual infatuations

of a sort that would never be countenanced in a straightfaced history of art,"[70] John Russell wrote in an ecstatic review in a Sunday edition of the *New York Times;* on the first page of the arts section he announced the piece as "The most ambitious single work of new art that has come my way since I started to live in New York."[71] In one work, Bartlett had spread out the possibilities of Conceptual Art in terms of both color and figurative image in a way wholly alien to Sol LeWitt's earlier white configurations. Bartlett was that rare thing, an instant New York success, included almost automatically in subsequent Whitney Annuals and given her own one-person show at New York's esteemed Clock Tower alternative space.

In 1967, The Whitney Museum mounted its first one-person exhibition of Louise Nevelson's sculptures after Nevelson's works had represented the United States in the 1963 Venice Biennale. Nevelson is generally considered a sculptor of the fifties, with her outstanding wall wood constructions like the all-black *Sky Cathedral* and the all-white wood environment *Dawn Wedding Feast* dating from 1958 and 1959, respectively. During the seventies, in interviews in *Ms.* magazine and in Cindy Nemser's book *Art Talk,* Louise Nevelson bore witness—giving names and dates—to the kind of indignities women artists were subjected to during the fifties and up to and including the sixties by the American art world establishment, and became a feminist heroine. Partly in response, The Whitney Museum put on another retrospective, this time of all Nevelson's environmental works, to commemorate the artist's eightieth birthday, and New York renamed the plaza at Sixtieth Street and Fifth Avenue as the Louise Nevelson Plaza in a kind of belated recognition of Nevelson herself and of women artists in general. The Whitney Museum also put on an exhibition of the work of Lee Krasner, Jackson Pollock's widow, who is an outstanding, long-neglected woman painter of the Abstract Expressionist generation. And finally, the museum mounted an even more belated show, devoted to Alice Neel's work. Neel, born in 1900 and sometimes described as an "expressionist realist,"[72] in 1975 was described by the art historian Ann Sutherland Harris as "the most underrated artist of the last seventy-five years."[73] The next year Neel was elected to the National Institute of Arts and Letters. Meanwhile her corrosive portraits have become important to a younger generation of semi-realist painters.

Thus, by 1976 (especially after the advent of Pattern Painting and the popularity of Decorative Art), women artists believed they had more or less "arrived" and so were wholly unprepared for being left out of the year's major museum shows: the Museum of Modern Art's "Drawing Now" and the Guggenheim Museum's "Twentieth-Century American Drawing: 3 Avant-Garde Generations." About the Museum of Modern Art's survey of the work of current artists, John Perreault wrote in the *SoHo Weekly News,* " 'Drawing Now' as one art critic friend proclaimed should have been called 'Drawing Then.' "[74] The show, Perreault said, was not even about drawing or art on paper, citing as an example Robert Morris's contribution, which consisted

of the artist's handprints on the wall. Almost immediately after the opening, women artists from various groups met and, naming themselves the MOMA and Guggenheim Ad Hoc Protest Committee, sent out a news release on February 20, 1976, pointing out that the Museum of Modern Art's drawing show of 46 artists included only 5 women (one deceased), and that in the Guggenheim's exhibition of 230 works by 29 artists, the only woman artist represented was the octogenarian Georgia O'Keeffe. They announced they would hold protest demonstrations in front of The Museum of Modern Art on February 27th and at The Guggenheim Museum on March 4, calling for shows with 50 percent women artists. The media covered the demonstration at The Museum of Modern Art, and in the *New York Times* report the curator Bernice Rose said she was "extremely sympathetic to the women's cause, but when I do art exhibitions I can't consider work on the basis of whether it was done by a man or a woman"[75]—which sounded like a replay of museum statements from the early seventies. The fact that the exhibitions at The Museum of Modern Art and The Guggenheim Museum had been mounted by women curators made the situation seem at once more bitter and hopeless to women artists.

As a counter-show, "Drawing Now: 10 Artists," consisting of nine women and one man, was put on at the SoHo Center for Visual Artists on June 3, 1976. The exhibition was "a mix of abstract, figurative, calligraphic, paper-making and process artists, who work with line and the mark in terms of graphite, string and stone,"[76] and was reviewed in the *New York Times,* the *Village Voice,* and the *SoHo Weekly News.* Many of the artists were well known and had major gallery representation,[77] and the show's exhibition catalog was underwritten by an emergency grant from the National Endowment for the Arts.

In retrospect, then, one can see the start of the anti-women backlash beginning in 1976, at the height of the women artists' movement, when there were two national magazines, the *Feminist Art Journal* and *Womanart,* appearing regularly[78] and shows of women artists seemed omnipresent. In 1978–79, however, government-sponsored exhibitions of new artists from France and Germany began, many of which did not include a single woman artist, and, subsequently, the art dealer Leo Castelli paraded the fact that his was an all-male art stable in a group picture of "Leo with his boys" which appeared on the cover of *Art News.* In 1982, Mary Boone, "New Queen of the Art Scene,"[79] insisting on the quality of her all-male artist roster, announced, "It's the men now who are emotional and intuitive . . . and, besides, museums just don't buy paintings by women."[80] In 1982 pluralism was suddenly over, and life in the art world became all-male and all-figurative with the advent of the conservative eighties.

To end this chapter on a more positive note: the one landmark exhibition for women that was held in 1982 was the Louise Bourgeois retrospective at The Museum of Modern Art, which opened on February 8, 1982. A long-time "loner," Bourgeois became the archetypal artist of the seventies whose personal, idiosyncratic work

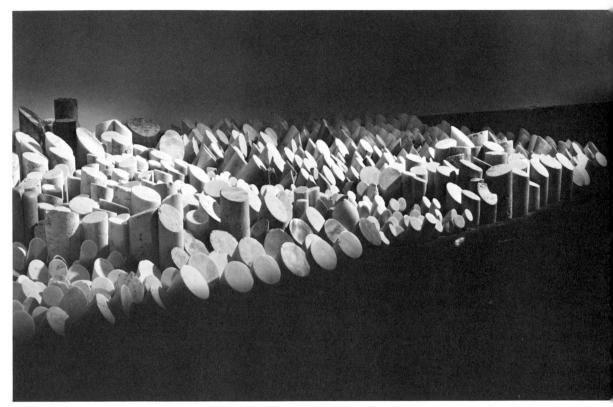

[27] Louise Bourgeois. *No. 2 (The No Marches).* 1972. Storm King Art Center.

appeared in a wide range of modes and materials. In the late sixties, Bourgeois began using Process techniques and pouring pendulous forms into latex rubber molds, along with casting the work in bronze and having it executed in marble. "People always mention the material. Material means nothing to me," the artist said in a 1982 interview."[81] To me, Bourgeois's work has always been concerned with body images, with gender, albeit on an unconscious level, since her beginnings in the French Surrealist movement some forty years ago. From the Surrealist house drawings and the slender wood pole-like sculptures of the early forties to the 1974 latex *The Destruction of the Father*—a cavelike environment of low pendulous shapes hanging over a floor strewn with animal-like fragments—her work has dealt with a sense of androgynous sexuality and the sexual component of feelings. *The Destruction of the Father* seems like an enactment of a scene from Sigmund Freud's classic *Totem and Taboo;* at the same time it celebrates the daring of Bourgeois's approach. In 1974 the artist also made a cloak of pendulous latex breasts, which she wore on the photograph announcing her one-person show at 112 Greene Street. The exhibition, in a high, dark

loft space which Bourgeois turned into a series of alcoves, included the artist's low marble sculptures, such as the 1972–73 *Marches* **[27]**, consisting of fragments of marble columns diagonally beveled and grouped together low on the floor. At The Museum of Modern Art, Bourgeois's work ranged from single phallic-like forms to baskets or clusters of pendulous breasts and phalluses. The show no doubt in part came about as the museum's belated tribute to the feminist movement (in this way, on a par with its Romare Bearden/Richard Hunt exhibition ten years before). But it also raised other issues: first, the fact that women are not a minority either in the United States or in today's art world, and that the backlash that began with the eighties may soon be over. And, more important in terms of art, as Robert Hughes wrote in his *Time* magazine article: "Louise Bourgeois's discovery in the seventies is not just a retribution for decades of neglect but a reassessment of the possibilities of sculpture."[82] And, indeed, Bourgeois's pioneering path could indicate new directions for the possibly pluralist art world that may be arriving by the late eighties.

NOTES:
ART AND POLITICS

1. Artworkers Coalition, *Documents 1,* 1969, p. 5.
 The *New York Times,* Sunday, August 14, 1983, on page one carried a story by John Barnell, which read as follows: "Governor Cuomo [of New York State] signed legislation yesterday giving artists the right to sue when they believe that alterations made in their works have damaged their reputations. Under the legislation, New York has recognized what France, Italy and West Germany have long regarded as the 'moral right' of artists to protect their works through the courts.
 "The law was opposed by the major New York museums, including the Metropolitan Museum of Art and the Museum of Modern Art. It was supported by artists, some of whom complained that it did not go far enough."
2. Artworkers Coalition, *Documents 1,* 1969, pp. 9–10.
3. It should be noted that El Museo del Barrio at 1230 Fifth Avenue, New York City, was founded the year after the Studio Museum and since 1969 has served "as a showcase for Puerto Rican Culture." Aside from a large historical collection, El Museo del Barrio also regularly shows work by contemporary Puerto Rican and New York artists and filmmakers.
4. Artworkers Coalition, *Documents 1,* 1969, p. 102.
5. Lucy Lippard, "The Artworkers Coalition," in Gregory Battcock, *Idea Art* (New York: Dutton, 1973), p. 108.
6. *Ibid.,* p. 109.
7. Corinne Robins, "The New York Art Strike," *Arts Magazine,* Sept./Oct. 1970, pp. 278–79.
8. Benny Andrews, "The B.E.C.C.," *Arts Magazine,* Summer 1970, p. 18.
9. Grace Glueck, "Art Notes: Black Show Under Fire at the Whitney," *New York Times,* Sunday, Jan. 31, 1971, Section 2, p. 25.
10. *Ibid.,* p. 25.
11. Benny Andrews, "On Understanding Black Art," *New York Times,* Sunday, June 21, 1970, Section 2, pp. 21–2.
12. Melvin Edwards, "Notes on Black Art," *Melvin Edwards,* exhibition catalog, Studio Museum in Harlem, New York, 1978, p. 20.
13. Charles Allen, "Have the Walls Come Tumbling Down?" *New York Times,* Sunday, Apr. 11, 1971, Section 2, pp. 1, 28.
14. Elsa Honig Fine, *The Afro-American Artist* (New York: Holt, Rinehart, Winston, 1973), p. 158.
15. *Ibid.,* p. 233.
16. Robert Hughes, "Art: Going Back to Africa—as Visitors," *Time* magazine, March 31, 1980, p. 72.
17. Mary Campbell Schmidt, "Introduction," in *Edward Clark: A Complex Identity,* exhibition catalog, Studio Museum in Harlem, New York, 1980–81.
18. Corinne Robins, "Ed Clark," *Arts Magazine,* Oct. 1975, p. 8.
19. Elsa Honig Fine, *op. cit.,* p. 265.
20. *Ibid.*
21. The "Afro-American Abstraction" show was in a

suite of rooms at P.S. 1, Feb. 17 through Apr. 6, 1980, with the following artists: Ellsworth Ausby, Barbara Chase-Riboud, Edward Clark, Houston Conwill, Melvin Edwards, Sam Gilliam, David Hammons, Maren Hassinger, Richard Hunt, Jamillah Jennings, James Little, Alvin Loving, Tyrone Mitchell, Senga Nengudi, Howardena Pindell, Martin Puryear, Charles Searles, Jack Whitten, and William T. Williams. It was organized by April Kingsley. The show traveled to the Everson Museum in Syracuse, N.Y., Feb. 6– March 29, 1981.

22. Jean Bergantino Grillo, "A Home for the Evolving Black Esthetic," *Art News,* Oct. 1973, p. 48.

23. From a conversation with the author in March 1976.

24. Mary Campbell Schmidt, "Introduction," *Rituals: Betye Saar,* exhibition catalog, Studio Museum in Harlem, New York, 1980.

25. *Ibid.*

26. See Merry A. Foresta, "A Personality in Art," and Adolphus Ealey, "Remembering Alma," in *Alma Thomas: A Life in Art* (Washington, D.C.: Smithsonian Institution Press, 1981).

27. Elsa Honig Fine, *op. cit.,* p. 209.

28. *Ibid.,* p. 210.

29. "Mod Donn" and an earlier show, "X¹²," are the first New York feminist group shows on record. "X¹²" took place in Jan. 1970.

30. Charlotte Streifer Rubinstein, *American Women Artists* (New York: Avon, 1982), p. 409.

31. Miriam Schapiro, "Our Beginning," *Womanspace Journal,* vol.1, no.1 (Feb./March 1973), p. 7.

32. Judy Chicago, *Through the Flower* (New York: Doubleday, 1977), p. 106D.

33. *Art Documentation,* Bulletin of the Art Libraries Society of North America, vol.1, no.5 (Oct. 1982), p. A-4.

34. "Judy Chicago Talking to Lucy R. Lippard," in Lucy Lippard, *From the Center* (New York: Dutton, 1976), pp. 219–20.

35. *Ibid.,* p. 220.

36. Roberta Smith, "The Dinner Party: Nuts and Bolts," *Art in America,* Apr. 1980, p. 121.

37. Slide lecture given by Chicago in 1980 concerning vaginal imagery, at a women's meeting in New York City.

38. Lawrence Alloway, "Women's Art in the 70's," in Judy Loeb, *Feminist Collage: Educating Women in the Visual Arts* (New York: Teachers College Press, Columbia University, 1979), pp. 66–70.

39. Also printed in *Feminist Collage,* p. 103.

40. From a conversation with the author, Aug. 1983, New York City.

41. Paula Bradley, "Interview with Miriam Schapiro, November 1977," in *Miriam Schapiro, a Retro-*spective, 1958–1980, exhibition catalog, College of Wooster, 1980, p. 44.

42. *Ibid., passim.*

43. Ann Sutherland Harris, "First Report," *Feminist Art Journal,* Spring 1973, p. 3.

44. *Women's Caucus for Art Newsletter,* no. 3, 1974.

45. Judith Brodsky, "Women's Caucus for Art: Report from the President," *Womanart,* Spring/Summer 1977, p. 11.

46. Letter to John Hightower, director of The Museum of Modern Art, dated June 1, 1970, and signed by Dolores Holmes, Sarah Saporta, Nancy Spero, Corinne Robins of WAR.

47. Letter from Stephen Weil of The Whitney Museum of American Art to Dolores Holmes, June 18, 1970.

48. Peter N. Caroll, *It Seemed Like Nothing Happened* (New York: Holt, Rinehart, Winston, 1982), p. 34.

49. *Ibid.,* p. 35.

50. Grace Glueck, "Women Artists Demonstrate at Whitney," *New York Times,* Dec. 12, 1970.

51. *Women Choose Women,* exhibition catalog, New York Cultural Center, New York, 1973, pp. 4–5.

52. Corinne Robins, "The Woman Artist 1973," *Christian Science Monitor,* Sept. 24, 1973.

53. Corinne Robins, "Artist in Residence: The First Five Years," *Womanart,* Winter 1977–78, p. 5.

54. *Ibid.*

55. *Ibid.,* p. 6.

56. Ellen Lubell, "Interview with Joan Semmel," *Womanart,* Winter 1977–78, p. 19.

57. Corinne Robins, "Dotty Attie," *Drawing Now: 10 Artists,* exhibition catalog, SoHo Center for Visual Artists, New York, 1976.

58. *Ibid.*

59. Both Elaine Reichek and Anne Healy are 1983–84 gallery members.

60. The following is a brief list of other women artists using such feminist materials in the seventies: Harmony Hammond, Jane Kaufman, Rosemary Mayer, Patsy Norvell, Miriam Schapiro, and Paula Tavins.

61. For more about Anne Healy's Site work, see pp. 108–110.

62. Corinne Robins, "Anne Healy: Ten Years of Temporal Sculpture," *Arts Magazine,* Oct. 1978, pp. 129–31.

63. Joan Marter, "Elaine Reichek," *Arts Magazine,* Jan. 1978, p. 7.

64. Corinne Robins, "Pat Lasch," *Arts Magazine,* June 1977, p. 17.

65. Statement by Howardena Pindell in *Drawing Now: 10 Artists.*

66. Ellen H. Johnson, "Introduction," *Jackie Winsor,* exhibition catalog, The Museum of Modern Art, New York, 1979, p. 9.

67. John Gruen, "Jackie Winsor, Eloquence of a Yankee Pioneer," *Art News,* March 1979, p. 61.
68. *Ibid.*
69. Corinne Robins, "Artists Who Think and Art That Talks," *New York Arts Journal,* Apr. 1980, p. 23.
70. John Russell, "Gallery Review," *New York Times,* Sunday, May 16, 1976, Arts and Leisure Section, p. 31.
71. *Ibid.,* p. 1.
72. Charlotte Streifer Rubinstein, *op. cit.,* p. 381.
73. Ann Sutherland Harris, "A Note," *Art News,* Nov. 1977, p. 113.
74. John Perreault, "Drawing It Out: Castelli and Weber," *SoHo Weekly News,* Feb. 5, 1976, p. 20.
75. "Women Call Show at Modern Sexist," *New York Times,* Feb. 28, 1976.
76. Grace Glueck, "Art People," *New York Times,* May 28, 1976.
77. The artists in "Drawing Now: 10 Artists" were: Dotty Attie, Blythe Bohnen, Natalie Bieser, Nancy Grossman, Phoebe Helman, Howardena Pindell, Deborah Remington, Lucas Samaras, Nancy Spero, Michelle Stuart.
78. The *Feminist Art Journal* suspended publication in 1977, and *Womanart* in 1978.
79. "Mary Boone, New Queen of the Art Scene," *New York* magazine, Apr. 19, 1982, p. 28.
80. *Ibid.*
81. Michael Berenson, "Sculptor Louise Bourgeois," *International Herald Tribune,* Nov. 16, 1982.
82. Robert Hughes, "A Sense of Female Experience," *Time* magazine, Nov. 22, 1982, p. 116.

4

Earth Sculptures, Site Works, and Installations

Artists at the beginning of the seventies began to introduce the idea of a new kind of dialogue with the gallery as an art space, in reaction to the conventions of Minimalism which had reduced gallery and museum spaces alike to the dimensions of an impermeable white cube. "The ideal gallery subtracts from the artworks all cues that interfere with the fact that it is 'art'. . . . The work is isolated from everything,"[1] wrote the critic Brian O'Doherty. And by the end of the sixties the gallery had indeed become the Minimalist temple *par excellence,* a place wholly devoted to the "technology of aesthetics."[2] Both the Process artists and the Earth sculptors, in turn, were against technology. And the physical presence of these artists and their work brought a new reality into the gallery, with a "kind of eternity of display, where though there is lots of period (late modern), there is no time."[3] The Earth artists in the seventies wanted to make contact with time, to reintroduce space/time coordinates into art. They started making their pieces in and from the earth as a way of starting over, of beginning again at the beginning. On the other hand, they were not primitivists. When Robert Morris in 1975 wrote his article "Aligned with Nazca,"[4] where he discusses the effects of the ancient Nazca Earthworks and their place as a point of departure for understanding pieces by the new Earth sculptors, he was reversing the actual chronology of development. Robert Smithson, for example, was not inspired by ancient burial mounds but by the ecological wastelands of industrial New Jersey. If the Earth artists could be said to be echoing any of the national preoccupation with returning to the land, it was only in terms of a search for new space, rather than as a gesture toward conservation or a reawakened interest in primitivism. In a discussion in 1970, Robert Smithson very specifically described his visual impetus: "I started taking trips to specific sites in 1965: certain sites would appeal to me more—sites that had been in some way disrupted or pulverized. I was really looking for a denaturaliza-

tion rather than built up scenic beauty."[5] The indirect influence of primitivism and Indian burial mounds could have reached the Earth artists through their renewed interest in Abstract Expressionism, in the strength of the gesture and scale that Barnett Newman and Jackson Pollock had brought to art. (It was, after all, Barnett Newman, Jackson Pollock, Mark Rothko, and Adolph Gottlieb in their quest for the American sublime who were interested in Indian burial mounds and primitive religious symbols.)

And the Earth artists' interest in the gallery wasn't a simple either/or situation. While an artist such as Michael Heizer felt a moral satisfaction carving out pieces in the desert and thereby "not adding new objects to an already surfeited world,"[6] neither Heizer's nor Smithson's interest in making Earthworks precluded gallery exhibitions. Indeed, Robert Smithson, who organized the first Earth sculpture show at the Dwan Gallery in New York in 1968, insisted he liked the idea of the ponderousness of the earth material, and the idea "of shipping back rocks across the country."[7] Bringing earth into the gallery was bringing in a fresh idea as to what might constitute art at the end of the twentieth century. The Conceptualists had already established the primacy of the verbal concept. Smithson and Heizer were countering them with their insistence upon the importance of physical matter, Smithson even going so far as to complain that photographs of his pieces "steal away the spirit of my work."[8] But photographs became as important to the Earth artists as they were to the Conceptualists because Earthworks were often temporal and existed, for the most part, on faraway sites. Thus photographs of pieces by Robert Smithson, Michael Heizer, and Walter De Maria were all donated to Celant's book, *Arte Povera,* with the idea that earth is a poor material. On the other hand, reshaping the earth, as these artists were soon to learn, was a very expensive proposition.

In 1966 and 1968, Smithson's first essays introduced the idea of temporality and change—in the forms of dirt, rock, and crystals—into art, equating their duration with reality. "Every object," he wrote, "if it is art, it is charged with the rush of time, even though it is static,"[9] thus shattering John Keats's ideal of art as "a bride of quietness, eternity and slow time." In 1968, Michael Heizer made a drawing by using his motorcycle to cut a narrow track on a sand floor near Las Vegas—such a drawing was a temporal work, rather than an object to be bought and owned. Thus, the majority of Earth artists were presenting art as an experience in time and, often, an experience with time as well. Artists such as Alan Sonfist and Michelle Stuart became concerned in the early seventies with re-creating time as lost time-landscapes on the one hand, and with the mapping of time by recording its mark in terms of layers of the earth's crust on the other. The idea of making site-specific works that were not necessarily made of earth materials, although many of them did involve wood and stone, also became popular with a large group of artists. Such site-specific works, for the most part, were not purchasable. And each of them, built outside the gallery and

conceived in terms of a specific outside place, became part of a concerted attempt at opening up the hidden window of the white cube onto a new kind of vision—a vision that included life factors of weather and time, and of the effects of sunlight, as opposed to electricity. Finally, in the mid-seventies, the gallery was transformed from the white cube into an oversized barn or vast hall of four walls and sixteen-foot ceilings. In places such as "Sculpture Now," the gallery became almost unrecognizable as a framework for artists' installations that literally resituated the viewer.

The categories Earth sculpture, Site work, and installation in this chapter are not meant to serve as hard-and-fast divisions. Christo's *Valley Curtain* and *Running Fence* could just as easily be classed as performance pieces as Site works. Nancy Holt's *Stone Enclosure: Rock Rings 1977–78* fulfills the conditions for both Earth sculptures and Site works. And Walter De Maria's *New York Earth Room* on Wooster Street exists as that most contradictory thing of all, a permanent installation in the temporal world of three-to-five-week changing art exhibitions. And in all of these contexts, where art is concerned, dirt itself is the opposite of cheap. Earth sculptures, Site works, and installations all involve extensive and expensive gallery, museum, or private patronage. Robert Smithson's definition of an Earthwork—"instead of putting a work of art on some land, some land is put into a work of art"—becomes a costly undertaking at the close of the twentieth century, which may explain why "the major works in the new Earth art are American."[10] Whatever the individual artist's personal, social, and political beliefs may be, Earth, Site, and installation works seem to require "vast uninhabited space and a good deal of capitalization on which no direct return is to be expected."[11] The chief patrons of Earth and Site work throughout the seventies were the art collector Robert C. Scull; Virginia Dwan, who directed the Dwan Gallery from 1966 through 1971, and then continued to extend private patronage to selected artists; and the Dia Art Foundation. As of this writing,[12] the largest number of permanent Earthworks (all funded by the foregoing patrons) are in not too accessible areas of the United States—in landscapes of desert and in deserted spaces that seem ready and waiting to be converted into art. Thus, on a most basic level, today's Earth artists are uncovering new ground.

Earth Sculptures and Non-Sites

The Biographical Note prefacing *The Writings of Robert Smithson* states: "Until Robert Smithson arrived on the art scene, sculpture was basically a gallery art or seen as an addition to architecture. . . . Smithson's earth work proposals of 1966 and the Non-sites exhibited in New York City in 1967 dislocated this prevailing look by returning sculpture to the landscape."[13] While this statement does not explain the hows or whys, it is nonetheless a fairly accurate assessment of Robert Smithson's

almost one-man successful attempt to reshape the course of sculpture at the end of the 1960s. It was, for example, at Robert Smithson's urging that Virginia Dwan mounted the first group exhibition devoted to Earthworks, at the Dwan Gallery in 1968, presenting the work and the artists to the New York art world as a formal movement. No doubt a major factor contributing to Robert Smithson's success, aside from his art itself, was his personal persuasiveness and brilliance as a writer and polemicist for the sculptors whose works he believed in or whom he believed were progressing in a direction contingent with his own.

The effect of Robert Morris's "Anti Form" article, helping to launch Process Art, is easily matched by at least three major articles which Smithson published between 1966 and 1968. The first, "The Crystal Land," appeared in the May 1966 issue of *Harper's Bazaar* and recounts a trip Smithson made with the sculptor Don Judd to an Upper Montclair stone quarry. The article begins, "The first time I saw Don Judd's pink plexiglas box it suggested a giant crystal from another planet."[14] Smithson goes on to reveal his admiration for Judd, based on the nonorganic aspect of Judd's work. The trip was the result of Smithson's discovery that Judd shared his interest in geology and was willing to become a collaborator with Smithson, in his exploration of the walls of quarries, "the cracked broken shattered earth, of fragmentation, corrosion, decomposition, disintegration, rock crisis, debris slides, mud flow, avalanche"[15]—all of which make up Smithson's subsequent Non-Site works and Earthworks. In the second essay, "Entropy and the New Monuments," published in *Artforum* in June 1966, Smithson established himself as a formidable art critic in a discussion of other sculptors' work in the 1966 "Primary Structures" show at The Jewish Museum; it was the most important show of Minimal Art to date, and in it, Smithson himself had a small work, *Cryosphere*. The essay divides the "Primary Structures" sculptures into those which deal with entropy, or "energy drain," and those "retrograde" works which, dealing with organic/body imagery, support the "myth of progress." Interspersed between discussions of specific sculptures are descriptions of "the formal logic of crystallography," the science fiction interests of a new generation of artists, and the existence of impure and purist surfaces. Entropy and dissolution are the essay's major themes; the article is proof of Smithson's power to discuss contemporary philosophic concepts in terms of specific sculptures, and, in the process, come up with crystallization as the art paradigm of the future. Following this discussion of entropy, in 1968 Smithson published "A Sedimentation of the Mind: Earth Projects," his most direct exposition of his own work, together with that of other artists. In this essay, Smithson stresses the importance of the time factor in art and attacks the English sculptor Anthony Caro and other "beautiful" art makers as the "Better Homes and Industries School," as opposed to "the more compelling artists today, concerned with 'Place' or 'Site'—Smith (Tony), De Maria, Andre, Heizer, Oppenheim, Huebler."[16] These artists, Smithson says, are breaking formal boundaries and reintroducing time and

"parallactic perspectives" into art. Thus, "A Sedimentation of the Mind" is both a defense of current Earthworks and a manifesto for all the sculptures Smithson and his friends had yet to make.

Robert Smithson was born in Passaic, New Jersey, in 1938 and attended the Art Students League in New York while still in high school. In 1956 he attended the Brooklyn Museum school and then for two years hitchhiked around the United States and Mexico. He returned to New York in 1958 and had his first show of paintings, at the Artist Gallery, at the age of twenty-one. These paintings were gestural works, containing a few figurative-expressionist angels lightly sketched in. Dissatisfied with these works, Smithson next did a series of biological pieces involving specimen sponges and chemical compounds. In 1961 he married the artist Nancy Holt, and had a show of the specimen pieces at the Richard Castellane Gallery, after which he withdrew from the art world for a few years. In 1964, Smithson began making sculptures more in keeping with the then current Minimalist idiom; the impetus for the work, however, came from Smithson's own interest in crystallography. A rock collector as a boy, the artist felt he found in crystallography "a way of dealing with nature without falling into the old trap of the biological metaphor."[17] Mineral life forms and the changing of earth matter provided Smithson with a cool framework on the one hand and on the other, ideas about crystallization are very much in accord with his love of science fiction. Finally, the concept of entropy, the tendency of systems to dissolve, of things to decay, became an intellectual peg on which he structured his entire aesthetic approach. Smithson presented his idea of entropy as a process as follows: "Picture in your mind's eye the sand box divided in half with black sand on one side and white sand on the other. We take a child and have him run hundreds of times clockwise in the box until the sand gets mixed and begins to turn grey; after that we have him run anti-clockwise, but the result will not be a restoration of the original division but a greater degree of greyness and an increase of entropy."[18] Entropy thus is about the irreversibility of destruction, which, in the hands of the artist, may become a contradictory possibility of being turned into a creative process. Included among the "monuments" Smithson writes about in the essay "Tour of the Monuments of Passaic" (in *Artforum* in December 1967) are "great pipes, sand boxes, bridges with wooden sidewalks, all standing for the irreversibility of eternity. Under the dead light of the Passaic afternoon, the desert becomes a map of infinite disintegration and forgetfulness . . . suggesting the sullen dissolution of entire continents, the drying up of oceans."[19] Here Smithson is recounting his trips to industrial wastes, which provided him with materials for his Non-Site sculptures.

In 1968, for his exhibition at the Dwan Gallery, Smithson showed his first Non-Site Earthworks based on trips to Passaic, the Pine Barren Plains, and Atlantic City. These Non-Sites are "a kind of three-dimensional abstract map that points to a specific site on the surface of the earth." As seen at the Dwan Gallery, they consisted

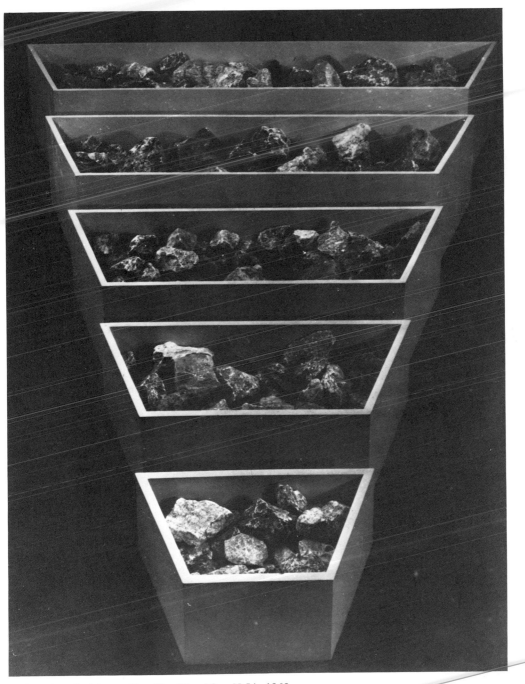

[28] Robert Smithson. *Non-Site (Franklin, N.J.).* 1968.

of maps or aerial photographs, together with rocks or earth from particular locations placed in metal bins. *Non-Site, Franklin, New Jersey* [28], which consisted of wood, limestone, and aerial photographs, offered the viewer five trapezoidal bins filled with ore, together with an aerial photograph of the site from which the ore had been taken. Smithson has described the intent and components of his first Non-Site of Pine Barren Plains as follows: "The map of my Non-Site #1 (an indoor earthwork) has six vanishing points that lose themselves in a pre-existent earth mound that is at the center of a hexagonal airfield in the Pine Barren Plains in South New Jersey. Six runways radiate around a central axis. These runways anchor my 31 subdivisions. The actual Non-Site is made up of 31 metal containers of painted blue aluminum, each containing sand from the actual site."[20] Non-Sites for Smithson were about absence, a very ponderous, weighty absence. In a later essay, he worked out the following "Dialectic of Site and Non-Site"[21]:

Site	*Non-Site*
1. Open limits	Closed Limits
2. A series of points	An array of Matter
3. Outer coordinates	Inner coordinates
4. Subtraction	Addition
5. Indeterminate certainty	Determinate uncertainty
6. Scattered information	Contained information
7. Reflection	Mirror
8. Edge	Center
9. Some place (physical)	No place (abstract)
10. Many	One

Both sites, he explains, "are present and absent at the same time. The land or ground from the Site is placed in the art (Non-Site) rather than the art is placed on the ground. The Non-Site is a container within another container—the room."

Smithson's Non-Sites are permanent pieces, in contrast with Robert Morris's Earthworks made in 1968 and 1969. Robert Morris, who had accompanied Smithson on the Pine Barren expedition, made his first Earthwork of loose dirt for the 1968 Earthwork exhibition at the Dwan Gallery. He made a second work for a 1969 Castelli warehouse show. Both pieces, according to the critic Marcia Tucker, "exist only in the present tense since their removal (from the site) entails their total destruction." Morris's Process-oriented pieces "represent an attempt to expand the area of possibilities to include a physical framework that allows disorder to inform it," Tucker concludes.[22] And Smithson himself subsequently became more involved with a Process/Conceptual approach, with his *Dead Tree* piece for a 1969 show in Düsseldorf and *Asphalt Rundown* on a hillside in Rome the same year. His most important non-Earthwork is already finished: a painted steel sculpture titled *Gyrostasis* which stands 73″ × 57″ × 40″. Smithson's use of the spiral shape in *Gyrostasis* is outside

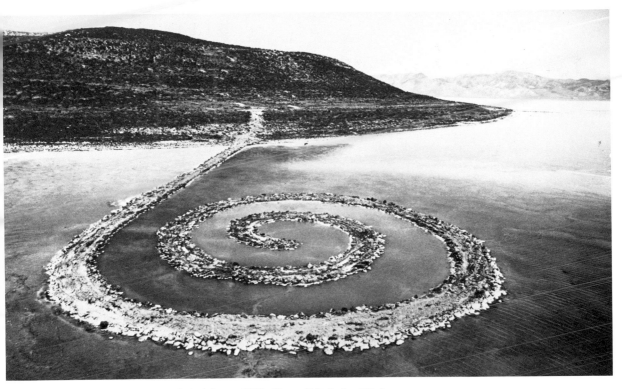

[29] Robert Smithson. *Spiral Jetty*. 1970. Great Salt Lake, Utah.

contemporary (1968) art logic, and seems in deliberate opposition to the obsession with the grid then shared by most Minimal artists. "The title GYROSTASIS," Smithson explains, "refers to a branch of physics that deals with rotating bodies, and their tendency to maintain their equilibrium. The work is a standing triangulated spiral. When I made the sculpture I was thinking of mapping procedures that refer to the planet Earth."[23] More important, *Gyrostasis* anticipates the configuration of Smithson's *Spiral Jetty* Earthwork. Writing in 1973, Smithson describes his preoccupation with the shape and his making of the sculpture in relational terms, giving us a choice of considering it either "as a crystallized fragment of a gyroscopic rotation, or as an abstract three-dimensional map that points to the *Spiral Jetty,* 1970, in the Great Salt Lake, Utah"[24] **[29]**.

Robert Smithson's interest in salt lakes actually began the same year he completed *Gyrostasis.* Immediately after making the *Mono Lake Site/Nonsite* piece in California, Smithson started reading a book describing salt lakes in Bolivia, filled with micro-bacteria which gave the water surface a red color matching the pink flamingos that lived around the area. Excited about the idea, Smithson called the Park Depart-

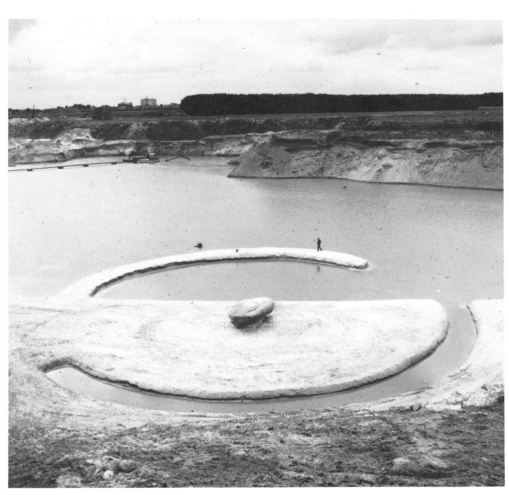

[30] Robert Smithson. *Broken Circle.* 1971. Emmen, Holland.

ment of the State of Utah and learned that such red and pink coloration was characteristic of several salt lakes in that state and that at least one, thanks to the local algae and mineral wastes, was reputed to be the color of tomato soup. Soon after, Smithson and Nancy Holt went to Utah to explore the salt lake region and fixed on a lake at Rozel Point, one mile north of the oil seeps, with irregular beds of limestone and a network of mud cracks under its shallow pinkish water. The site, as Smithson then experienced it, was of "a rotary that enclosed itself in an immense roundness." And "from that gyrating space emerged the possibility of Spiral Jetty,"[25] which the artist began building in April 1970, simultaneously filling and excavating the construction, which required moving some 6,650 tons of material. *Spiral Jetty,* in Great Salt Lake, was made with the support of Virginia Dwan in New York and Ace Gallery in Vancouver: Dwan helping Smithson to acquire a twenty-year lease on the land and defray construction costs, and the Ace Gallery paying for the camera, the crew, and the film equipment needed for making a movie of the work as it was being built. The

jetty itself—of mud, precipitated salt crystals, rocks, and water—was formed into a coil of earth fifteen hundred feet long and fifteen feet wide, the scale of the piece fluctuating with wherever the viewer happened to stand. When a person walked to the end of the jetty, in keeping with Smithson's entropic philosophy he found nothing there. And today, while the movie *Spiral Jetty* and the photographs of the work have entered art history, the Earthwork itself has all but disappeared under the waters of Great Salt Lake.[26]

Smithson's next Earthwork, a two-part piece titled *Broken Circle* [30], in Emmen, Holland, thanks to the support of the local Dutch citizenry, is a permanent piece, since local funds have been set aside to preserve and maintain it. In the summer of 1971, a year after completing *Spiral Jetty,* Smithson was invited to create a work for a park in Holland as part of an international sculpture exhibition. Smithson declined the exhibition committee's proposed sites and set about exploring the countryside. He discovered an area near an abandoned stone quarry in Emmen, where glacial movements had created strange multicolored layerings of soil. With bulldozers, he made a black cone shape, which was then lined with a path of white sand. The *Broken Circle* part of the work is a floating earth/water open circle, approximately 140 feet in diameter, with a canal approximately 12 feet wide. At the center point of the circle is a prehistoric boulder, which turned out to be one of the largest rocks in Holland, and is considered almost immovable. Smithson, despite the fact he "was haunted by the shadowy lump in the middle of my work," finally allowed the "accidental center" to remain, nevertheless feeling "it became a dark spot of exasperation, a geological gangrene on the sandy expanse."[27] Nevertheless, it is the only industrial location that Smithson actually "reclaimed in the name of art."

In 1972–73, Smithson tried to finance new Earthworks by appealing for funding from various strip-mining companies. During talks with one such mining company in Colorado, he heard about a ranch with its own desert lakes in the Texas Panhandle. Smithson contacted its owner, Stanley Marsh, and went out to visit the ranch, which is fifteen miles northwest of Amarillo and includes an area around the Tecovas Lake silted with fine red clay. Smithson convinced Marsh to let him build a piece on this site, and Marsh hired a plane so that the sculptor could take aerial photographs to chart the piece's position and size. Smithson staked out a work approximately 150 feet in diameter across the lake and on July 20, 1973, Smithson and Marsh went up again. This time the plane, flying low over the site, stalled and, diving into the ground, killed everyone aboard.

After Smithson's funeral, Nancy Holt, with the help of the sculptor Richard Serra, decided to complete the Amarillo piece according to Smithson's drawn specifications. She and Serra returned to Texas and in three weeks finished the Earthwork's construction. *Amarillo Ramp* is a round curve made out of rock pilings from a nearby quarry. "Seen from above, it is a circle. . . . As you climb, it becomes an inclined

roadway. The top is a sighting platform."[28] Also, according to the critic John Coplans, the work gives "an acute sense of temporality, a chronometric experience of movement and time, pervades one's experience of the interior of the earthwork."[29]

Spiral Jetty, Amarillo Ramp, and *Broken Circle* all involve locomotion in that the works require the viewer to move in and through them. None are in picturesque places by conventional, nineteenth-century landscape standards, but exist "rather in dramatic isolation, in places of extremes of climate where, for example, the barren deserted land changes constantly between seven and eight in the morning when it is heavily shadowed until late in the afternoon when the surroundings seem flattened by the haze of heat and sun."[30] It is as if the works set out to introduce the viewer to a new experience of climate and light, different from twentieth-century man-made shelter conditions. Indeed, all of Smithson's work seems to refer to the earth itself, to its presence before and very possibly after human beings have occupied it.

Though Robert Smithson explored the outreaches in Texas and Utah for possible earth sites, he nevertheless remained a highly visible, articulate member of the New York art community, a practicing critic and participant in its life of gallery openings, discussions, and magazine publications. Michael Heizer, by contrast, has spent most of the last twelve years away from New York, and his position vis-à-vis gallery art has been more equivocal. In 1967, for example, Heizer called for an end of intrusive objects and proposed the removal of all art from the galleries, the museum, and the city. He resented the way art was treated as a bauble to be bought and sold. A sometime painter, he had a show of shaped canvases at Fourcade Droll Gallery in 1974, but Heizer's chief interest lies in mass and scale, form and location. "Man will never really create anything large in relation to the world. . . . The most formidable objects man has touched," he says, "are the earth and moon."[31]

Born in Berkeley, California, in 1944, the son of an archeologist, Michael Heizer grew up on archeological digs until an interest in art took him to the San Francisco Art Institute, where, in 1963, he determined to be a painter. Heizer came to New York in 1965 to continue to paint and, on a trip to Reno, Nevada, did his first Earthwork in 1967. He accompanied Robert Smithson on several rock expeditions in 1968, and invited Smithson and Nancy Holt to Nevada, where the three stayed at Heizer's parents' cabin at Lake Tahoe while making day tours to local sites. Heizer, Holt, and Smithson collaborated on a super-8 film called *Mono-Lake,* and Mono Lake became subject matter for a 1968 Non-Site by Smithson, while Heizer himself made *Circular Surface Displacement* by using his motorcycle as a drawing pen to inscribe a series of linear circles in a dry-bed lake north of Las Vegas. In aerial photographs, the shallow tire cuts in *Circular Surface Displacement* form a series of circles, some 200 feet in diameter, adjacent to a larger circle 400 feet in diameter. Seen on the ground, the earth drawing appears to be little more "than a series of gently overlapping curved arcs."[32] From 1968 to 1970, with the help of the art collector and patron Robert Scull, Heizer did a series of works involving the displacement of large amounts of earth and

[31] Michael Heizer. *Double Negative.* 1969–71. Virgin River Mesa, Nevada. Photographs Collection Virginia Dwan.

rock. In 1969, Heizer was offered a show at the Dwan Gallery, contingent on his making a major Earthwork in conjunction with the indoor exhibition. The sculptor left for the desert in the fall of 1969, and returned two months later with photographs of *Double Negative* [31]. This now famous Earthwork required the removal of 40,000 tons of earth from the two mesas facing each other across a canyon at the site known as Mormon Mesa, Nevada. In the photographs, the trenches—40 feet deep and 100 feet long, and 30 feet wide and 50 feet deep, respectively—do not appear accessible, but a ramplike entrance exists for viewers to walk down. Heizer himself believes *Double Negative* "is the smallest piece [he's] done in relation to the size of the site."[33] Another work, *Nine Nevada Depressions* (1968), consisting of five shallow cuts, each 12 feet long and spanning 50×50 feet in the Blackrock desert, the pattern of which was arrived at by throwing matchsticks on a sheet of paper, is now being cement-lined to withstand wind erosion. Meanwhile, Heizer's 1969 work for a German exhibition titled *Munich Depression,* which consisted of a 1,000-ton displacement to make a line 15 feet deep into the earth, has now disappeared.

Some critics see Heizer's cuts and displacements, his man-made gestures on the earth, as a continuation of the tradition of the Abstract Expressionist gesture,[34] a latter-day echo of points three and four of the Abstract Expressionists' 1943 *New York Times* letter, which said: "It is our function as artists to make the spectator see our way not his way. We favor the simple expression of the complex thought. We are for the large shape because it has the impact of the unequivocal."[35] Nevertheless, Heizer's 1974 paintings do not reflect Abstract Expressionist gesture painting, but rather represent a continuation of his own work now being carried out in terms of hard-edge geometric art. These painted works, executed on tondo- and ellipse-shaped canvases, echo the imagery of such Earth pieces as the Earthwork *Aboriginal Painting* of 1969, consisting of black organic dye sprayed on the ground of Coyote Lake in California, and of the round forms of *Circular Surface Displacement*—only translated now to latex on canvas. These paintings also no doubt represent part of Heizer's ongoing efforts to secure funds for the continuing construction of his monumental *Complex of the City,* an Earth sculpture that, the artist intends, will cover three square miles of already purchased desert land. Heizer has already completed the first section of the work, titled *Complex 1,* which is situated in a desert valley north of Las Vegas, close to where he now lives. *Complex 1* consists of a huge elongated mound of earth with concrete sides framed by steel and concrete columns. It was completed in 1976, and work on the second section of *Complex of the City* is now in progress.

Walter De Maria's approach to Earthworks and to art in general differs sharply from both Heizer's and Smithson's. As Lawrence Alloway has observed, Smithson's interest was in "creating finely articulated forms . . . using what was at hand, material collected on the shore and carried out into the water."[36] Up until beginning *Complex 1,* Michael Heizer created his sculptures solely through removal, or displacement, of earth. Walter De Maria's pieces, by contrast, disturb the landscape scarcely at all. While the poles that make up his *Lightning Field* were imported to the site, they function there as indicators to be seen through rather than as objects blocking the landscape. But then, De Maria's background and interests also contrast sharply with those of Heizer and Smithson. De Maria's first interest was music, and only after attending the University of California at Berkeley and earning the B.A. degree in history, did he become interested enough to continue his studies and obtain the M.A. degree in art. The California-born artist settled in New York in 1960, and by 1964 was playing as a drummer with the rock music group known as "The Velvet Underground"; at the same time he was working on a number of art projects. In 1962, for example, he proposed that a pair of mile-long concrete walls 12 feet high and 12 feet apart should be built somewhere in the United States; the idea was "when you walk between, you can look up and see the sky . . . as you continue to walk and get near the halfway point, the perspective will appear to close . . . and when you come out, you'll be able to see for an enormous distance and you'll really feel what space is."[37] The sculpture wasn't built and De Maria, meanwhile, did a series of "invisible draw-

[32] Walter De Maria. *The New York Earth Room.* 1977. Dia Art Foundation.

ings," in which the light penciling of a single word such as "sky," "river," and "tree" appears. These works were included in his 1965 exhibition at the Cordier Ekstrom Gallery in New York, together with a rather Duchampian work—the *High Energy Bar* of chrome steel, 10 or 12 inches long and about 1½ inches in section, which was inscribed with the title *High Energy Bar* and accompanied by an engraved certificate affirming that it was indeed a High Energy Bar. In 1967, De Maria made his first Earthwork, consisting of a 4½-mile-square indentation in the desert floor of Nevada. To build it, the sculptor rented a bulldozer equipped with a 6-foot blade and, following the primary compass headings, carved the shape into the earth. The next year, De Maria did a mile-long chalk drawing in the desert and, also in 1968, in the Galerie Heiner Friedrich in Munich, made his first *Earth Room,* which consisted of the entire gallery filled with 1,600 cubic feet of dirt. Ten years later, De Maria had the same installation in Heiner Friedrich's SoHo Gallery. It opened in 1978 with the title *New York Earth Room* [32] and, as Roberta Smith wrote, the initial effect was shock— "shock to see so much earth contained by interior architecture, a shock to see space

[33] Walter De Maria. *The Lightning Field.* 1971–77. New Mexico, U.S.A. Dia Art Foundation.

normally filled with other things (people, furniture, manageable art objects), so completely monopolized and rendered inaccessible by this foreign substance. . . . The dirt carried its own absence, was somehow a living substance."[38] Both visually and physically in the viewer's way, to this day, it allows only for visual entry as one looks across the dirt field at the far wall of the gallery.

De Maria had accomplished an equally shocking though different effect with his *Bed of Spikes* installation in 1969 at the Dwan Gallery. There, the floor of the gallery contained five planks, from which a total of 153 razor-sharp metal spikes pointed upward. Visitors were required to sign a release exempting the gallery from legal responsibility from accidents before entering the room, and Harold Rosenberg, discussing the work in Celant's *Arte Povera,* singled it out as "an instance of the inability of the photograph to do justice to the quality of the object," which Rosenberg saw as "a piece of Dadaist Sadism."[39] But the shock value of *Bed of Spikes* aside, the work's configurations very much anticipate De Maria's later *Lightning Field* sculp-

tures. The sculptor built the original *Lightning Field* [33]—consisting of a regular grid of slim, polished steel poles 2 inches in diameter, 18 feet high and 30 feet apart, in five rows of seven—forty miles out of Flagstaff, Arizona. The second version of the work, completed in 1977, was financed by the Dia Art Foundation and includes 400 stainless steel poles averaging 20 feet high and standing in an evenly patterned rectangular grid in the New Mexico desert. According to Howard Smagula, "during the period of greatest lightning storm activity, from late May through early September, as many as two or three storms per week cross this field of poles." To Smagula, though, "walking through the grid on a warm sunny day is just as meaningful an experience."[40] With the work, it would seem De Maria succeeds in making weather conditions and air movements visual presences and, in a unique way, he has created his own lightning patterns. While the work is not easily accessible, the Dia Foundation has set up a system whereby viewers can come and study and experience the work firsthand. They have to submit their request in writing and are required to remain a guest of the Foundation for at least twenty-four hours, which it is believed is the minimum time needed to experience the work in terms of sunrise and nightfall, and the feeling of the desert heat and the effects of the shifting light on De Maria's forest of spare geometric forms.

Alan Sonfist, a younger Earth artist, at the end of the seventies completed the building of his own *Time-Landscape* forest on the outskirts of SoHo, which New Yorkers, artists, and others daily pass on their way to and from the local supermarket. *Time-Landscape* reconstructs the development of a pre-colonial forest, which the artist researched with the help of New York City botanical experts. In 1976, for his one-person show at 112 Greene Street, Sonfist built models projecting how the forest would look after ten years' growth, and after twenty-five and fifty years, on the plot of land at La Guardia Place between Bleecker and Houston Streets. The 112 Greene Street exhibition was intended as a moving back and forth in time, as was the reshaping of the natural environment intended both as art and as a reworking of the artist's primal fantasies.

Born in 1946—"10:10 P.M.: My first experience was air," one of his many autobiographical works begins[41]—Alan Sonfist grew up in the Bronx near one of the few natural hemlock forests left in New York, a forest which has since been partially destroyed, so that building *Time-Landscape* became in part a personal reclamation project. Even more important to the artist, though, is the fact that the work will continue to grow and change, to live on after its initial expression as an art piece. Earlier works by Sonfist in the beginning of the seventies include *Tree Tracings,* done with resin on muslin; arrangements of rocks and twigs on the wall; and *Gene Boxes,* in which Sonfist collected elements from different forests. The idea there, according to Sonfist, is that forests are fast becoming extinct, and "it is possible that from these Gene Boxes future generations may be able to reconstruct them."[42]

Today, *Time-Landscape* on La Guardia Place takes up only half the area Sonfist had originally landscaped. The other half of the lot at the last minute was given by the city planners to a local gardening group, whose segmented professional garden, half vegetable, half flowers, is a bit of interesting incongruity in the neighborhood. Meanwhile, *Time-Landscape* behind its wrought-iron fence has grown dense and mysterious in the last four years, giving off its own forest odors and attracting unusual birds. Kept clean by the artist and his helpers, it seems to project rushes of cool air into the surrounding area.

Alan Sonfist's *Gene Boxes* and Michelle Stuart's 1973–76 Earth scrolls, or drawings, can both perhaps be classified as Non-Sites, or seen as following and/or continuing in the direction established by Robert Smithson. But Michelle Stuart's connection with the earth and arrival at making sculptures and drawings based on particular sites differs from both Smithson's and Sonfist's in that she grew up in southern California, where her concern with the earth was immediate. At the time, "There was an earthquake every year of my life," she reports,[43] and the evidence of this in terms of fissures and gaping holes in the land's crust were part of her everyday terrain. Stuart's father was an engineer concerned with searching out rights-of-way for water sources, and she accompanied him on many of his trips. Her first job to support herself after finishing art school was as a topographical draftswoman for a group of engineers.

A sculptor for many years, at the end of the sixties Stuart became concerned with locations and began making a series of map drawings. In 1968, she began a series of works based on photographs of the moon's surface. These works, which began as topographical renderings of cratered surfaces, evolved into time unit pieces of geological sites, on which she attached actual strings to suggest branching waves and currents. When the idea of drawing representations of geological surfaces ceased to satisfy her, she began collecting rocks and earth and rubbing them into paper scrolls, thereby inventing a new kind of surface to express her sense of geological time. By 1973, Stuart was using rocks from different earth strata, which registered different colors on her muslin-backed paper scrolls. These works, through 1977, are very large, some measuring as much as 12 feet by 5 feet, hang from the ceiling and roll out onto the gallery floor. The marks on the paper surface, created by Stuart's rubbing and breaking of rocks, assume the texture of earth terrain, with the specific color, according to the artist, coming from the particular site. In 1974, Stuart began making her own paper, and used it to make *Rock Books*—landscape works consisting of a pile of such paper tied together and colored by the earth from a particular site. In the summer of 1975, with the help of a crew of assistants, Stuart prepared a scroll 360 by 62 feet long with earth from the Niagara Gorge—the location of Niagara Falls 12,000 years ago—and then unrolled the work on the site to make the piece entitled *Niagara Gorge Path Relocated* **[34]**. The scroll was laid out joining water and sky and, in the process of

[34] Michelle Stuart. *Niagara Gorge Path Relocated.* 1975. Art Park, Lewiston, N.Y.

its disintegration, its union with the land was meant to evoke the perception of time and, with it, an awareness of its continual flow in the evolutionary process.[44]

Site Works

Geological time, from Smithson through Michelle Stuart, has been a constant preoccupation of Earth artists. Time in another sense was also a preoccupation with the large group of artists in the seventies involved with site-specific pieces. Time in this case, however, referred to the time of the moment and to time in terms of the movement of the sun, and in how long a piece would stand in a wood before being overgrown. Duration time was also involved in wrapping a coastline in plastic cloth for four weeks or in curtaining off a canyon of a valley for twenty-eight hours, which was also the time involved in bringing an art experience as a moving and changing force into a non-art, everyday environment. Sculptors have always made pieces for the outdoors and worked in terms of their surroundings. The difference in approach

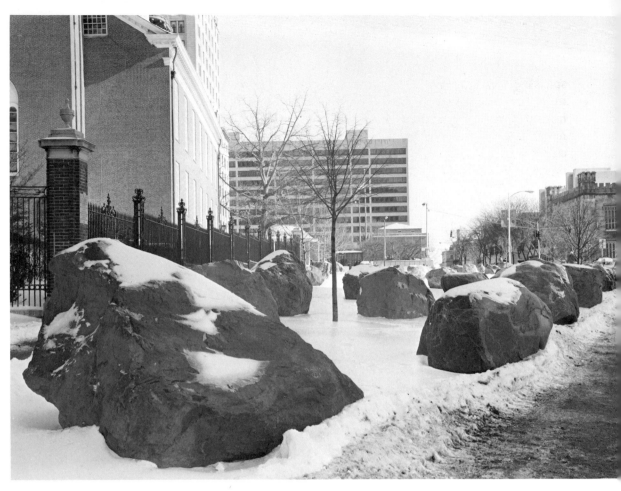

[35] Carl Andre. *Stone Field Sculpture.* 1977. Hartford, Conn.

of the Site sculptors of the seventies lies in these artists' attempts to make their work merge with the landscape, to go to an area to try to make a piece coexist with that particular location. Also, these works require active participation from the viewer to obtain a new visual experience from that particular area. One must stand in specific places to see the vistas created by Mary Miss's outdoor works. One enters an Alice Aycock piece and climbs down a ladder to experience the claustrophobic interior of her structures. George Trakas's sculptures are broken walkways. At Art Park, a Trakas work consisted of a steel footbridge 10 inches wide and 400 feet long which was intended to be felt as a line drawn along the landscape. Michael Singer's works up until 1975 could be seen only in their relationship to the land. Singer's pieces were not monumental occasions such as Smithson's *Spiral Jetty* or Michael Heizer's pyramidal desert city work. The single exception in current Site Art would be *Stone Field* [35], a sculpture in a public setting made by Carl Andre in 1977. Andre, who did a series of Site works in the seventies, has always made his sculptures in terms of a

specific place, starting with his famous firebrick work traversing a room in the "Primary Structures" show at The Jewish Museum in 1966: "I once described the change in sculpture in the 20th century as moving in its concerns from form to structure and now having a concern with place. . . . I believe now you can make sculpture you can enter," Andre has said,[45] suggesting Japanese gardens as an example of work one moves through. Andre's *Stone Field* consists of twenty-six glacial boulders arranged in a triangular formation; as the rows of boulders grow wider, the actual rocks become smaller; the largest one, weighing eleven tons, is situated at the point of the triangle. *Stone Field,* across from a church graveyard in downtown Hartford, relates, in its use of material, to earlier rock works, such as Stonehenge. In terms of its public setting, *Stone Field* has a different aura from most Site pieces, which, like Earthworks, are generally in remote, rather private locations—locations which are part of both the artist's and the work's sense of acting as a locator, a site indicator on the land.

One of Mary Miss's most written about Site works was done on a public yet remote city site—at the landfill in Battery Park, New York City, in 1973. For this untitled work, Miss built five wood sections, each one-half by 12 feet, and placed them at 50-foot intervals on the beach. Each of the wood barriers had a hole cut through it, centered left to right, and then each hole was positioned in descending order. Lucy Lippard wrote of this work: "The experience is telescopic. As the modestly sized holes (and the adjacent walls that these holes incorporate into your vision) are perceived, they expand into an immense interior space."[46] As shown in photographs, you look through these holes to the pictured landscape. Miss's structures, "the plank fences, only false facades nailed to supporting posts on the back, become what they are—not the sculpture but the vehicle for the experience of the sculpture."[47] This is true of most Site works, before and after Miss's 1973 Battery Park work. In George Trakas's, Michael Singer's, and Alice Aycock's work, the sculpture's importance is not as an independent structure vis-à-vis the landscape, but is a way of intensifying, of making, the landscape itself into another space—literally, the site of a visual/tactile sculptural experience. The structures Miss, Trakas, and Singer (through 1975) create are not intended as independent configurations.

Born in 1944, Mary Miss was the child of a professional army couple moving from base to base, and had traveled all over the western part of the United States before beginning studies at the University of California at Santa Barbara in 1962. Miss studied sculpture during the summer of 1963 at Colorado College and, graduating from the University of California in 1966, went on to attend the Rinehart School of Sculpture at the Maryland Art Institute from 1966 through 1968.

It was in 1966 that Miss set out to find for herself a personal sculptural vocabulary. She began by investigating materials in terms of their densities and pliability, using wood and wire mesh—wood as convenient and workable, and wire mesh because it is a material to be looked through as well as being a thing in itself, a material

that occupies space rather than blocks it off. One of Miss's early outdoor works consisted of a line strung every 20 feet, made of a ¾-inch hemp rope, with a double knot 100 feet above a dry bed of Fountain Creek in Colorado. Another, a "water line" sculpture involved 16-foot stakes weighted down with rocks which she threw in the water at 20-foot intervals off Ward's Island in New York in 1969. Yet another early work by Miss consisted simply of V-shaped markers placed at 75-foot intervals in an open field, about which the artist says: "because you had to walk up a hill or across a field the exposure of the piece was gradual."[48] Miss's 1974 *Sunken Pool* [36] was made in the middle of an almost impassable wood in Connecticut. Built around a 20-foot hole which Miss had dug 3 feet into the ground and filled with a foot of water, *Sunken Pool* consisted of a 10-foot-high structure made of lattice-like wood, its interior lined with galvanized steel. Miss had an entrance and an exit built to the piece so that the viewer could either step down into the water or climb up the exterior frame and look in over the top. Thus, *Sunken Pool,* in the deep wood, with its two choices of entry, was both private and accessible.

Mary Miss's most ambitious piece to date was a work titled *Perimeters/Pavilions/Decoys* [37], commissioned by the Nassau County Museum in Roslyn, New York in 1978. The sculptor conceived of this work as a narrative, cumulative experience

[36] Mary Miss. *Sunken Pool.* 1974. Connecticut.

[37] Mary Miss. *Perimeters/Pavillions/Decoys.* 1978. Nassau County, New York.

set in a field which is part of the 173-acre Frick Estate that today makes up the Nassau County Museum grounds. A five-part work, *Perimeters/Pavilions/Decoys* consisted of an earth mound, three towers, and an underground atrium excavation from which a ladder reached above ground to signal its location in the landscape. Miss's three towers of wood and wire mesh resembled roofless pagodas or topless tree houses set on stilts. These openwork wood structures ranged from 15′ × 8′ × 8′ to 18′ × 10′ × 10′ to the smallest, measuring 13′ × 6′ × 6′. These structures, standing apart from each other, were places not to climb but either to stand under and look up through or to experience as locations from which to both see and site the sky. The work's underground 16-foot-square pit's inner recesses echoed the wood pole configurations of the towers. Its 7-foot hole opening to the sky also led to the subterranean cantilevered structures of earth and wood that allowed the viewer an entranceway. In the *Perimeters/Pavilions/Decoys* there were towers above the earth one could see into, with wire mesh screen openings that could not be entered, while below the earth one could enter underground chambers that could not be seen.

"When I looked at Heizer's work or Smithson's, there's always been an aspect which impedes my relating to it. . . . It's like a mark on the earth," Miss has said.[49] In her own art, the sculptor aims for a more personal contact between the site, the work, and the person who is looking at it. Her scale, she believes, is tied to human experience and human scale. The imagery is of corridors and passages made by human beings, creating their own ways of existing in America's Western earth and sky. And Miss's sculptures, whether indoors or out, require the viewer to move from one place to another in order to experience the layering, the successive physical/visual levels of the artist's vision.

Throughout the 1970s, George Trakas was also involved with making spaces for people to "physically get on or get into." Trakas was born in Quebec, Canada, in 1944. His concern with perception in terms of architectural, physical space started when he took a sculpture and architecture course in Montreal which required the study of minutely scaled models of structures ranging from prehistoric caves, to the Parthenon, to the Empire State Building. These models established for him a sense of scale for his work; he related it to the outstretched arms of a standing man, as he was becoming increasingly preoccupied with the problem of traversing space. In almost all of Trakas's work, we exist in transit: each piece is conceived "as a phenomenological journey."[50] Time is an important aesthetic element, present in terms of the time it takes to make the circuit of Trakas's various structures, as well as in the time involved in the body's ascent and descent. Equally important are the physical/tactile dimensions of the artist's ramps, which are planned in terms of the viewer's head, shoulder, and leg positions. Several of Trakas's works have included mirrors reflecting the image sculpture, for the viewer, which allowed the viewer to check his direction and, in the process, heightened his awareness of himself as a participant within the art work. One

early Trakas gallery piece included a window of tinted glass with a slot cut in the middle so that viewers could see both out and in and decide in advance whether or not to enter and experience the inner area. This approach is a constant with Trakas, in keeping with his belief that his work should involve two ways of seeing and/or offer a succession of choices. At Merriewold West Gallery in New Jersey, Trakas's 1975 Site work *Union Station* consisted of two bridges, one of wood, one of steel. Trakas dynamited their meeting point with a small explosive charge that splintered the end of the wood bridge and made the steel bridge twist back onto itself, leaving a concave pit in the earth below, which Trakas filled with water. "Walking out on either bridge was like approaching the scene of some violent collision," Roberta Smith wrote. And walking 30 inches above ground upon the trestle wood bridge extending 184 feet into space "mechanized you, riveting your eyes downward in an effort to stay upright."[51] As Smith and others reported, traveling the path of the streamlined steel bridge, by contrast, became an easy walk into the wood. From either bridge, at their meeting point the viewer could look down into Trakas's reflecting pool and see the treetops 40 feet above. *Union Station,* like all Trakas's bridge works, was designed to coexist with the terrain and to bring to the viewer a new awareness of his own motility in the artist's chosen landscape.

When Michael Singer says, "I'm not out there working to compete with the environment,"[52] he could be speaking, perhaps without knowing it, also for George Trakas, Mary Miss, and almost all of today's Site sculptors. Singer has given the name "ritual" to the majority of his drawings and sculptures done in the past ten years because "going to see the piece is to partake of the ritual," he says. The "ritual" also includes "discovering the path in the woods, trying to sense the quiet of the marsh, and the piece nestled within it."[53] Most of Singer's work is made of bamboo poles, marsh grass, wood dowels—materials present at the site where the sculptures were created and intended to be seen. The New York-born artist earned a B.F.A. degree from Cornell University in 1967, a graduate degree from Rutgers University in 1968, and in 1971, at the age of twenty-five, he was selected to be in a new-talent show at The Guggenheim Museum. Singer's sculpture there consisted of two large steel beams; showing his work in a museum so early "scared the hell out of me," the artist said, and immediately afterward he retreated to Vermont, where he spent the next three winters in a rented farm house. In Vermont, he began getting up early and walking to a nearby beaver bog. The bog became Singer's studio, where he began to work with wind-felled logs, "trying to get all those trees to the point where there was a weightless situation."[54] Singer called these early Site works *Situation Balances;* pictures of the sculptures were persuasive enough to earn the artist a Creative Arts Public Service grant, several outdoor commissions in Hecksher Park on Long Island and in Harriman State Park in New York, and an artist-in-residence fellowship in the Everglades National Park in Homestead, Florida. In each place, Singer worked with materials

indigenous to the site. The overall shape of the work each time consisted of slender woven pieces of wood secured with dowels, which resulted in a naturally curving grid. Singer's piece at Everglades National Park in 1975 consisted of fourteen such sections, of bamboo and phragmite grass, covering 700 feet of a vast open glade. The structure of these works was altered with the shifting conditions of sunlight and wind. In photographs, Singer's pieces resemble woven nests floating on top of the water. For an exhibition at the Nassau County Museum, the artist made a piece 200 feet long and approximately 70 feet wide, an intricate web of horizontal lines that was intended to be perceived through a break in the trees, because for Michael Singer the landscape —such as a break in the trees—is part of the work [38]. Kate Linker has described Singer's sculptures "as optics. Like prisms, microscopes, monocles . . . they magnify observed objects until the visual fields develop in distance, depth and meaning."[55] One is meant to look through the bamboo openings of Singer's work, and the artist, in talking about his *Lily Pond Ritual Series,* has spoken of "building an apparatus to see more of what I am, where I am."[56]

The influence of Oriental thinking is apparent in Singer's approach to nature in the sense that all the artist's works are meant to be revelatory of their surroundings.

[38] Michael Singer. *First Gate Ritual Series.* 1976. Nassau County Museum of Fine Arts, Roslyn, N.Y.

The pieces act in concert with the landscape rather than in contrast to it. In this way, Singer's work recalls Carl Andre's idea about sculpture in the twentieth century functioning in terms of space, becoming a space to enter—an example being Japanese rock and sand gardens. This Oriental influence seemed even more evident at Singer's first indoor gallery exhibition at Sperone Westwater, in 1975, where a sculpture of balanced forms rested on the gallery floor; its horizontal wood bands with contrasting supports of tree stumps and small stones had the quality of a temple altarpiece.

Michael Singer's sculpture has remained deliberately fragile, and the ephemeralness of his, Mary Miss's, and George Trakas's Site pieces is part of their work's intent. Making the present moment timeless and creating a not-to-be repeated experience in space and time is an important part of these sculptors' aesthetics. In contrast, the materials and philosophy of the Site artist Nancy Holt are deliberately at odds with this acceptance of evanescence. Nancy Holt shares Michael Singer's interest in optics and, on one level, her sculptures are literally seeing devices. But her vision involves tracking the positions of the earth, the sun, and the stars, and creating permanent sites for perceiving them. Holt's materials are rocks, steel, and occasionally water. After obtaining a bachelor's degree in science from Tufts University, Holt married Robert Smithson in 1963; she worked with him on the Non-Sites, assisted with the plans for *Spiral Jetty,* and, as noted above, with sculptor Richard Serra completed Smithson's *Amarillo Ramp* as a memorial to him.

Nancy Holt made her first trip to the desert with Robert Smithson and Michael Heizer in 1968, and immediately felt connected with the area; it was a feeling of being in touch, she said, that she had experienced only once before, in the Pine Barrens in southern New Jersey. "Time is not just a mental concept or a mathematical abstraction in the desert," Holt has written. "The rocks in the distance are ageless; they have been deposited in layers over hundreds of thousands of years. Time takes on a physical presence."[57] And it is this aspect of time rather than the wonder of the moment that makes Holt's approach to Site work different from that of Michael Singer, George Trakas, or Mary Miss. Almost from the very beginning, Holt has been addressing her work to the concept of geological time (like Smithson, considering time in terms of the ages of the earth), but also to time in terms of the earth's yearly revolution around the sun. In a recent interview, Holt explained she is "attracted to materials that have a time-span beyond our human life. It isn't that I'm trying to build monuments that will last forever. Rather," she says, "I'm interested in conjuring up a sense of time that is longer than the built-in obsolescence we have all around us."[58]

Holt, who was born in Massachusetts, had spent most of her life in New England and New York City until her first trip to Nevada in 1968, which established for her a sense of connection; since then, she has gone west for a few months every year. She made her first outdoor Site work, though, on a secluded beach along the New England coastline. Made in 1972 at Narragansett in Rhode Island, the work, called *Views*

Through a Sand Dune, consists of a single steel pipe 5½ feet long and 8 inches in diameter that has been embedded in an irregularly sloping sand dune. By looking through the pipe you can see the ocean, ordinarily obscured by the dune, so that Holt's pipe becomes a connecting eye, a fixed point from which to see land, sky, and ocean. The next year, while working to complete *Amarillo Ramp,* Nancy Holt got the idea for her *Sun Tunnels* piece, and spent almost all of 1974 exploring New Mexico, Arizona, and Utah searching for a suitable site—land that would include a desert area ringed by low mountains. She finally bought a 40-acre site in the Great Basin Desert in northwestern Utah and began building a sculpture which would mark the yearly extreme positions of the sun on the horizon. *Sun Tunnels* [39], completed in 1976, consists of four concrete tunnels laid out in the desert in an open X configuration 86 feet long. Each tunnel is 18 feet wide, with an outside diameter of 9 feet, 2½ inches, and an inside diameter of 8 feet. Holt had cut holes through the wall in the upper half of each tunnel 7, 8, 9, and 10 inches in diameter to correspond to stars in four different constellations. During the day, the sun now shines through the holes, casting a changing pattern of pin-pointed ellipses and circles of light on the bottom half of each tunnel. At night, if the moon is more than a quarter full, moonlight shines through the holes casting its own, paler pattern. Each of Holt's four tunnels rests on a buried concrete foundation.[59] In terms of the desert location, *Sun Tunnels* relates to Smithson's, Heizer's, and De Maria's Earthworks—and in its use of permanent, non-earth materials the work relates most to De Maria's *Lightning Field.* But Holt's intent (especially in her work up to 1978) has been to make sculpture as a vantage point from which to see the earth and sky, rather than work to be seen occupying the ground.

One of the first artists to install a work at Art Park in Lewiston, New York, Holt chose as her site for *Hydra's Head* a shelf along a gorge trail above the Niagara River. Here, in 1975, the artist installed six concrete pipes, each 3 feet long, in circular pits so that the top of each pipe was flush with the ground. Holt then poured water into the hollows, creating circular pools that mirror the sky, sun, moon, and stars. Holt based the configuration of her circular pools on the position of the six stars in the head of the constellation Hydra. Hence, the work's title—*Hydra's Head* [40]. The piece can be walked along at night so that "the moon is seen moving from pool to pool around the site, with the rush of water from the Niagara River always sounding below."[60]

More recent works by Holt involve the building of above-ground structures. For a 1977–78 Site work done at Western Washington University, Holt used 200- to 230-million-year-old schist rocks known as brown mountain stone. These rocks, which are classed as metamorphic because they have been changed without melting as a result of having been for some time deep in the crust of the earth, are indigenous in the Washington State area. Holt's Site sculpture *Stone Enclosure: Rock Rings 1977–78,* however, entailed extensive excavation and the pouring of two circular concrete foundations before the artist's arch forms from this rock could be built. *Stone*

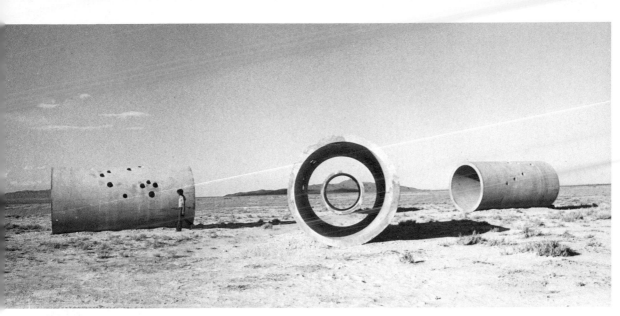

[39] Nancy Holt. *Sun Tunnels.* 1973–76. The Great Basin Desert, Utah.

[40] Nancy Holt. *Hydra's Head.* 1974. Art Park, Lewiston, N.Y.

Enclosure consists of two rings 10 feet high, within whose walls are 12 holes 3 feet in diameter and four arches, 8 feet high, to be walked under. *Stone Enclosure* is both a structure to be seen from outside (its outer-ring diameter is 40 feet, its inner-ring diameter 20 feet), and a work to move within and see various views of the landscape framed through its northeast, southwest, east-west, northwest-southeast openings. The work, Holt has said, relates to a point in the universe, a dead center, a true north,[61] and in both its stone material and its astral positions would seem to hark back to ancient monuments such as Stonehenge. Only in terms of works like Nancy Holt's *Stone Enclosure* does Robert Morris's essay "Aligned with Nazca," which links contemporary Earthworks with primitive earth works, begin to make sense, because the primitive works, like Holt's, were based on weather, time, and the positioning of the stars. Indeed, a recent work by Holt, *30 Below,* a red brick tower near Lake Placid, New York, seems to be a rather atavistic structure. Built for the 1980 Olympics, Holt's tower is sited according to the points of the compass, with its arched openings aligned with the North Star. The idea is for the viewer entering the tower to pass "from the outside open, limitless condition" to observe nature from within, as if standing inside a telescope where the sky above appears detached and clouds pass as if on film."[62] While very much a work about seeing, *30 Below* also functions as an inexplicable, mysterious object, a physical presence existing in tandem with the landscape rather than as merely a prism for the experiencing of nature, of rendering more visual the visible. The piece presents another way of seeing the earth while being a visual phenomenon upon its surface.

In contrast with Nancy Holt's Site works, which seem to be evolving into independent architectural structures, most of Alice Aycock's early works have been about experiencing nature specifically in terms of architectural sites, and about the psychological implications of such spaces. In the summer of 1973, Aycock constructed *Low Building Made with Dirt Roof (for Mary)* near a farm in Pennsylvania. The work, consisting of wood, stone, and earth, was 20 feet wide and 12 feet long. In order to enter it, the viewer had to crawl through an open doorway 30 inches high—the highest interior point of the sculpture—from which it was possible to pull one's body along and enter succeeding packed earth chambers. *Low Building with Dirt Roof* was a work intended to create the sensation of being in a cellar, and was about the feelings of claustrophobia inherent in such spaces. It was built by Aycock and her mother with stones from a field and wood from a partly collapsed building on the farm property.

Aycock, born in Harrisburg, Pennsylvania, studied at Douglass College, Rutgers University, and earned an M.F.A. degree from Hunter College in New York in 1971. The following year she built her first large outside structure, *Maze* [41], on the Gibney Farm near New Kingston, Pennsylvania. *Maze* was a twelve-sided wood structure of five concentric rings, approximately 32 feet in diameter and 6 feet high. While Aycock has said the idea was suggested by a circular plan for an Egyptian labyrinth in an

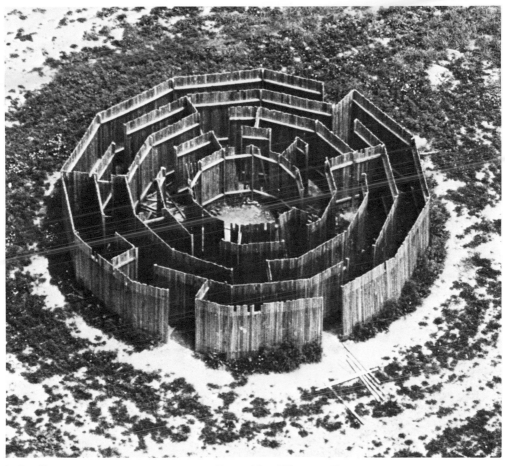

[41] Alice Aycock. *Maze.* 1972. Gibney Farm, New Kingston, Pa.

encyclopedia, a labyrinth designed as a prison, her intention in *Maze* "was to create a moment of absolute panic—when the only thing that mattered was to get out."[63] She wanted the circular building, demanding a sequence of eye and body movements that would prevent a viewer from comprehending the work, "to fabricate a moment of drama."

In 1975, Aycock was invited to make a piece for a show at the Merriewold West Gallery in Far Hills, New Jersey. Choosing a site at the edge of a corn field, the artist marked off a 28 × 50′ area with a square row of concrete blocks. Inside this square, she excavated a 20 × 50′ area that was barely visible from ground level, installing six square wells, arranged in two rows of three. Three of these wells were capped, the others were open; two had ladders that led 7 feet down into connecting tunnels which were dark and damp. About this work, which Aycock titled *A Simple Network of Underground Walls and Tunnels,* Roberta Smith wrote: "Alice Aycock's materials and building methods are cooly contemporary, but her actual forms are layered with ominous historical precedents, caves, catacombs, dungeons and beehive tombs."[64]

And Alice Aycock herself, when discussing the work, has cited historic architectural edifices and her own childhood fears and dreams as its principal sources.

In 1976, Alice Aycock returned to Pennsylvania to build *Circular Building with Narrow Ledge for Walking,* an isolated circular structure 13 feet above the ground, against which leaned an exterior ladder. Climbing the ladder, the viewer could see, looking down into the well, three narrow concentric ledges, 8 inches wide, coming off the inner wall. It was possible but uncomfortable to descend and travel around the course of the first ledge, and also to travel the concourse of the second ledge. The wall, 7 feet into the ground, the artist has claimed, was "no more perilous or threatening than a treacherous cliff."[65] *Circular Building with Narrow Ledge for Walking* is probably the most dramatic example of the content of Aycock's work, which, accord- situations for the perceiver; to be known only by moving one's body through them . . . and involve experiental time and memory."[66] Like most Site pieces, the sculptures were sited in terms of preexisting landscape features. Along with these works, in the mid-seventies Aycock began building indoor pieces, which she regarded as stage sets for her personal fantasies; currently, she seems to be moving more and more in the direction of independent, non-sited sculptures.

Charles Simonds, Gordon Matta-Clark, and Anne Healy are three artists who have been making Site works for urban spaces. Their sculptures, which work with and are about the city environment, have very different configurations from those made by the Site artists and Earth artists described thus far. Charles Simonds, who studied sculpture in the early sixties at the University of California at Berkeley, gave up making his welded-steel pieces soon after moving to New York in the late sixties. Art at that time became for Simonds a way of finding himself. He began by exploring his own body and then created his imaginary *Little People,* who evolved out of his body and personal imagery to populate the vacant lots and window ledges of the city. In 1970 Simonds made a film entitled *Birth,* in which he buried himself in a clay landscape which rises as he emerges slowly, being born still covered with clay. For Simonds, clay is a sexual material—"symbolic of the earth, and physical in the way it behaves." The film *Birth* and a subsequent movie, *Landscape/Body/Dwelling,* trace the evolution of Simonds's *Little People* in terms of a group of clay buildings and ritual dwellings. The later film, Simonds has explained, is about "a process of transformation of land into body, body into land. . . . *Birth* and *Landscape/Body/Dwelling* are rituals the *Little People* would engage in. Their dwellings in the street are part of that sequence."[67] Simonds built these *Little People* dwellings first in his loft, then on walls and window ledges in SoHo, and finally in vacant lots on New York's Lower East Side. In each site, Simonds prepared the brick or concrete surface by smearing it with wet red clay, then placed tiny bricks on this foundation. The sites of his *Little People* are terraced dwellings that resemble museum scale models. In his small Site works, Simonds uses the circle, spiral, and line to express distinct urban philosophies, and

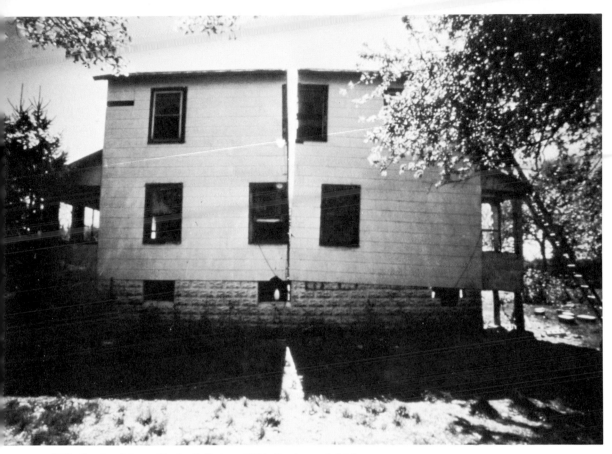

[42] Gordon Matta-Clark. *Splitting*. 1974. Englewood, N.J.

every site he has built he regards as a new chapter in the life of his *Little People*. One of their few permanent sites is on a shelf in a stairwell between the second and third floors of The Whitney Museum of American Art.

Gordon Matta-Clark's urban Site work took the form of transforming architecture into sculpture by cutting holes through it. Matta-Clark's art was an art of excision. The son of the Surrealist painter Matta, Matta-Clark was raised in New York's Greenwich Village and went to the Dalton School before studying architecture at Cornell University and the Sorbonne. In 1969, he returned to New York to make sculpture and, in 1970, as part of both his art and urban concerns, dispensed oxygen to people walking on Wall Street, planted floating gardens on rafts in the Hudson River, and once planned a "forest" on a Canal Street traffic island. His 1974 *Open House* was built in a garbage dumpster parked on Greene Street with doors taken from abandoned buildings serving as walls. *Open House* was not limited to SoHo gallery goers, but rather was intended to be and existed as an open invitation to all Greene Street passersby. One of Matta-Clark's most famous works was the massive building cut titled *Splitting* [42], which he did in 1974, bisecting a whole house. Slicing through

buildings reveals the stratification of materials, spaces, and processes. "By undoing a building," he has said, "there are many aspects of the social conditions against which I am gesturing."[68] Another project of his, *Pier 52,* was a piece made from an abandoned pier on the Hudson River where the sculptor worked, unknown to city officials, for months, breaking away walls and creating new vistas in the abandoned structure. By the end of the piece, Matta-Clark had cut a canal across the pier floor, revealing the Hudson River below. Matta-Clark died of cancer in 1978 at the age of thirty-five; while many of his projects were burned down or otherwise destroyed, the artist's photographs remain to provide a clear narrative of what his Site works were about.

Anne Healy's Site sculptures, while not readily understood as art at the start, were immediately accepted as a contemporary phenomenon. Her first outdoor work, a sailcloth sculpture titled *Two to One* and made in 1968, was installed to hang off a building while attached to a sidewalk on West Broadway—the sidewalk in front of her loft. *Two to One* [43], a 48-foot high, 12-foot-wide, piece consisted of three triangles made of red and blue nylon sailcloth. The triangles, each with its own triangular negative space, were made of two strips of red cloth attached to one strip of blue. *Two to One* caught the attention of Paul Smith, the director of the Museum of Contemporary Crafts, who in 1970 commissioned Healy to do a 53-foot-high piece from the roof to the awning of the Crafts Museum building on West 53rd Street in New York. What was recognized, what provoked an almost immediate response in people, was the celebratory nature of Healy's work. For many, this idea had long been lost and Healy's work therefore became a kind of personal discovery. On the other hand, the artist's sculptures to others at once seemed too familiar and too alien: her use of geometric shapes, for example, while it did relate to contemporary painting, was not in keeping with the then current Pop tradition—except in terms of outsize scale, as in Oldenburg's work. Healy's large scale was an outgrowth of her interest in set design, which she studied at Queens College, during which time she learned to think "in terms of thirty-foot-high spaces." Between 1968 and 1972, Healy made five more outdoor Site works, which for some were suspect as art because they were made out of cloth. For Healy, however, "Cloth is something we all relate to from birth to death. It is associated with every event of our lives. . . . It's a magical medium which is itself and yet appears to be so many other things."[69]

In 1972, Anne Healy joined A.I.R., a cooperative gallery in SoHo, and for her first one-person show built indoor pieces of materials hanging from the wall and ceiling—seemingly free-falling pieces that were actually shaped by a hidden underlying aluminum structure. These were "heavy pieces, heavy at least in psychological content," deliberately evocative of the artist's interest in witchcraft and the ancient religious belief in a mother goddess. The mood of indoor works such as *Black Hecate* and *White Goddess* are in sharp contrast to Healy's 1972 *Hot Lips,* for example. *Hot Lips,* consisting of three red satin circular shapes, was first strung up a building in

[43] Anne Healy. *Two to One*. 1968.

New York and later was hung across an open body of water at the "Monumenta" sculpture exhibition in Newport, Rhode Island. At Newport, the sheen of the red satin color and the way the light caught the creases of the three bending shapes made them at once unexpected and funny presences, hanging red-mouthed over the open water. Since 1972, although Healy has made many indoor sculptures for exhibitions, she has continued to put her pieces outdoors because, for her, "the street is like a stage and I feel that the pieces I put out become a way of changing the setting for a play."[70] Her interest in theater is in its illusionary aspect, in making things seem what they're not while at the same time placing them in a "real context." The tension between the artist's illusion and exterior reality accounts for the strength of her triangular sail sculpture *Cathedral,* $3\frac{1}{2} \times 20'$. The sculpture, made of interlocking bands of blue, green, purple, and orange cloth strips, was first shown in Newport in 1975, and later the same year at the Nassau County Museum in Roslyn, New York. *Cathedral* contains three negative blue and purple-edged triangles through which the viewer sees the landscape behind. The work, which can billow out 5 feet from its moorings, also creates the illusion of being a much deeper, more solid form because of the solid-seeming architectural shapes within it. The colored stripes of the work overlap at the two ends, at the inside point of a small inner triangle and, again, at the topmost point of the overall shape, creating a series of internal shadows that increase in density as the light alternately comes through the transparent and cut-out open sections of the work. *Cathedral* is a Site work that, while remaining somehow apart from the landscape, unfurls a series of changing illusionary shapes set forth by cloth, sun, and wind.

Like Anne Healy, the artist Christo has worked indoors and out, but with the single idea of covering, of wrapping objects, for the twenty-five years of his artistic career to date. In 1969, Christo began doing his first large-scale building and land works by wrapping the building of the Museum of Contemporary Art in Chicago and, the same year, in *Wrapped Coast,* literally wrapping up a section of the Australian coastline with open-weave cloth. Three years later, in 1972, Christo hung a 200,000-square-foot, orange-colored *Valley Curtain* 1,250 feet across a wide canyon in Rifle Pass, Colorado, and in 1976 he installed his 18-foot-high diaphanous *Running Fence* across more than 24 miles of farmland in Marin and Sonoma counties in California, thus uniting farmland with ocean. These works exceed the time span of Happenings because of their preparation and their life spans of four weeks for the Australian coastline, twenty-eight hours for *Valley Curtain* (after which the *Curtain* was destroyed by wind), and two weeks for *Running Fence.* This was time enough not only for the works to be filmed but for them to become part of the consciousness of the literally thousands of people whose lives were touched and changed by these projects. Also, in terms of their ambition, *Wrapped Coast, Valley Curtain,* and *Running Fence* helped to define the scope of Site works during the late sixties and early seventies.

Christo has described his work as being involved with a "new art form. If you

take all of my packages," he has said, "they are all bundles. It makes a new form, a very abstract one. Perhaps you recognize some elements in it, some bottles for example. You like to see what is behind the package as well as appreciating the new form that has been created, the new visual value. The disturbance is important."[71] Speaking about the scope of some of his recent projects, he has said, "It always looks to other people like it is impossible, but I never propose what cannot be done. . . . Our work is almost on the edge of the impossible, but that is the exciting part. The road is very narrow."[72]

Christo was born Christo Javacheff in Bulgaria in 1935 and attended the Fine Arts Academy in Sofia from 1952 to 1956, studying painting, sculpture, and set design. While he didn't enjoy the school's emphasis on social-realist art, he became quite excited by the government-sponsored trips on which the art students improved the look of the countryside for the benefit of foreign travelers by covering existing bales of hay and old farm machinery with tarpaulins and generally sprucing up the landscape along the route of the Orient Express. From Sofia Christo went on to Prague to study set design, and in the basement of that city's art museum was introduced to modern art in the form of hidden-away paintings by Matisse, Miró, and Kandinsky, which helped him to decide that his artistic career lay in the West. He escaped from Prague by hiding in a medical-supply truck bound for Vienna, and from Vienna he made his way to Paris. In Paris, Christo joined the Nouveau Réalisme, or New Realists, movement, concerned with presenting actual objects rather than making representations of things. In 1958, Christo made his first series of objects, some wrapped, some not, entitled *Inventory,* and the next year exhibited tables on which were objects wrapped in such a way as to obscure their identity. By 1963, for his exhibition at the Galerie Apollinaire in Milan, Christo was using transparent plastic as wrapping material. He moved to New York in 1964, where, fascinated by the buildings and storefronts of lower Manhattan, he fabricated a series of life-scale replications: storefronts whose empty windows were covered with cloth or paper to prevent viewers from seeing inside, transforming physical space into psychological response. From the beginning, Christo used life-size objects, transforming an actual chair, tree, motorcycle. Now, in retrospect, it seems a logical next step for him to have undertaken wrapping, in 1969, the Chicago Museum of Contemporary Art, in 10,000 square feet of brown tarpaulin, with the help of students from The Art Institute of Chicago. *Museum of Contemporary Art, Wrapped* [44] drew the attention of Chicagoans who had heretofore been unaware of the museum's very existence. The piece also dramatically posed the question of a museum's function, according to the museum's director at that time, Jan van der Marck, who wrote, "With the whole idea of a modern museum and its usefulness somewhat up for grabs, Christo's packaged monument succeeds in parodying all the associations a museum evokes: a mausoleum, a repository for precious contents, an intent to wrap up all of art history."[73] At the

[44] Christo. *Museum of Contemporary Art, Chicago, Wrapped.* 1969.

[45] Christo. *Wrapped Coast—Little Bay, Australia.* 1969.

same time that Christo packaged the outside of the museum, he also, at the director's invitation, constructed a piece called *Wrapped Floor*, made of 2,800 square feet of rented drop cloths, which covered the entire first floor of the museum. Art students found the shrouded interior visually soothing, and many returned more than once to sit on the floor and contemplate the new space Christo's drop cloths had created.

In 1968, John Kaldor, a collector from Australia, had invited Christo to visit Australia, do a series of lectures, and make a piece. In 1969, Christo accepted Kaldor's invitation and offered to wrap a section of the Australian coast as a way of calling attention to art and its impoverished condition in that country. Christo and his wife, Jeanne-Claude, persuaded government officials to issue the necessary permits, raised the requisite funds, and, using an open-weave cloth which would not harm the insect life, wrapped one mile of coast, at a site called Little Bay near Sidney, in one million square feet of fabric for four weeks, during which time the shrouded Australian coast won worldwide attention [45].

Christo's dramatic *Valley Curtain* three years later, in 1972, in Rifle Pass, Colorado, did not involve wrapping but rather the screening off of a section of natural landscape. Financing the curtain required the raising of $400,000, so Christo's wife organized a Valley Curtain Corporation, a non-profit organization to which Christo donated drawings, scale models, and older works to raise funds for the project. The bright-orange curtain was finally hung across the canyon, blocking off a vista and thus changing a visual passageway. Christo subsequently explained, "When I was doing *Valley Curtain* everybody knew that this is a huge curtain crossing a valley. Now everybody knew what it is that is behind the valley. The thing that is behind is not so important . . . only that motion, the passing through."[74] From packaging and concealment, creating a new art form in the sixties, Christo had moved to the idea of wrapping as a means of marking a transition, of instituting a barrier in order to re-form and re-state a vision. Whereas Oldenburg's proposed large-scale monuments of the sixties were large-scale new objects intended to be added to the landscape, Christo's wrappings, his curtain, and his fence of the seventies were created to underline and outline the presence of land and sky; they were relational works erected to expand our visual perception of things. The *Running Fence* project, begun on Christo's drawing board at the beginning of the seventies, sent the artist traveling 6,000 miles up and down the American West Coast in search of a possible site. Christo finally selected the countryside north of San Francisco, in northern Marin and southern Sonoma counties, which had grazing land on hills crossed by old farm fences. Christo's *Fence* finally extended over forty miles, disappearing into the sea at Bodega Bay. The ocean part of *Running Fence* [46] was 558 feet long and consisted of a single panel of cloth descending from its height of 18 feet on land to 2 feet at the anchored sea end. The piece cost over three million dollars and took three years to bring into existence. From 1974 through 1976 it was the subject of national controversy. A committee was formed "to stop Running Fence," which succeeded in alerting the

[46] Christo. *Running Fence.* 1972–76. Sonoma and Marin Counties, California.

California Coastal Zone Conservation Commission and bringing the matter to the attention of the Superior Court of the State of California three times, resulting in the issuing of a 280-page Environmental Impact Report, which was presented to the Sonoma County Superior Court. This report, which took eight months to prepare and cost $39,000, informed concerned environmentalists, "With the possible exception of the Brown Pelican, no rare or endangered animal species are present in this region. It is estimated that the construction of the *Fence,* if modified as suggested, will not particularly influence the animal population."[75] The report concluded that, after the two-week existence of *Running Fence,* "the only large scale irreversible change may very well be in the ideas and attitudes of the people."[76] *Running Fence*'s 2,050 eighteen-foot panels of white nylon were finally erected on steel poles in September 1976; after two weeks, the panels were taken down, the posts removed, holes filled, and bare spots reseeded. Today all physical traces of the actual piece are gone—except those pieces of cloth that were taken as souvenirs. *Running Fence* continues to exist in the form of photographs, in the classic documentary film the Maysles brothers made of the work, and in the consciousness of the people of Marin and Sonoma counties, for whom the piece became a revelation of the beauties of their own earth

and sky. Wrapping as a means of revealing unseen forms and contours, and the importance of involving the public in art, have been constants in the work of Christo, who seems to me to be the quintessential Site artist involved with expanding the territories of art.

Installations

At the same time Site artists were making works involving landscape and city scapes, an even larger group of sculptors was creating indoor installations that changed the look and shape of the interiors of art-world spaces and changed our perceptions of what sculpture could do and be. Literally hundreds of artists were making room installations during the sixties and seventies. In New York, a mammoth exhibition space, called Sculpture Now, from 1974 through 1979 was devoted to exhibiting such installations. Robert Irwin in Los Angeles, Chicago, and New York; Charles Ginnever at the Walker Art Center in Minneapolis and at Sculpture Now in New York; Loren Madsen at the Walker Art Center and at The Museum of Modern Art in New York; and Phoebe Helman, Bernard Kirschenbaum, Salvatore Romano, and Robert Stackhouse at Sculpture Now did some of the more outstanding installations of the period; in addition, Cynthia Carlson and George Sugarman, in the decorative mode, and Jonathan Borofsky, with his dreams, brought a whole set of differing sensibilities to the concept of the room environment. Nevertheless, all these installations on some level were about changing the viewer's perceptions about what space is, as the artists brought in elements to alter the four walls, ceiling, and floor of the gallery.

The installation sculptor Robert Irwin has defined art as "the placing of your attention on the periphery of knowing. It is . . . a state of mind, ultimately."[77] And, indeed, Robert Irwin's use of tape, scrim, and light to create space change is one of the most pared-down approaches to installations of any artist during the seventies, with the possible exception of the work of the Minimalist Dan Flavin. Flavin, who began using fluorescent lights as his medium during the mid-sixties, confined himself to working with a corner of the room or using a single wall until 1976. Robert Irwin has been involved with the room as space container since 1970, his work being grounded in ideas about visual perception, the control of visibility, effects of transparency, and even the properties of "whiteness" as color as opposed to light. In an interview with Jan Butterfield, Irwin described his installation pieces as "a means of inquiry. They represent good questions and I arrived at them reasonably and I want to leave them there. I want them to stay in the air as questions."[78]

To understand Irwin's early development, one can look at his installations as attempts to create, in terms of three-dimensional environment and physical experience, the perceptual effect of entering into a Minimal painting. After Irwin attended

art school in Los Angeles and had his first one-person show, at the age of twenty-nine, he became aware of Abstract Expressionist art and began his struggles first with gesture and then line in painting. By 1961, "aiming to take the mark down to the base point of power,"[79] he restricted himself to painting no more than four lines on monochrome, moderate-sized canvases. The painting *Crazy Otto,* from 1962, contains four blue lines on a field of olive green, creating a series of optical color effects. By 1964, Irwin had reduced the number of lines to two and eliminated all color difference and figure-ground distinctions. After this, he made dot paintings that "were blank, imageless and emitted a circular haze of light."[80] By 1968, Irwin was making wall pieces of thin aluminum discs whose off-white granular sprayed surface seemed at times to be tinged with faint rings of color. Two lights above and two lights below these discs were used to create receding circular shadows. After the disc pieces, Irwin made a series of clear, acrylic columns, also suggesting non-objectness and existing as space markers away from the wall. From certain places, these 1970–71 columns become invisible or seem to lose all object quality and exist merely as vertical lines in space. They are the last "real objects" Irwin made. In 1971, using a semi-transparent fabric he brought back from Europe, Irwin began his scrim works, which create wedges of light in particular rooms. In 1970, for his first installation, he confined himself to using black tape in a back-room gallery of The Museum of Modern Art. The next year, in 1971, Irwin's installation at the Walker Art Center was a piece made with scrim and fluorescent light, 9 feet 11 inches high, which created a magical white fluorescent rectangle coming forward from the wall for the viewer to contemplate. In 1974, at the Mizuno Gallery in Los Angeles, Irwin's scrim, stretched tight across the ceiling, had an almost blue tonality. The piece was held taut by a metal bar, and its real physical presence ended somewhere below eye level, at which point a mirror image of its black band appeared on the floor beneath and extended up the walls to the edge of the scrim to form a clear rectangle. For his 1976 one-person exhibition at the Museum of Contemporary Art in Chicago, Irwin used a scrim to make a wedge-shaped corridor that started at the two pillars near the museum's entrance and met at a far wall 80 feet away, becoming an enormous white volume cutting into the space that could be looked both into and through to the large empty area of the gallery it blocked off [47]. More subtle in its effect, perhaps, was the floor-through scrim made for the fifth floor of The Whitney Museum, where the only light was daylight coming in through the museum windows, which made Irwin's long, high scrim fence into a shadowy presence, a wavering moving line that was almost but not quite there. Robert Irwin's "subject is sight"[81] involves almost the dematerialization of the object as a visual presence. In this regard, his installations are at an opposite end from work by other installation sculptors, most of whom are involved with introducing a new emphasis on materials in space with regard to gravity and in employing material presence to expand our ideas about the physical reach of the gallery environment.

[47] Robert Irwin retrospective exhibition, Museum of Contemporary Art, Chicago, 1974.

In 1974, Phoebe Helman's *Moro* took up half a room at the Max Hutchinson Gallery on Greene Street. The next year, Charles Ginnever's 90-foot-long *Zeus,* made of three steel I-beams swaying and clanging into each other, zigzagged its way around the columns of the new downstairs Sculpture Now Gallery, and Loren Madsen installed 400 red bricks attached by fine stainless steel wires at a 90/60-degree angle from brick to wall or ceiling in the "Projects" room at The Museum of Modern Art. In 1976, Bernard Kirschenbaum suspended 298 circles to hang just below waist height, from the ceiling at Sculpture Now; the following year Robert Stackhouse erected a 212-foot-long wooden *Running Animals* structure there, and then the same space became a water environment, with standing pillars and floating forms and a narrow walkway, for viewers to maneuver through in the first of Salvatore Romano's indoor water-site works. In each case, the material presence, the play of brick against steel, the invisible hum of vibrating Upson board circles, and of forms and their reflections moving in the water was a central issue. Whereas light became an almost tangible substance in Robert Irwin's room/scrim manipulations, the physical presence of diverse materials and of material-into-form was the chief concern in the work of these other installation artists.

[48] Phoebe Helman. *Checkpoint.* 1975.

In her first show of sculpture in 1974, at the Max Hutchinson Gallery, Phoebe Helman built *Moro,* an installation of conflicting posts and geometric shapes that became a core existing between floor and ceiling, giving the viewer little ground on which to stand. Helman, a New-York-born sculptor, earned a B.F.A. degree from Washington University in St. Louis in 1951, and was a painter for many years before turning to sculpture in the late sixties. Her installations, from the start, had no beginning, middle, or end, but rather only movement and direction. The poles and leaning triangular and rectangular forms in *Moro,* made of wood and Lamite, combined a mass of thin rods with geometric planar forms that "invited one to walk into it and be encompassed though that was impossible."[82] A writer described the work, 25 feet long, 14 feet high, and 12 feet deep, as an "impenetrable forest." In subsequent installations, at Sculpture Now and the Hudson River Museum, Helman continued with the same imagery—the imagery of the Abstract Expressionist brush stroke made physical—in complex works that allowed the viewer to enter even while the mazes of rods and planar angles kept him or her from reaching its complex core. "I'm interested in expressing the dangerous, the aggressive, of contradicting space," Helman has stated.[83] In a work like her massive *Checkpoint* [48] at the Hudson River

Museum, the museum's walls, floor, and ceiling became the container of Helman's sense of danger. *Checkpoint,* 30 feet long, 14 feet high, and 22 feet deep, was a place itself, with unexpected walls of slitted openings and planks leaning toward each other to create structures diametrically opposed to our notion of classic post-and-lintel building.

Loren Madsen's installations, like Helman's, are about risk. The sculptor, who grew up in southern California, uses building bricks and steel rods, the bricks suspended in midair with tensile wires anchoring them to wall and ceiling. During the seventies, Madsen's wires became a phalanx of lines, with the attached bricks forming a geometric shape that hung cloudlike between floor and ceiling.

Loren Madsen studied philosophy and political science at Reed College and spent a year in Europe before earning an M.A. degree in art at the University of California at Los Angeles. The sculptures in his first show in Los Angeles in the early seventies consisted of wood planks bent like archery bows set up between walls 20 feet apart. From the wood pieces, he moved on to working with inexpensive bricks and wires to express a feeling of tension, of physical stress. Madsen says his installations seem to him to parallel his own psychological development, to reflect in material terms what is happening inside him at the time. In 1975, his installation for the "Projects Room" at The Museum of Modern Art consisted of 400 red Norman bricks leaning at an angle of 60 degrees to the floor. To each brick was attached a fine stainless-steel wire, making a configuration of 400 shimmering wires contrasted with the mass of the brick wall. What the artist had created was an angled brick wall that sliced off an entire end of the gallery. According to Madsen himself, the wire side was "appealing but physically inaccessible, while the brick was accessible but unappealing."[84]

In 1976, for a three-person show at the Walker Art Center, Madsen did a brick-and-wire installation with the bricks forming an L-shaped configuration suspended by steel wires from the ceiling and far wall of the gallery. Another installation the same year, at the David McKee Gallery in New York, was titled *Floating Arch* and consisted of a network of stainless-steel wires attached to the ceiling and gallery walls supporting a tilted right-angled arch of 278 brown bricks hovering above the viewer's head. The massive form hung together, not fused but tensely balanced. It represented a departure from Madsen's previous installations in that it was a piece which could be experienced from within. Centrally placed to relate to the gallery's existing square columns, *Floating Arch* [49] allowed the viewer to stand under the installation as well as to see into it. It thus had a slightly more open feeling. Reversing this direction, in 1978 Loren Madsen built a false floor onto the existing one at the David McKee Gallery to serve as the base for his installation of rows of raised bricks formed into an inverted rectangular mass. These bricks were balanced on the steel rods that were, in turn, planted in Madsen's false floor. Thus, underneath the brick layer was an "environmental forest of horizontal rods" that guided the brick canopy

[49] Loren Madsen. *Floating Arch*. 1976.

in its descent toward the center. Madsen's 1978 brick-and-rod installation, measuring 31 × 12 × 3′, was a rectangle within the rectangular form of the gallery, which served as its cradle or shell, providing the viewer with a narrow passageway in which to walk around and view the work.

Charles Ginnever exhibited his *Zeus* [50] in the 1976 "Sculpture Made in Place" exhibition at the Walker Art Center in Minneapolis. *Zeus,* one of the sculptor's indoor installations, had originally been created for the downstairs gallery of Sculpture Now in New York; it was the second work created for that 75-foot-long and 50-foot-wide sculpture space. Ginnever worked on the piece during the whole summer of 1975, and when the gallery opened in September, the *Zeus* installation, in its ambition and drama, was an immediate and immense success. Ninety feet long, *Zeus* divided the space into three sections by its three 30-foot-long I-beams suspended from the ceiling, which literally zigzagged around the huge sustaining pillars of the gallery. The first beam of *Zeus* hung lowest to the floor, from the vantage point of a viewer entering the basement gallery by way of the stairs. This beam, angling up as it crossed in front of the first two pillars, was joined by a higher one hanging behind a column that was, in turn, met by a third ascending beam; swaying together, they carried out the thunder-and-lightning theme suggested by the title. Charles Ginnever's work follows the gestural sculpture of Mark di Suvero at the end of the fifties and Tony Smith's and Ronald Bladen's work of the middle and late sixties. Ginnever, however, repudi-

ates the influence of a specific artist or of gestural abstraction, believing his works to be very much a compendium of influences. A long-time outdoor sculptor of welded geometric forms, Ginnever has said *Zeus* "was a reformulation of an old idea first attempted in 1970 and left hanging." He was inspired to create it for the downstairs Sculpture Now Gallery "primarily to short-circuit any literal reading of that space."[85] Existing between mammoth support columns, *Zeus* opened up wholly new terrain for art; it was an environmental gesture that was inseparable from the space made by the gallery walls. With its gentle clanging and horizontal movement, *Zeus* posited itself against the post-and-lintel structure of the gallery space, posited itself as another way of being, its beams nudging against each other and remaining sufficient unto themselves as dynamic lines in space.

In September 1976, Sculpture Now opened its second season with an installation by Robert Stackhouse entitled *Running Animals—Reindeer Way* [51]. Robert Stackhouse, born in New York, had graduated from the University of South Florida and the University of Maryland. For the exhibition, he built a 66-foot-long wood sculpture that was a walk-through wooden corridor curving through the 5,000 square feet of the downstairs gallery. *Running Animals*'s two tilted walls, 12 feet high, were made of wood two-by-fours woven into a slat fence. The sculpture was a place and a passageway in the space, an installation which somehow remained apart from the Sculpture Now environment, even though its numerous slits let in the gallery light to enable the viewer to see the two sets of deer antlers positioned on its overhead walls. According to Stackhouse, the deer symbolize his "other self," the animal nature in

[50] Charles Ginnever. *Zeus.* 1975.

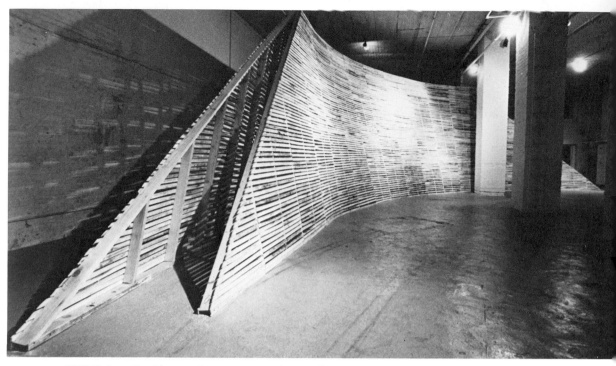

[51] Robert Stackhouse. *Running Animals/Reindeer Way.* 1976.

all of us. From inside the sculpture one could look out into the gallery, while from the outside one could observe the shadowy forms of people moving through the sculpture. Describing the work, Jean Louis Bourgeois concluded, "the interior was the fastest part of the piece," its slat ends resulting in the "impression of continuous bands that swept toward and beyond us."[86] To another critic, "*Running Animals* recalled something made by a hunting tribe, a religious edifice dedicated to the movement of game itself."[87]

Three years later, in 1979, Stackhouse made an installation entitled *Sailors* for the upstairs gallery of Sculpture Now. *Sailors* consisted of two big wood constructions: a 37-foot skeletal wood lath entitled *Ship's Hull,* suspended from the ceiling; and below it, a 72-foot-long curving structure, *Ship's Deck,* which could be walked on and which, with its lattice-like construction, was reminiscent of the inside of a hull. Both works, like *Running Animals,* were concerned with passage and employed atavistic, almost primitive, notions about ships and animal shapes in a way that was poetic and moving. One stood on Stackhouse's *Ship's Deck* and experienced the *Ship's Hull* sculpture seemingly swaying overhead and was transported. Although *Running Animals* and the pieces in *Sailors* were subsequently shown in other museum and outdoor spaces, the works seemed to retain their own sense of place, seemed to project their own primordial effect onto the new surroundings.

In contrast to the installations by Robert Stackhouse and Charles Ginnever,

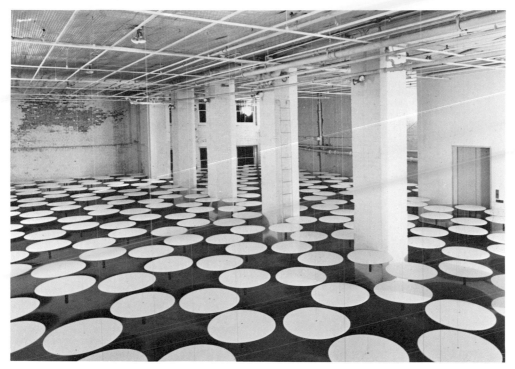

[52] Bernard Kirschenbaum. *298 Circles.* 1977.

Bernard Kirschenbaum's works have always been involved with the walls, floors, and ceilings of their room spaces in an architectonic way. After attending Cornell University, with majors in theater arts and in architecture, Kirschenbaum spent two years at the Institute of Design in Chicago before beginning to work on geodesic domes in the mid-sixties. He had his first one-person show, of modular forms covering the walls and floor, at the Paula Cooper Gallery in 1969. Kirschenbaum's main interest has been in sculpture that "physically engages the spectator and, at the same time, activates and dominates the space it is in." In 1977, continuing with his interest in modular forms, the sculptor built the installation *298 Circles* [52] for the downstairs gallery of Sculpture Now. The piece required almost six weeks to install, and consisted of 298 die-cut plywood discs, 30 inches in diameter; each one was painted with one of twelve off-white shades of car paint. The ceiling of Sculpture Now was an elaborate series of grids constructed to support these circles, suspended some 30 inches from the floor; clustering together, they turned the floor space into an overgrown Constructivist jungle through which the viewer could maneuver only by pushing the discs aside. One disc would push against the next, causing a whirring chain reaction. The circles, hung to swing free, were weighted beneath with steel cylinders and were installed in groups of four, one disc touching the other three. In photographs, one can see them forming an octagonal pattern, but being in their midst, the viewer had the sense of being inside a "ruffling lily pond."[88] John Russell, in the *New York Times*, described

the experience as moving from our usual sense of "the ground beneath us as firm, and if we want to put on the speed along the street there is nothing to stop us except our fatter fellow citizens and the state of our own legs to the experience of the power exerted by Bernard Kirschenbaum's installation. 298 large white-painted disks that hang from the ceiling parallel to the floor . . . fill the whole of the downstairs space at Sculpture Now. They do more than fill it, in fact. They crowd us out. All we can do by way of retaliation is to wade into them as a hunter wades into a marsh. They come up to a point somewhere between knee and navel, and they give way quite politely. But there comes a point when we really feel (as it were) that we are out of sight of land. Against all reason, the piece gets us confused; and when we finally make it back to the door, we know ourselves a little better."[89]

In 1979 Bernard Kirschenbaum built his next installation, an 85-foot curtain of blue spring-steel stripping that hung in an arclike configuration down from the center of the 18-foot-high ceiling of the first-floor space of the Sculpture Now Gallery. Built as part of a three-piece one-person exhibition, the work, subsequently titled *Blue Steel for Gordon* [53], became an enormous space indicator rather than room divider. One

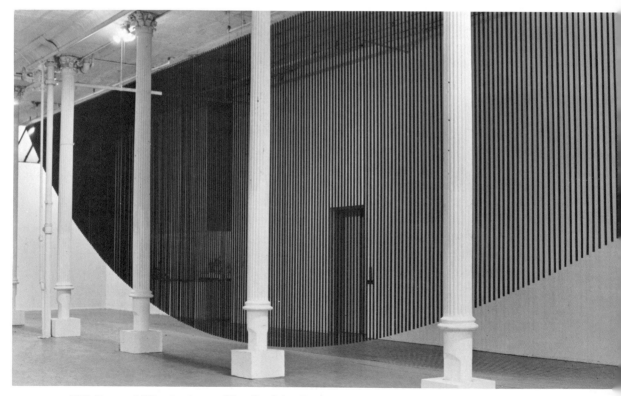

[53] Bernard Kirschenbaum. *Blue Steel for Gordon.* 1979.

saw through the gently moving steel strips to the wall behind, even as one saw the huge arc leave gracefully curved triangular forms of negative space where the curtain ended, on both sides of the bare portions of the background walls. *Blue Steel for Gordon* brought one into dramatic relationship with the gallery's ceiling, making one conscious of the overhead dimensions as the curtain swept through the space. The piece's gentle swaying movement increased its effect as a live work charging the air around it and insisting upon its metallic material as a moving presence.

Movement, almost a byproduct in Bernard Kirschenbaum's work, is a major factor, together with reflection, in Salvatore Romano's water-site installations starting in 1977. The first one was at Sculpture Now, and others followed at Mt. Holyoke College in Massachusetts and at the Frank Marino and Greene Space galleries in New York. After Romano had spent a summer working on the installation *Greene Street Oracle,* in September 1977 this water site opened the season at Sculpture Now. In the downstairs gallery, water in two shallow pools covered 90 percent of the floor, with narrow walkways only around the periphery of the space. From the black-vinyl-lined, seemingly bottomless square pools rose slender black columns in sets of two. At the

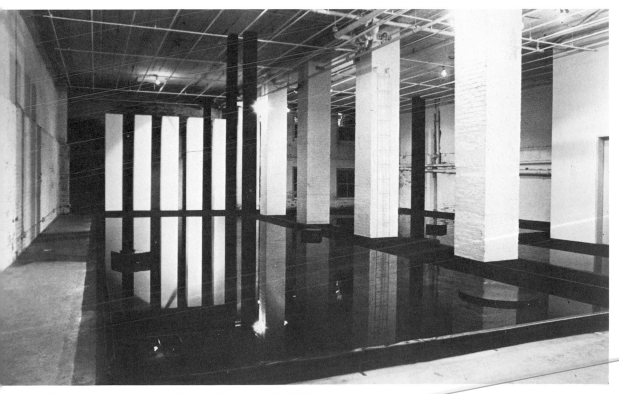

[54] Salvatore Romano. *Greene Street Oracle.* 1977.

far edge of a pool stood rows of 12-foot-high square white columns in apposition to the middle four of the 12-foot-square columns which supported the ceilings of the Sculpture Now space. Floating in the black pools quite silently, their motion controlled by unobtrusive small water pumps, were squares and discs of black polystyrene plastic. In the space's discreet lighting, the black surface reflected both the army of white columns and, in the lights from the ceiling, the slow movement of the geometric shapes along the watery surface. *Greene Street Oracle* **[54]**, 55 feet long and 44 feet wide, was labeled by one critic as a work of "baroque abstraction."[90] Another described it as "peaceful as a Japanese garden and possessing a Zen freshness . . . and combining a minimalist philosophy with environmental concerns."[91] The chance movement of the small shadowy forms, the overall stillness of the black pools, the classical pristine shapes of the white and black columns—all combined to make *Greene Street Oracle* in that space a temple-like place for meditation and a work of strange tranquillity.

Salvatore Romano had been a painter and a Minimalist sculptor before he began working with water in 1966, first making outside floating pieces and then using hidden pools to launch and move his forms. "The first impression of these works is of geometric massiveness," Lawrence Alloway has written. "But gradually one realizes that monolithic form is compatible with delicate motion. Water acts as a cushion to carry large forms, with the water trays located inside the piece, out of sight, and as in *Sliding Blue* (1970) above eye level."[92] It was almost seven years later that Romano began making indoor water environments involved with kinetics. Starting with *Greene Street Oracle,* he made a series of water sites dealing with light, movement, and reflection, and not a few also including color. One of the founding members of the Tenth Street Brata Gallery in 1957, Romano made hard-edge paintings through 1965. In the seventies, his water sites combined his preoccupations with painting and kinetic sculpture by being environments where the water surface acted as a canvas for free-floating geometric forms. At Wave Hill Sculpture Garden in the Bronx and at Mt. Holyoke in Massachusetts, Romano worked with existing pools. At Mt. Holyoke, in the piece called *Three Encounters* (1978), Romano set afloat three bronze-colored discs, 7 feet in diameter, resting on an unseen Styrofoam layer so that these bronze circles seem to float above the water. The discs in turn were anchored to yellow discs with a blue line, marking the radii pointing north, which were weighted to rest at the bottom of the pool. From the center of each anchored disc was attached a chain to link it with the bronze disc floating above the surface of the water. The Mt. Holyoke pool, 55 feet long and 30 feet wide, became a bed for *Three Encounters'* slowly moving, slowly changing spatial configurations. The indoor pools that Romano built at Frank Marino and at Greene Space galleries were, respectively, *Reflections,* a shadow and light work, and *Urban Dilemma* (shown in the exhibition "OIA at Greene Space," and then in Purchase, New York). *Urban Dilemma* set afloat an armada of 8,000 resin-treated wood matchsticks in a 10 × 10' black pool, which also contained four

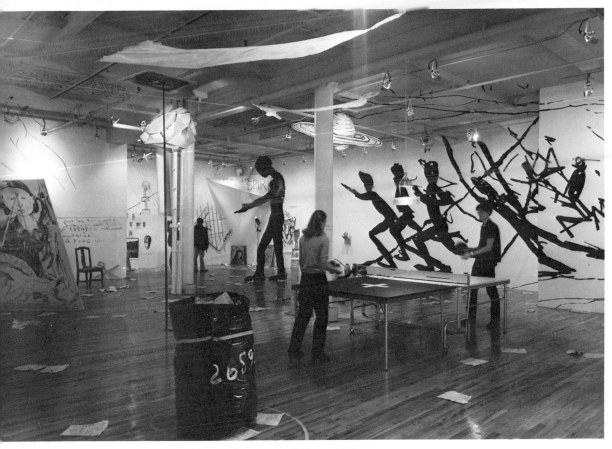

[55] Jon Borofsky. Installation, Paula Cooper Gallery, 1980.

small see-through Plexiglas boxes. Small water pumps kept the water gently moving, the forms flowing in a constantly changing pattern; sometimes they collected along the periphery, other times dodged the corners in a way that was both dynamic and disturbing, as befitted a piece made in the eighties. "Most of my works are a result of various levels of fantasy," Romano has said. "They are built on dreams while being based on the absurd contradictions that make up reality."[93] Including light, mass, silence, weightlessness, and reflection these sites are finally about contradiction, about tranquillity and continual movement, with water serving as the container for both the artist's fantasy and our own.

In his many installations, Jonathan Borofsky's images have the intensity of "remembered dreams or nightmares," in the artist's own words. "The images I create," Borofsky has explained, "refer to my own personal spiritual and psychological self. They come from two sources: an inner world of dreams and other subconscious scribbles such as doodles done while on the telephone, and the outer world of newspaper photographs and intense visual moments remembered."[94] A Borofsky installation includes drawings on the wall, small paintings on the floor, and floor sculptures. His 1980 installation at the Paula Cooper Gallery [55] also included,

among the papers on the floor and drawings on the wall, a motorized, silhouetted figure and a half-black, half-white Ping-Pong table. For the most part, Borofsky's vision seems to be of a black-and-white dream world full of drawings and sculptures that are meant to express archetypal states. A personal vision of intense fear, of a childlike fear of shadows, of following monsters prevails throughout.

Born in Boston in 1942, Borofsky graduated from Carnegie-Mellon Institute in 1964 and earned an M.F.A. degree from Yale University in 1966. About the end of 1967, he gave up making art objects to spend most of his time thinking. In 1967, he began writing down his thoughts and in 1968, almost as a relaxation exercise, began to write sequences of numbers on small sheets of paper. At a friend's suggestion, he programmed a computer with his number series, to go from one to infinity; Lucy Lippard used the computer printout in a traveling Conceptual Art show. When Sol LeWitt invited the younger artist to be in a show at the Artists Space Gallery in 1973, Borofsky exhibited his numbers as a *Counting Piece,* consisting of several stacks of paper in the middle of the gallery. The artist began making little scribbles on the corners of his number sheets, and then decided to make paintings from the scribbles, assigning each image its own number. The paintings were based on Borofsky's child-hood, on his viewing as a child the world through his dreams. Sol LeWitt in 1974 suggested that Borofsky transfer the dream images that were on canvas board and on paper to the wall, and Borofsky subsequently made them in groups of installations in various colleges and galleries. In 1976, at the Fine Arts Gallery at the University of California, Borofsky drew a blimp in three parts, on three separate walls, so that it hovered over the gallery entrance; he signed the blimp with the number 2,415,923. Other images include drawings of a moose against a mountain top and a Shinto priest. Borofsky enlarges his images by taking photographs of them and then projecting the image and drawing it in a new scale on the wall.

Preceding the expressionism and figuration of the eighties came the looming figure of Borofsky's *Hammering Man,* 12 feet high, in his second show at the Paula Cooper Gallery. Next, the same man out of wood, now 14 feet tall and with a motorized arm, appeared in his 1980 exhibition. Almost all of Borofsky's work is made in terms of installation. Since 1974 he has made several hundred images which have been painted over afterward; for Borofsky, though, they are still there. *Running Man,* once painted on the wall, is now in The Museum of Modern Art in New York, and another work is in Holland. During the seventies, however, if you wanted to buy a Borofsky painting, the artist would make one on your wall. Obviously, as Borofsky has said, you had to appreciate the work for itself and not for its resale value. Thus, the dream world of Borofsky, installed in museums around the United States and in Europe, nevertheless has remained apart from the very art market system that exhibited it. Some of Borofsky's figures were political—*Molecule Man,* with a briefcase, whose silhouette was full of holes, and a Hitler type of figure who was also not too

far from the German mythical Mr. Hunchback, *Der Bungle,* who makes one bungle one's life away. The figures, however, are never separate entities. "I think of the whole room as a painting," Borofsky has explained. "When I work I make decisions based on visual aspects of the subject matter as well as its content. If I have a lot of scribbling here, let's have a silhouette there—because opposites that play off each other create energy. I work with the whole space, activating the entire area. That's the reason for placing objects throughout the room, running a line of plastic through space or suspending objects from the ceiling."[95]

One could describe Jonathan Borofsky as a maker of psychological installations during the seventies, as opposed to, say, Salvatore Romano's meditative places. What connects such diverse artists is their use of the room, its floors, four walls, and ceiling as the boundaries of their art. Each of these indoor-installation artists set out to create a whole world, to make it exist three-dimensionally, and to insert the audience into it and have them live within the artist's vision.

NOTES:
EARTH SCULPTURES, SITE WORKS, AND
INSTALLATIONS

1. Brian O'Doherty, "Inside the White Cube: Notes on the Gallery Space, Part 1," *Artforum,* March 1976, pp. 24–25.
2. *Ibid.,* p. 25.
3. *Ibid.*
4. Robert Morris, "Aligned with Nazca," *Artforum,* Oct. 1975, pp. 26–39.
5. Excerpted from "Discussion with Heizer, Oppenheim, Smithson," *Avalanche,* Fall 1970. Reprinted in Ellen H. Johnson, ed., *American Artists on Art* (New York: Harper & Row, 1982), p. 182.
6. Hayden Herrera, "Michael Heizer Paints a Picture," *Art in America,* Nov./Dec. 1974, p. 92.
7. Ellen H. Johnson, *op. cit.,* p. 184.
8. *Ibid.,* p. 185.
9. Robert Smithson, "A Sedimentation of the Mind: Earth Projects," in Nancy Holt, ed., *The Writings of Robert Smithson* (New York: New York University Press, 1979), p. 90.
10. Adrian Henri, *Total Art* (New York: Praeger, 1974), pp. 81–82.
11. *Ibid.*
12. September 1983.
13. Nancy Holt, *op. cit.,* p. 5.
14. *Ibid.,* p. 19.
15. *Ibid.,* p. 20.
16. *Ibid.,* p. 85.
17. Robert Hobbs, *Robert Smithson: Sculpture* (Ithaca: Cornell University Press, 1981), p. 12.
18. Holt, *op. cit.,* pp. 56–57.
19. *Ibid.,* p. 56.
20. *Ibid.,* p. 90.
21. *Ibid.,* p. 115.
22. Marcia Tucker, *Robert Morris,* exhibition catalog, The Whitney Museum of American Art, New York, 1970, p. 43.
23. Holt, *op. cit.,* p. 37.
24. *Ibid.*
25. *Ibid.,* p. 111.
26. Nancy Holt has discussed the possibility of raising and rebuilding the jetty, but there are no definite plans yet.
27. Hobbs, *op. cit.,* p. 212.
28. John Coplans, "Robert Smithson: The Amarillo Ramp," in Hobbs, *op. cit.,* p. 53.
29. *Ibid.,* pp. 53–54.
30. John Coplans, *op. cit.,* p. 55.
31. Jane Bell, "Positive and Negative: New Paintings by Michael Heizer," *Arts Magazine,* Nov. 1974, p. 55.
32. Howard J. Smagula, *Currents: Contemporary Directions in the Visual Arts* (Englewood Cliffs, N.J.: Prentice-Hall, 1983), p. 284.
33. *Ibid.,* p. 286.
34. Lawrence Alloway, Harold Rosenberg, and Thomas Hess have all made a particular point of the connection between Earthworks and Abstract Expressionism.
35. Diane Waldman, "Holes Without History," *Art News,* May 1971, p. 48.

36. Lawrence Alloway, "Site Inspection," *Artforum,* Oct. 1976, p. 51.
37. Howard J. Smagula, *op. cit.,* p. 289.
38. Roberta Smith, "De Maria: Elements," *Art in America,* May/June 1978, p. 104.
39. Harold Rosenberg, *The De-Definition of Art* (New York: Horizon Press, 1972), p. 36.
40. Smagula, *op.cit.,* p. 290.
41. Corinne Robins, "Alan Sonfist: Time as Aesthetic Dimension," *Arts Magazine,* Oct. 1976, p. 85.
42. *Ibid.,* p. 86.
43. Corinne Robins, "Michelle Stuart: The Mapping of Myth and Time," *Arts Magazine,* Dec. 1976.
44. *Ibid.,* pp. 83–85.
45. Statement by Carl Andre in "Object vs. Phenomenon," *Sculpture Today* (10th International Sculpture Conference), International Sculpture Center Catalog, 1978, p. 31. Toronto, Canada.
46. Lucy R. Lippard, "Mary Miss: An Extremely Clear Situation," *Art in America,* March/Apr. 1974, p. 76.
47. *Ibid.*
48. Laurie Anderson, "Mary Miss," *Artforum,* Nov. 1973, p. 65.
49. *Mary Miss: Interior Works,* exhibition catalog, Bell Gallery, University of Rhode Island, Fall 1981, pp. 6–7.
50. Kate Linker, "George Trakas and the Syntax of Space," *Arts Magazine,* Jan. 1976, p. 93.
51. Roberta Smith, "Sculpture Sited at the Nassau County Museum," *Art in America,* March/Apr. 1977, p. 120.
52. Benjamin Forgey, "Art Out of Nature Which Is About Nothing but Nature," *Smithsonian,* Jan. 1978, p. 63.
53. *Ibid.*
54. *Ibid.,* p. 65.
55. Kate Linker, "Michael Singer: A Position in and on Nature," *Arts Magazine,* Nov. 1977, p. 102.
56. *Ibid.,* p. 104.
57. Nancy Holt, "Sun Tunnels," *Artforum,* Apr. 1977, p. 34.
58. Ted Castle, "Nancy Holt, Siteseer," *Art in America,* March 1982, p. 88.
59. The principal and best source for material on *Sun Tunnels* is Holt's own *Artforum* essay, cited above.
60. Nancy Holt, "Hydra's Head," *Arts Magazine,* Jan. 1975, p. 59.
61. *Ibid.*
62. Craig Owens, *Art at the Olympics,* catalog, New York, 1980, p. 9.
63. Ellen H. Johnson, ed., *American Artists on Art* (New York: Harper & Row, 1982), p. 223.
64. Roberta Smith, "Review," *Artforum,* Dec. 1975, p. 68.
65. Nancy D. Rosen, "A Sense of Place: Five Ameri-

can Artists," *International Sculpture,* exhibition catalog, Merriewold West.
66. Ellen H. Johnson, *op.cit.,* p. 221.
67. Lucy R. Lippard, "Charles Simonds," *Artforum,* Feb. 1974, p. 36.
68. Joan Simon, "Gordon Matta-Clark 1943–1978," *Art in America,* Nov./Dec. 1978, p. 13.
69. Corinne Robins, "Anne Healy: Ten Years of Temporal Sculpture Outdoors and In," *Arts Magazine,* Oct. 1978, p. 129.
70. *Ibid.,* p. 130.
71. Ellen H. Johnson, *op. cit.,* p. 197.
72. *Ibid.,* p. 198.
73. Jan van der Marck, *Wrapped Museum,* exhibition catalog, Chicago Museum of Contemporary Art, 1969.
74. Ellen H. Johnson, *op.cit.,* p. 198.
75. Werner Spies, *The Running Fence Project, Christo* (New York: Harry N. Abrams, 1977), unpaged.
76. *Ibid.*
77. Jan Butterfield, "Robert Irwin: On the Periphery of Knowing," *Arts Magazine,* Feb. 1976, p. 74.
78. *Ibid.,* p. 77.
79. Roberta Smith, "Robert Irwin: The Subject Is Sight," *Art in America,* March/Apr. 1976, p. 70.
80. *Ibid.*
81. *Ibid.*
82. Ellen Lubell, "Review," *Arts Magazine,* Sept. 1974, p. 59.
83. Statement by Phoebe Helman in *Drawing Now: 10 Artists,* exhibition catalog, SoHo Center for Visual Artists. Quoted in Corinne Robins, "Phoebe Helman: Inner and Outer Energy," *Arts Magazine,* Feb. 1978, p. 11.
84. The Museum of Modern Art Press Release No. 9, Feb. 14, 1975, p. 2.
85. Charles Ginnever, letter to editor in "Letters," *Artforum,* May 1976.
86. "Review," *Art in America,* Jan./Feb. 1977.
87. Phil Patton, "Review," *Artforum,* Dec. 1976.
88. Sarah McFadden, "Review," *Art in America,* May/June 1977, p. 110.
89. John Russell, "Art," *New York Times,* Friday, April 1, 1977.
90. Donald Kuspit, "Salvatore Romano at Sculpture Now," *Art in America,* Jan./Feb. 1978, p. 117.
91. Lindsay Stamm Shapiro, "New York Sculpture," *Craft Horizon,* Dec. 1977, p. 71.
92. Lawrence Alloway, "The Sculpture of Salvatore Romano," *Arts Magazine,* Oct. 1977, p. 138.
93. Artist's statement, *OIA at Greene Space,* exhibition catalog, Greene Space Gallery, New York, unpaged.
94. Ellen H. Johnson, *op. cit.,* p. 262.
95. Joan Simon, "An Interview with Jonathan Borofsky," *Art in America,* Nov. 1981, p. 183.

5

Pattern Painting and Decorative Art

An art movement has many beginnings. In retrospect, it is easy to recognize that it rises to fill a gap, a need of the time. In the mid-seventies there was a vacuum that Pattern painting and the Decorative Art movement filled because, while sculpture in the form of Process, Arte Povera, Site, and Environmental work was becoming ever more ambitious, abstract painting for the most part continued to look backward toward Minimalism for its inspiration, to a Minimalism based for the most part on Ad Reinhardt's concept of the invisible as subject matter. In 1975 the Minimalist/ Process painter Brice Marden had a ten-year retrospective exhibition at the Guggenheim Museum that seemed the final summation of the problem of painting "silence." That same year *Artforum* magazine devoted its September issue to discussing "the crisis in painting." Meanwhile, gallery-goers uptown and downtown were being confronted with literally hundreds of nearly blank paintings of tranquillity and stillness, which led more than one critic to pose the question whether, in fact, painting had come to an end. It was in this climate that such diverse artists as the Color Field/Minimalist Robert Zakanitch on the one hand, and the feminist leader and hard-edge painter Miriam Schapiro on the other, began seeking a new kind of content for their art in the idea of the decorative. There were already signs of change. The July 1975 issue of *Art in America* was devoted to discussions of the later works of Henri Matisse, including an essay by Amy Goldin titled "Matisse and the Decorative," which became the first in a series of articles on the decorative she was to write between 1975 and 1978; a newly re-installed Islamic wing of The Metropolitan Museum of Art opened in 1976; and that same year an exhibition of women's decorative quilt work traveled to museums throughout the country. The following principles concerning the new Decorative Art seem to have been very quickly agreed upon: 1) Decoration and Decorative Art, rather than being secondary, represent a different kind of aesthetic

experience from high art. 2) High art is the locus of spiritual experience transmitted by visual means (Minimalism and Expressionism, for example), whereas decoration's aim is in the delight of the senses and in pleasure. 3) Decoration aims at a unified environment, in actually filling in the space where it extends, as opposed to projecting its vision as a single unit—a painting, for example—into an alien environment. 4) Decorative focuses on pattern and structure rather than imagery; the imagery by definition is incorporated into the overall design.[1]

One of its leading advocates, John Perreault, defined Pattern painting as "non-Minimalist, non-sexist, historically conscious, sensuous, romantic, rational, decorative. . . . As a new painting style, pattern painting, like patterning itself, is two-dimensional, non-hierarchical, allover, a-centric and aniconic. It has its roots in modernist art but contradicts some of the basic tenets of the faith, attempting to assimilate aspects of Western and non-Western culture not previously allowed into the realms of high art."[2] In a subsequent article, Perreault asserted that "pattern/decorative art is a political statement," adding that this aspect "was particularly true for women artists."[3] Both Robert Kushner and Joyce Kozloff, for example, felt that the decorative mode could become a means of doing away with the gap between art and life, and become a way of re-inserting life and its concerns back into art. For Joyce Kozloff and Miriam Schapiro, though, the issue was further complicated by the fact that the decorative or beautifying role had usually been assigned to women, all of whom were supposedly adept at the minor arts. Weaving, quilt-making, even Islamic carpets in the West have carried the stigma of being secondary—that is, crafts as opposed to painting, one of the higher, spiritually imbued arts. Thus, for a short while, simply by painting in a pattern or decorative mode, they were making a feminist statement. But if we leave the feminist movement aside for the moment,[4] Joyce Kozloff and Robert Kushner, Kim MacConnel and Miriam Schapiro and Robert Zakanitch all in their very different ways in 1976 were protesting this kind of classification, this dividing of art into high and low categories.

A very convincing argument has been made that the new Decorative movement and the New York school of Pattern painting both originated and were fostered in California.[5] It was at the University of California at San Diego in 1970 that Miriam Schapiro began investigating feminist, decorative imagery as a painting source. Also, from the late fall of 1970 through the spring of 1971, the critic Amy Goldin was a visiting professor at the same school, teaching courses in aesthetics and art criticism. One of Goldin's major concerns at the time was to start an inquiry into the motifs and philosophy inherent in Oriental design, and at least two of her students from this period, Robert Kushner and Kim MacConnel, were very influenced by Goldin's thinking. During the spring recess, Amy Goldin took Robert Kushner with her on a visit to George Sugarman's studio in New York, where Sugarman and Goldin discussed Sugarman's complex colorful new public sculptures, and the ideas in Islamic

and Baroque art. The next year Kim MacConnel and Robert Kushner held a joint exhibition of their work titled "Decorations"[6] before Kushner left for New York and MacConnel for Boston. Meanwhile, Joyce Kozloff moved to Los Angeles and took part in a conference with Miriam Schapiro that was held to unite women of southern and northern California in a joint effort "to establish a new content-oriented visual vocabulary that would ignore past taboos against decorative and feminine materials and objects."[7] The finding of alternative aesthetic systems soon became the core of feminist art in the seventies. The painter Robert Zakanitch was invited to teach a semester at the University of Southern California at Davis in 1976, and six months later, back in New York, he and Miriam Schapiro held the first meeting of the Pattern and Decorative Artists group, in January 1975.

The group held a second meeting in New York the following month. Meanwhile, on February 7, 1975, the first public discussion of Pattern painting took place in the form of a panel held at the Artists Talk On Art organization in SoHo. The panel, titled "The Pattern in Painting," was organized by the painter Mario Yrisarry, who invited the critic Peter Frank to serve as moderator. The panelists included Tony Robbin, Valerie Jaudon, Rosalind Hodgkin and Martin Bressler. The panel and the group meetings served as a kind of release. As Valerie Jaudon explained, "At the time when everybody assumed there was no more painting being done, it was terrific to be able to talk to other painters and to share ideas."

In 1976, the Pattern and Decorative group organized their own show, "Ten Approaches to the Decorative," which opened at the Alessandra Gallery in SoHo on September 25, 1976. The artists in this show were Jane Kaufman, its curator, Valerie Jaudon, Joyce Kozloff, Tony Robbin, Miriam Schapiro, Arlene Slavin, George Sugarman, John Torreano, Robert Zakanitch, and Barbara Zucker. By the time the exhibition closed, on October 19, 1976, the Decorative movement had become a subject of controversy that soon brought new energy and new collectors into the art world. The movement's unofficial home became the Holly Solomon Gallery in SoHo, which had opened its doors in 1975. Among Solomon's first group of artists were Robert Kushner, Kim MacConnel, Valerie Jaudon, and Robert Zakanitch, all of whom were active members of one or another of the Decorative artists groups. The new Decorative movement quickly filled the Minimalist vacuum and less than a year after the Alessandra exhibition, John Perreault organized "An Interim Survey" show at the Institute for Art and Urban Resources at P.S. 1 in Long Island City that was a mammoth, twenty-six-artist, floor-through exhibition he titled "Pattern Painting at P.S. 1."

From the very beginning, George Sugarman on more than one level functioned as an unofficial adviser and even elder statesman to the movement. He participated in the first show, at the Alessandra Gallery, but his attitude toward the Decorative label was always ambivalent. In 1978, Sugarman made a statement declaring, "Calling

my sculpture decorative is utterly ridiculous to me."[8] After that, Sugarman went on to participate in a 1979 exhibition entitled "The Decorative Impulse," which started at the Institute of Contemporary Art in Philadelphia and traveled to Minneapolis and La Jolla. And in *The Decorative Impulse* catalog he states, "Decorative art is now being made by artists born into the Western cultural traditions and they are using it as an area of exploration by means of which both traditions (East and West) will be perhaps blended, and most certainly extended. They are producing objects, though perhaps inspired by principles of decoration, that are independent of decoration's formerly supporting role. They are changing the intention, the meaning, the feelings and the function of decorative art."[9] The fact that George Sugarman's approach to the decorative was complex should come as no surprise, seeing that complexity has become almost the rule in his sculpture. While agreeing with Amy Goldin's definition of the decorative, he has insisted on a multiple approach to his own work: "Metaphor, stimulation (decoration's sensuous appeal), formal relationships are three ways to meaning," he has written. "Is it necessary to choose?"[10] This statement came long after George Sugarman's meetings with Amy Goldin, with whom he became friends in 1964. In 1966 Goldin wrote an article titled "The Sculpture of George Sugarman,"[11] in which she discusses many of Sugarman's ideas, and two years later she devoted several pages to his work in her essay entitled "Beyond Style."[12] Goldin was attracted to the work because already in 1964, in the middle of the beginnings of Minimalism and reductivist sculpture, George Sugarman's polychrome wood works (such as *Iniscape*) were extending across the floor in what seemed like a wholly irrational and idiosyncratic fashion.

George Sugarman was born in New York City in 1912; he graduated from City College in 1934, taught arts and crafts for the Works Projects Administration, and didn't begin to paint seriously until 1950. The next year, using money from the G.I. Bill, Sugarman went to Paris, studied with the Cubist sculptor Ossip Zadkine for a short time, and then, from 1952 to 1955, utilized the studio facilities at the Académie de la Grand Chaumière in Paris. He returned to New York in 1955, and in 1957 became one of the founder/members of the Tenth Street Brata Gallery, where he participated in a three-person show. Sugarman had his first solo exhibition in 1960 at the Widdifield Gallery in New York, where his sculpture consisted of sprawling forms of laminated wood. The following year, for his one-person exhibition at the Stephen Radich Gallery, he introduced zigzagging and curvilinear forms in even more complicated sequences and compounded the work's complexity by introducing color. At the time, the artist was fascinated by the color theories of the American painter Stuart Davis, who wrote, "Color must be thought of as texture which automatically allows one to visualize in terms of space. . . . Everytime you use a color," Davis said, "you create a space relationship."[13] With this in mind, in 1960 and 1961 George

Lucas Samaras. *Photo-Transformation*, 1973–74. 3 x 3″. The Pace Gallery, New York City.

Virginia Cuppaidge. *Nizana*, 1978. Acrylic on canvas, 6½ x 10'. Private collection.

Salvatore Romano. *Three Encounters*, 1978. Floating sculpture, 55 x 25 x 2', discs 7 in. diameter. Mount Holyoke College.

Joyce Kozloff. *An Interior Decorated*, 1979. Tibor De Nagy Gallery, New York City.

Robert S. Zakanitch. *Savannah Nights*, 1978. Acrylic on canvas, 84 x 144".

Sol LeWitt, drawing. Photograph shows a detail of two different works as they appeared at The Museum of Modern Art, New York City. One of the four parts of *Lines to Points on a Grid, White Lines from Center, Sides, and Corners,* 1976. Chalk on black wall. Collection The Whitney Museum of American Art. Photo: Akira Hagihara.

Milton Resnick. *Untitled,* 1976. Oil on canvas, 103½ x 109½″. Max Hutchinson
Gallery, New York City.

Richard Diebenkorn. *Ocean Park 115,* 1979. Oil on canvas, 8′4″ x 6′9″. Collection The Museum of Modern Art, New York City. Mrs. Charles C. Stachelberg Fund.

Sugarman began polychroming his forms in relation to their different shapes. Certain forms and their particular relation to an adjacent form dictated they should be one particular color, and even a certain shade of that particular color, according to the sculptor. In the mid-sixties, Sugarman began to make similar forms in clusters or masses, with each cluster in a particular color. In 1969, while preparing for a retrospective exhibition in Europe, he made his last wood piece, *Ten,* which was also almost his first and last large-scale monochromatic work to date. *Ten,* 91 × 149 × 71', was the last piece Sugarman made with the help of assistants, who had been working with him on the sculptures and serving as the artist's hands since 1965. "It was also a unique work in that in it, Sugarman completely abandoned disassociation and extended space and instead focussed on interior volume."[14] Composed of ten separate vertical parts arranged in an oval whose shadowed inner space the viewer can barely glimpse as he walks about it, *Ten* is today part of the permanent collection of The Museum of Modern Art. To myself, *Ten* seems almost a personal farewell gesture to modernism on the part of the artist. Certainly, it is very much at odds with Sugarman's first public commission, a nearly baroque metal environment the artist made for the First National Bank of St. Paul, Minnesota, in 1971 **[56]**. Sugarman was awarded the commission for the sculpture in 1968, and it was at this point he thought about introducing his notions about field sculpture (sculptures extending out in space) into a public outdoor setting so as to make work that would relate "not only to buildings but people and their relationship to the work of art."[15] The St. Paul sculpture today hangs 30 feet off the ground and, attached to the ceiling, fills the overhead area space, 20 × 32 × 46', with nineteen tons of sheet aluminum cut into sprawling, multicolored forms. Red discs, blue discs rimmed with yellow, yellow circle shapes, green C shapes in ribbons of metal reach out over the sides of the National Bank building's street floor. The piece is a decorative environment, an endless intertwining of shapes. Its repetitive forms are in keeping with the notion of the decorative as rhythmic patterning, although the work is the opposite of the restful armchair of Henri Matisse's art prescription. Even while the St. Paul's flat metal shapes would seem to invite some comparison with Matisse's late cutouts, because of the work's maximal effects, specifically achieved through its use of manifold forms, it goes beyond notions of beauty, tranquillity, and calm. It manages, rather, to compete successfully with and to activate the space of the bland rectangular openings in the bank's modernist building facade.

In 1969, after finishing *Ten,* Sugarman began using the firm of Lippincott to fabricate his work in metal. And, in 1970, when he returned to the studio after his European retrospective exhibition, he began working on cardboard models for metal pieces, not a few of which he would study by tacking up on the wall. These, in turn, were the beginnings of Sugarman's metal relief collages, which he made through the

[56] George Sugarman. *Saint Paul Commission*. 1971. First National Bank, Saint Paul, Minn.

1970s and which introduced the idea of color fragmentation and pattern, thereby helping to shape the thinking of a whole generation of young Decorative artists [57].

"Decoration is not jealous of the past, of the contexts it borrows from, is not envious of the Other it finds itself infatuated with; it borrows from love out of love," Jeff Perrone has written.[16] It was with this kind of love that feminists in the 1970s researched the decorative works done by anonymous women of previous generations. As Miriam Schapiro explained, "The politics of the high/low art split so supported by mainstream artists was confronted with passion by all of us feminists. We needed

to affirm the strength of decorativeness in history—since its history was one of work by women almost exclusively. 'Decorative is not a dirty word' became a phrase almost as important as 'The personal is the political.' For the first time in the history of art we women were able to influence the culture of our time."[17] Schapiro, together with Sugarman, are the two artists of the older generation who became leaders of the Decorative movement of the seventies. Sugarman, however, arrived at his ideas of decorative complexity and contradiction by way of a very personal, outsider stance. Schapiro came to the decorative by way of political and aesthetic conviction: through a love of the look of decorative work and through a need of defining herself as a woman artist. Following the exhibition of "Womanhouse" at the California Institute of the Arts, Schapiro went back to her studio and began using the dollhouse image to make works that combined the ideas of collage with geometric acrylic painting. By 1973, she had arrived at her new style, which employed abstraction, decorative pattern, and feminist imagery within the architectural framework of the house. Pattern, in the form of floral bouquets, lacy borders, floating flowers on gatelike shapes, appears throughout. In 1976, her *femmage* painting for the "Ten Approaches to the Decorative" exhibition was a four-panel work of acrylic and collage on shaped canvases titled *Cabinet for All Seasons* [58]. Each of its four 70 × 40" panels was shaped like a doorway and contained a rectangular window insert. "The Season-Cabinets are ultimately states of visual feeling: vernal greeny-yellow and open for Spring; richer, deeper green, more densely vegetative for Summer; ruddy, sensuously black and crimson for Autumn; light, prickly silver floating and pale for Winter," the art historian Linda Nochlin wrote in an article on Schapiro.[18] And Jeff Perrone wrote that the four-part work "created out of embroidered handkerchiefs from around the world laid out in a grid had an unmistakable beauty and wit."[19] At the same time the Alessandra Gallery exhibition was taking place, Miriam Schapiro also had a solo show, at the Emmerich Gallery, in which she exhibited her monumental *Anatomy of a Kimono* installation, a fifty-foot painting/collage which she designed for the gallery. Inspired by a Japanese kimono which seemed to her to contain Cubist references, Schapiro explained she also "chose the kimono as a ceremonial robe for the new woman . . . I wanted the robes to be rich and dignified . . . I wanted them to be a surrogate for me—for others. Later I remembered that men also wore kimonos and so the piece eventually had an androgynous quality."[20] Jeff Perrone wrote, "It is possible to list only a few of the themes running through these works." And with regard to *Anatomy of a Kimono* in particular, he said, "Schapiro's art has been renewed through her involvement with feminism, but there are a thousand ways of filling in the void left by the demise of formalism. Schapiro has filled in her decorative forms with the content of feminism, but the same forms can relate to architecture . . . or the dialectic of literal and metaphorical collage, the layering of material and the depth of experience."[21] Jeff Perrone, like John Perreault, is an impassioned advo-

[58] Miriam Schapiro. *Untitled.* 1974 (follows *Cabinet for All Seasons* series).
Collection Cal-Arts.

cate of Miriam Schapiro's work. *Anatomy of a Kimono,* to me, however, seemed a little over-programmed and, in its patterning and juxtapositioning of geometric shapes, rigid rather than flowing.

Following the *Kimono* installation, Schapiro went on to make large canvases in the shape of fans, hearts, and houses, which seem to achieve a better balance of the decorative with formal painting. Her 1979 *Barcelona Fan,* shaped and structured like a fan, uses its layers of patterning to echo rather than subvert its not unexpected ornamental designs. Most of Schapiro's house-shaped paintings repeat her house form within their framework and *Eye Dazzler*'s (1979) rick-rack bordering makes this ornamentation into an effective geometric shaping device. In all these works, the sentiment of the heart and the house is always governed by Schapiro's geometric controls. She is not, despite the multiplicity of sources in her work, an artist who makes works about such sources and/or systems, but one who uses pattern to structure and define her life experiences.

In the "Ten Approaches to Decoration" exhibition, the feminist Joyce Kozloff showed two large abstract paintings; her work, according to Jeff Perrone, "decontextualizes the patterns making them decoration alone removed from their functional base of object." In *Hidden Chambers,* a 78 × 120″ work which Kozloff also included in her 1976 solo exhibition at the Tibor de Nagy Gallery in New York, "the decorative systems of the painting are opposed in color, style and motif, but are grounded in their common surface."[22] In the painting, Kozloff balances against three bands of patterning and three bands of solid color a large square of a floral-like pattern of bright oranges and blues superimposed over a more rigidly geometric pastel one, making the light from the two patterns vibrate off each other, and shift in space.

Born in New York City, Joyce Kozloff graduated from the Carnegie Institute of Technology and earned an M.F.A. degree from Columbia University in 1967. A geometric painter at the beginning, Kozloff had her first one-person show at the Tibor de Nagy Gallery in 1970, and later that year moved to Los Angeles. In 1971, she joined the Los Angeles Council of Women Artists and collaborated on a project that documented gender-based adjectives such as "soft," "pretty," and "feminine" and their contextual use in current art magazines. A trip to Mexico in 1973 confirmed her interest in pattern, as she came to know Churresquersque church architecture. "In Mexico I found built patterns . . . patterns that were central to the structure and function of a building or a piece of woven cloth (created through the stacking of bricks or the pulling of threads). I decided in Mexico that I wanted to break down the hierarchies between the decorative and the high arts. I wanted to accept all these art forms on equal terms," Kozloff has stated.[23] A year later, she went to Morocco, which she found to have been the basis for the Churresquersque church architecture; it had come to Mexico from Spain and in Spain had been influenced by North African art. In Morocco, Kozloff, wanting to see as much Islamic art as possible, attempted to visit

[59] Joyce Kozloff. *Tent-Roof-Floor-Carpet/Zemmour.* Diptych, 1975. Collection Dr. Peretz; Collection Morganelli, Heumann and Associates.

the mosques, which she found, as a non-Moslem, she was not permitted to enter. The painting *Hidden Chambers* and others in the Tibor de Nagy exhibition were derived in part from her experience of looking across courtyards and into open gates as well as from fantasizing about the kind of ornamentation that lay inside.[24] In Morocco, Kozloff found in the roofs and floors, in the heavily treated Arabic wall surfaces that were designed to be seen in flickering and dazzling light, an inspiration for future paintings, as well as the source of the star pattern included in her large-scale, 6 × 8′, 6 × 4′ diptych *Tent-Roof-Floor-Carpet/Zemmour*, 1975 [59].

Kozloff's paintings from 1975 to 1977 were followed by a series of print collages she made, based on her set of prints duplicating Islamic patterns. Kozloff took a run of the prints, cut them in pieces, and reassembled the pieces in long formats, in places filling them in with passages of drawing in colored pencil. The collages, begun with Kozloff's using a discarded print run (discarded by her printer, Solo Press, and returned to her at her request) allowed her to make yet another transition from art to life and into art again. At the University of New Mexico as an artist-in-residence in 1978, Kozloff next began making and then painting ceramic tiles. She began doing installations of these star-shaped and hexagonal tiles, starting with her *Cincinnati Tile Wall* in the "Arabesque" exhibition in 1978, which served

as an announcement of her intention to address issues of architectural ornamentation. In her statement in the catalog of the Cincinnati exhibition, she wrote: "Last year I finished the paintings, at least for now. The abstract and the metaphorical no longer satisfy me. Now I want to make my architectural fantasies concrete, even literal. I am making a room which will have patterns everywhere, on the floor, the walls, the ceiling, and they will be made of tile, fabric, glass and other materials. Perhaps through this process I can answer the questions about decoration and my work that have begun to obsess me."[25]

"You are what you wear," Carrie Rickey decided, was a 1970s rediscovery of a universally acknowledged truth.[26] The idea of using fabric, of making and seeing fabric as an art material, was a major aspect of the seventies Decorative movement. Robert Kushner's costumes and Kim MacConnel's loose panels, in insisting upon their subject for art. The use of clothing was in fact a way of removing art from the high seriousness of the Minimalists' exclusionary aesthetic.

Robert Kushner's definition of the decorative as applied to his own work includes: "1) flatness rather than illusion, 2) expansiveness rather than containment, 3) use of pattern, and 4) subject matter or meaning that is secondary to visual effect."[27] The California-born artist began working in a somewhat decorative style while still in art school at the University of California at San Diego. A sculpture student, he started by making clouds out of polyurethane and leather, and by cutting up and remaking leather jackets into objects in ways that were intentionally strange. The son of a well-known Los Angeles artist, he had been taken to museums and galleries and, long before going to art school, had learned to look at and analyze art. Thus, Kushner's first attraction to the decorative was that it was something an artist wasn't supposed to do. "It was avant garde. It was like what can I do that is unacceptable, what can I do that is not art," he has explained.[28] And this was to remain his attitude toward the decorative style until his trip to Iran in 1974 with the critic Amy Goldin.

For his graduation show in 1971, Kushner, with the painter Kim MacConnel, put on a joint exhibition entitled "Decorations," in which Kushner exhibited costume works that were intended to function as both art objects and performance costume. He then moved to Boston, where he continued to make and exhibit these costumes in performance pieces. At the end of 1972, Kushner moved to New York, where he continued his performances, which included as many as fifty-five costume changes and were a combination of burlesque strip-tease and avant-garde fashion show. According to one *SoHo Weekly News* critic, they were also a "visual feast" which succeeded in showing up the visual impoverishment of most Conceptual performance works, which left audiences with only the artist's body to contemplate and not much else.[29] The 1974 trip to Iran with Amy Goldin was a revelation. "On this trip, seeing those incredible works of genius, really master works which exist in almost any city, I really became aware of how intelligent and uplifting decoration can be," Kushner has said.[30] Back

[60] Robert Kushner. *Slavic Dancers.* 1978.

in New York in 1975, while supporting himself as an Oriental rug restorer, Kushner began drawing daily in a calligraphic style with India ink. The Holly Solomon Gallery, which opened that year, became a home base for both his paintings on cloth and evenings of costume performance.

In his 1975–77 works, Kushner used brightly colored floral foliage imagery and abstract patterns carried out in the style of wallpaper designs. Many of his paintings were made in the oddly shaped form of chadors, the traditional cape and veil garb of Moslem women. Kushner's prints appear on one side of the cape, printed from one screen, and then a free-hand mirror rendering of this side appears on the other, repetition with slight variations being an essential element in Kushner's decoration concept. Late in 1976, Kushner began using animal forms, then human faces, and finally bodies, all executed in a flat, decorative manner reminiscent of Matisse and Egyptian wall paintings. Works such as the artist's 1978 *Circus Romance* (acrylic on paper) or the acrylic panel *Embrace* and his 119 × 240″ *Slavic Dancers* [60] mural, done on acrylic on cotton, show the introduction of the figurative into his patterning as opposed to the floral and kimono dragon imagery of the earlier works. All of Kushner's art, made to be worn or to decorate the wall, provides the viewer with constantly changing patterns and with image reversals that are at once pleasing and disturbing.

Kim MacConnel, a little older than Kushner, was born in Oklahoma in 1946 and spent part of his childhood in Mexico. He had been a college student in the East and had served in the merchant marine before enrolling in the M.F.A. program at the University of California at San Diego, where he met Robert Kushner. At the time, MacConnel was making rigidly geometric abstract paintings, to which he began applying polka dots of color. From a stringent, exclusionary attitude toward art, he moved to one of acceptance, encouraged by the critic Amy Goldin. He became committed to the use of symbolic systems and began incorporating the conventions of calligraphy, pattern, and geometric ornamentation into his work. American Indian and Oriental rug design, as well as primitive hieroglyphics and arabesque patterning, became some of his sources. Chief among them, though, was "bad" decoration, in the form of machine-printed textiles, which he joined by deliberately vulgar or obtrusive stitching. "Good decoration," MacConnel explains, "plays off what is around it. In the sense much good art can in fact be bad decoration. It doesn't relate to anything around it. It is self-contained, self-referential. Further, I think bad decoration can be good art in that even though it may be bad as art it can somehow transform an environment into something interesting."[31]

Much of MacConnel's work appears in a hanging panel format. But even though his pieces are designed to hang in a particular fashion, there are no directions as to how the work should be "read," in the sense that there is no top or bottom to a pattern, or to MacConnel's pattern juxtapositionings. What "reading" there is exists in the lateral format, in terms of one panel being placed next to another. Kim MacConnel began showing his paintings with Holly Solomon in 1975. In 1976, he made a series of furniture pieces, which enlarged the scope of his presentation. Using furniture from the San Francisco Bay area thrift shops, including old tables, chairs, and a vinyl TV couch, MacConnel painted the upholstery and assorted surfaces with decorative patterns and symbols, for an exhibition in California.

With the exception of this exhibition of furniture, MacConnel's paintings since 1976 have all been composed of vertical fabric strips of varying widths, sewn together into rectangles which are pinned to the wall. They are hung loose rather than taut, with an emphasis on the softness and fragility of the material. Some of MacConnel's panels are hand-painted in acrylics, others are machine-printed. In the mid-1970s, many were purchased in textile stores. Patterns from the past, icons from the present, and animal, fruit, and vegetable motifs presented together thus appear on a single plane. There are no hierarchical arrangements in MacConnel's work or in his patterning in general. After describing the artist's large acrylic mural *Parrot Talk* [61] of 1980, the critic Douglas Blau summarized MacConnel's approach and underlying aesthetic aims in this way: "By placing images that we usually conceive of as being unrelated opposites onto the same plane, he exposes the sympathies that connect them. Ignoring previously delineated notions of 'good' and 'bad' and 'high' and 'low,'

[61] Kim MacConnel. *Parrot Talk*. 1980.

he is able to undermine our established sense of values. . . . MacConnel is a hawk discreetly masquerading as a parrot. Subtly camouflaged, his paintings look like garden parties, sound like cocktail conversations, but, on closer examination, reveal themselves to be deceptively worded declarations of war."[32]

In contrast to Robert Kushner's and Kim MacConnel's work with fabric, the painter Cynthia Carlson is concerned with the paint in terms of the wall, and much of her work during the 1970s could be described as paint installations. Carlson uses the actual surface of the wall, and makes the room itself into a canvas for her decorative borders, edges, and all-over patterning. "My working with decorative concerns," she has explained, "is to take something (art) historically located in the periphery (usually as well as philosophically) and move it to center stage. Borders,

[62] Cynthia Carlson. *Homage to the Academy.* 1979.

edges, ornamentation, decoration, embellishments and adornments are first dislocated as the focus of attention, and then re-located in the conceptual idea of home."[33]

Born in Chicago in 1942, Cynthia Carlson graduated from the Art Institute there before coming to New York, where she earned the M.F.A. degree from Pratt Institute in 1967. An abstract painter for a number of years, following a period of teaching in Colorado in the early seventies, Carlson stopped painting for six months, after which she began making two versions of each painting: one painted thickly and very fast, the other, more slowly, with thinly applied paint. In 1974, she made a thick abstract painting she titled *Squiggles,* which became a seminal work in establishing her new way of working. *Squiggles,* which consists of a pink and white surface with ribbons of oil paint applied with a pastry tube and arranged in stripes, is a painting that is about its own surface—it makes its surface the subject matter. From then on, as

Patricia Stewart has observed, Carlson's color "evokes an innocent world of low-cost consumer goods. Her strong, off-primary tones including pink, purple and bright acid green all refer to the commercial world."[34]

Cynthia Carlson made her first wall/room installation in the fall of 1976, in a show at the Hundred Acres Gallery in SoHo. As part of the show she painted the walls of the gallery's large basement room pale gray. Then she added a grid of marks in gray and yellow acrylic in extremely thick bits of impasto, which on the wall finally became a kind of allover handmade wallpaper and which raised all kinds of questions about decoration and the role of the wall as its receiver in "fine" art. Many of Carlson's subsequent installations referred to the architectural details of the buildings in which they were housed, and in their color suggested specific periods. An example of this was Carlson's treatment of the Morris Room in an exhibition at the Pennsylvania Academy of Fine Arts in 1980. The recurrent decorative architectural elements in the Victorian-style building, designed by Frank Furness, are the diamond and the rosette. Thus, on the west wall of her room, Carlson used the rosette in blue, and on the east wall the diamond form appeared in red terra cotta, both of which were framed by floor-to-ceiling rows of light, matt grids. Then, in keeping with the Morris Room's function as a contemporary art gallery, Carlson hung her own paintings against these decorated wall surfaces. (The paintings Carlson made in the mid-1970s are paintings of fragments of her own painted, that is, decorated walls.) In a note to this exhibition, which she had titled *Homage to the Academy* [62], Carlson wrote, "The exhibition has its sources in architecture and decoration, with specific reference to 'wallpaper.' It is an homage to the Academy building itself, which represents what Paul Goldberger ('Ten Buildings with a Style of Their Own,' *Portfolio Magazine*, June/July 1979) calls 'much of what modern architecture rebelled against: rich ornament, complex details, picturesque massing and a reliance on history.' "[35]

In Cynthia Carlson's work at the P.S. 1 "Pattern Painting" exhibition in Long Island City in 1977, as well as at the "Decorative Impulse" group exhibition in Philadelphia in 1979, the viewer, when entering Carlson's section, was surrounded by the artist's three-dimensional wallpaper painting environments that began and broke off their repetitive patterning unexpectedly, as if at the artist's whim. Even while referring to the architectural concerns of the specific building, Carlson puts her own mark on the entire space by the creation of her paint environments, which are always the opposite of restful or easy. Bright, patterned, and demanding, they make the viewer experience ornament as a structuring device, and transform it from the afterthought of "mere decoration" to something of central concern.

Robert Zakanitch since 1975 has used wallpaper patterning as part of the subject matter of his painting, but for Zakanitch, the canvas, the represented image rather than the thing itself, is the central issue. "I didn't start out to paint decorative paintings," he has said. "I started by trying to break out of formalism and get into something that was called pattern." Over the last seven years, Zakanitch has made

his peace with the critical language applied to Decorative Art partly by countering it with a personal definition for his own approach to decoration. He begins with Webster's definition—"Decoration—to adorn or embellish"—and goes on to explain, "In a sense all the arts are decorative but the differentiating element of all arts, attitudes and cultures is Style, and it is style or stylization that I am more concerned with."[36]

Born in Elizabeth, New Jersey, in 1935, Robert Zakanitch regarded the older Abstract Expressionists as "the heroic generation," while he himself worked in a formal, Minimalist manner. He used the circle as a structure on which to base his color paintings in a one-person exhibition at the Stable Gallery in New York in 1967. By 1969, Zakanitch was making hexagonal paintings with colored lines that, shifting ambiguously, fulfilled the requirements of Optical Art and a short-lived movement called Lyrical Abstraction. All these works, along with his paintings done during the seventies, were concerned first and foremost with color and light; the Minimalist grid in them remained an underlying compositional structure. In 1973–74, from working with subtle color modulations, Zakanitch moved to using color in repeated patterns of abstract geometric shapes, making paintings that employed undulating stripes and arcs. In 1974 he was invited to teach a semester at the University of California at San Diego and, while there, met Miriam Schapiro. Both artists had background in the basic tenets of formalist painting, and were now moving toward referential imagery. There were many discussions and, upon their return to New York, Miriam Schapiro and Robert Zakanitch jointly organized the Pattern and Decorative Artists group. Following the group's first meeting, Zakanitch started working on *Late Bloomer,* his first tentative move toward a floral motif, in which he added leaf forms to his abstract brush strokes. *Late Bloomer* started 1975 off as a transition year in which Zakanitch continued to make paintings with marks which resemble flowers or patterns of flower forms, rather than flowers derived from nature. As John Perreault predicted, almost as if in retrospect, "Critics fond of perfect cubes and unicolor paintings will be dismayed by Robert Zakanitch's lavender-and-plum paintings which are derived from wallpaper patterns."[37] And indeed they were. A work such as the 1975 *Dubarry* was a surprise to critics and collectors alike. The top half of *Dubarry* is permeated with a deep green that fades into pale white on the lower half of the canvas. Its entire surface receives clusters of brown brush strokes at the juncture of mauve blue and pink diagonal lines which cross the painting field. It was in 1976 that Zakanitch finally allowed all kinds of referential motifs; flowers of every color, size, and variety blossomed on his surfaces, the underpinnings of stems and vines becoming a continuation of Zakanitch's ever-present grid. Zakanitch's painting in the "Ten Approaches to the Decorative" exhibition was described by Jeff Perrone as one where "flowers do not appear as abstract forms but are pictorially represented. Pasty lavender, browns and

salmons seem to be mixed with a milky white. It is almost as if Zakanitch wished to start all over again, like Klee, knowing nothing."[38] That same year Zakanitch's tripartite painting *Spring Fever,* 27 × 93″, consisted of side panels of rows of pink-beige flowers flanking a center panel of white blooms on a lavender background. The surface was lush with wavy white bands traveling down the left panel through the center white flower field and up to the top of the right panel. The flower imagery was not real. The movement of the paint itself, the flowing line on the decorative field is what makes the painting work. "What I was doing," Zakanitch has explained, "was bringing together the tools of my trade: particularly all that I had learned through abstract expressionism—the experience of paint, of lushness, controlled spontaneity, the physicalness of painting, and formalism—the beauty and purity of surface, texture and materials."[39]

The energy of Zakanitch's odd palette of pinks and purples, his use of wallpaper colors that seemed at first so startling soon won many converts among collectors to the decorative. The artist showed his decorative paintings as a body of work first in one-person shows at the Holly Solomon Gallery in 1977 and then at the Robert Miller Gallery in 1978. Writing about the Robert Miller exhibition, the artist Paul Brach observed that Zakanitch had no camp, no "this is so bad it's good" attitude toward his subject matter, that a painting such as Zakanitch's 8 × 12′ *Elephant Rose* "is both gorgeous and oppressive. There is no rest from the action of the paint and the lush hot color is not just a convenient format for a rich juicy painting but literally a floral decoration enlivened and elevated by paint."[40] The next year Zakanitch began work on a group of *Trellis* paintings, works in which white diagonal lines underpin the floral profusion. A work such as *Venus Trellis,* a triptych measuring 88 × 234″, with no literal resemblance to Jackson Pollock's long wall paintings, nevertheless does call them to mind. Zakanitch's *Venus Trellis* is lush, with the paint seemingly moving forward to almost hang off the canvas, and it has a rather studied rhythmic pattern in contrast to Pollock's work, which is a record of physical gesture and calligraphic line. The scale, though, is in keeping with the older painter's ambition, and in terms of size and physicality, Robert Zakanitch is painting about art's ambition, is making works that transform the decorative impulse into an aggressive, unavoidable painting statement.

Robert Zakanitch, Mary Grigoriadis, and Valerie Jaudon are all Decorative artists concerned with formal painting problems, with using pattern as subject matter in order to introduce new issues into the painting dialogue. Whereas Zakanitch took his ideas of patterning from books of linoleum patterns of the fifties and from woodcuts, prints, and wallpaper samples, Mary Grigoriadis and Valerie Jaudon invent their own patterns; Jaudon's come from the patterning of Islamic and Celtic traditions, while Grigoriadis uses Byzantine church icons as a starting point. Both Grigoriadis

and Jaudon use layers of paint, literally building up and out from the canvas. Both work with flat surfaces, using light to achieve unexpected shifting depth. Jaudon's paintings of 1982–83, while maintaining their earlier pattern structuring, achieve a new kind of dimensionality, of depth perspective, through the artist's introduction of different color elements.

Mary Grigoriadis was born in New York City and earned the B.A. degree from Barnard College and the M.A. degree from Columbia University. She believes that, besides the work of the abstract painter Paul Feeley, her chief visual influences were the icons in the Greek Orthodox church she attended as a child, and that all of her current paintings stem from childhood visual experiences. The paintings themselves are the end products of a complex working process somewhat akin to that of the twelfth- and thirteenth-century icon makers, who painted in a thin film on highly reflecting gold surfaces which became halos and backgrounds, making their figures appear literally lit from behind. Mary Grigoriadis's rows of circles, squares, boxes, yellow triangles, and blue ribbon shapes, with ornamental circle and stripe borders, are painted so thickly as to literally step out as they move up, down and across her canvases in paintings such as her 1975 *Rain Dance* [63] or the 1978 *Pegasus.* The sense of claustrophobia in Grigoriadis's painted surface is relieved by the few raw linen spaces that introduce another kind of light into the painting, a quiet, almost meditative light among the noisy patterning activity. According to a statement made by the artist in 1977, her works "are a paean to beauty, opulence and order."[41] This order, like her patterning, is achieved in a way peculiar to Grigoriadis. Working on square canvases of uniform 12 × 12″ and then 66 × 66″ dimensions, Grigoriadis "first puts down layers of white acrylic gesso to protect the linen, then layers of oil paint which she sands down to make them adhere to each other. The colors grow progressively darker as the surface thickens until after eight to ten layers Grigoriadis has her final color combinations worked out. She then outlines all her forms in black acrylic ink to make them stand out from the linen and sprays the entire surface with acrylic varnish. The unpainted areas then become the light source, a moving 'other' surface."[42] The artist's work included in the "Pattern Painting at P.S. 1" exhibition was described by Carrie Rickey as one whose "paint quality and thickness has a chewy delectability which, juxtaposed against the rawness of their unadorned backings, produces a tension between bareness and pattern."[43]

Mary Grigoriadis had her first one-person show at the A.I.R. women's cooperative gallery in SoHo in 1972, which consisted of rather simply structured, thickly painted geometric paintings. By her 1975 solo show, the work had developed into her current heavily patterned paintings, which she described as "a series of secular icons." Besides participating in numerous Decorative group shows, from 1976 through 1981, she has had one-person shows at the A.I.R. Gallery, the O.K. Harris Gallery and the Helen Schlien Gallery in Boston.

[63] Mary Grigoriadis. *Rain Dance.* 1975.

"As far back as I can remember," Valerie Jaudon said in 1979, "everyone called my work decorative, and they were trying to put me down by saying it. Attitudes are changing now, but this is just a beginning."⁴⁴ Valerie Jaudon, born in Greenville, Mississippi, was educated at the Memphis Academy of Art in Tennessee, the University of the Americas in Mexico City, and the St. Martins School of Art in London, where she did graduate work in painting. Her paintings such as *Jackson* [64] in the "Ten Approaches to the Decorative" exhibition were described by the critic Jeff Perrone as "monochromatic copper on unprimed canvas which restricts the complex-

ity of her design to a linear figuration. . . . It is shiny, reflective unnatural color, the color of things which are nonfunctional or decorative."[45] Jaudon had her first one-person show at the Holly Solomon Gallery the next year, where she exhibited work "characterized by a complicated use of interlacing forms based on Islamic and Celtic sources: ribbon-like shapes pass over and under each other to create a lively complex shape."[46] These 1977 paintings were about line moving in and out, about decorative mural space with no top and bottom. In 1978 Jaudon designed a 22 × 90′ mural for the ceiling of the Insurance Company of North America building in Philadelphia, which consisted of a maze of delicately indicated forms on a creamy blue ground. Jaudon started out as an abstract painter and was interested in Conceptual ideas, but decided not to deny the decorative aspects of abstraction, which had been the attitude of most painters in the sixties, but instead to embrace them. Her 1975–79 paintings had no surface thickness, but were about flatness and symmetry, employing repetitive patterns as a rhythmic device, as a way of expressing movement through their interlocking forms. These paintings were executed in such non-colors as bronze and silver, in contrast to her recent thickly painted three-color works that refer to illusionistic architectural wall painting. Her 1983 painting *Canaan,* for example, is a 92 × 130″ canvas with oil and gold leaf, painted in red, black, and gold which, with its architectural dome/door shapes, is a painting concerned with deep space. A smaller work, *Saris,* 80 × 80″, done in red and aqua mosque-pattern forms on a blue background, seems to project forward even while moving back on its seemingly shifting blue ground. These paintings, shown at the Janis Gallery in New York, indicate that Valerie Jaudon is beginning new investigations into the intricacies of making paintings from schematic patterns, and is finding new meanings in working with flat and deep space.

There were many, many other artists working in the decorative mode between 1976 and 1983. The sculptor Ned Smyth very early began showing his cement palm trees in decorative arrangements that were not Moorish but that owed a lot to ersatz Moorish- and Mediterranean-inspired southern California architecture. Thomas Lanigan Schmidt made kitsch religious icons out of aluminum foil as well as aluminum foil/mixed media environments which included crinkled aluminum mice and/or rats. By 1978, the crossover between Decorative Art and high fashion, however, started to become a little confused. "What happened to the decorative's other aspects, its sources and beginnings in patterns and the decorative crafts of third world cultures? This year (1980) these aspects almost disappeared under a wave of environments which at best seemed a witless reworking of Whistler's *fin de siècle* room decorations. Many artists buffeted by pluralism's conflicting pressures, by formalist concerns with color and light and by feminist emphasis on crafts, for example, finally settled for a kind of high fashion Victorian nostalgia."[47] Meanwhile, Carrie Rickey,

[64] Valerie Jaudon. *Jackson.* 1976.

a staunch defender of the movement, argued decoration now had another dimension —utility.[48] This "utility," however, took the form of bead curtains and glass gazebos, works which exuded the sensuality of money rather than any aesthetic ideas. While the artists who had begun Pattern painting, like Valerie Jaudon, Robert Zakanitch, and others, were finding new areas to explore within its framework, decorative energy in a general art-world sense had more or less vanished. Like Pop and Minimal Art before it, by 1981 the Decorative Art movement had become part of art history.

NOTES:
PATTERN PAINTING AND DECORATIVE ART

1. Holliday T. Day, *The Shape of Space: The Sculpture of George Sugarman,* exhibition catalog, Joslyn Art Museum, 1981, p. 61.
2. John Perreault, "Issues in Pattern Painting," *Artforum,* Nov. 1977, p. 33.
3. John Perreault, "The New Decorativeness," *Portfolio,* June/July 1979, p. 46.
4. See Chapter 3, "Art and Politics."
5. Judith Bettelheim, "Pattern Painting: The New Decorative, A California Perspective," *images & issues,* March/Apr. 1983, p. 32–36.
6. The show opened November 14, 1977, and ran through December 4, 1977.
7. Conversation with Miriam Schapiro and author, August 1983.
8. Holliday T. Day, *op. cit.,* p. 57.
9. Artist's statement in Janet Kardon, *Decorative Impulse,* exhibition catalog, Institute of Contemporary Art, University of Pennsylvania, Philadelphia, 1979, pp. 34–35.
10. Holliday T. Day, *op. cit.,* p. 61.
11. Amy Goldin, "The Sculpture of George Sugarman," *Arts Magazine,* June 1966, pp. 28–31.
12. Amy Goldin, "Beyond Style," *Art & Artists,* Sept. 1968, pp. 32–35.
13. H. H. Arnason, *Stuart Davis,* exhibition catalog, Walker Art Center, Minneapolis, 1957, p. 22.
14. Irving Sandler, "George Sugarman and Construction Sculpture in the Sixties," in Holliday T. Day, *op. cit.,* p. 78.
15. Author's conversation with George Sugarman, April 1983.
16. Jeff Perrone, *Do Not Throw a Stone at Mouse and Break Precious Vase,* exhibition catalog, Loch Haven Art Center, Orlando, Florida, 1983, p. 10.
17. See Chapter 3, "Art and Politics."
18. Linda Nochlin, "Feminism and Formal Innovation in the Work of Miriam Schapiro," reprinted and expanded from *Arts Magazine,* Nov. 1973, in *Miriam Schapiro, a Retrospective: 1953–1980,* exhibition catalog College of Wooster, Wooster, Ohio, 1980, pp. 23–24.
19. Jeff Perrone, "Approaching the Decorative," *Artforum,* Dec. 1976, p. 30.
20. Miriam Schapiro, "How Did I Happen to Make the Painting *Anatomy of a Kimono?*" in Thalia Gouma-Peterson, *Miriam Schapiro, a Retrospective: 1953–1980,* pp. 28–29.
21. Jeff Perrone, "Approaching the Decorative," p. 30.
22. *Ibid.,* p. 29.
23. Joyce Kozloff, statement in *Name Book 1, Statements on Art,* N.A.M.E. Gallery, Chicago, 1977, p. 65.
24. Corinne Robins, "Joyce Kozloff," *Arts Magazine,* June 1976, p. 5.
25. Ruth K. Meyer, *Arabesque,* exhibition catalog, Contemporary Arts Center, Cincinnati, 1978, p. 8.
26. Carrie Rickey, "Art of Whole Cloth," *Art in America,* Nov. 1979, p. 80.
27. Roberta Bernstein, "The Joy of Ornament: The Prints of Robert Kushner," *The Print Collector's Newsletter,* Jan./Feb. 1981, p. 194.
28. Ellen H. Johnson, ed., *American Artists on Art from 1940 to 1980* (New York: Harper & Row, 1982), p. 253.
29. Wendy Perron, "Concepts in Performance," *SoHo Weekly News,* Thursday, March 28, 1976, p. 19.
30. Ellen H. Johnson, *op. cit.,* p. 253.
31. Janet Kardon, *op. cit.,* p. 26.
32. Douglas Blau, "Kim MacConnel," *Arts Magazine,* May 1980, p. 11.
33. Janet Kardon, *op. cit.,* p. 20.
34. Patricia Stewart, "High Decoration in Low Relief," *Art in America,* Feb. 1980, p. 97.
35. Ellen H. Johnson, *op. cit.,* p. 250.
36. Janet Kardon, *op. cit.,* p. 35.
37. John Perreault, "The New Decorativeness," *Portfolio,* June/July 1979, p. 46.
38. *Ibid.,* p. 29.
39. *New Decorative Works,* exhibition catalog, Loch Haven Art Center, Orlando, Florida, 1983; artist's statement, p. 22.
40. Paul Brach, "Robert Zakanitch at Robert Miller," *Art in America,* May/June 1978, p. 116–17.
41. Corinne Robins, *Walls of the 70s* exhibition catalog, Queensborough Community College Gallery, Catalog No.4, 1982, p. 4.
42. *Ibid.*
43. Carrie Rickey, "Pattern Painting," *Arts Magazine,* Jan.1978, p. 17.
44. John Perreault, "The New Decorativeness," p. 49.
45. Jeff Perrone, "Approaching the Decorative," p. 28.
46. John Perreault, "The New Decorativeness," p. 49.
47. Corinne Robins, "Late Decorative: Art, Artifact and the Ersatz," *Arts Magazine,* Sept. 1980, p. 150.
48. Carrie Rickey, "Of Crystal Palaces and Glass Houses," *The Village Voice,* Apr. 14, 1980, p. 77.

6
Representation

Super Realism, New Image Painting, and "Bad" Painting

The desire for the "real thing," for an art that looks like what we see, for an art of resemblance, is a recurring phenomenon. Each decade searches for its own kind of realism, seeks to discover a new way of seeing that will become a contribution to the tradition of representation in the history of art. In short, each new realist wave is an attempt to make realism in some way contemporary and coherent in terms of modernist and post-modernist art. Attempts at creating a new realism began at the end of the 1960s, with a series of shows beginning with the "Realism Now" exhibition of twenty-five artists at Vassar College in 1968, followed by the show "Aspects of a New Realism" at the Milwaukee Art Center in 1969 and the "22 Realists" survey at The Whitney Museum in 1970. In 1971, Ivan Karp, proprietor of the O.K. Harris Gallery in SoHo, gave a lecture on the work of his own group of Photo-Realist painters to an audience of traditional realist artists at the Alliance for Social Progress in downtown New York. The traditional realist painters were outraged, while Karp clearly enjoyed the audience's highly vocal protests at the slides of the work of Richard Estes, Ralph Goings, and others. What the new realism in the 1970s was to be about, however, was finally clarified in the 1972 exhibition entitled "Sharp Focus Realism" at the Sidney Janis Gallery. As the critic Harold Rosenberg reminded his *New Yorker* readers,[1] the Janis "Sharp Focus Realism" exhibition followed almost ten years to the month the dealer's 1962 "New Realist" show in which Janis introduced work by Pop artists to the general public. The "new realism" of the 1970s, sometimes called Photo-Realism, sometimes Super Realism, differs from Pop Art in almost as many ways as it resembles it. Super Realism, or Photo-Realism, for the most part is based on photographic views of ordinary street scenes and/or landscapes and cityscapes. It contains few references, and most of them scenic, to the advertising and commercial imagery that was the subject matter of Pop Art. In painting, Photo-Realism's subject

matter is reality as seen and altered by the focus of the camera lens; in sculpture, the realists deal with reality as represented and made more "real" via lifesized figures resembling store mannequins. And even the Janis exhibition, in this respect, proved to be a potpourri, mixing *trompe l'oeil* artists such as Stephen Posen and Marilyn Levine with Photo-Realist painters. Most of the essential artists of the movement, however, were presented; the single exception was Chuck Close, who declined to participate and who since that time has become probably the most popular of all the modernist Photo-Realists. In any case, despite a few minor discrepancies, the Janis "Sharp Focus Realism" exhibition established Super Realism as an official art movement. About the same time, *Arts Magazine* published Ivan Karp's essay/assessment of the movement, titled "Rent Is the Only Reality, or the Hotel Instead of the Hymns."[2] A few months later, *Art in America* published a "Photo Realism Special Issue," containing interviews with twelve Photo-Realists along with a lead essay by William Seitz entitled, "The Real and the Artificial: Painting of the New Environment."[3] Two years later, in what turned out to be a more or less retrospective survey, *Arts Magazine* devoted its February 1974 issue to writings about Super Realism. Henry D. Raymond's lead essay in the issue argued that Super Realist artists "have two sources for self-esteem. They have broadened the base of the buying public while being taken seriously by the art world. They have their cake and also eat it. They make visual embodiments of societal values. Their world is cool and it is beyond freedom and dignity. They share their public's mistrust of the instinctive and the spontaneous and the messy. They lust after specificity and certitudes. They offer a reassuring sense of craftsmanship—to themselves and their audience. . . . They paint only things. Their culture believes in things and little else."[4]

The two exceptions to the above are the artists Chuck Close and Duane Hanson, in that Close deals with representations of photographs of people—photographs of himself and personal friends—while Hanson makes true-to-life mannequin sculptures of Middle America people. Both these artists' popularity in part stems from the *trompe l'oeil* aspect of their work—and the exhibition of skill involved on the part of both Close and Hanson in making their representations seem to come almost unbearably close to their model subjects. Close, however, in dealing with photographs of individuals—by painting his particular, eyes-forward, frontal "talking heads" photographs—is at once the more abstract and the more modernist of the two men. As John Perreault has observed, "the system is so emphasized and clarified in Close's mug-shot portraits that unlike in the work of most other artists called photo-realist, it becomes the dominant content verging upon the conceptual."[5] Close's approach, as described by the artist himself, is totally systemic, even to his devising of a seat mounted on a Big Joe forklift so he can move up and down without dripping paint while working on his 9-foot photo-paintings. Duane Hanson's sculptures, also achieved through a step-by-step work process, aim at absolute replication of both scale and accoutre-

ments; their reality content in terms of choice of subject matter can be taken as a form of social content. Because what matters is the thing itself, bereft of any aesthetic element, and because the recognition factor is both the beginning and the endpoint of Hanson's sculpture—in contrast to Close's paintings—Hanson's work seems to remain wholly apart from contemporary art issues.

"I didn't set out to make New Realist paintings. My paintings are a result of certain self-imposed restrictions that I set up for myself," Close explained in a 1972 interview;[6] almost a decade later he added that he had "wanted to make large aggressive confrontational images that knock your socks off . . . and also I wanted to rip the photo image loose from its normal context."[7]

Born in New York City, Chuck Close earned the B.F.A. degree from the University of Washington in Seattle in 1962, and the M.F.A. degree from Yale University in 1964. By that time, he was painting in an Abstract Expressionist style, making work which he later described "as looking like someone else's stuff."[8] As a means of getting away from gestural brush strokes, which had become a cliché, Close began to impose new limitations upon himself. "Using the photograph," he has explained, "was a way of forcing my hand to move in a different way. And with the photography I became aware that there were real issues in painting to deal with." The use of the photo image became a freeing device, allowing Close to concentrate on problems of shape, surface, texture, and detail. Where Close leaves painting conventions behind is in his use of the closeup, his transformation of the human face into a nine-foot edifice on which he can zero in to examine the details of the shape of a nostril or the tip of an eyebrow. Also, because of the gigantic scale of the paintings, we are made aware of the fact that we ordinarily accept photographs of people as absolute representations of the way they really look. Blown up to 9 feet, the photograph takes on a mythic quality. As William Dykes has pointed out, the flat photographic image in our culture is accepted as the "real." And Photo-Realism, he has written, "is essentially critical. Its artists do not present photographs as a more truthful way of seeing but as a means of understanding more about what we do see. It is . . . not only unconcerned with realism, it is actively concerned with artificiality."[9]

Chuck Close made his second painting from a photograph, using himself as the subject, in 1968. His first, begun in 1967, was a 22-foot horizontal painting of a nude, and Close was unhappy with the body proportions, with the size of the foot and the hand which finally emerged on that scale. He was, he has explained, interested in a bigger scale and, wanting greater impact, decided to focus on one part of the body, a picture of just his head. After taking a picture of himself, head-on, he selected a $9 \times 7'$ canvas and went to work using the traditional Renaissance technique of overlaying the photograph with a grid and then, unit by unit, transferring the image in pencil to his white gessoed canvas. Next, using an airbrush with a mixture of black acrylic paint, he began to spray in the image roughly, working from top to bottom.

[65] Chuck Close.
Keith. 1970.

The painting took four months to complete and resembled a colossal photograph. It was only as a viewer came closer that Close's face changed into a landscape of painting details with skin pores and wrinkles turning into brush strokes. Pleased with both the process and the result, Close immediately set to work on more portraits. At the end of 1969, he joined the Bykert Gallery in New York, and one of his newly finished large heads was included in the Whitney Annual of 1970. The artist's first one-person show at the Bykert Gallery consisted of seven 9-foot paintings of heads of himself and his friends, with names such as *Keith* [65] as titles of the paintings. Close chose his friends as subjects and continues to take their pictures himself because "if you're going to spend several months painting a face," he has explained, "it makes the job easier if it belongs to someone you care about."[10]

[66] Chuck Close.
Self-Portrait. 1976–77.

In April 1970, after completing nine black-and-white 9-foot paintings, Close began working from a color transparency of his friend Kent Floeter. Close's approach to color was to simulate as best he could the photo-mechanical process by which color reproductions are made. Simulating the red, blue, and yellow color separations that go into making a color reproduction, Close limited his palette to these three colors and painted three one-color paintings on top of each other to achieve similar results. But whereas Close had been able to complete a black-and-white photo-portrait in four months, the 9-foot color painting required fourteen months to complete.

Both Chuck Close's black-and-white Photo-Realist heads and the later color paintings proved to be enormously popular. Following a series of one-person shows at the Bykert Gallery, Close was included in the international Documenta exhibition

in Kassel, Germany, and a one-person exhibition traveled to museums around America. In 1977 Close joined the Pace Gallery in New York; a full-scale retrospective of his first twelve years of painting was organized by the Walker Art Center in Minneapolis in 1980, which traveled to the St. Louis Museum, the Museum of Contemporary Art in Chicago, and The Whitney Museum of American Art from 1980 through 1981 [66].

"The man in the shirtsleeves near the gallery entrance was Sidney Janis, except he was too heavy and relaxed and, besides, he was made of plastic by Duane Hanson," Harold Rosenberg began his description of the 1972 "Sharp Focus Realism" exhibition. "Through the crowd, I saw Janis flit into his office, but he looked too tan and a bit more wizened than I remembered, as if he had been modeled by John De Andrea, creator of two nubile nudes of painted polyester and fiberglass in another part of the gallery." And, Rosenberg admits, "it was difficult to tell which was the real Janis because "nothing can match super realistic art in subverting one's sense of reality."[11] Thus, experiencing a Duane Hanson work is at the opposite pole from confronting a Chuck Close portrait, whose colossal scale sets it apart from that kind of *trompe l'oeil* speculation. The only link is that both artists begin with a human image: Close with photographs of actual faces, and Hanson with the faces and bodies of actual people. While Chuck Close feels no kinship with the earlier generation of Pop artists and not too much relationship to other Super Realists, Duane Hanson's introduction to the sculpture of George Segal was crucial to his development toward figurative realism. Pop Art "certainly spurred me on," he has said. He liked George Segal's plaster figures, but felt the work was too mechanical, too austere and impersonal.[12] Hanson was forty years old in 1965 and was teaching art and sculpture at Miami Dade Community College. Born in Minnesota in 1925, Hanson had earned an M.A. degree from the Cranbrook Academy of Art in Michigan in 1951 and then had spent some time in Germany in the early fifties, learning about polyester resin and Fiberglas. Until the mid-sixties, he worked in a formalist abstract mode which he was never comfortable with, because he felt it was too remote from people and didn't change or touch their lives. In 1965, about the same time he became aware of Pop Art, Hanson began reading newspaper stories about Cuban doctors performing illegal abortions in Miami on women who came from all over the United States, many of whom lost their lives or became ill as a result. Abortion became both the subject and the title of Hanson's first figurative sculpture, which was a realistic depiction of the body of a young pregnant woman lying dead on a table. A number of Hanson's friends liked the work. Others called it disgusting. Still more people were outraged when Hanson entered it in the 1966 Annual Sculptors of Florida exhibition. The following year, the artist made a piece he titled *Welfare 2598,* consisting of a mannequin figure of a gaunt corpse. From 1967 through 1970, Hanson continued to make pieces with titles such

us *Hard Hat, Riot,* and *Gangland,* which dealt with human situations and which were meant to be provocative social statements.

In 1968, Hanson sent slides to the Castelli Gallery, to the attention of its then director Ivan Karp, who was immediately interested but warned that the sculpture's violent subject matter would make the work difficult to launch. The curators at The Whitney Museum, however, were immediately interested in the price of Hanson's sculpture *Accident,* and Ivan Karp went to Miami to meet Hanson in December 1968. Karp persuaded the artist to move to New York, promising him a one-person show and that he would make him rich and famous.[13] By 1969, New York critics were praising Hanson's *Riot* as one of the best works in that year's Whitney Annual. Hanson had moved to New York, and was hard at work on a three-figure work, *Bowery Derelicts*, for his first solo exhibition at Ivan Karp's O.K. Harris Gallery. In 1972, the sculptor won international acclaim when his work was included in the Documenta 5 exhibition in Kassel, West Germany. In 1973, Hanson moved back to Florida, and continued to produce work for his third one-person show at O.K. Harris.

From 1973 on, Duane Hanson's figures have all been narrative rather than social/expressionist. The figures he makes, for the most part, are of middle-class Americans, mixed with a few working-class types. Making the molds on the actual body, he says, takes less than three hours. After a mold is finished, cleaned, and coated with a thick gelatinous substance to prevent sticking, successive layers of flesh-colored polyester resin are poured in, which are immediately reinforced with Fiberglas. When the separate parts of the body are assembled, the artist begins the painting process. "When I started to paint them," Hanson has explained, "I used to mix a little paint in the resin. Then I would go over that with a little color and make the highlights. I used acrylic at first . . . then went to oil paints. . . . The main thing is the flesh."[14]

Today, Duane Hanson's figures, in their store-bought clothing and lifelike settings, are almost always being mistaken for the real thing. One of the most startling of these works was the artist's *Security Guard* [67], in Hanson's large traveling exhibition, which, starting at the Wichita State University Museum October 6, 1976, toured to museums in Kansas, Nebraska, Iowa, Oregon, California, and four other states before reaching The Whitney Museum for a two-month stay from February 8 through April 16, 1978.

As Harold Rosenberg has pointed out, "The interval during which a painting is mistaken for the real thing or a real thing for a painting is the triumphant moment of *trompe l'oeil* art. The artist appears to be as potent as nature if not superior to it."[15] At the Whitney's Duane Hanson exhibition, visitors and Hanson sculptures seemed almost interchangeable, to fall in and out from life. About John De Andrea's figures at the Janis show, Harold Rosenberg complained that precisely "to the extent the works seem to be made of flesh, they are a bit grisly in their prettiness" and suffer

[67] Duane Hanson. *Security Guard.* 1975. Collection Palevsky.

from "a failure to be alive."[16] John De Andrea's work differs from Duane Hanson's in that De Andrea makes mostly nude figures, and in their nudity the figures seem to be somehow smaller than life. Also, the surfaces of his mannequins simulate flesh, but don't have the help of clothing to further the illusion.

Born in Colorado in 1940, De Andrea began working with the figure in 1962 while still in school at the University of Colorado in Denver. He began, he has said, the same way George Segal did, using mannequins and bandages soaked in plaster of Paris. Like Segal and Hanson, De Andrea starts with a real figure, treating color "as loosely as possible. There are so many things going on under the skin . . . that if you try to control it too much, you can't get as much variation. In the underpainting I

even treat the extremities, especially the legs, like something containing blood."[17] De Andrea had his first one-person show at the O.K. Harris Gallery in 1970, was included in the Documenta 5 exhibition, and has had numerous one-person shows. He believes in being as real as possible, in "wanting his sculptures to breathe."[18] But this, according to the critic Joseph Mashek, is the problem with the work: "in a real room, the feeling that these figures are altogether inanimate is actually the source of their disappointment as well as their fascination: we feel the full impact of the fact that unlike real men, women and works of art, these objects lack souls."[19] John De Andrea claims, however, "I always work toward some idea of beauty, and I thought that if nothing else comes of this at least I'm going to make a beautiful figure. . . . I set up my own world, and it is a very peaceful world—at least my sculptures are"[20] [68].

In contrast to both De Andrea's and Hanson's work, the world of Photo-Realist

[68] John de Andrea. *Man and Woman Leaping* 1971. Collection Galerie Nothelfer.

painters such as Richard Estes, Robert Bechtle, and Robert Cottingham is more impersonal and indirect; their work consists of painted images of photographs of images of things and places. The human figure appears only in Bechtle's painting, as an occasional, secondary image. All three men deal with camera views of outside urban scenes. The Photo-Realist Audrey Flack paints souvenir objects, art icons, and intimate still-life objects, as seen through her particular soft-focus camera slide lens. In contrast to these four artists, the work of Malcolm Morley begins with a souvenir postcard, depicting a group of vacationers, for example, or a famous scenic spot, but this postcard view or photo image is only a part of his subject matter, and never the work's entire content. In the mid-1970s, Morley began mixing photo representations with iconic animal subject matter; thus to this day he remains an important artist standing a little apart from both Pop and Photo-Realist painting.

According to one critic, "The Photo Realist replaces the artist's personal interpretative vision with the recording of visual fact: he replaces the subjectivity of the artist's eye with the objectivity of the camera lens."[21] And one of the movement's principal promoters, Ivan Karp, has asserted, "the categorical clarity in the works of Richard Estes and Ralph Goings may be taken for what it seems: totally noninterpretative, matter-of-fact transpositions of 35 mm color slides."[22] These views, however, do not necessarily coincide with those of the Photo-Realist artists. According to Ivan Karp, "the photograph intercedes between the subject and the art of describing it and serves to cancel 'content' and emotional response,"[23] which would seem on more than one level to be in flat contradiction to the way the artists themselves describe their work processes. Chuck Close says he believes his paintings are in part a critical examination of the accepted fiction of the photographic image representing our normal way of seeing. And, rather than "making totally matter-of-fact transpositions of 35 mm color slides," the painter Richard Estes has said, "I am not trying to reproduce the photograph. I'm trying to use the photograph to do the painting. The great thing about the photograph is that you can stop things—this is one instant. . . . The idea occurs and is involved with the photograph. But there are a lot of things in painting that you have more control over than you have in a photograph. In a painting you make this line a little stronger, change the depth, things like that. I try to make it a little clearer. . . . Sometimes a photograph, if you really examine it, can not be very realistic. It doesn't really explain the way things really are or how they really look. There is no consistency in the way it flattens out. It's not organized."[24]

Richard Estes, who has been described as among the best of the Photo-Realist painters,[25] was born in Evanston, Illinois, in 1936, and he graduated from The Chicago Art Institute in 1956. A figurative painter in school, he began using the photograph to paint from after he graduated, in part influenced by Pop Art's expansion of the use of secondary images as subject matter for painting, and partly because he couldn't afford to hire models to pose for him. Estes says he arrived at his type of painting

almost by accident, inspired by photography in general and in particular by the work of a 1910 French photographer who took numerous pictures of window reflections. One of the things that sets Richard Estes's paintings apart to this day is the artist's use of reflection, the way he paints reflected images on glass and metal surfaces, in works such as his 1968 *No. 2 Broadway* and his 1969 *Escalator* [69] and the 1973 *Paris Street* paintings. The artist transposes these reflections of objects and streets in store windows into compositions of brightly colored verticals and horizontals that become immediately recognizable as "Estes" scenes. He has explained, "I only eliminated the garbage on the street because I couldn't really get it to look right,"[26] adding that in photographs things never look as dirty as they really are. At times, Estes's color seems more akin to that of the color of certain Technicolor movies and snapshots from the early forties than to "natural" urban light. Estes represented the United States in the 36th Venice Biennale, and was included in Documenta 5 in 1972 in Kassel. He lives and works in New York, a city whose natural light is much less white and rarely as sharp as the light in his canvases. The artist uses the camera, he says, to give specificity, color, and sharp-focus veracity to urban scenes he often finds ugly. "I don't

[69] Richard Estes. *Escalator.* 1969. Neumann Family Collection.

enjoy looking at the things I paint, I enjoy painting them because of all the things I can do with it," he has said. "It's funny, all the things I was trained to paint—people and trees and landscapes and all that—I can't paint. We're living in an urban culture that never existed even fifty years ago."[27] Estes seems very much the urban artist painting pictures of reflections that reflect this very contemporary landscape.

The same urban culture—somewhat more populated—is the subject matter of Robert Bechtle's Photo-Realist works. Bechtle, born in San Francisco in 1932, and a graduate of the California College of Arts and Crafts in Oakland, makes paintings whose light, according to one writer, is the peculiar white light of the Bay area—a light that washes over and flattens out things.[28] Bechtle's paintings of immaculate streets, of automobiles parked on streets and in front of supermarkets, of a photo of a family posed in front of a car (titled *'61 Pontiac*) are both more personal than Estes's and closer to a conventional snapshot image, and also more redolent of Middle America. Robert Bechtle paints the automobile, and his people and street scenes are all for the most part centered on a specific car, as in the 1971 painting of a car in front of a restaurant titled *'64 Valiant* [70].

Robert Bechtle, who has had one-person shows at the San Francisco Museum

[70] Robert Bechtle. *'64 Valiant.* 1971. Collection Richard Brown Baker.

of Art in 1959, 1964, and 1967, and whose work was also included in the 1972 Documenta 5 exhibition, looks at photography as a tool to help him paint things he couldn't paint otherwise. "You can't very well paint a car by setting your easel up on the street for three months. But of course the use of photographs starts to affect the way you think and see too," he admits.[29] Bechtle is always curious to see photographs of his paintings—to see whether the painting will go back to the original photo image that inspired it. "The reproduction or photograph of the painting has nothing really to do with the painting," he has said. "The painting can only be seen as a painting when you are in its presence."[30] Bechtle, like Richard Estes and Robert Cottingham, is concerned with stopped time, but for all three artists this stopped time of photography is only a means—the physical presence of paint and canvas is the crucial thing in creating a work of art.

Robert Cottingham, a graduate of the Pratt Institute in Brooklyn, worked in advertising for a few years before he began making his paintings of marquee signs. Cottingham, who had his first show at the Molly Barnes Gallery in Los Angeles in 1968 and was included in the 1972 Documenta 5 exhibition, takes his own photographs, doing part of the "composing of the painting" with the camera. Afterward, he makes sketches from the photographs, editing them in terms of what's extraneous and what he wants to add. "Most of the signs are from the thirties and forties," he has said, but he claims he is not concerned with nostalgia. They just happen "to be the most interesting signs around—the ones with the most texture, the most activity."[31] Cottingham is not concerned with focus, but with the edges and surface of the painting—the edges where two colors meet. He believes his paintings, such as *Discount Store* and the 1971–72 *Roxy,* can say more about man than a direct painting of a man. He believes the presence of who put the sign up is implicit, and becomes a statement in itself. In terms of the cropping, the focus on thirties and forties Art Deco modernism, and the painting's dramatic angling, the viewer is left in no doubt about the artist's own admiration for his subject.

In his essay "Rent Is the Only Reality Etc." Ivan Karp described Audrey Flack "as one of a number of painters of technical ability who enliven the spectrum of hyperrealism. Flack . . . paints European shrines with a rich admixture of devotion, irony and calm detachment."[32] For Audrey Flack irony does not enter into the making or contemplating of such paintings as her 1971 *Jolie Madame* or *Macarena Esperanza.* She has described her first encounter with the Spanish statue this way: "When we arrived in Seville I saw this polychromed, life-sized, wooden statue of the *Macarena.* It's a great work of art; the carving on the face, the patina, the pink cheeks are utterly beautiful. . . . Then, another aspect of this sculpture that flipped me out was that since the seventeenth century people have been worshipping it. On her full-length robe they have pinned emeralds; they have put rings on her fingers, strung pearls around her neck . . . all that love has become attached to this statue and is part of its greatness.

. . . All that kitsch, all that love poured into it. That is not just kitsch and I don't want people to laugh at it. It might be cheap lace, but it is love lace."[33] And it is in this spirit that Audrey Flack painted her high-colored, glossy rendition of *Macarena Esperanza,* a work which to this writer is literally stunning in its garish vulgarity [71].

Audrey Flack, who was born in New York City and attended the Music and Art High School and Cooper Union, won a scholarship to Yale University while Josef Albers, the veteran abstract artist, was the school's dean; this was during the 1950s, when Abstract Expressionism was the major movement among New York artists. Nevertheless, Flack began as and remained a determined realist painter. It was President Kennedy's assassination in 1963 that moved her to paint *Kennedy Motorcade—Nov. 22, 1963,* using a newspaper photograph for reference. After this work, Flack made a series of paintings based on photographs of public figures. In 1969, while working on a commissioned portrait of Oriole Farb, then the director of the Riverside Museum, Flack decided to turn the photograph into a slide and project the slide onto her canvas as a way of saving time in scaling up her image. The process fascinated her. She became interested in linear mass and began to study how light comes through a slide, and the problems of translating that kind of light into color. Audrey Flack soon arrived at a translation process somewhat akin to that of Chuck Close's, but Close's paintings appear almost naturalistic next to the high-gloss surface of Flack's paintings. Flack, in fact, seems to take the retouched photograph and its effects as subject matter. Speaking of her 1971 *Jolie Madame,* Flack has said that when she painted the piece of glass it was so that you could see right through it, and that she painted the crystal beads in the work just the way light reflects on them.[34] Using a slide as a starting point, she first painted popular statues, a reproduction of Michelangelo's *David,* then the *Macarena Esperanza* with *Jolie Madame*—taking the myth of beauty involving highlighting such objects as perfume bottles, jewelry, glamor toys, and gambling tables as her subject matter. The glamor of these objects, as portrayed on slick magazine pages, is reiterated in Flack's work. Audrey Flack, who has been in numerous group exhibitions and had many one-person shows in the seventies, was also represented in the only New York museum survey of Photo-Realism, the "Seven Photorealists in New York Collections" exhibition put on by The Guggenheim Museum in 1981.

Malcolm Morley, who was born in England in 1933 and moved to New York in 1958, has never used a projector to make his paintings, even in the sixties, when he started with illustrations from magazines and travel brochures, which he scaled up in the traditional mural-technique fashion, and finished by painting a white border around them as part of the painting. Works such as his 1966 *Ship's Dinner Party* and 1968 beach scenes from brochures seemed to have a social impact similar to that of the early Pop works of Tom Wesselmann and Claes Oldenburg. Morley's use of Kodachrome scenes of happy vacationers as subject matter seemed laden with irony

[71] Audrey Flack. *Macarena Esperanza.* 1971.

in the socially conscious sixties. As we look back now, the artist appears to have worked alongside Photo-Realism, picking up techniques from it, from Pop Art, and from the history of academic mural painting. When Morley arrived in America in 1958, Jasper Johns and Robert Rauschenberg's proto-Pop works were introducing new figurative ideas into American art. The English artist, who had graduated from the Royal College of Art in London, was during these years an abstract painter who came to New York because of the work of de Kooning and Barnett Newman. It wasn't until 1964 that Morley began making his ship series, paintings of ships which he could see docked on a New York pier outside his window—of Atlantic liners like the one he had come to the United States on six years earlier. But after a few paintings of actual ships, in 1964 Morley began painting ships, ship parties, and people on cruises as depicted in travel brochures. By 1968, he was also painting photo reproductions of commemorative postcards such as *Marine Sergeant at Valley Forge* and *Vermeer, Portrait of the Artist in His Studio,* in each case painting the image in the middle of the canvas bounded by a white border or frame to isolate it and make sure it was perceived as a painting of an image rather than as being a representation of the original image. Making art out of copies of art, he explained, "was like making art that couldn't be reproduced because it reverts to the subject it came from."[35] By 1970–71, however, Morley began introducing his own commentary, thus doing away with the fiction of painting an impersonal reproduction. The 1970 *Race Track* offers a painted rendition of a Kodachrome placard advertising a race track with the words "South Africa" printed beneath; very painterly brush strokes apply a red X across the face of the picture. Morley's 1971 painting of the cover of the Los Angeles Yellow Pages, worn, damaged, and weathered in a way reminiscent of the surfaces of paintings by Robert Rauschenberg in the late fifties, signaled the more personal, more painterly direction the artist was to take. Even in a work such as *New York City Postcard Fold-out,* done in 1974, the rendering of the card is no longer in the manner of sharp-focus realism, but has become softened and more painterly. In 1974, Morley began using his photographic images as part of the overall composition of his paintings, and by 1975–76 the images were executed in a completely painterly rather than photographic manner. In the second half of the decade, Morley freely combined realistic and iconographic subject matter, mixed his earlier art images and beach and landscape renditions, and made art history, animals, and objects all part of an integrated subject matter. In works such as his 1977 *Day of the Locust* and the 1978 *Mash* [72], the integrated subject matter is narrative and never without some underlying ironic social comment. Morley here has taken the tag ends of Photo-Realist imagery and has used them to make paintings that are very much about his and our current reality.

Malcolm Morley's development as an artist began with Abstract Expressionism, and his subsequent quasi-realist painting was in many ways a reaction to it. Philip

[72] Malcolm Morley. *Mash*. 1978. Museum of Contemporary Art, Chicago.

Guston was considered to be one of the original giants of the Abstract Expressionist movement. In 1962, Guston was given a retrospective exhibition by The Guggenheim Museum that covered twenty-five years of the artist's work—from his representational canvases of the early 1930s through the Abstract Expressionist painting, starting in the early fifties, and up to the mature Abstract Expressionist works of the mid-fifties to early sixties. The show included many examples of Guston's paintings of black, red, and soft gray squares, of his delicate moving light forms coming forward from the canvas surface. The paint stroke in the 1956 *The Dial* and his 1958 *Fellini* seemed to convert the works into a wall whose presence became unavoidable. The Guston retrospective traveled throughout the world. But "I got sick and tired of that purity, wanted to tell stories,"[36] Guston said, and for two years, from 1966 until 1968, he didn't paint at all. In 1966, he began making drawings. "One day in the house I would take up a bunch of pure drawings I had just done, feel good about them, think that I could live with this. And that night, go out to the studio to the drawings of objects —books, shoes, buildings, hands—feeling relief and a strong need to cope with tangible things. I would denounce the pure drawings as too thin and exposed, too much 'art,' not enough nourishment. The next day, or the day after, back to doing the pure constructions and to attacking the other. And so it went,"[37] he has said. In 1966, at the age of fifty-five, Guston began painting images of a cup, a light bulb, two shoes,

initially on small canvases, and in the next two years he completed the first group of his new-image paintings that were to influence a generation of artists thirty years his junior. The imagery in the first show of Guston's new figurative work consisted of comic-strip hooded Ku Klux Klan figures smoking cigars, making paintings of them-selves, and popping out of rows of bottles. "Like Babel with his Cossacks, I feel as if I have been living with the Klan. Riding around empty streets, sitting in their rooms smoking, looking at light bulbs," Guston said.[38] The paintings—done with heavy lines and a thick, impasto surface, with black lines adjoining red, blue, and green areas, which were the colors of Guston's early abstract paintings pressed into figurative shapes—upset most people who saw them. The 1970 show at the Marlborough Gallery in New York won the artist a host of negative reviews, led by Hilton Kramer, who entitled his *New York Times* article "A mandarin pretending to be a stum-blebum."[39] Among Guston's friends, only the critic Harold Rosenberg and the painter Willem de Kooning applauded the new work. Indeed, according to Roberta Smith, this 1970 show made Philip Guston for the first time in his life into "an underground artist."[40] But "underground" artists aren't given one-person shows at the Marl-borough Gallery, and David McKee, first at the Marlborough and afterwards at the David McKee Gallery, became one of Guston's strongest supporters, organizing a number of one-person Guston exhibitions throughout the seventies and helping with the mammoth retrospective of the new Guston work that was organized by Henry Hopkins at the San Francisco Museum in 1980.

Talking about his new imagery, Guston has said, "In 1970, I became a movie director."[41] Soon after, from the rough, cartoon-like Ku Klux Klan hooded figures, Guston moved on to making cartoon heads of himself, of his feet, of his hands holding cigars. The figurative style in which Guston worked echoed the newspaper cartoons of the thirties, for they were deliberately heavy-lined, rough-edged, and broad-humored. The line is a powerful and poignant describer of the image in the way Guston uses it to build up piles of shoes in his 1976 *The Pit* and to order feet and shoes in his *Green Rug* of the same year. A painting finished in 1980 depicted the artist's eyes with eyelashes like nails in the form of spreading sunbursts over and under them. Although the critic Clement Greenberg referred to de Kooning's and Guston's figurative work as "homeless representations," Guston continued in his new direction, making unabashedly narrative paintings telling "stumblebum" stories about life. The 1977 *Coat* painting, for example, describes Guston's feelings about "Guston as painter, Guston as diaspora Jew, Guston as overcoat."[42] By 1976, Guston had had his second one-person show at the David McKee Gallery, and his message had already been accepted by younger painters. Guston's paintings proved that painting need be neither decorative nor formal, that all kinds of images are available for serious art, and a generation of new-image painters had already begun following the older artist's lead, making paintings about people, about animals—making paintings that were and are, like Guston's, about their very personal selves [73].

[73] Philip Guston. *Feet on Rug.* 1978.

In 1978, two exhibitions, "Bad Painting" at the New Museum in January and "New Image Painting" at the Whitney in December, attempted to make a movement out of a group of widely idiosyncratic artists who were working with a recognizable image not in a realistic context, and who emphasized the narrative, verbal, and humorous possibilities inherent in figurative imagery. The Whitney show, with ten artists, was "a real loser that nevertheless featured excellent works by three totally unrelated artists, Joe Zucker, Neil Jenney and Nicholas Africano," John Perreault reported in the *SoHo News.* [43] As for the rest of the Whitney painters, such as Susan Rothenberg and Jennifer Bartlett, Perreault claimed they were included on the basis of the success they had already achieved in previous one-person shows. The "Bad Painting" exhibition, with fourteen artists, seemed to offer a somewhat more primitive and less literary approach to figuration. The painter Neil Jenney was, however, included in both exhibitions, and Jenney, together with Joan Brown and Charles Garabedian, were probably the New Museum's most outstanding artists—not counting the photographer and Conceptual artist/filmmaker William Wegman, who in fact doesn't make paintings and who, for reasons known only to the curator, was also included in the exhibition.

One of the paintings in the Whitney show was from Joe Zucker's *Land of Cotton* series, which are works based on romantic media images of a southern past. Zucker, born in Chicago and with an M.F.A. degree from The Chicago Art Institute in 1966,

[74] Nicholas Africano. *The Cruel Discussion.* 1977.

makes paint-soaked cotton-ball paintings that all tell stories, stories woven around the materials from which they are made. Zucker's *Paying Off Old Debts* of 1975, which was in the Whitney show, depicts a man guiding a wheelbarrow full of cotton. In Zucker's *Two Malay Pirates in the South Seas,* the coloring-book type of images contain just enough detail to be recognizable as they spread themselves across the quilt cloth story-telling work. Zucker has said, "The subject matter becomes a format for making paintings about material,"[44] and the material, Zucker's use of acrylic, cotton, and Roplex paint on canvas, is omnipresent. John Perreault has claimed that Zucker is more process- than narration-oriented. And Zucker is not concerned with the realities of cotton production; even though one of his paintings is titled *Boll Weevil,* it is the insect of song that Zucker's work deals with, in the same way that other legendary stories become the main concern of his subsequent paintings.

Neil Jenney shares with Joe Zucker a concern with Americana, verbal puns, and simplistic story material. Whereas Zucker employs thick cotton padding in his surfaces, Jenney, in works from 1969 through 1970, provides a heavy brush stroke surface. In the New Museum exhibition, Jenney's acrylic *Man and Machine* pictured a man standing beside a long automobile, while his *Here and There* (also done in 1969,

and included in the Whitney show) consisted of a fence separating a brushy earth and sky. His 1969 *Them and Us* presented two differently colored fighter planes, which are both funny and archetypal "boys'" images aswim in a brush-stroke background. Jenney, who was born in Connecticut in 1945 and describes himself as "self-taught,"[45] had his first one-person show of paintings at the Noah Goldowsky Gallery in New York in 1970. Both the Whitney and the New Museum chose work from this series for their exhibitions, rather than including the artist's later image work, which achieves a kind of Magritte-like precision, and in which the painting is sunk into heavy dark frames on which are painted descriptive titles such as "Melt Down Morning" and "American Urbania." In this 1971–76 work, frame, title, and realistic image are inseparable parts of the content of Jenney's painting.

While Neil Jenney and Joe Zucker's titles always suggest or underline their works' thematic subject matter, Nicholas Africano's titles and story paintings are theater pieces. A painting by Africano usually consists of one figure, at most two small figures, lost in a large canvas space, and they have such titles as *The Scream* (1977), *The Cruel Discussion* [74] (made in 1976–77, and included in the Whitney show), and a 1978 series entitled *Daddy's Old,* which was intended to depict emotional dramas between father and son. Africano's figures are all made in partial relief out of wax or Magna before being set in their expanse of blue, black, or brown monochromatic backgrounds. These tiny symbolic figures are generally seen in profile as in cartoon stories, and are, in fact, psychological setups. Africano was born in Illinois in 1948, and before graduating from Illinois State University, wanted to be a writer. "As a writer," Africano has explained, "I was after a direct and immediate image and began to substitute small drawings for words within the writing. . . . In order to present figurative imagery and the content it involves most blatantly, I minimize the physical issues and painterly considerations in the work."[46] Africano is most concerned that his painting "be about human experience," and the blank spaces which the artist's figures inhabit thus are more psychological than painting spaces, made to indicate the literal dimensions of the loneliness his figures experience.

Susan Rothenberg describes herself "as an image maker, who is also an image breaker." Her paintings of horses, of the drawn-animal figure bisected by line and left standing dumbly divided, are works that offer both formal and emotional content. The heavy layers of paint Rothenberg uses, and the ways she finds to bisect her image— an image always dark and seeming to refer to the edges of the painting as limits— suggest a space in which both artist and image find themselves trapped. Rothenberg, who graduated from Cornell University in 1966 and began exhibiting her work in New York City in 1974, began using the form of a horse, she has claimed, "because the image divides right, and for the first three years that I worked with the horse, the divisions related mostly to the rectangle."[47] Also, "the black paint that forms the horse's body also forms the geometry of the painting," she says, and in this way

[75] Susan Rothenberg. *Nonmobilizer.* 1974.

manages to sidestep the issue of the emotional content involved in the form of a dumb, nonverbal beast of burden who has become literally almost invisible in most people's daily lives [75]. Deborah Butterfield, another 1970s artist using the same sort of imagery, constructs large- and small-scale horses out of mud, sticks, and even tin cans. Butterfield regards these works not as lifesized figures of animals she knows (the works range anywhere from three to seven feet high) but rather as "metamorphic self-portraits."[48] And, despite her emphasis on the work's formal intent, the bisecting of Rothenberg's almost archetypal horse form assumes a similar, nonverbal presence, suggesting the poignancy of physicality in a culture being consumed by unceasing verbalization.

The works of two California artists, Joan Brown and Charles Garabedian, in the New Museum's "Bad Painting" show seemed to call into question all our academic notions about good and bad drawing, and by their presence raised the question of how, today, we should define "primitive art." Joan Brown, born in California in 1938 and graduating from the San Francisco Art Institute in 1970, is an artist who moved quickly from painting in an Abstract Expressionist style to, by 1968, making works resolutely figurative, subjective, and anti-academic in feeling. The works are mostly portraits of herself dancing, of her with her children, of her pets, and even at times,

[76] Charles Garabedian.
Prehistoric Figures.
1980–81.

of making paintings of her pets. Occasionally, she will use animal and people parts interchangeably in the same figure to portray her preoccupation with birth and death. Brown began showing with the Hansen Fuller Gallery in San Francisco in 1968, and was represented by the Alan Frumkin Gallery in New York throughout the 1970s. Her unashamedly autobiographical works include paintings of both her dreams and nightmares as part of her attempt to document the range of life offered to her as both painter and human being.

Charles Garabedian is another artist whose work has been exhibited for a long time in California, beginning with a one-person show at the Ceeje Gallery in Los Angeles in 1963. It wasn't until the mid-1970s, however, that Garabedian was shown in New York. The artist had his first one-person show at The Whitney Museum in 1976. Garabedian's work in the New Museum exhibition included an *Adam and Eve Collage,* and his fourteen-year retrospective at the La Jolla Museum in 1981 contained paintings and sculptures on such diverse subjects as China, ancient Greece, classical ruins, and primitive figurative works on biblical themes. Garabedian's most consistent and impressive body of work, to me, is his *Prehistoric Figures* [76], a series of nine paintings made in acrylic on wood panels in 1980–81. This series, subsequently shown at the Holly Solomon Gallery in 1982, consists of very pink nudes posed against

porcelain-blue skies, almost all of them drawn as if seen from the feet up. Their carefully drawn, almost delicately indicated small sexual characteristics take on a funny look within the bodies' overall massive proportioning. The La Jolla Museum catalog stated, "Garabedian has paid close attention to the work of earlier masters such as Titian, Rubens, Cézanne and Matisse."[49] But with regard to the synthesis Garabedian has made for himself out of modern art in his *Prehistoric Figures,* it seems fitting that he himself should have the last word: "I certainly try to paint out of a position of searching and questioning of logic and reason—of questioning some of the basics of the past. Yet," he insists, "within this questioning, I believe I equally have recognized some of the incredible things of the past which are, in fact, the basics of the nude figure in the landscape."[50] And in a general sense, he adds, "I believe in anarchy only as it relates to my work. Maybe everything else I just don't believe in at all. But anarchy is important. For the artist it is critical. . . . Freedom is just a word and anarchy implies that something has to be done. You know, the anarchist is always pictured as eccentric. He's really not. He just believes in something and is risking something on that belief."[51]

It is this anarchistic spirit, I believe, that unites many of the "new image" and "bad" painters of the late seventies—a spirit very much in keeping also with Philip Guston's approach to doing a new kind of figurative work and to starting all over again in 1970.

NOTES:
REPRESENTATION: SUPER REALISM, NEW
IMAGE PAINTING, AND "BAD" PAINTING

1. Harold Rosenberg, "Reality Again," *The New Yorker,* Feb. 5, 1972.
2. Article published in *Arts Magazine,* Dec./Jan. 1972.
3. Published in *Art in America,* Nov./Dec. 1972, p. 58.
4. Henry D. Raymond, "Beyond Freedom, Dignity and Ridicule," *Arts Magazine,* Feb. 1974, p. 25.
5. John Perreault, "Encounters of the Close Kind," *SoHo News,* Apr. 29, 1981, p. 45.
6. William Dykes, "The Photo as Subject: the Transformation from Photo to Photo-Realism in Chuck Close," *Arts Magazine,* Feb. 1974, p. 31.
7. Grace Glueck, "Artist: Chuck Close," *New York Times,* June 10, 1981, p. C 26.
8. *Ibid.*
9. William Dykes, *op. cit.,* p. 30. Also reprinted in Gregory Battcock, *Super Realism* (New York: Dutton, 1975), pp. 145–62.
10. Lisa Lyons and Martin Friedman, *Close Portraits,* exhibition catalog, Walker Art Center, Minneapolis, 1980, p. 33.
11. Harold Rosenberg, "Reality Again," *op. cit.;* reprinted in Battcock, *op. cit.,* pp. 137–38.
12. Martin H. Bush, *Duane Hanson,* McKnight Art Center Book, Wichita State University, 1976, p. 21.
13. *Ibid.,* p. 31.
14. Linda Chase and Ted McBurnett, "The Verist Sculptors: 2 Interviews," *Art in America,* Nov./Dec. 1972, p. 99.
15. Harold Rosenberg, *op. cit.,* p. 138.
16. *Ibid.,* p. 139.
17. Linda Chase and Ted McBurnett, *op. cit.,* p. 98.
18. *Ibid.*
19. Joseph Mashek, "Verist Sculpture: Hanson and De Andrea," *Art in America,* Nov./Dec. 1972, p. 91.
20. Linda Chase and Ted McBurnett, *op. cit.,* p. 98.

21. Linda Chase, "Existential vs. Humanist Realism," in Battcock, *op. cit.,* p. 85.
22. Ivan Karp, "Rent Is the Only Reality Etc.," *Arts Magazine.* Reprinted in Battcock, *op. cit.,* p. 27.
23. *Ibid.*
24. Richard Estes in "The Photo Realist: 12 Interviews," *Art in America,* Nov./Dec. 1972, p. 79.
25. William C. Seitz, "The Real and the Artificial: Paintings of the New Environment," *Art in America,* Nov./Dec. 1972, p. 65.
26. Richard Estes, *op. cit.,* p. 80.
27. *Ibid.*
28. Kay Larson, "Dead-End Realism," *New York,* Oct. 26, 1981, p. 94.
29. Robert Bechtle in "The Photo Realist: 12 Interviews," *Art in America,* Nov./Dec. 1972, p. 78.
30. *Ibid.*
31. Robert Cottingham in "Photo Realists: 12 Interviews," *Art in America,* Nov./Dec. 1972, p. 77.
32. Ivan Karp, *op. cit.,* p. 34.
33. Cindy Nemser, *Art Talk: Conversations with 12 Women Artists* (New York: Charles Scribner's Sons, 1975), pp. 312–13.
34. *Ibid.,* p. 311.
35. Artist's statement in São Paulo catalogue, 1967.
36. Cited in *Philip Guston: Paintings 1969–80,* exhibition catalog, Whitechapel Art Gallery, London, 1982, p. 11.
37. In *Philip Guston: Drawings 1947–1977,* exhibition catalog, David McKee Gallery, New York, 1978; statement, 1976.
38. *Philip Guston,* San Francisco Museum of Art (New York: George Braziller, 1980), p. 41.
39. Hilton Kramer, *New York Times,* Oct. 25, 1970.
40. Roberta Smith, "The New Gustons," *Art in America,* Jan./Feb. 1978, p. 101.
41. *Philip Guston: Paintings 1969–80, op. cit.,* p. 14.
42. Ross Feld, "Philip Guston," in *Philip Guston* (New York: George Braziller, 1980), p. 29.
43. John Perreault, "Whitney Turkey," *SoHo News,* Jan. 4, 1979, p. 37.
44. Richard Marshall, *New Image Painting,* exhibition catalog, The Whitney Museum of American Art, New York, 1978; artist's statement, p. 68.
45. Marcia Tucker, *Bad Painting,* exhibition catalog, The New Museum, New York, 1978, unpaged.
46. Richard Marshall, *op. cit.* Nicholas Africano statement, p. 14.
47. *Ibid.* Susan Rothenberg statement, p. 88.
48. Mary Mathews Gedo, "Deborah Butterfield," *Arts Magazine,* Nov. 1983, p. 9.
49. Fred Hoffman, *Just a Great Thing to Do: Selected Works by Charles Garabedian,* exhibition catalog, La Jolla Museum of Contemporary Art, 1981, p. 49.
50. *Ibid.*
51. Fred Hoffman, *op. cit.,* p. 31.

7
Abstraction

Plain and Planar Painting
After Pop Art and Minimalism

Abstract painting in the seventies can be roughly divided into flat and planar painting, geometric and allover or monochromatic art, smooth surface and/or relief constructions. Characteristic of most painting during the seventies was the size and scale of the individual artist's ambition as he searched through art history to come up with a personal discovery that would reaffirm his sense of self. Art history, the work of the Cubists, and that of Picasso and Matisse, in particular, hovered in the background as painters tried to find ways through Minimalism into making a new statement, even succeeding at times in becoming one-person movements.

Plain, or flat, painting in the 1970s can be seen to start with Brice Marden, who, toward the end of the sixties, managed to make a new and seemingly final, end-all Minimalist type of painting. Then, Richard Diebenkorn's 1972–73 *Ocean Park* series raised again issues of color in geometric abstraction that opened a path for many younger artists. Elizabeth Murray, Frances Barth, and Virginia Cuppaidge make works which carry on a dialogue between color and geometric shapes in highly individualistic formats. Most idiosyncratic of all, Deborah Remington makes nighttime geometric works whose color has a kind of electric glow and whose geometric forms bend into not quite recognizable icon-like objects. Finally, there is Milton Resnick, whose heavily encrusted paint surfaces are about color breaking through paint texture to create pools of light in green, black, and gray paint walls. Resnick, who was the inspiration of a momentary movement called "Purism," became a school unto himself, and was emulated by a group of younger artists.

The above artists can be said to represent one half of the world of 1970s abstract painting. There is also planar painting, constructs, and relief painting—all popular terms that have been applied to the enormous range of three-dimensional wall works

which appeared during the decade, and which will be discussed in the second half of this chapter.

Plain Painting

The 1975 Guggenheim catalog of Brice Marden's ten-year museum retrospective includes a "Technical Statement" by the artist, which describes the steps he undertakes in making a painting, and ends, "I try to keep the surfaces in one painting constant and total. There are variables. Extensive heating of the medium results in some evaporation which can make the paint gummy and softer. Left-over paint, with wax added, is often used in mixing subsequent colors. I am never exactly sure of how much wax is added to the oil paint in the final surface, but oil remains the primary binder as opposed to encaustic where the wax is the binder."[1] Indeed, this statement serves to stress the importance of process in Marden's work, which was apparent in the beginning by the fact he chose to eliminate both interior drawing and color from his paintings and to concentrate on one aspect—the painted plane itself, its surface and the shape which contains it. Like most reductive art, Brice Marden's work involves a sense of time. Looking at his paintings one becomes aware of the many layers of paint that make up each surface. As the Guggenheim curator Linda Shearer wrote: "These layers in turn convey a feeling of the artist's ponderous pace. . . . And, as one comes to recognize the time involved in the making of the work, one simultaneously experiences the time involved in the perception of the painting. Although each picture can be seen as a totality at a glance, in Marden's work, as in much reductive art, the perceptual process, like the painting procedure, is extremely slow."[2]

Brice Marden, who was born in Bronxville, New York, in 1938, earned his B.A. degree in fine arts from Boston University in 1961, and an M.F.A. degree in painting from Yale University in 1963. In the summer of 1963, after finishing school, Marden moved to New York City, where he took a job as a guard at The Jewish Museum. That summer he spent a lot of time looking at Jasper Johns's 1958–59 paintings such as *Gray Numbers,* along with Johns's earlier flag, target, and map works, which were on view as part of Johns's retrospective at The Jewish Museum, and it seems logical to me that Marden was attracted to the immobile quality, the inert objectness, of these Johns canvases. Marden has described his own paintings made from 1963 through 1965 as works "done when war was a major issue. It was like the call of death." Also, Marden says he was personally depressed at this time and "wanted the viewer to come away from my paintings feeling twisted. They have walked into a situation that they thought was a certain way, and begin to see that it is not what they thought it was." He explained, "Gray was the way I could deal with color at the time. What I liked

[77] Brice Marden. *Untitled.* 1964.

about it was how you could twist it, how you could make it be gray, and also be red
—how you could get two readings out of one thing"[3][77].

 Marden had his first one-person show of all-brown, green, and gray paintings at
the Bykert Gallery in 1966. The paintings hung like unfinished color blocks because
Marden, instead of closing off the bottom by bringing the paint stroke to the canvas
edge, left a one-inch, sometimes two-inch, margin where paint could drip down.
About this first exhibition, Scott Burton in *Art News* wrote, "The colors, like the skin,
are closed; you can't look into them, only at them. Each color holds. They are dry
paintings, full of heat and have the arid airless look of Spanish paintings, but their
austerity is extremely romantic, and they are also very sensual and beautiful."[4] That
same year, Marden went to work as a general assistant to the artist Robert Rauschen-
berg, and in 1968, after a second show at the Bykert Gallery, Marden began to make
diptych and triptych panel paintings in which, as Linda Shearer observed, "although
the color in each panel was different, the value of the various colors was the same";[5]
the feeling was that all panels, that the entire painting, existed on a single plane.
Following his first trip to Europe, in 1969 Brice Marden began working as an instruc-
tor of painting at the School of Visual Arts in New York, and the same year he had
his first one-person exhibition in Paris at the Galerie Lambert. From 1970 to 1973,
he was included in museum group shows of paintings across the country, and in 1974

[78] Brice Marden. *Grove Group III.* 1973–80.

he participated in the "8 Contemporary Artists" exhibition at The Museum of Modern Art in New York.

In a special issue devoted to painting in 1975, the magazine *Art-Rite* featured an interview with Brice Marden, where the critics Edit de Ak, Alan Moore, and Mike Robinson discussed with Marden the present state of painting and speculated why so many younger artists in the Whitney Biennial were copying Marden's work—and in fact not even copying from the paintings themselves but from reproductions of work they'd seen in *Artforum.*[6] Thus, the Guggenheim Museum's ten-year retrospective exhibition of Marden's work in 1975 came more or less as a confirmation of the idea that Marden alone had brought something new to Minimal painting, which in the sixties works by Ad Reinhardt and Robert Ryman had seemed to have reached a logical end. As Carter Ratcliffe wrote in a review of a 1975 two-person show in Houston, Marden's work was following "a modernist tradition condensed into a rule by Gleizes and Metzinger: 'A painting contains within itself its raison d'être. You may take it with impunity from a church to a drawing-room, from a museum to a study.' "[7] And to this day, Marden's paintings seem to exist as a separate entity of and for themselves.

Marden's paintings the next year at the Sperone Westwater Gallery in SoHo seemed just a further extension of those in The Guggenheim Museum. As one critic

wrote in April 1976 (which was also at the beginning of the Decorative Art movement), "After Marden's ten-year retrospective at the Guggenheim, his new show is no surprise. It's the same, only perhaps he's doing it better than ever: one painting is beautiful—pause, respectful silence. A beautiful presence and another and another and another. . . . I think maybe it's time to bring on the dancing girls before the last whisper of life goes out of abstract art."[8] Marden's work seemed to have become a new Minimalist end [78].

Two years before the Marden retrospective at the Guggenheim, Richard Diebenkorn's first *Ocean Park* series works were shown at the Marlborough Gallery, heralding the fact that the former Abstract Expressionist artist, who had turned to figuration at the beginning of the 1960s, had found his way back to abstract painting. Moreover, the now well known California figurative painter was introducing movement through color, and once more dividing up the picture plane into differently weighted areas. In the early seventies, not a few artists were heard to remark, "Well, I guess painting isn't supposed to sing any more." Diebenkorn's show of 8-foot-tall abstract paintings, which Marlborough Gallery had first shown in its galleries in London and Zurich, became an immediate refutation of this idea. As the critic John Russell wrote in the catalog for Diebenkorn's 1973–74 London show at Marlborough Gallery, "Within the new paintings there is a very great variety of touch, and of flow, and of diction . . . linked horizontals never quite regular in their progression, relate to experience in the way that Klee sometimes used linked horizontals to exploit his experience of Egyptian agriculture. But Diebenkorn's horizontals work together as *feeling,* not as something schematic, and in their utterance mystery alternates with the light of day."[9] And, indeed, the *Ocean Park* series, from 1972–73 through 1975–76, did seem to be about light and color—the bleached light perhaps of southern California recorded in shades of blue, yellow, and umber. In summing up these works in his review of the Diebenkorn retrospective, the *Time* magazine critic Robert Hughes observed that these paintings have received "their share of hyperbole," and then added, "However, they are certainly among the most beautiful declamations in the language of the brush to have been uttered anywhere in the past 20 years."[10] The Diebenkorn thirty-year retrospective that originated at the Albright Knox Gallery in Buffalo traveled to The Whitney Museum in 1977, and established Diebenkorn's status as a major painter. The large-scale exhibition confirmed the range of Diebenkorn's work, presenting several rooms of the *Ocean Park* series, and including the earlier figurative paintings from the mid-sixties—paintings that Diebenkorn had based in part on Matisse's compositional arrangements, which won the *New York Times* critic Hilton Kramer's approbation. The exhibition made clear both Diebenkorn's achievements in various modes, and how his painting had stylistically zigzagged its way through the history of American art from 1946 to the present.

Richard Diebenkorn was born in Oregon in 1922, and after serving in the army

majored in art at Stanford University in California. In 1946, he won a traveling fellowship and came to New York. He arrived in the summer of 1946 and settled outside the city in Woodstock, where he worked from "6 A.M. to 10 P.M. every day teaching myself how to paint."[11] The influence of Picasso and Miró was important to him at the time and, at the end of the year, it was as a dedicated modernist that he returned to California to finish his B.A. degree from Stanford, in 1949; he received an M.A. degree from the University of New Mexico in 1952. The next year Diebenkorn returned to New York, where he became friendly with a number of Abstract Expressionist painters, among them Franz Kline and Ray Parker. The paintings from this period are sandy-colored Abstract Expressionist works, where the line seems more wandering and the space less dynamic than in say, de Kooning's work, and the horizontal divisions at once less-clear-cut and more varied than Mark Rothko's. At The Whitney Museum, these works seemed to be paintings of their time, no more and no less.

In 1954, after a year in New York, Diebenkorn headed west again. His return to Berkeley was a real homecoming. This was the year the artist began to include blue in his palette. "I decided," he said, "no matter what, I like the color and started using it. And then the next review I received referred to me as an abstract landscape painter, which was a terrible putdown. But I decided it was okay, because you have to pay for what you like."[12] In California, Diebenkorn resumed his friendships with David Park and Elmer Bischoff, two West Coast artists who had returned to making figurative paintings two years earlier. At the time, the San Francisco art scene was polarized into Abstract Expressionists and the new figurative school of Bischoff and David Park. By the end of the year, Diebenkorn went into his studio and painted his first still life in many years, a study of a knife and a tomato. It was the beginning of a series, which were almost academic exercises, in which the artist attempted to paint, directly and objectively, still-life subjects in the studio. In 1956, Diebenkorn had his first one-person show in New York, at the Poindexter Gallery; the show consisted of his Berkeley series of Abstract Expressionist paintings, and the same year the artist's first figurative paintings were included in a group exhibition at the Oakland Museum. Diebenkorn continued to work in a realistic vein, painting interior and outside scenes, making paintings which rarely contain figures, but where a human presence is implied. Diebenkorn, who was teaching at the California College of Arts and Crafts, had numerous one-person shows through the early sixties, and was soon recognized as one of California's leading figurative painters.

In 1967, Diebenkorn's close friend David Park died, and Diebenkorn moved to Santa Monica and began teaching at the University of California at Los Angeles. The move from northern to southern California and to a town abutting the ocean played a big part in Diebenkorn's subsequent return to abstraction. After ten years of being recognized as a realist painter, Diebenkorn began changing the amount of paint he

put on the brush, and changed his painting technique because he didn't mean to go back to Abstract Expressionism, but to move forward. "And I guess working thinly was a kind of relief," he said.

The *Ocean Park* series was named after the Los Angeles suburb which Diebenkorn moved to in 1967, and where the artist has lived ever since. In the 1977 Whitney exhibition, the early tall *Ocean Park* paintings were vertical compositions whose 8-foot scale was something of a measure of their ambition. These paintings, dealing with the movement of light seen through sky and space, introduced a new kind of luminosity into abstraction. In the 1973 and 1975 series, the record of the artist's tentative gestures, the record of his decisions about representing inner and outer vistas, of distant and closed-up space, can be seen. The works contain no flat or wholly opaque color areas. Behind their few black and heavily painted blue color areas is always the suggestion of other forms, other moves. In the Whitney, these paintings were hung close together rather than spread out as they had been in the Marlborough Gallery shows of 1973 and 1975, where they came as a shock, an opening up, or a revelation again, to a generation of younger artists, of the possibilities of what could be done with color and form.

Matisse's influence seems omnipresent in Diebenkorn's paintings from the early to the mid-sixties. Many correspondences in fact exist between Diebenkorn's *Ocean Park* series and Matisse's 1914 *Interior with Goldfish* and his 1916 *The Piano Lesson* paintings, among them that both artists are working with frontal, shifting vertical rectangular forms moving forward and back. And Matisse's influence, together with the idea of making a personal language from geometric shapes, support the idea of a connection between Diebenkorn's aims and those of such younger artists as Frances Barth, Virginia Cuppaidge, and Elizabeth Murray. The differences between Diebenkorn and them, especially when it comes to color, are equally apparent. Whereas Diebenkorn's palette, his blues and yellows and greens, are sun-bleached California colors, Frances Barth's first one-person show included New York grays, mustards, browns, and rusted purples. These paintings, at the Susan Caldwell Gallery in 1974, represented the artist's first four years of work, in the form of 10- to 16-foot-long horizontal paintings. "Since 1969, my paintings have evolved from a set of common shapes, the triangle, the trapezoid and the circle. . . . I have been trying to make a personal language where the shape or forms can hold color and space in such a way as to transcend itself, where a space exists that's delicately indeterminable, but conveys a sense of interior rightness," Barth explained in 1978.[13]

Born in New York City, Frances Barth attended Hunter College, earning her M.F.A. degree in painting while performing as a modern dancer with the Yvonne Rainer Dance Company at both the Judson Church and Hunter College. Her interest in movement, music, and sculpture led her to spend six months making three-dimensional forms while she studied painting with the sculptor Tony Smith at Hunter College. "In the beginning, my art wasn't coming out of art, it was coming out of

[79] Frances Barth. *Vermillion So. D.* 1973.

poetry and confusion. I started making interlocking figures, then shaped paintings.
. . . There was a certain kind of time in Yvonne Rainer's dance piece 'The Mind is
a Muscle,' something magical and simple that I wanted to get in my paintings," Barth
has said.[14]

The movement, expressed by the artist's use of paint layers and scumbled sur-
faces, in Barth's first show was slow. *Gadara,* a long painting done in 1974, contained
only two medium-size triangles afloat within its 16-foot length; one was a soft aqua
triangle whose softness of color and outline suggested two sets of picture planes gently
shifting, changing places, while making no effort to draw attention to itself against
the scumbled red background. Her *Vermillion So. D.* [79] painting, also made in 1973,
achieves a similar effect. Four years later, in her third one-person show in SoHo, at
the Susan Caldwell Gallery, Barth's array of forms had become increasingly complex,
occupying all of the painting ground. In the 1977 painting *Mariner,* an off-center gray
polygon acts like a shaft of light to set off the solidity of a dark circle, deep-brown
trapezoid, and shadowy, rust-colored adjacent forms. These works, from 1976 and
1977, became like geometric painted walls. Interlocking triangles, trapezoids, and half
circles became a friezelike bar as opposed to Barth's earlier single and paired triangles
floating up from the bottom of the canvas. In all her best work, Frances Barth
succeeds in doing two contradictory things: in the early paintings, she managed to
project intimate shapes across a large canvas to suggest a feeling of isolation; in the
later works, her interlocking forms assume the stance of a closed-off mural but

nevertheless, in terms of their highly individualized color surfaces, they make the public mural form convey the intimate dimensions of a personal painting statement.

Australian-born Virginia Cuppaidge is an artist whose color range is much closer to that of Richard Diebenkorn than that of Frances Barth. But Cuppaidge, like Barth, is an artist who employs her own personal geometry to make room-long horizontal paintings. Cuppaidge's exhibition at the Susan Caldwell Gallery in 1975, her second solo show in New York, consisted of very simple geometric works made of horizontal bars defining space in terms of color. The painting *Second Transition,* for example, was made up of painted bars of aqua, yellow, diaphanous gray-pink, and mustard; her *Mauve Breaker,* also done on acrylic on canvas and measuring 78 × 120", had two different shades of pale blue against a strong green so that the rectilinear forms floated like waves out into the gallery.

Virginia Cuppaidge came to New York from Australia in 1969, bringing with her a knowledge of American art gained from art magazines. "I was very influenced by Kenneth Noland and the color painters from reproductions I saw when I was a teenager, and wanted to enter some day into the New York art dialogue."[15] In Australia, Cuppaidge had had four years of formal art training, after which she worked for three years in textile design. A tall woman, Virginia Cuppaidge has always been involved with space because "in Australia," she has explained, "you can walk out in any place and just grab it. You have to harness the energy of space."[16]

Soon after her arrival in New York, Cuppaidge began making paintings that were very much influenced by Hans Hofmann. These works consisted of complex arrangements of horizontal and vertical geometric forms set off by contrasting ribbons of color. After a first show at the A.M. Sachs Gallery, Virginia Cuppaidge began to play off hard-edge rectilinear forms against softly painted areas in such a way as to introduce a kind of landscape-horizon space peculiarly her own. In 1977, the sharply defined rectilinear forms disappeared. Instead, the entire 10- to 20-foot canvas became one field into which the artist launched a handful of small, quirky shapes. A ruffle of three lines, a silver arc, a blue bar—the playful nature of these elements in itself became a form of risk-taking. But, on a technical level, it is in the placement of her eccentric shapes that Cuppaidge achieves her aim "not just to paint a beautiful field, but to take the field and turn and twist it around" and forces us to locate ourselves in a point-to-point way that sets at odds our personal equilibrium and visual perception.[17] "In paintings such as *Nizana,* from the late 1970s, Cuppaidge begins with a basic color such as a very pale blue and then uses as many as twenty or thirty layers of acrylic paint applied with a sponge. Ten feet long, the opalescent *Nizana* seems just large enough to contain the play of its set of elements—the fading circle, crossed baton lines, floating triangle and square—so that one is caught in the space between them, in the movement of the moment, even in the act of asking, 'Is this enough—are movements and light enough for a painting to be about?' "[18]

Elizabeth Murray's work is concerned with the integration of paint with the

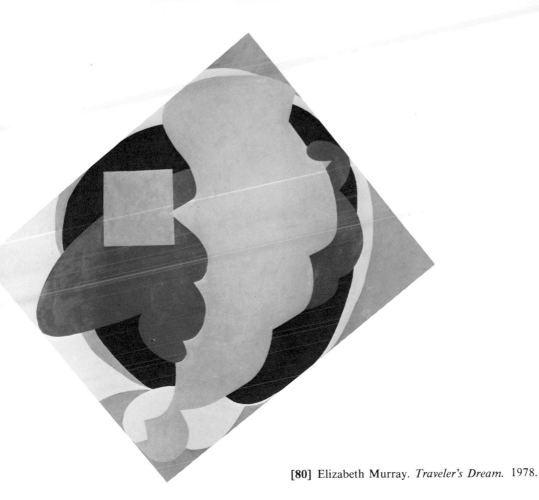

[80] Elizabeth Murray. *Traveler's Dream.* 1978.

elements of surface, color, shape, and line. Like Virginia Cuppaidge's paintings, "Murray's work begins with her surfaces which are built up of layers of rough, packed-down oil paint and which, although uniformly dense are never uniform: strokes varying according to the size of the area, and remaining visible according to the way the color dries."[19] Also, like Cuppaidge, Elizabeth Murray deals in eccentric shapes, but hers come out from the surface to break up the canvas rectangle until— by the second half of the 1970s—by virtue of the artist's designs of their structured stretcher bars, the paintings in themselves became eccentric presences in their angling, tilted, and overall configuration on the wall. By 1980, color and form inside these oddly built paintings existed in tandem, and played against the painting's outward shape. "Part of their dynamism," Jeff Perrone observed, "comes from Murray's use of the normally rectangular canvas, as standing it on a pointed corner she transforms it into an elongated diamond." Also, "Murray invents shapes which look like toy airplanes, blobby sci-fi monsters and cartoony illusionisms."[20] Across her surfaces these appear alongside geometric shapes transformed into swimming balloons, zigzagging lightning marks, and notched-out semi-circles. The appearance of a simple small rectangle in the complex 1978 *Traveler's Dream* [80] seems a little startling even while

it serves as a confirmation of the painting's overall shape before the artist began to turn it. Looking at Murray's work from 1973 through 1980, one becomes aware of the artist's march toward greater and greater complexity in her use of both color and shape. By 1980, she was able to do more and more things with color, as her vocabulary of shapes increased. Meanwhile, her strange purples, bright blues, light greens, and blue aquas served also to increase each work's spatial reading.

Elizabeth Murray was born in Chicago and attended the Art Institute there, earning her B.F.A. degree in 1962. She came to New York after spending three years at graduate school at the San Francisco Art Institute. "It was Pop Art time and I thought Warhol was incredible, and I got interested in Oldenburg," Murray remembers. "I began doing weird fantasy painting, and then regressed more and more in terms of the images I began to use."[21] After a time, she began using small forms repeated throughout the painting. In her 1972 *Madame Cézanne in Rocking Chair,* the chair in each of the picture panels in a row is drawn at a somewhat different angle, which may have led, in turn, to the all-over line painting she made in 1973 titled *Wave Painting.* The connection between this work and the work of the mid-seventies, according to Murray, "would be the paint, which I'm very involved with."[22] From the wavy line paintings, she turned to making soft-colored, rough-surfaced geometric abstracts in 1974. The painting called *Flamingo,* done in 1974, has conventional square dimensions (7'6½" × 7'3½"), which Murray chose to bisect so that half of the painting consists of a painted dark pink triangle which abuts against the other half, a deeper blue-black triangular shape. This is the established order of the painting, and against it the artist has posited a white line traveling through the two triangles' opposite corners and making a small circle just beyond the division edge of the blue side so that the space from triangle to triangle in terms of drawn line and painting edge (where the two contrasting colors meet) is always on the move. In relation to Murray's subsequent work, *Flamingo* is a relatively simple, direct painting statement about shifting space. The painting is important, as the critic Jesse Murray wrote, "because it advances the artist's aesthetic of establishing and denying order in her paintings."[23]

In 1975, Elizabeth Murray participated in a two-person show at the Paula Cooper Gallery in SoHo, and the next year had her first solo exhibition at that gallery. In 1977, her paintings were included in the Whitney Biennial, and she received a Theodoran Painting Award and participated in the "Nine Artists Award Exhibition" at The Guggenheim Museum. In the second half of the 1970s, Murray's work moved from such conventionally shaped canvases as *Flamingo* to the off-center, off-kilter 122 × 52" rectangular shape of *Parting and Together.* To move from the 1974 *Flamingo* to the 1978 *Traveler's Dream* and *Parting and Together,* with its lavender, aqua-green, black, pink, and small red elements, is to experience the increasing dimensionality of Murray's eccentric geometric landscape during the decade.

Deborah Remington's paintings don't relate to Elizabeth Murray's work, Vir-

[81] Deborah Remington. *Tanis.* 1973. Private collection.

ginia Cuppaidge's, Richard Diebenkorn's, or that of any other artist painting in the late sixties to mid-seventies. In fact, "to insist on frontality, to work with a central image, to set this image within the given edges of the canvas the way Remington does is to go against the history of American painting since 1950, and of European art after surrealism."[24] The acceptance of and subsequent popular response to Remington's work after she was included in the Whitney Museum's annual painting exhibitions of 1965, 1967, and 1973 says something about Pluralism, and of a decade in which, though there was no overt interest in paintings of quasi-mystical symbols, there was nevertheless wholehearted response to such idiosyncratic subject matter.

Deborah Remington, born in Haddonfield, New Jersey, graduated from the San Francisco Art Institute in 1957 and then spent two years in Japan learning Japanese calligraphy and supporting herself by acting the Westerner in Japanese movies. She came to New York in 1964, and had her first solo exhibition at the uptown Bykert Gallery in 1967. Remington remained with Bykert until the gallery closed in 1974. In 1977, she had a one-person exhibition at the Hamilton Gallery in New York, and has since been represented in museum exhibitions around the country.

Remington's paintings deal for the most part with night light and dreams, in a surreal, mechanical world. Her bent and twisting images simultaneously suggest segmented automobile parts and heraldic forms floating free from the canvas. The

work has symmetry, but not a bilateral symmetry because "in reality the two sides of the face don't match, nor do the two sides of my paintings, although they may seem to," the artist has explained.[25] The two sides of the painting are always held in balance while their mirror forms give back no reflection, as in the painting *Tanis* **[81]**, with its side panels occupying different spatial levels. Despite the use of an occasional red border and moving line, the 1973 *Tanis* is basically a black-and-white painting made up of infinite gradations of gray, from matt gray to gray glazed into white. Complex, complicated, and quirky, *Tanis* is typical of Remington in that it is a labyrinth of ideas and shapes, and the places where light comes together in the work are points of drama. In 1977, her work began to change: first in a series of drawings and later, in 1979, through the use of brighter color areas. From being centrally organized, Remington's heraldic shapes turned into window and door forms floating off from the corners. Remington works very slowly, and thus far, only the drawings, her Seurat-like spray-paint works, and her pencil-on-paper newer works have been widely shown.

Milton Resnick, an artist who chronologically belongs to the Abstract Expressionist generation, in 1962 announced: "I am not the follower of Monet. I am not an admirer or follower of de Kooning. I am not an action painter. I am not an abstract expressionist. I am not younger than anybody or older. I will not take my hat off to any other artist living or dead in all the world."[26] Two years later, in 1964, Resnick had a last show in New York at the Howard Wise Gallery, and then turned his back on New York and moved to New Mexico. In 1971, at the Fort Worth Art Center in Texas, Resnick resurfaced with paintings that introduced a new kind of nuanced texture into abstract painting. The paintings, shown again at the Max Hutchinson Gallery in New York in 1972, according to the *Time* magazine critic Robert Hughes, displayed "an iron will to form."[27] The works in his 1974 and 1977 New York exhibitions inspired a whole group of younger artists, many of whom produced Resnick-look-alike canvases, and others who use Resnick's approach to color as a starting point for their own paintings. Not exactly "field painting," although the term was applied to the work in a 1971 *Art News* article,[28] the new canvases contained literally hundreds of pounds of paint, and the edge of each canvas was "literally the edge of the world; a thick, heavy textured world in which one cannot locate a picture plane or horizon line, where the movement is all in the congealing surface and pinpoints of light which seem to emanate from within."[29] Resnick's paintings have been described as "monochromatic" and several exhibitions—at the Susan Caldwell Gallery, the Max Hutchinson Gallery, the Siegel Contemporary Gallery—have been built around Resnick and like-minded artists, often described as "monochromatic painters." The difference between Resnick and the other artists, as Robert Hughes observed, is in terms of nuance: "Resnick's work," he wrote, "always has one dominant color, whether cobalt blue, pink or a peculiarly sensuous acid green—which discloses on study fascinating inflections and qualifications. These nuances constitute

a structure."[30] The structure remained, and the chroma seemed to intensify as the pinks and blues gave way to deeper colors in the second part of the 1970s. *Night,* a 93 × 104½″ painting shown in Resnick's 1977 Max Hutchinson exhibition, is dark, almost black-green. *Winter X,* another painting in the same show, appears at first glance to be all gray. In both, where the pigment seems to have been applied tactilely, the movement is in the degree of light color versus thickness of the paint; this is also true in Resnik's gray-green *Earth.* Within the single chroma Resnick selects for a painting are concealed half the colors of the spectrum, and each work is concerned with color buildup where many layers of different colors meet, pass, and leave their mark on each other.

Milton Resnick, who was born in Russia in 1917 and emigrated to the United States in 1923, had his first one-person exhibition at the Poindexter Gallery in 1955, and by the end of the 1950s was recognized as "one of the most brilliantly developing of the younger painters"[31] of the Abstract Expressionist artists. The late fifties and early sixties Monet-like paintings—especially in Resnick's 1964 show at the Howard Wise Gallery—showed a relationship to Impressionism in that the paintings seemed drenched with spots of color, like petals thrown up in a shower on the canvas. It was after this 1964 exhibition that Resnick decided that these and his earlier works were made by taking a series of "fingerholds," or position points, on the canvas, and what interested him was the total picture rather than things in the picture. His approach to painting changed. "He began to work in terms of an accumulation of small strokes, using the brush, the edge of the brush and sometimes his hand until the paintings became an accretion of an experience rather than the tracing of a series of gestures."[32] His application of literally hundreds of pounds of paint is based on the idea that images which project themselves like ghosts in the early stages of the work must be painted out, that paint buildup equals removal. In both the intimate-sized and room-long canvases, there is "a striving after wholeness, a striving to see and express with infinite care the nuances of a single moment, and thus make each painting into a separate, life-time journey."[33]

Planar Painting

Planar painting has a long history in the 1970s as a continuation of a unique twentieth-century art tradition. As Joan Marter has stated, "The history of relief constructions begins in the early 20th century with the Cubists and Constructivists. The true nature of the pictorial surface was first questioned by Paul Cézanne and the challenge continued by Pablo Picasso and Georges Braque." And, "in most Cubist constructions, the wall serves as a pictorial ground while the work extends through several spatial planes."[34] In the 1970s, painters approached working directly on and building

out from the wall in two distinct ways: in the first, they took the canvas off the stretcher bars and attached it to the wall; in the second, they began to build their paintings from materials other than canvas. Working with canvas, draping and folding it, can be looked at as a natural extension of the work of the Color Field painters of the 1960s, and certainly Sam Gilliam's approach to planar painting follows this path. Alan Shields's use of dyed fabric—of 1960s "hippie" materials—can be looked at as having a certain anthropological intent. Frank Stella, Ralph Humphrey, and a large group of other 1970s artists built their paintings from wood and aluminum, made collages on wood, and used found objects in their relief constructions, and thus their work fits more easily into the category of relief painting. In April 1978, at a building known as the "Bleecker Renaissance" at 644 Broadway, the artist Eliot Lable organized what was described in *Arts Magazine* as "a museum-scale show of 55 artists registering the presence of a direction spanning two different movements from its base and anchor the wall."[35] The curator, Eliot Lable himself, described "constructs as the addition of sculptural elements into painting, and the concrete working with the illusion; the concrete being the sculpture part, the illusion, the painting part—what painting introduces."[36] The difficulty throughout the seventies was in fact cataloging the vast amount of relief work being done. Critics as diverse as Carter Ratcliffe[37] and Jeanne Siegel[38] tried to describe the dimensions of this new interest in working directly on and out from the wall and, in 1980, two large-scale exhibitions, "Three-Dimensional Painting" at the Museum of Contemporary Art in Chicago and "Planar Painting: Constructs 1975–1980" at the Alternative Museum in New York, attempted to document and describe the works of the major artists involved in this new, yet historically oriented art movement.

In his statement in the "Planar Painting" catalog, Sam Gilliam said: "My paintings aren't three-dimensional structures though they use wood, rocks and rope as part of the frame, part of the total control of the work. It began back in 1969 when for me one of the real ways of getting away from the stretcher was to take the canvas out of it and just attach it to the wall."[39] That same year, in 1969, the first full-scale exhibition of Gilliam's suspended canvases took place at The Corcoran Gallery in Washington, D.C. This show consisted of eight suspended works displayed in two rooms and the central atrium of the museum. There, "*Baroque Cascade* filled a 44 × 22-foot area beneath the skylight of the atrium with great interweaving arcs of color. The hovering forms in all these works established a powerful sense of interaction and great masses and gestures of cloth would shift from density to openness depending on one's perspective."[40] Throughout the 1970s, Gilliam explored the possibilities of suspension from two or three points, close to the wall like massive reliefs or extending through space. He built armatures to set under his canvases, as in *Autumn Surf* [82] in 1973, reverted on occasion to conventional stretcher bars, and also made collage and assemblage works. The physicality of the paint on the canvas

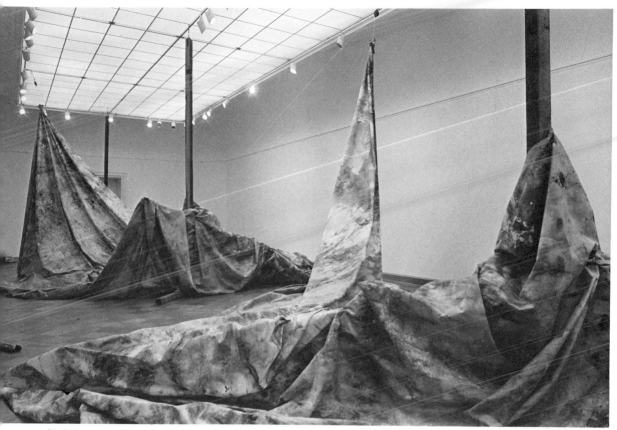

[82] Sam Gilliam. *Autumn Surf.* 1973. San Francisco Museum of Modern Art.

has been an important element in all of Gilliam's work. A new emphasis on the structural support, however, became important about 1975. As Gilliam has explained, "There is an attempt in my own work of continuing the dialogue with what was happening with Pollock and Louis working on the floor, but I am taking that dialogue to the wall. I establish as much facticity as possible, but keep certain elements of illusion. The illusion has been most important in making these shapes on the wall, in isolating shape against shape. It is a painter's illusion, but I am also carrying on a dialogue with sculpture."[41]

Sam Gilliam was born in Tupelo, Mississippi, in 1933, grew up in Kentucky, and earned his B.F.A. degree from the University of Louisville in 1961. In 1962, he moved to Washington, D.C., and for the next three years his painting belonged to the hard-edge, geometric school. Gilliam's first poured and stained works in 1966 were a dissolution of the preceding planes and bands into luminous color stains that were not unrelated in procedure or impact to the works of Morris Louis and Kenneth Noland, the two central figures of the Washington Color Field school. In 1967, Gilliam, using presoaked canvas permeated by acrylic paints applied in different ways, began to fold the canvases to make intervals simultaneously suggesting and denying

structural edges. The innovation of suspending such canvases was Gilliam's own. As the critic Walter Hopps wrote, "Gilliam achieved the unique insight that the flexible properties of the canvas fabric could be literally revealed as a major structural quality of his work."[42] The canvas in Gilliam's hands thus took on new spatial properties as it extended into the room. In 1975, for a show at the Philadelphia Museum of Art, Gilliam made his first outdoor painting, *Seahorses,* consisting of two canvases, 60 and 95 feet high, draped and hanging down the museum's outside wall. "The orchestration of its colors was conditioned by the warm shade of the stone structure, and the richly textured hues had a softening effect against the stark walls," one critic wrote.[43] With Gilliam's use of soaked-in color, the heavily textured effect of his surfaces in some ways corresponds to those of Milton Resnick's in that an overall chroma expressing a single tonality is generally achieved. The use of armature in the form of aluminum supports in Gilliam's 1979 *Air Birds* reflects the increasingly structural direction his work took toward the end of the seventies.

Sam Gilliam has remained an abstract painter despite pressures on him as a black artist to make work directly concerned with the black movement, though one of his aesthetically most radical early suspended canvases was called *April 4 (1969),* referring to the day on which the Reverend Martin Luther King, Jr., was assassinated. Gilliam's concern is with color more as painting pigment than as human skin tone. He has explained this is in part probably true because he comes from an older generation, one not directly concerned with politics. He sums up his experience as an artist in these terms: "The more you live, the more art and life, esthetics and politics tend to merge. You're less concerned with success and more concerned with the quality of your existence as an artist, how things look outside your own window."[44]

Alan Shields's first one-person show, at the Paula Cooper Gallery in 1969, consisted of "a single tentlike structure with canvas sides banded in misty colors." His second exhibition, in 1970, offered huge "canvas wall hangings suffused with soaked-stained earth, rock and sky colors . . . stitched and patched with totemic clan symbols, touched with blobs of paint and adorned with tiny bead strings that roam through the field like mini-snakes."[45] Both Alan Shields's and Sam Gilliam's paintings are made and, to a great extent, shown apart from canvas bars and stretchers. They are not planar in the sense that they build a new kind of armature to extend out from the wall. Gilliam's and Shields's works, rather, involve the movement and texture of the material from which they are made and make the surface and cloth a central part of their aesthetic. Both artists' work seems remote from the conventional stretched paintings of the 1970s and, in a certain sense, both artists do suggest a different kind of planar painting. Sam Gilliam has been represented in several planar-painting exhibitions. Alan Shields, on the other hand, according to one critic, seems to retain his one-man-movement status as an artist "trying to destroy all barriers between life and art."[46] Thus, "the activity of his art making has become inseparable from the craft of living"[47] **[83]**.

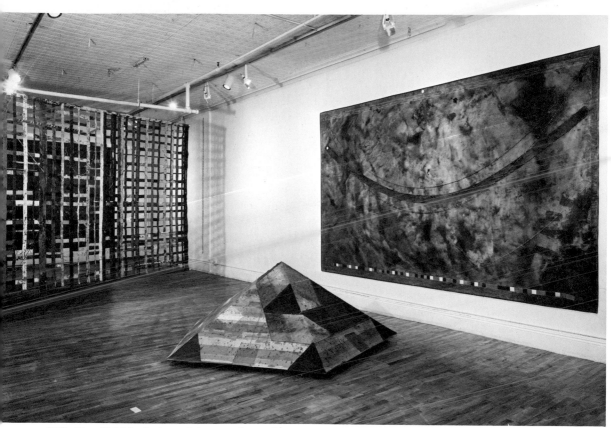

[**83**] Alan Shields. Left to right: *Devil, Devil Love; Whirling Dervish; S.P.*

Alan Shields's paintings are full of dots, circles, arcs, and signs like traffic lights across a landscape of pyramids and cubes. The works are never symmetrical, and they have passages that remind one of Miró's Surrealistic images, or perhaps of Spanish folk art. Color is achieved as often by dyeing pieces of material as by applying pigments to specific areas. Through the decade of the seventies, the work underwent few changes. But Shields has moved on to other materials through which to record his imagistic medium. For example, in 1971, he began making silkscreen prints at a workshop near Madison, Wisconsin, which were an elaboration of his watercolors and drawings.

Shields was born in Harrington, Kansas, in 1944, and although he attended Kansas State College, for the most part, he is a self-taught artist. All of his work involves the revitalizing of materials, and emphasizes a handmade, nonmechanical, nature-oriented attitude toward life and art. Shields lives apart from the New York art community, on an island off the north shore of Long Island, where he works as a professional fisherman. In both his prints and paintings he incorporates techniques such as dyeing, sewing, and flocking. His aim in the prints as in his wall works is always toward greater personalization, intimacy, and immediacy. In 1971, the work was described as the product "of an ultrasophisticated Southwestern cult devoted to

self-anthropology."[48] But another, perhaps more accurate, way of looking at Alan Shields's work is as a translation into art of the ideas and impulses of the hippie culture which was adopted by a generation of younger Americans in the late sixties.

The planar works of Frank Stella were a subject of constant controversy throughout the 1970s. Whereas Shields's work could be described as being about a state of mind, Stella's oeuvre in the 1970s was about a state of change. Stella, the Minimalist painter par excellence, the volatile leader of a school of "cool" abstract art, by 1966 had already made works that differed sharply from the straightforward configurations of his all-black paintings of the early sixties and his green-and-tan pinstriped shaped canvases of the first part of the decade. In fact, 1970 becomes a cutoff point for Stella. It was the year he had a full-scale retrospective exhibition of his work at New York's Museum of Modern Art, with a book-length catalog by the museum's director, William Rubin. After the exhibition, and following the short period when he was hospitalized with a knee injury, Stella ceased using stretcher bars as painting supports and began gluing his canvas directly onto cardboard, and then made paint and collage works on cardboard, wood, and finally honeycombed aluminum.

Born in Malden, Massachusetts, in 1936, Frank Stella studied painting at the Philips Academy with Patrick Morgan, and art history at Princeton University with William Seitz and Stephen Greene. He moved to New York City in 1958, where he has lived ever since.

The works of Stella since 1970 have been divided as follows: a Polish series, or *Polish Village* series, consisting of relief paintings made from 1971–1973; the Brazilian series, works done on honeycombed aluminum that were planned in 1974 and executed through 1975; the *Exotic Birds* built and painted in 1976 and 1977; and, finally, the artist's *Circuit Paintings,* begun the second half of 1979 and shown in 1981 and 1982.[49] The art world reactions to Frank Stella's stylistic changes follow very closely this description by Philip Leider: "Every artist who hopes to attain a major change of style, within abstraction especially, must prepare himself for a period in which he will have to 'compromise with his own achievement.' During this period he can expect to lose friends and stop influencing youth, and discover he has 'fallen off,' 'retreated,' experienced 'a failure of nerve,' become confused."[50] The reaction to Stella's *Polish Village* paintings, and then the Brazilian works and the *Exotic Birds* was exactly as Philip Leider wrote. The primary fact about Frank Stella in the seventies was that he insisted on remaining a developing artist and refused to arrive and remain at a fixed painting style. His work has literally come farther and farther out from the wall without leaving the domain of painting. The 1971–73 *Polish Village* paintings are now described as "constructivist," in the "constructivist tradition," made in the period when Stella "entered the territory of Constructivism."[51] These works are relatively flat, simple wall reliefs, which actually repeat many of the configurations in the artist's 1966 geometric shaped-canvas paintings. The *Polish Village* series involves tilted planes and directional stripes in flat, almost bland colors. These are in some ways the

most historically oriented works of Frank Stella's career to date. Full of Constructivist and architectural references, in their use of interlocking tongue-and-groove forms, the works, according to the artist, are based on the configurations of now-destroyed wooden Jewish synagogues of eighteenth- and nineteenth-century Poland. Stella even uses the place names of these synagogues for the sober green, yellow, maroon, and sky-blue works that constitute the series. After completing forty of these paintings, Stella began a new group, his Brazilian series, whose forms were fabricated in honey-combed aluminum and then painted in different styles and textures to introduce new ideas of surface illusion. The 1975 Brazilian works in brilliant purples, blues, scumbled pinks, yellows, and whites are works that still adhere fairly close to the wall, uniting fairly closed arrangements of Constructivist planar shapes. In the series, Stella kept to a standard geometric vocabulary of rectangles, triangles, and rhomboids. The painting frame seems implicit, while surface combinations of different painting effects challenge the viewer to keep up with the artist's visual synthesizing. Stella's emphasis here is on illusionary painted surfaces rather than structural innovation, to the point of painting two different versions of the same built-out aluminum form. This is the very opposite of the artist's approach in his 1976 *Exotic Birds* works. Here, Stella's relief constructions include curling tentacle forms, stepped-out rectangles and inward-tilting French curves angled onto the painting form. It is only because these works are resolutely frontal, and are comprehensible only when seen straight on, that they remain in the domain of painting. The reaction to these works was quite mixed. The critic Jeff Perrone complained that "Frank Stella had deliberately set out to infuriate the people who found his aluminum paintings last year some of the best modernist paintings ever."[52] According to Perrone, the new Brazilian work was "so large that it obliterates our orientation to the wall by being as big as the wall." And, "there are large gaps of space between parts, unlike the paintings last year—space that remains dead and empty because Stella has not seen fit to deal with it. . . . The drawing that fills in the plane is also done at random, and it usually occurs over a layer of glitter mixed with acrylic."[53] It seemed, even for such an aficionado of the decorative as Jeff Perrone, that Stella's adhering glitter to his surfaces was going too far. One of the things that Stella does in such works as his 1976 *Puerto Rican Blue Pigeon* and *Eskimo Curlew* is to reintroduce questions of the Abstract Expressionist surface and ambition into painting. According to Noel Frackman, the works' "staggered sense of angled rectangles subverts the idea of the existence of any single picture plane and, beyond that, the very nature of the space of abstract expressionist painting. In these works there would seem to be at least three picture planes or maybe four, if we include the curved rectangular forms themselves."[54] But these multilevel spatial complications aside, Stella's use of glitter, baroque French-curve forms, and combinations of the heroic gesture of the artist's touch in his scumbled and painted surfaces (which by themselves seem to reverberate with the weight of their Pollock-like configurations) add up to an affront of total physicality. Compared to the 1977 *Exotic Birds* reliefs,

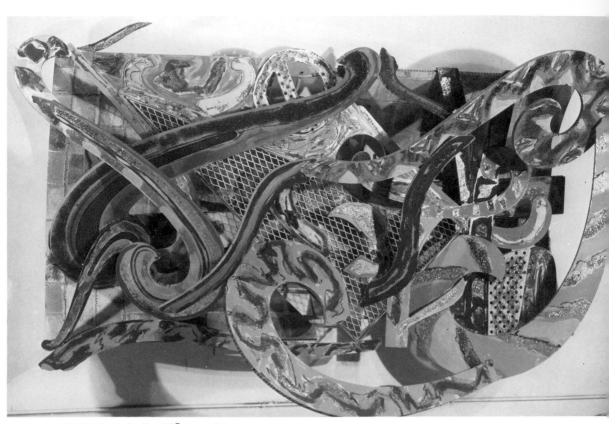

[84] Frank Stella. *Shāma.* 1979.

"the (1974–75) Brazilian series maintained a straightforward clarity in the interplay between color and large spatial relation."[55] But Stella had set clarity of this sort aside in favor of gesture, and critics alternately applauded and scolded the artist for reintroducing this kind of Abstract Expressionist vocabulary into contemporary painting.

With Stella's next works, the *Indian Birds* series of 1977–78, viewers were "exposed to the most intense and energized art works extant," Frackman wrote, observing that, by contrast, "a firm structure was maintained in the Exotic Bird series."[56] With each subsequent series in the late 1970s, Stella seemed to be moving further and further from painting concerns. And, in fact, the 1980–81 *Circuit* reliefs were rid altogether of any suggestion of rectangular painting space, of all painting and framing edges; from their underlying grid support they extend out as much as a foot and a half from the wall. The *Circuit* relief paintings were named after automobile race tracks around the world, and are concerned with speed and change, which Frackman sees as being presented "within a landscape canvas." To myself, Stella's use of projecting shapes to create a shallow rather than a deep painting space seems to hark back to Cubism, and follows Cubist geometric space more closely than, say, some of Jackson Pollock's calligraphic drip paintings. The *Circuit* works present a medley of interlocking forms, color surfaces, and configurations which demand the viewer

stop and spend time looking in order to comprehend them. These fast-moving works, through their shifting shapes and opposing colors, cannot be seen at a glance but require stillness and concentration. To use and refer to Cubist space while simultaneously dispensing with the canvas edge, which was its governing factor, would seem to justify the notion of making planar works that set up a new, canvas-like relationship with the wall **[84]**.

Throughout the 1970s, Frank Stella documented each painting series by making successive corresponding prints that can serve as a reference point to his development. These prints of course have an illusionistic rather than a planar dimension. In 1982 Stella made a set of color relief etchings, together with a series of black-and-white engravings which aimed at introducing into prints the relief qualities of the different spatial levels achieved in his *Circuit* series. The black-and-white works titled *Swan* engravings were run off from printing plates built by Stella from discarded pieces of the *Circuit* reliefs—pieces which, in effect, he collaged together. In these works, we seem to find ourselves back once more at the beginning of abstraction. In his *Swan* engravings, Stella traced his lineage back to the early Cubist masters and made us see how far, by the eighties, we have traveled and how circuitous the route of abstract art can be.

Ralph Humphrey, like Frank Stella, had a long history as a Minimal artist in the 1960s. In 1957–60, he made monochrome paintings, and then moved on to "frame" works and shaped canvases at the end of the decade. "I've always been interested in pushing paint into the room space," he has explained. "At one point (in the minimalist paintings of 1964–65), I wanted infinite space so I used very pale colors which you could hardly see, trying for this endless space you look into," Humphrey told an *Artforum* interviewer.[57] A little later, he became interested in actual, that is, literal, space and moved outward, making the paintings into specific objects. These planar works, or "constructed paintings," which he began building in 1971, were first made by pasting one canvas on top of another, as he painted one plane over another, creating a new space. "The move was in part intended to convey the attitude that painting can be convincing now only if it is evidently constructed in every respect," Kenneth Baker wrote, explaining that in Humphrey's work "to make a painting is to assert something in physical terms."[58] In this respect, Humphrey preceded Stella, by using his constructed surfaces as a building platform for his thickening brush stroke. As I wrote in an introduction to a planar painting exhibition, "Today, on his thickly painted surfaces Humphrey attaches architectural fragments, embeds them in the paint and builds out, in turn, real shapes that make a perspectival illusionistic statement *vis-à-vis* his rectangular surface. One looks across and down into a Humphrey painting as though looking down on an elevation. The reality of the raised wood shapes both as place markers and as forms further actualize the painting's planar dimension. In the 1977 *Rainbow Grill* and 1979 *Decade* **[85]**, the attached shapes are real, the structure

[85] Ralph Humphrey. *Decade.* 1979.

is that of a real object and the color is an integral part of this reality, built into a rich thick crust that makes it also part of the form. And, in them, there is also the abstract play of squares and rectangles which suggest allusions to buildings and courtyards, to imaginary archetypal houses, which seem to emerge, to raise themselves from Ralph Humphrey's encrusted surfaces."[59]

Ralph Humphrey was born in Youngstown, Ohio, in 1932, and graduated from Youngstown University in 1956. He had his first one-person exhibition at the Tibor de Nagy Gallery in New York in 1959, and was subsequently described as "a romantic minimalist." The years 1970–71 marked a change in his approach not only to planar construction but also to the use of color as surface texture. In his first early wood paintings, Humphrey began by making very dark, somber all-blue-and-black works, literally painting in color layers. "I want," he explained, "each of my colors to exist on their own, not to fudge. . . . For Mondrian the realism of paint as part of the subject provided a physicality which I relate to my work."[60]

All of Humphrey's surfaces are built up by thick coatings of coarse modeling paste, followed by a fairly uniform underpainting which in the beginning of the 1970s was usually black or blue, but by 1974 was more often red. The undercoat established a key for Humphrey's layered strokes of complementary colors, which he applied to the paste coating. Thus, according to one reviewer writing in *Art in America,* Humphrey's colors achieve "duration and intensity, its wavelets scintillate and dazzle."[61] There are no solid planes of color; rather, shifting color points in various all-over chromas come from Humphrey's window-like and/or outside the window street view paintings that are all boxlike projections standing out from the wall. On them, not only their color, but their small attached wood rectangle forms appear to shift. One is aware of a color, of the prominence of a pink or blue tone played against a red or orange in the later works, but this color is always embedded in the surface, seeming to come up from the work's understructure. Meanwhile, another superimposed illusionary structure of window frames and door openings, suggestive of looking in and out, emphasizes the fact that Humphrey's constructed paintings are works from the 1970s, a time when it was fairly well established that, since painting was no longer essential as a window on the world, it should become a thing, an object unto itself. In Ralph Humphrey's and Frank Stella's hands, this painting object possesses enormous mystery, becomes a work of continuing fascination.

In 1977, the name "constructs" was given to paintings similar in intent to those by Stella and Humphrey, and were being made by a group of younger artists. The 1977 exhibition of Stella's *Exotic Birds* became a public confirmation of the direction younger painters such as Stuart Diamond and Barbara Schwartz had already privately embarked upon. These younger artists, in part, were reacting against Minimalism and trying via the planar surface to bring a new energy into painting, by literally moving it out from the wall. The example of Stella on the one hand, and Ralph Humphrey on the other, became a kind of permission which was seized upon by many artists. "The planar dimension is the painter's dimension," wrote Margit Rowell in the introduction of the catalog for *The Planar Dimension: Europe 1912–1932* at The Guggenheim Museum in 1979. This show was in part an effort to provide background for the younger American planar painters, to give their work credence and history.

Barbara Schwartz and Stuart Diamond express two extreme directions undertaken by the younger artists. Schwartz built her relief works out of casein on Hydrocal, making two-sided object pairs on the wall. These reliefs had different lateral coloring and were built so that the shadows of their forms played a part in their frontal expression. Stuart Diamond, by contrast, continued working within a large (sometimes implicit) rectangular space, using found objects and collaging his works on a scale and dimension which, while harking back in feeling to the assemblages of Kurt Schwitters, at the same time took in and summed up all the ideas about junk sculpture in American art in the preceding twenty years.

Stuart Diamond is one of the few artists among the younger planar painters to

use concrete images—a small boat, a part of a chair, a hat mold, a toy bird—all of them are objects he found in the streets of SoHo. As Diamond himself has said, he often begins with other artists' leavings—old stretcher bars, discarded bits of machinery. All these objects, though, lose their original associations; through repainting and recycling they take on strange new guises and enter and become part of Diamond's landscape, where they form new abstract relationships, join onto other shapes and, in turn, assume new significance. "The work done in the 70s," Diamond has explained, "started out as a need to slow down the speed of the large gestural paintings on canvas I had been doing. These paintings had become more physical and required a different format to handle the increasing weight and numbers of materials applied to them. Found wood and materials from the street became the elements for drawing and building the new structures."[62]

Stuart Diamond was born in New York City in 1942 and grew up in Brooklyn, where he earned the B.F.A. degree from the Pratt Institute in 1963. One of the organizers of the 1977 "Constructs: 55 Artists" at the Bleecker Street Renaissance Building, and a participant in many group shows, including the Whitney Biennial of 1973, Diamond had his first uptown solo exhibition at the David McKee Gallery in 1977. *Above and Below* [86], the piece which was reproduced on the announcement of the exhibition, is a work made in 1976. It measures 71 × 65½", and is perhaps typical of the assemblage planar works the artist made from 1974 through 1979. *Above and Below* is at once both old and new in conception, filled with references going back "some 60 odd years to Picasso's 1912 Guitar constructs, not only in terms of physical shape, but also in terms of breaking free of an actual picture frame. The movement of the painting's opening back or emptying on to the wall, and its contrasting movement forward in terms of layering specific wood shapes built onto the work's 'frame' portions testify to the complexity of Diamond's spatial conception. Also impressive is the amount and variation of color and of physical surface treatment, ranging from leaving bits and pieces in their original wood and metal coloration to stippling, building edges up and out with acrylic paints and plasters that focus on the visual activity of a live (i.e. non-fictional) surface in the process of being transformed by paint materials. The work, while actually extending only six inches from the wall, takes us into the concept of limitless space, but a space unlike Sam Gilliam's or Ralph Humphrey's because it always refers to a behind, a backward as well as a forward movement." Since the 1974–79 works, however, Diamond's surface has become more filled-in so that the wall behind becomes almost invisible even while the dimensions of the actual paintings increase.

Barbara Schwartz in 1973 began using wire laths and Hydrocal (plaster) and casein paint to make circles like broken discs, and then played these plaster shapes against the open spaces of the wall. From the beginning, form and color were of equal import. Born in Philadelphia, Schwartz received her B.F.A. degree from the Carnegie-

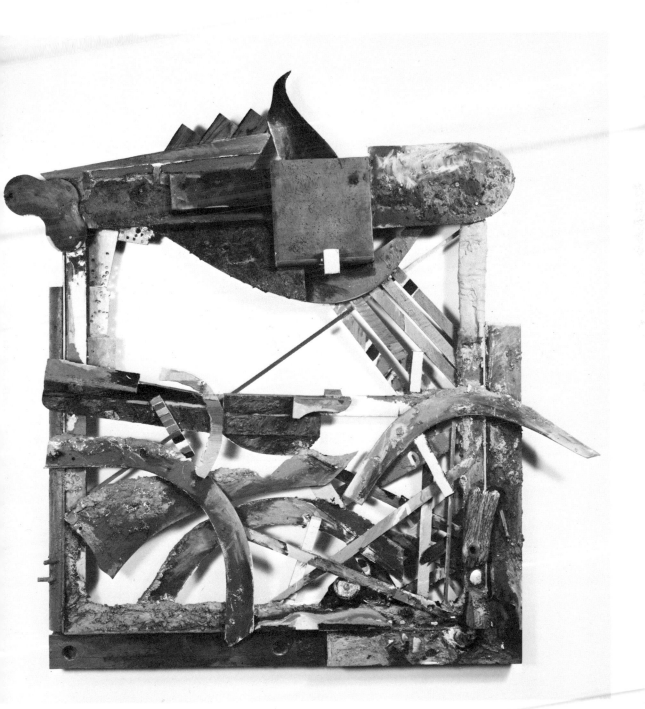

[86] Stuart Diamond. *Above and Below.* 1976.

Mellon Institute in 1970. She started out as a painter, discovering plaster only after she came to New York in 1972; her plaster pieces were shown in her one-person exhibition at the Artists Space Gallery in New York in 1975. That same year, Schwartz began a series of constructs she called the *Disquenella* series, which consisted of a group of plaster pieces curving out from the wall like shields. In the *Disquenella* works, the curving plaster field becomes the ground for illusionary painted geometric shapes whose contrasting colors of blues and darker blues and grays are literally soaked into the painting's material structure. "It was the satisfaction of making her own materials to paint on which led the artist to stop using the rectangle." In 1976, Barbara Schwartz embarked on building a second series of forms, which she titled the *Affinbandi* series. "Affinbandi is a composite of two words, affinity and bandit or 'a banding together,'" Schwartz has explained, adding that of course the most important thing about the new series was that the elements actually remain separate, confronting each other across at least six inches of wall space. The play of shadow also was important in these double hornlike works that have something of an atavistic feeling, suggesting primitive African sculpture in the way they thrust out from the wall. Schwartz deliberately made a double-faced painting of each surface: the outer side being one color, the inner another, with the inner surface of the second side occasionally matching the outer side of the first. Schwartz, whose works were exhibited next to those of Ralph Humphrey in the 1977 Whitney Painting Annual, has had successive one-person exhibitions at the Willard Gallery in New York from 1976 through 1981.

Planar artists such as Barbara Schwartz and Stuart Diamond, together with Ralph Humphrey, Sam Gilliam, and Frank Stella, represent only a small part of the 1970s approach to abstract three-dimensional painting. Many Decorative artists, described in a previous chapter, had similar approaches to color and movement on a three-dimensional plane. Indeed, Frank Stella's relief paintings were included in not a few Decorative exhibitions of the period, and the lines between abstract painters, Decorative artists, and flat painters are far from fixed. Also, other abstract artists, such as Al Held and Richard Pousette-Dart, who had major exhibitions beginning in the 1960s, continued to develop their own unique approaches to abstraction, and the period was full of differing and complementary painting voices. In abstraction, as in all areas in the decade, no one way or manner can be said to have prevailed.

NOTES:
ABSTRACTION: PLAIN AND PLANAR
PAINTING

1. Linda Shearer, *Brice Marden,* exhibition catalog, The Solomon R. Guggenheim Museum, New York, 1975, p. 28.
2. *Ibid.,* p. 12.

3. Maurice Poirier and Jane Necol, "The '60s in Abstract Painting: 13 Statements . . . Brice Marden," *Art in America,* Oct. 1983, p. 122.
4. Scott Burton, "Reviews and Previews," *Art News,*

Feb. 1968, pp. 14–15.

5. Linda Shearer, *op. cit.,* pp. 19–20.

6. Edit de Ak *et al.*, *Art-Rite/Painting,* No. 9, Spring 1975; "Conversation with Brice Marden," pp. 39–42.

7. See Carter Ratcliffe, "Abstract Painting, Specific Spaces: Novros and Marden in Houston," *Art in America,* Sept./Oct. 1975, p. 85.

8. Corinne Robins, "Empty Paintings," *SoHo Weekly News,* Apr. 22, 1976, p. 19.

9. John Russell, *Richard Diebenkorn*, exhibition catalog, Marlborough Fine Arts, London, 1973, p. 8.

10. Robert Hughes, "Art," *Time magazine,* June 27, 1977, p. 58.

11. From the author's conversation with the artist, New York, June 1977.

12. *Ibid.*

13. Artist's statement issued by the Susan Caldwell Gallery, 383 West Broadway, New York.

14. Author's conversation with the artist, May 1975, New York City.

15. Author's conversation with the artist, April 1978, New York City.

16. Corinne Robins, "Light in Another Environment: The Paintings of Virginia Cuppaidge," *Arts Magazine,* June 1978, p. 154.

17. Author's conversation with the artist, May 1978, New York City.

18. Corinne Robins, *op. cit.,* p. 155.

19. Roberta Smith, "Elizabeth Murray at Paula Cooper," *Art in America,* March/Apr. 1977, p. 114.

20. Jeff Perrone, "Elizabeth Murray at Paula Cooper," *Artforum,* Jan. 1979, p. 65.

21. Allan Schwartzman, "Elizabeth Murray Interview," in *Early Work by Five Contemporary Artists,* exhibition catalog, New Museum, 1977, unpaged.

22. *Ibid.*

23. Jesse Murray, "Quintet: The Romance and Order and Tension in Five Paintings by Elizabeth Murray," *Arts Magazine*, May 1981, p. 61.

24. Corinne Robins, "Deborah Remington: Cool Fire," *Arts Magazine,* Oct. 1975, p. 50.

25. Corinne Robins, "Deborah Remington: Paintings Without Answers," *Arts Magazine,* Apr. 1977, p. 142.

26. Quoted in *Milton Resnick: Selected Large Paintings.* exhibition catalog, Fort Worth Art Center, 1971, unpaged.

27. Robert Hughes, "An Iron Will to Form," *Time* magazine, May 29, 1972, p. 64.

28. Harris Rosenstein, "The Fathomless Field," *Art News,* Nov. 1971, p. 69.

29. Corinne Robins, "Milton Resnick," *Arts Magazine,* Sept. 1977, p. 2.

30. Robert Hughes, *op. cit.,* p. 64.

31. Harris Rosenstein, *op. cit.,* p. 69.

32. Corinne Robins, "Milton Resnick," *op. cit.,* p. 2.

33. *Ibid.*

34. Joan Marter, introductory essay, *Beyond the Plane: American Constructions 1930–1965,* exhibition catalog, New Jersey State Museum, 1983, p. 8.

35. Corinne Robins, "Constructs and Animals," *Arts Magazine.* June 1978, p. 18.

36. *Ibid.*

37. Carter Ratcliffe, "The Paint Thickens," *Artforum,* Summer 1976, pp. 43–45.

38. Jeanne Siegel, "Recent Colored Reliefs," *Arts Magazine,* Sept. 1978, pp. 152–154.

39. Corinne Robins, *Planar Painting: Constructs 1975–1980,* exhibition catalog, Alternative Museum, New York, 1980, unpaged.

40. Jay Kloner, "Sam Gilliam: Recent Black Paintings," *Arts Magazine,* Feb. 1978, p. 151.

41. Corinne Robins, *Planar Painting, op. cit.*

42. Jay Kloner, *op. cit.,* p. 150.

43. *Ibid.* p. 151.

44. Elsa Honig Fine, *The Afro-American Artist* (New York: Holt, Rinehart and Winston, 1973), p. 225–26.

45. Grace Glueck, "Alan Shields," *New York Times,* Nov. 29, 1970, p. 15.

46. Lizzie Borden, "Alan Shields," *Artforum,* Dec. 1972, pp. 87–88.

47. *Ibid.*

48. Grace Glueck, *op. cit.,* p. 15.

49. Cited in Philip Leider, *Frank Stella Since 1970,* exhibition catalog, Fort Worth Museum, 1978.

50. Philip Leider, *op. cit.,* p. 96.

51. *Ibid.,* pp. 94–95.

52. Jeff Perrone, "Review," *Artforum,* Dec. 1976, p. 74.

53. *Ibid.*

54. Noel Frackman, "Frank Stella's Abstract Expressionist Aerie: A Reading of Stella's New Painting," *Arts Magazine,* Dec. 1976, p. 125.

55. Noel Frackman, "Tracking Frank Stella's Circuit Series," *Arts Magazine,* Apr. 1982, p. 134.

56. *Ibid.*

57. Amy Baker, "Painterly Edge: A Conversation with Ralph Humphrey," *Artforum,* Apr. 1982, p. 38.

58. Kenneth Baker, "Ralph Humphrey," *Artforum,* Sept. 1980, p. 63.

59. Corinne Robins, "Planar Painting: Painting Constructs 1975–1980," in *Planar Painting, op. cit.*

60. Amy Baker, *op. cit.,* pp. 40–41.

61. Elizabeth Frank, "Ralph Humphrey at Willard," *Art in America,* Summer 1980, p. 157.

62. Corinne Robins, *Walls of the 70s,* exhibition catalog, Queensborough Community College, 1983; artist's statement, p. 8.

8

Photography, Video, and Performance

Photography became part of the world of painting and sculpture in the 1970s. Before that, it existed—and for some, continues to exist—as a separate entity with its own magazines and galleries. In the 1970s, magazines such as *Artforum* and *Art in America* devoted whole issues to photography and/or incorporated articles on photographers into their overall art coverage. Meanwhile, the medium itself seemed to grow more eclectic. Photographers as artists, artists who used photography only as data or for documentary purposes, artists who altered photographs and "transformed them into art," artists who created situations and/or landscapes for the camera, even the discovery of the movie still as an art form—all these just begin to indicate the kinds of camera work that were reviewed and widely discussed. Susan Sontag's essays on photography began appearing in 1973 and were a subject of instant controversy. Her book of these pieces, titled *On Photography* published in 1977,[1] presented to the general public one intellectual's estimate of photography's "moral weight" as an art form as compared to, say, that of literature, painting, or sculpture. Also, in 1977 the *Aperture History of Photography* issued its first six volumes, making photography's historic importance suddenly seem incontrovertible. Nevertheless, many people's unwilling acceptance of the camera as an art medium persisted. Two years later, in another of *Art in America*'s special sections devoted to photography books, the artist and critic Peter Plagens blandly proclaimed: "In photography, as everyone knows, content is 90 percent of the ball game. To get good subject matter, you find it. This makes photography the only art form in which shopping is considered a talent."[2] But Plagens's statement, to me, underscores the major difference between 1970s photographers and many of their predecessors. In the 1970s, what A. D. Coleman described as the "Directorial Mode"[3] became very important in contemporary photography. Many photographers concentrated on making up or creating scenes for the camera

in terms of their own inner vision. To them, reportage as such had become the job of the video artist, who had the heritage of *cinéma vérité* behind him. To the 1970s camera people, realism belonged to the earlier history of photography and, as seventies artists, they were embarked on a different kind of aesthetic quest. It was not, however, the romantic symbolism of photography of the 1920s and 1930s, with its emphasis on the abstract beauty of the object, that had caught their attention, but rather a new kind of concentration on narrative drama, on the depiction of time changes in the camera's fictional moment. The photograph, instead of being presented as a depiction of reality, was now something created to show us things that were felt rather than necessarily seen. Thus, the camera took on both drama and dream as its province.

Duane Michals, it is generally agreed, is the person "who pioneered the photographic serial narrative."[4] Before "story art" was coined by the post-Conceptual art world, Michals began working on narrative sequences in the late 1960s—sequences that focused on superrational subject matter, on surreal connections that deliberately place in question the fictional camera image. Michals's work from the mid-1960s through 1980 was one of continuous exploration of his medium's implications. In 1974, for example, Michals began introducing handwritten captions, sometimes above his photographs as titles, sometimes below, so that the sequential picture story simultaneously also offered a verbal narrative that might or might not be true. Certainly, the photographs that accompany Michals's written text seem to comment on the words in such a way that the photographic and verbal images don't quite match reality. Michals's words change what we think we see in the picture, and the photo image in turn seems to question the artist's handwritten message. In 1981, Duane Michals began painting certain objects onto his prints so that the very surface of the photograph is interfered with and reclaimed by the artist. As with Michals's 1982 *The Letter,* in each case, with each stylistic alteration, the artist raises new questions with regard to the camera as an aesthetic and/or truth-telling medium.

Duane Michals, born in McKeesport, Pennsylvania, in 1932, graduated from the University of Denver in 1953. Five years later, in 1958, on a trip to Russia, someone lent him a camera and Michals began taking pictures—first of streets and buildings, then of Russian sailors, peasants, and children, all of whom were willing subjects. Thus, at the age of twenty-six, Michals discovered his profession and, beginning as a photographer-journalist taking essentially documentary pictures, supported himself for the next fifteen years doing fashion and magazine work. In his book *Real Dreams,* published in 1977, Michals sums up his experience as follows: "Some photographers literally shoot everything that moves, hoping somehow in all that confusion to discover a photograph. The difference between the artist and amateur is a sense of control. There is great power in knowing exactly what you are doing, even when you don't know."[5]

[87] Duane Michals. *Things Are Queer.*

 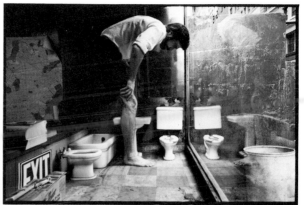

In the mid-sixties, Michals decided to create his own stories in photographs by setting up a plot line or idea and then making a series of photographs about and around it. In his 1969 sequence titled *Chance Meeting,* the viewer is presented with a sequence of six photographs, which begin with two dark-suited men walking toward each other from opposite ends of a littered city street. The men approach, pass, and then, in turn, each looks back in the direction of the other. The last frame presents the figure whose back has been toward the camera turned in the direction of the other, now vanished, man. The story is implicit and completely open-ended. In *Chance Meeting,* the viewer knows neither whether an actual meeting took place, nor, in fact, whether the two men were in some way already acquainted. In the sequence we have witnessed a "sighting" by two men on a city street. We know nothing except the possibilities of a story that the photographs and title project. In 1970, Duane Michals's first book, *Sequences* (published by Doubleday and Company), which included *Chance Meeting,* according to the critic Jonathan Crary "created a haunting set of modern fables . . . each consisting of six photographs with titles like *The Fallen Angel, The Defenseless Act* and *Death Comes to the Old Lady.*"[6] These works, Crary observed, "stay within a conventional narrative syntax whose very straightforwardness often is played against the enigmatic content of his fictions."[7]

In 1973, Michals produced a somewhat longer narrative work, titled *Things Are Queer,* in which, by moving the camera close and then far away, he transforms what first appears to be a normal-sized set of bathroom fixtures—tub, toilet, douche, and sink—into a set of miniature doll's furniture by introducing what first appears as a giant-sized man's leg into the photograph. The bathroom fixtures in Michals's third picture prove to be miniature pieces, and in the fourth are reduced to a photographic reproduction on the page of an open book. Michals subsequently presents us with the man reading the book, and the sequence continues until the photograph of the man reading the book picturing the bathroom is seen framed as a picture decorating part of the space allotted to the original bathroom fixtures. The title, *Things Are Queer* [87], serves to underline the effect of the series rather than explain or alter it; the work was published in book form in Germany in 1973. The next year Michals showed his first photographs with captions, with lines of handwritten words appearing in the bottom margin of his prints. These works were shown at the Light Gallery in New York in 1974 and 1975. The 1975 exhibition consisted of ten sequences of photographs, seven of which relied on handwritten captions. Some of Michals's most powerful work, however, consisted of single captioned photographs. One, titled *Self-Portrait with My Guardian Angel* [88], showed Michals with a specter-like double created by a double exposure. This specter Michals named "Pete" and described as follows at the bottom of the print: "His name is Pete. He was born in 1898 and died in 1930. Pete had been a merchant seaman all his life, and he drowned in the North Sea in a terrible storm. In his life he never became what he might have been. He guides me and watches over me."[8]

My guardian angel's name is Pete. He was born in 1892 and died
in 1932. Pete had been a merchant seaman all his life, and he drowned
in a terrible storm in the North Sea. ~~In his~~ lifetime he never
became what he might have been. Pete guides me and watches over me.

[88] Duane Michals. *Self-Portrait with My Guardian Angel.* 1973.

Michals had an eighteen-year retrospective exhibition at the Sidney Janis Gallery
in New York in 1976. This exhibition consisted of 130 photographs, dating from 1958
through 1976, which included Michals's *Photo-Portraits & Street Scenes/Sequences:
Black & White and Color/Photographs with Text/Text without Photographs.*[9] The
gallery catalog printed an excerpt from Michals's book *Real Dreams,* which read:
"Everything is subject for photography, especially the difficult things in our lives:
anxiety, childhood hurts, lust, nightmares. The things that cannot be seen are the most
significant. They cannot be photographed, only suggested."[10] It seems to me that it
is in this area, of photographing the things that cannot be seen, that Duane Michals
has been a pioneer figure. In 1982, for example, he began producing painted photo-
graphs such as *The Letter,* which deliberately combine two aesthetic (painting and
photography) unrealities. This is a territory which has interested a great many people
—artist-photographers and photographer-artists such as Lucas Samaras, Eve Sonne-

man, Robert Mapplethorpe, and Sandy Skoglund—who have worked, via photography, to change our notions about ourselves and what we think we know as the boundaries of our reality as well as to explore new possibilities inherent in the photography medium itself.

Of course, the investigations into the aesthetic possibilities inherent in film carried out by the Surrealist artist Man Ray in Paris in the thirties and forties provided the ground for the experiments of artists such as Lucas Samaras during the 1970s. Samaras, whose work has had a Surrealist content and/or edge evident even in his earliest sculptural transformation works, has from the beginning been preoccupied with the unseen, uncontrollable side of real objects. From 1959 on, the artist has used kitchen utensils, china, cotton, and hardware in various "food" and "room" works. By 1963, Samaras had embarked on his first series of boxes, small intimate works using colored yarn and containing photographs of Samaras himself. For him, the world and his work centers on the self. In 1972, Samaras had a two-floor retrospective at The Whitney Museum of American Art which included rooms full of *Transformation: Chair* pieces, boxes, and a room-sized mirror box in which the viewer could behold himself endlessly multiplied on the floor, the ceiling, and in a mirrored table that literally vanished into the surrounding reflections which it, in turn, reflected. Neither a straightforward conventional sculptor or painter, Samaras appeared in this exhibition to be the ultimate transformer-magician of ordinary objects into art. His identifying "stamp," in bands of rainbow colors, use of sharp pins, of sharp-pointed scissors and chairs converted into decorative objects, and his status as an eccentric artist-outsider seemed confirmed by the museum show. But most of the works included had become familiar through the years, and to some extent tied Samaras to the middle to late sixties, when they were first exhibited. But what was to make Samaras an important figure for the 1970s also became clear at the Whitney—specifically in the form of two narrow rooms whose long walls held a series of the artist's auto-Polaroid works. These auto-Polaroids, which Samaras first started making of himself and his own body in 1969, were at first startling, and then became emblematic of the 1970s interest in the self. Narcissism and the "me decade" have been labels for this period but in Lucas Samaras's camera work we are confronted with the fact that vanity and narcissism and/or preoccupation with the self can be made into a voyage of discovery, that the self in such self-referential works can indeed, in Walt Whitman's words, "contain multitudes."

Lucas Samaras, who was born in Macedonia, Greece, in 1936, came to America in 1948, and graduated from Rutgers University in 1959, began making his first Polaroid pictures in 1969. After acting in Happenings, making pastels, and doing a series of transformations of rooms and boxes, in 1969 Samaras also began his first *Transformation: Chair* work and did a film with Kim Levin entitled *Self.* The film and the auto-Polaroids to me seem interconnected. The impersonality of the photogra-

phy/film mediums must have presented itself as a challenge to Samaras—both in terms of the impersonality on the one hand, and the possibility for self-communion on the other. "I wait until dark before I take out the camera," Samaras has said. "Fewer interruptions. Nostalgia, cuddliness and other warm feelings of the night envelop my psyche and chase away logic, anxiety and the needs of other people. I have the radio or TV on as an emotionally steady artificial waterfall. It camouflages extraneous sounds from other apartments," he wrote in an essay titled "I Use the Whole Body,"[11]

In another instance, Samaras noted, "What I really wanted to be was an actor. Basically, I'm a performer."[12] Samaras's auto-Polaroids of 1970–71 demonstrate this facet of the artist's personality, at the same time that they show what Samaras can do and make out of a narcissistic preoccupation with the self as erotic subject matter. Mirrors lie. The camera lies, and Samaras with his first auto-Polaroids (a term the artist coined himself) set out to prove that in his hands the camera can be a fabricator of major fantasies. The photographs are small, $3 \times 3''$, and the first series was done from 1970 to 1971; the second, using another camera, known as the SX-70, Samaras made in 1973 and 1974 and titled "photo-transformations." Both series feature the artist naked performing for and at the camera. In these works, Samaras, of course, is not only performer, but editor, art director and, finally, transformer of the final Polaroid print. The first auto-Polaroids, collected in the *Samaras Album,* were published by The Whitney Museum with the Pace Gallery in 1971. These prints display a naked Samaras crouching, dancing, and posing, holding two chairs aloft against a dot-painted backdrop. Samaras, the camera man, uses double and triple exposures of his body, fades images of his hands in and out of the holes in his furniture, transforms his face into a phallus and becomes, after Marcel Duchamp, his own female persona. He seems endlessly inventive in making gestures to alternately seduce and repel the viewer. Finally, even Samaras dancing with his own image, acting the part of his own double and lover, becomes a clue to the dilemma that seemed to pervade human relationships during the decade.

In Samaras's 1973–74 series of photo-transformations, the artist goes even further, and interrupts the picture in the very process of its being born. Samaras draws, scratches, and even paints on the photoemulsion while it is still undergoing chemical development. Thus, each of these photo-transformations, done within a period of five minutes, offers a metamorphosis of the Samaras self achieved either through manipulation of the subject by lighting, gesture, and focus, or through manipulation of the medium, by the artist's drawing on the still-wet photoemulsion to the extent where the image begins to resemble a still from a Surrealistic film. Some of the later photo-transformations, indeed, seem to have the ultra-literalism of Freudian fantasy symbols, and in Samaras's 1975 photo-transformations,[13] many of the prints seem a rather self-conscious presentation of artist-plus camera effects. We watch Samaras turn into

"a Kafkaesque wolfman, pierced and protected by thorns." We watch him "double as human and animal";[14] in the very process of making his body disappear into the emulsion, Samaras loses hold of the specificity of the auto-Polaroid works, where, when we see color growing out of his body, we experience it in terms of our own body, our own self. Samaras disguised as double and animal is subtly less exposed, less moving than in his earlier auto-Polaroid images of the artist naked, crouching or curled up in a fetal position.

Another show of Samaras's photo-transformations took place at the Pace Gallery in late 1975. In this exhibition, each picture offered a double image. Samaras presented "a fixed image of himself as an old-fashioned tintyper silhouetted at the left . . . he seems to photograph another self-image: a trick image of his body, bloated like a balloon, skeletally skinny, adorned with dots, brushstrokes, glowing rays."[15] Thus Samaras's image as photographer begins to take on an almost trademark appearance, which was suggested in its first prophetic appearance in a tiny photo on the cover of the *Photo-Transformation* catalog. And finally, the artist as his own daguerreotype became Samaras's summation in reverse of his own history of working with the photographic process.

Lucas Samaras represents the outside artist's approach to photography, with the kind of inventive sense he brings to its mechanical processes. Duane Michals, in contrast, is a professional photographer who pioneered a new narrative approach, inventing an image-plus-word set of sequences in the 1970s. Eve Sonneman is an innovator of a different kind, belonging less to the directorial mode of photography than the other two artists. Her first works, paired photographs made in 1968, could or could not be seen as consecutive images. These diptychs (as she called them) were not concerned with narrative as such, except in terms of being a presentation of nonconsecutive minutes in a single location. Her book *Real Time: 1968–1974*,[16] published in 1976, consisted of forty-six sets of double images, adjacent to each other, the way they probably appeared on a photograph contact sheet, but enlarged so that their black frames became a kind of connecting border, reinforcing the idea of the camera being a window eye on the world. No one's right eye and left are a perfect match, and Sonneman's paired images never exactly duplicate each other. The changes between them can be a matter of time, of shifts in an event, or simply of shifts in the photographer's own stance, in the way she holds the camera to see "the picture."

"Critics often point out that Sonneman's photos represent an extreme departure from the decisive moment approach exemplified by Henri Carter-Bresson," a critic writing in *Life* magazine pointed out.[17] And Sonneman's book *Real Time* attempts to move photography away from this idealized conception of life and of the power of the artist to appear and select the right moment. Her use of the photographic diptych in the early 1970s was a way of juxtaposing the incidental with the sequential,

of thereby finding and making visible subconscious connections. As Andy Grundberg has pointed out, in Sonneman's work in *Real Time* "form approximates function, which does not mean," he explained, "that left picture equals thesis and right picture antithesis; her oppositions are more complexly woven into the side-by-side structure."[18]

Sonneman's *Sand Child, San Francisco 1968,* the first diptych in *Real Time,* presents two views of the same little girl who has buried her body in the sand. On the left, the child is seen alone with just another child's shadow in the extreme lower right corner; in the right image, with the camera differently positioned, we see the little girl moved into the left corner of the picture and, further up the beach, a boy lying on the edge of a blanket and the legs of a group of adult women cut off by the frame at the top. The sun and/or the photographer has moved. We have no knowledge of how much "real" time has passed. The same is true of Sonneman's 1969 diptych, *Central Park Rock,* which presents two views of the same rock: one containing people, the other from behind a tree, where we see the rock via the tree, experience the relationship of tree-to-rock without being aware of any human presence, except for Sonneman's implicit seeing camera eye. The shifts in *Real Time* are not always so spatial. In Sonneman's 1972 *Smoker* [89], there is the time frame on the left, where the man has put a cigarette in his mouth, and the one on the right where he holds it, exhaling smoke; evidence that only a few seconds have passed. Time is less certain in Sonneman's 1968 *Horse Passing, San Francisco.* Here, on the left bathers are sprawled sleeping on the beach, while on the right, the bathers maintain their sleeping position as a horse gallops by. Some time has passed because the tide has changed, as recorded in the different relationship of waves to beach. Things happen in time, horses ride by, and the camera moves and in Sonneman's hand registers this, far more succinctly and

[89] Eve Sonneman *The Smoker, Chinatown, New York.* 1972.

with a different kind of emphasis from Eadweard Muybridge's early (1879) time/motion photograph studies.

What Sonneman as a photographer does not deliver are precise explanations—a fact which led in the 1970s to her work being "widely shown, collected, published and admired, but . . . repeatedly scourged by critics with a relentlessness not ordinarily encountered in art criticism."[19] Perhaps Sonneman's own statement of her aims will make clear the problems for those in search of easy answers. In the 1970s, "I did not present a set theory. I did a series of images in which I combined simultaneous images of people in motion in both black and white and color. . . . The audience was given a multiplicity of choices in the final works to observe meaning in gestures, motion, perceptual changes from black and white to color, in invented time sequences between the frames. The audience could build its own syntax of esthetic pleasure or intellectual work. It was open."[20]

Eve Sonneman, who was born in Chicago, graduated from the University of Illinois in 1967 and earned her M.F.A. degree from the University of New Mexico in 1969. She came to New York at the age of twenty-three and convinced The Museum of Modern Art to buy two of her prints. It was while looking at contact sheets in the darkroom a year before that Sonneman first got the idea of making photographs in her diptych form. Her photographs in *Real Time* are a selection of black-and-white (gelatin and silver) prints made between 1968 and 1974. In 1975, Sonneman began working in color, making a transitional group of photographs that pair a color with a black-and-white diptych, thus presenting a set of four prints of roughly the same scene. The use of color changes both the focus and the sense of space, and there is a kind of factual reality in the black-and-white prints which contrasts strongly with the high-colored, more fantasy-like, almost duplicate images in Sonneman's *Coney Island Beach Scenes*. About this time, Sonneman also deliberately set out to break away from her own format by pairing moments separated in time and then in place. In 1976, she obtained permission to take photographs from the observation deck of the World Trade Center in lower Manhattan, and that year her show at Castelli Graphics consisted of paired color prints of people who were themselves spectators on the observation deck. One particularly memorable work from the series, titled *July 4, 1976,* gives us two frames of spectators watching and photographing the Bicentennial fleet of Great Ships sailing up the Hudson River.

From *Real Time* on, Sonneman's work has always contained social and political implications. The photographer shows us places she has been, and the way people behave and react to them. It is the way people behave that she photographed at the observation deck of the World Trade Center. As always, her concern is not with panoramic views, but rather with "gesture, innuendo and small changes."[21]

In 1982, Eve Sonneman was given a thirteen-year retrospective at the Hudson River Museum in Yonkers, N.Y., which included the artist's most recent works—

single-image large color prints that contain two contrasting realities. The most memo-
rable among these was her photograph on the cover of the catalog, which Sonneman
titled *The Deflated World.* Done in 1981, *The Deflated World* depicts a huge wall map
of the earth in brown and pink tones, in front of which stands a brightly lit blue, white,
and yellow wrinkled and deflated globe.

In contrast to Sonneman, Robert Mapplethorpe was probably the most popular
and certainly the most widely acclaimed avant-garde photographer of the 1970s, in
part, at least, because of his choice of erotic subject matter. His series of black men,
women body builders, "new wave" rock stars, and gay and sado-masochistic styles
and sexual activity all focused on the decade's secret and not-so-secret fashionable
proclivities. As a portrait photographer, Mapplethorpe is occupied with the same, if
somewhat younger, set of social subjects as Richard Avedon. The photographer of
high-fashion designers and the "darling" of Andy Warhol's *Interview Magazine,*
Mapplethorpe was also the only photographer invited to participate in the sixth
international Documenta exhibition at Kassel, in 1977.

Robert Mapplethorpe, born on Long Island, N.Y., in 1946, graduated from Pratt
Institute in 1970, and was determined to be a sculptor. That same year he moved into
New York's Chelsea Hotel with the soon-to-be-famous rock singer/poet Patti Smith,
who Mapplethorpe says greatly affected his life and way of thinking. In 1970, Mapple-
thorpe was making Joseph Cornell type of constructions, which incorporated images
from pornography magazines. Late in 1971, he bought a Polaroid camera with which
to take his own photographs. He intended to incorporate these into the constructions,
but instead became involved with the "pure photographic image itself."[22] In 1973,
Mapplethorpe had his first solo exhibition at the Light Gallery in New York and, in
1977, had a total of three such solo exhibitions in the same year: one of his portraits
at the Holly Solomon Gallery and another, at the same time, of his erotic pictures
at The Kitchen, a downtown showing space in SoHo. Late in 1977, he had the third
show, an exhibition of his flower images, also at Holly Solomon, images which to some
viewers had the same erotic impact as the patently sexual subject matter in the show
at The Kitchen. In 1978 and 1979, Mapplethorpe's many solo shows included exhibi-
tions at the International Center of Photography in New York, the Robert Miller
Gallery, The Corcoran Gallery in Washington, D.C., the Chrysler Museum in Nor-
folk, Virginia, and Galerie Jurka in Amsterdam, Holland.

While critics agreed about the shocking element in Mapplethorpe's work, the
questions that still remain for many are "Is Mapplethorpe only out to shock?"[23] and
what the value of the work is apart from its erotic content. In brief, what defines
Mapplethorpe's peculiar qualities as a photographer apart from his adulation of
homosexuality and "the polished world of high fashion and country houses"?[24] Re-
viewing an exhibition of Mapplethorpe's show of black men, Hilton Kramer wrote
that the exhibition was "devoted entirely to photographs of young black males, most

[90] Robert
Mapplethorpe.
Ajitto, Right. 1980.

of them nudes, with beautifully developed bodies and endowed with large sexual organs. Far from shying away from these subjects, Mr. Mapplethorpe's camera dwells on them with loving concentration, and the result always yields him a very arresting image. Yet the style, if not the subject matter of these pictures, has the look of something revived and refurbished rather than something freshly invented."[25] To other critics, Mapplethorpe's treatment of the nude seems to carry a rather heavy load of Neoclassic reference. We recognize, and this may be part of the power of these images, in the familiar poses the black men adopt constant references to Greek statuary [90].

There is also the issue of Mapplethorpe's unique surfaces, in his 30 × 40″ and 40 × 40″ black-and-white prints. Mario Amaya has observed that Mapplethorpe's "camera does not sympathize or caress, nor does it brutalize. However, it does varnish."[26] And what Amaya refers to as Mapplethorpe's "glamorous veneer" becomes in Kay Larson's words "a skin . . . a dark grey tonality smooth as hide, into

which the gleam of black muscles casts an erotic radiance."[27] According to the Dutch writer Rein von der Fuhr, this "typical" Mapplethorpe characteristic is most clearly present in his flower studies. The content of these photographs is much less controversial, whereby the style shows more directly. Furthermore, "A flower is not approached (seen) as . . . nature . . . but as a studio-object. Carefully posed and lit, the flower is freed of the sentimental charge of its flower-ness, and then registered in the much more detached and objective beauty of its form."[28] I believe Rein von der Fuhr is right, and this is also Mapplethorpe's objectness/objective approach to the nude body. Indeed, the photographer's fascination with body texture and with light on skin

[91] Robert Mapplethorpe. *Lisa Lyon.* 1980.

recalls a similar preoccupation with the flesh of the nineteenth-century Impressionist painter Pierre-Auguste Renoir. Mapplethorpe himself sees his photographs as being influenced by Nadar, and, on a certain level, his society portraits do recall the French nineteenth-century photographer's approach to portraiture. In discussing Mapplethorpe's photographs of Lisa Lyon [91], the 1979 winner of the first World Women's Body Building Competition, the critic Andy Grundberg described the work as combining "physical primitivism and a refined Neo-classical aesthetic."[29] The photographs of Lyon are collected in a book titled *Lady,* published by the Viking Press in 1983. In a series of interviews during 1981 and 1982, Lisa Lyon, discussing why she took up body building, summed up the 1970s androgynous attitude, and her own, and perhaps that of her photographer as well, when she said, "I have had a vision of an animal body, neither masculine nor feminine but feline."[30] And, finally, it may be Robert Mapplethorpe's contribution to photography to record, with sustained erotic interest, his own and his era's cool, detached attitude toward the physical body, and to make this body itself into a hothouse subject for photography.

Sandy Skoglund's fantasy pictures, such as *Radioactive Cats* and *Revenge of the Goldfish,* are "part photograph, part installation, part sculpture—and wholly captivating," wrote Andy Grundberg in 1981.[31] Neither the issues of society nor the literalism of erotic photography are her concern. A crossover figure, unlike Robert Mapplethorpe Skoglund never offends. What she does rather—which may be a more serious matter, finally—is undermine. Skoglund has taken the directorial mode in photography a step further than Samaras by making up and then literally building her imaginary scenes so as to present us with the photographic evidence of both their actualness in photographs and their unreality in execution.

Time-Life's 1981 edition of *Photography Year*[32] put Skoglund's *Radioactive Cats* on its cover, and in its "Trends" section highlighted fictional photographs as "Pictures that tell the truth by making it up."[33] The idea of fictional, directorial, and/or constructed photographs (the three terms seem interchangeable at this point) has many precedents, as Skoglund herself has pointed out: "There is William Wegman and Ed Ruscha and Man Ray."[34] And, to go back to photography's beginnings, there is also Julia Margaret Cameron in the nineteenth century.

Sandy Skoglund's exhibitions around the country have included the actual installation—in the 1980 *Radioactive Cats,* the tenement filled with green cats—together with, in a separate space, a large, 30 × 40" Cibachrome print of the scene. Missing from the room-sculpture and omnipresent in the photograph are the figures of an old man seated in the kitchen chair and a woman standing at the stove, also with her back to the camera. Skoglund's 1981 sculpture installation *Revenge of the Goldfish* [92] at Castelli Graphics in New York included suspended ceramic goldfish, painted red-orange, swimming under the ceiling, moving across the floor, resting on a pillow, and piled high on the room's unmade bed. In the photograph, Skoglund used her actual

[92] Sandy Skoglund. *Revenge of the Goldfish.* 1981.

neighbors, in the form of a woman posed asleep in the bed and a boy sitting at the bed's edge, looking down at his feet. As one reviewer pointed out, "There is a character to the photograph that can't happen in the installation because of its (the sculpture's) artificiality."[35] But this is probably more a matter of the room-sculpture's lack of human presence. Skoglund herself feels the photograph has stronger formal aspects than the sculpture, that working on a flat surface gives her more leeway by allowing her to use one-point perspective and compose her colors and forms according to the four corners of the rectangle.[36] In *Radioactive Cats* almost everything in the room is gray except for the bright green cats and the pink skin of the man and woman, who are primarily gray figures. *Revenge of the Goldfish* is basically two colors—a blue (walls and furniture) and orange-red (the fish)—and most of Skoglund's works to date have been primarily two-color compositions. Somewhat an exception was the 1980

Hangars, with its walls and chairs different yellows, the floor pink, and its blue-black hangar forms crossing from one color to the other, functioning somewhat like the compositional dots in Larry Poons's paintings.

Sandy Skoglund came to photography by way of fine art. Born in Boston in 1946, and the daughter of a Shell Oil Company executive, Skoglund lived all over the country, spending her late teen years in California, not too far from Disneyland. In part, as a reaction to this southern California world, Skoglund came east to attend Smith College, studied art history at the Sorbonne in Paris, and went on to earn her M.F.A. degree from the University of Iowa. After leaving school, she became a teacher at the Hartford Art School from 1973 to 1976 and, meanwhile, worked on Conceptual Art pieces. Her first photographs were documentations of these early pieces. The year 1976 was a turning point for her. "I lost faith for a while, and couldn't stand the rhetoric any more of conceptual art," she has explained. She left Hartford, moved to Newark, got a job teaching at Rutgers, and tried to make a documentary film on life in Newark as a way of connecting with the real world. The film didn't please her, and she began making photographs of still lifes of party plates and cutout papers, which were a kind of transition to her sculpture/photograph pieces.

Skoglund's two photographs in the 1981 Whitney Biennial—1981 was the first year that the museum had awarded photography its own, separate area in the exhibition—were considered by many a discovery. But while the fantasy aspect of Skoglund's work won approval on the one hand, the toylike nature of her sculpted animals, the three-dimensional comic-book aspect of her floating fish and running cats, upset many people. And the fact that her one-person exhibition included both sculpture installation and photography upset critics like Gene Thornton, who wrote in the *New York Times,* "Installed in a window at Bergdorf's or Bloomingdale's, 'Revenge of the Goldfish' would certainly catch the eye of the passers-by and direct their attention to the clothes that would be added. But," he asked, "what does it do when installed in an art gallery, besides give art writers something to write about?"[37] For myself, what Skoglund's installations seem to do is to open up a dialogue between photography and sculpture, to present in dramatic form the current dichotomies between illusion and reality, and to offer in the shape of the flocks of fantasy animals and babies a vision of the unimaginable afterworld that will follow the next nuclear explosion.

"My experimental TV is not always interesting, but not always uninteresting Like nature which is beautiful/not because it changes beautifully/but simply because it changes," Nam June Paik wrote in an essay published in the June 1964 issue of the *Fluxus* newspaper.[38] Any talk about experimental video works, tapes, and/or performances in the last decade, according to most video critics and curators, must begin with Nam June Paik.

In 1963, Paik presented his thirteen specially altered TV sets in a first solo

(non-concert performance) exhibition at the Galerie Parnass, Wuppertal, West Germany. In the doorway of the gallery, Paik suspended a slaughtered ox, which attracted more attention than the electronics, and certainly added something to the artist-composer's growing reputation. Nam June had come to Germany in the late fifties to please his parents by earning a Ph.D. in philosophy and to please himself by continuing his own, rather secret studies in contemporary music. A performance by the American avant-garde composer John Cage about this time gave Paik the impetus to create and perform his own avant-garde musical compositions. In 1963, Paik has said, he did not consider himself a visual artist, "but I knew there was something to be done in television and nobody else was doing it, so I made it my job."[39]

In 1964, the Korean-born artist settled in New York City and quickly became part of the American Fluxus avant-garde performance group. The year before, the cellist Charlotte Moorman had organized her first New York Avant-Garde Festival, which was mostly concerned with contemporary music. She scheduled a piece by the German composer Stockhausen for her second festival in 1964, and met Nam June Paik, whom, Stockhausen had said, he wanted as one of its performers. The meeting between Moorman and Nam June Paik led to a collaboration for more than fifteen years. Nam June Paik felt the cellist was the missing ingredient he wanted to introduce into music. Sex, which had been important in painting and poetry for centuries, he felt, had never been given much attention in music. To Paik, Moorman equaled sex, and the parts Nam June Paik wrote for Moorman's cello performances in the next ten years always involved the lady removing a good number if not all of her clothes at one point or another in the performance. By 1969, in fact, Paik had invented for Moorman the first TV Bra, consisting of two tiny television monitors.

In 1965, Nam June Paik exhibited a group of his electronically altered television sets at the New School for Social Research in New York. That same year Sony television produced its first videotape recorders for home use, and Paik bought one the day they went on sale. That same day, October 4, 1965, Paik immediately made his first videotape, which he showed to an audience the same night, after handing out flyers advertising the event and promising, "As collage technique replaced oil-paint, the cathode ray tube will replace the canvas."[40] This tape, which included shots of Pope John's arrival in New York that day, was shown at Café Go-Go in Greenwich Village for several nights. In coming to America, Nam June Paik said, he had "learned overkill. Putting in everything, that's the real spirit—thirty amplifiers, thirty contact microphones and so forth."[41]

In the late 1960s Paik persuaded the Japanese engineer Shuye Abe to come to New York and work with him on a video synthesizer that would alter and convert into any number of patterns images relayed by video cameras and sound generators. By 1968, Abe and Paik had perfected the synthesizer, and in 1970 Paik used it to produce a four-hour live show for station WGBH in Boston. This show Paik titled

Video Commune, and as its sound track he used the entire recorded works of the Beatles. Its imagery was made by Nam June Paik, his studio associates, and a large number of strangers whom Paik invited off the streets to play with the controls. Viewer response to *Video Commune* was so favorable that the station repeated it in an edited, one-hour version "as a New Year's Eve present to its viewers."[42]

The marketing of the Sony Portopak, or home videotape recorder, made the television medium available to a number of visual and Conceptual performance artists, most of whom used the TV camera as a recording or software device, a practice very opposite to Nam June Paik's approach. "My TV," he wrote in a 1963 manifesto, "is *Not* the expression of my personality, but merely a physical music."[43] He developed the video synthesizer specifically in order to create new images with the medium, and it is the medium in an almost nontechnological way that Paik calls to your attention. "Radio Free Europe is interesting and informative," he wrote, "but the noise which jams the station is also interesting and informative . . . enjoy both. Jam your TV stations and make it Radio Free America."[44]

In 1969 Abe and Paik had created for Charlotte Moorman a TV Bra, and in 1971 they made a TV Cello. The TV Bra was a fairly simple device, consisting of two 4-inch TV image tubes encased in two 8-inch-long Plexiglas boxes strapped on to her breasts. The TV Cello was more complex, consisting of several television monitors piled one on top of another in a cello shape. Moorman herself was wired to these boxes and as she played her "video cello," various shapes appeared and disappeared from the television screens.

Nam June Paik had his first full-scale retrospective at the Everson Museum in Syracuse, N.Y., in 1973, covering work made between 1959 and 1973. Paik has continued to be a very prolific artist. In 1976, for example, he showed new works simultaneously at two New York galleries: an "anti-gravity video" at the Bonino Gallery, and a piece about the phases of the moon at the Renée Bloch Gallery. The anti-gravity work was called *Fish Flies in the Sky,* and consisted of twenty video monitors suspended from the ceiling, hanging face down in the dark so that viewers were required to lie down on the floor to watch them. On one of the piece's two channel tapes appeared small fish moving leisurely from set to set, while the second tape presented a jet aircraft flying around leaving a trail of smoke. Between the two images appears a surface of water and/or sky; the tapes run about an hour. The piece at the Renée Bloch Gallery was titled *The Moon Is the Oldest TV Set* and consisted of fifteen television monitors, each displaying a phase of the moon.

The 1976 *Fish Flies in the Sky* was included in Paik's second museum retrospective, held at The Whitney Museum of American Art in 1982. Also included in this exhibition was Nam June Paik's 1974 piece *TV Garden,* consisting of twenty-five color television sets all playing a Paik tape titled *Global Groove.* At the Whitney, the "garden part" of the work consisted of a large array of live, small treelike plants,

arranged in bowers, among which the television sets were planted. The *Garden* tape *Global Groove* is a collage piece beginning with a Broadway version of a rock and roll dance number from 1960 performed to the song "Rock Around the Clock," changing to the gyrations of a Korean dancer, shifting to a distorted image of Allen Ginsberg, then going on to an excerpt from a performance by the Living Theatre Group, and so on. Each monitor plays the *Global Groove* in a different time frame, so one rarely sees the same images as one moves from set to set.

The two museum retrospectives and the numerous airings of his tapes around the world have made Nam June Paik into something of a video celebrity. In 1975, he was the subject of a Profile in *The New Yorker*,[45] and since then he has done several tapes that were commissioned by public television. He has of course participated in numerous avant-garde television programs around the world, and his tapes are frequently screened on public television stations around America. Even so, Nam June Paik's presence and/or persona is not a major factor—he is not the "star" of his own work, but the man behind the camera. Although he visited The Whitney Museum daily during his retrospective, checking to see whether the sets were all working, whether the lit candle inside his TV box sculpture remained lit, his presence seemed implicit. His was the invisible hand that lit the candle. In recent years, Nam June Paik, in fact, is never a main actor and, aside from lending support to Charlotte Moorman's various performances, rarely appears on his own video tapes. In this respect, Paik differs radically from other 1970s video artists, almost all of whom use their own bodies, and many even their own psyches, as part of their performance and/or tape material.

Joan Jonas, Vito Acconci, and William Wegman are all performance artists who have done and/or recorded a major part of their work on video tape during the 1970s. William Wegman's art also encompasses drawing and photography. Joan Jonas is a performer first, who sometimes uses the video camera as part of her performance and also works with it as a separate medium with which to make video works. Vito Acconci, who began as a poet and street performer at the end of the 1960s, makes tapes from his own private obsessional acts as well as from his confrontational experiences with audiences. And the last artist to be discussed here, Joseph Beuys, is a sculptor and performance artist whose few videotape works are records of his theater events, performances (along with speeches), and ideas, and who in person, in a 1979–80 solo Guggenheim Museum exhibition, brought a new cognizance of Europe and of European politics to the American art world.

According to the poet and critic Constance de Jong, Joan Jonas works "with an accumulating body of materials, costumes and props, sounds, images, activities and ideas . . . formed and re-formed into video tapes, films [and] in and out door performances."[46] Jonas herself says she focuses on issues of space, "ways of attenuating it, flattening it, turning it inside out."[47] Born in New York in 1936, she started doing performance works in the late sixties. An early one had the audience seated in the

sculptor Alan Saret's loft while Joan Jonas performed the piece in front of a mirror on the floor below. The audience, looking through a hole in Saret's floor, experienced the piece by seeing its reflection in the mirror. In 1970, Jonas did a work at Jones Beach with the audience a quarter of a mile away. In this piece, Jonas explains, she was using "sound in relation to space as the basic element."[48] Subsequent performances and tapes brought together Jonas's preoccupation with space in both aural and visual terms.

Jonas bought her first Portopak camera while on a trip to Japan, which also was her first introduction to the Japanese Noh play. "I think that the Noh and the Kabuki theatres put together probably contain every idea for theatre that you can think of,"[49] she has said; the Noh plays in particular were a great influence on her subsequent pieces. Certainly her 1972 tape *Vertical Roll* reflects an interest in the Noh concept of theater time. And the work also involves a not un-Japanese use of sound, costume, and formally staged movements, done in the beginning to the sound of a spoon banging against a glass.

A vertical roll is a technical effect in video that results from two out-of-synch frequencies: the first, that of the frequency signal being sent to the monitor; the second, the frequency by which it is interpreted. When both of these are the same, the image is stable. Jonas uses this, playing with the idea of the rolling picture both structurally and rhythmically. It is this aspect of the twenty-minute tape called *Vertical Roll* that imposes tremendous strain on the viewer and on his eyes, as Jonas manipulates her sideways image up and down the video screen. Here Jonas, like Nam June Paik, calls attention to the physical aspects of video's electronic vocabulary. As if to further underline this aspect, a little later on in the *Vertical Roll* tape, Jonas makes her camera zoom in on the spoon to display the Vidicon tube's reaction to light.

To the critic Rosalind Krauss, time is the hero and subject of *Vertical Roll.* The work, she feels, "visualizes time as a continuous dissolve through space. In it, sequences of images and actions are seen from different positions, both in terms of the camera's distance and its orientation to the horizontal ground."[50] Certainly in this tape Jonas presents us with her feet stepping in and out of "time," jumping up and down and only sometimes in synch with the image's vertical roll. We see her, sideways, in a jewel-studded costume with the camera focusing on her posed and turning stomach and hips. The movement, slow, then fast, projects us into video camera time.

From her very earliest pieces, Joan Jonas's concern with space has taken the form of an interest in the double image. She uses the mirror as a dislocating medium and, at the same time, employs masks to create for herself alternative selves. The 1972 seven-minute *Left Side, Right Side* work presents Jonas looking into the mirror and projecting double images shown on the screen through the use of two cameras and a split screen with a special-effects generator. The tape's pair of images leads to a complete discontinuity as to what is the right and left side, the real and reflected, which Jonas further complicates by introducing fictional drawn images on herself and

her reflection. In the work titled *Organic Honey's Visual Telepathy,* we watch Jonas put on the mask of the smooth doll face of "Organic Honey" and look out at us through the eye holes of this mask, making us aware that the mask has its own persona. Then, when the mask with Joan Jonas looking out of it at herself studies its mirror image, we discover a further doubling of illusion and almost quadrupling of personality. In live performances Jonas also often uses a fragment of mirror to flash light onto the walls around her and to flash a reflection of her own face out at the audience. In all of Jonas's works, image follows image in non-narrative sequence, and the theme of narcissism takes on a new resonance as she builds on it to peel away the outer trappings of personality.

Each work by Jonas is an accretion of earlier pieces. For a time, "Organic Honey was my alter ego," she has said. Then, "the woman merged with a dog and Organic Honey dissolved into a howl." In 1981, however, the dog reappeared as part of a theater piece titled *Double Lunar Dogs* that Jonas presented at the Performing Garage in SoHo. The work, "inspired by a Robert Heinlein science fiction story,"[51] takes Jonas's preoccupation with space and moves it into a semi-humorous investigation of an outer space world, which features such Jonas trademarks as her characters drawing on a pair of women's faces painted on a transparent screen. Also in the piece are familiar Jonas masks and costumes, only slightly transformed. Thus, *Double Lunar Dogs* represents a further extension of Jonas's sometimes funny, sometimes puzzling video/performance world.

Joan Jonas's interest in the mirror image and in narcissism is one of detached calm. Like Nam June Paik, she is not preoccupied with her own psychic outpourings. Consequently, her and Paik's tapes are at an absolute end of the spectrum from Vito Acconci's works. Acconci's preoccupation with himself and his own body has led to one of the largest collections of works in the Castelli-Sonnabend Tape and Film Catalogue. These tapes, while "filled with self-doubt and self-abnegation," as Ingrid Wiegand has pointed out, nevertheless establish "the Acconci art territory itself as intimate, revealing, exhausting and completely manipulative of its audience."[52] His most notorious performance work was a piece entitled *Seedbed.* In *Seedbed,* done in 1973, the artist lay under a temporary ramp built over the floor of the Leo Castelli Gallery and, fantasizing into a loudspeaker, masturbated for two weeks. "It started as an informal way to use the gallery space," Acconci has explained. "In *Seedbed* I was able to involve the viewers by fantasizing about them as I masturbated, talking out my fantasies about them."[53] This passive/aggressive attitude toward both audience and video camera was characteristic of Acconci's work through the decade. A tape he made in 1973 titled *Command Performance* demands the audience watch him "Dream into the space . . . dream myself out of here . . . drift out of here, into you . . . dream into you."[54] For fifty minutes he alternately seduces and threatens the audience, talking lying on his back with the camera looking down at him.

Vito Acconci, born in the Bronx in 1940, graduated from Holy Cross College in

Worcester, Massachusetts, and attended the Iowa Writers Workshop. A poet and a participant in many street-work events, Acconci turned from writing to doing live performances in galleries about 1970—performances which eventually included him biting his exposed flesh, picking hairs off his chest, and discussing his sometimes sado-masochistic relationships with women for the video camera. In 1975, Acconci decided to change the emphasis of the work. The issue for him was, "How do I deal with myself but without my physical presence?"[55] He accomplished this by making the "I" in his installation pieces implicit, and turning his hostility outward to a more generalized audience. A good example of this approach is the 1977 installation piece he made for the Whitney Biennial titled *Tonight We Escape from New York.* For this work, Acconci filled the entire stairwell of the museum (all of the four floors) with a 70-foot rope ladder and an inescapable set of audiotapes. Acconci's voice on tape accuses and insinuates and intones the phrases "We made you; you're a cunt. You made it: you're a nigger. We made you . . ." again and again with slight variations; according to Carrie Rickey, "his chants induced claustrophobia and that up-against-the-wall feeling."[56] What wasn't clear to Rickey or anyone else was exactly to whom Acconci was talking. "Was the voice chastizing those desiring upward mobility?" a critic speculated. But there was no answer on the tapes themselves, which at times were so inaudible that many visitors at the Whitney opening night and later couldn't make out the words or just didn't hear the inflammatory text.

Acconci represents an extreme narcissistic/voyeuristic aspect of video performance work. His tapes, though often written about, are rarely watched through to their conclusion. The works, though, have been exhibited and/or performed on a regular basis at the Leo Castelli Gallery since 1973, and Acconci had a retrospective of his installations and tapes from the 1970s at the Chicago Museum of Contemporary Art in 1983.

Listening to the Acconci tapes we become all-involved with the artist's personality, in sharp contrast to William Wegman's various tapes, which direct our attention to the personality of his dog, Man Ray, and to the difficulties of establishing a human/teaching relationship with an animal who persists in remaining an animal.

It was in 1969 that the Massachusetts-born Wegman, while making Conceptual Art pieces, began to feel that photographs could be something more than just evidence. He began making works for the camera's sake, rather than the other way around. About the same time, at the University of Wisconsin, where he was teaching, Wegman discovered the education department's half-inch video recorders, and soon was experimenting with the equipment every chance he had. In 1970, Wegman and his wife moved to Long Beach, California, where the artist began making narrative-type photographs and bought a Weimaraner puppy. He named the dog Man Ray after the famous American photographer and painter, and used it initially in much the same way as the inanimate props he set before the camera. "They always ask me what my art stands for," he said at a later date. "And I tell them it doesn't stand, it sits."[57]

Wegman's earliest videotapes, from 1970–72, are concerned with situations related to commercial television, with the artist himself acting as straight-man announcer. Toward the end of this first group of tapes (Selected Works, Reel 1),[58] Wegman began using Man Ray in routines such as the one where Wegman drips milk from his mouth in a line across the floor from one end of the frame, and then the dog enters and laps it up from the other. In another short piece, Wegman tries to teach Man Ray to spell, castigating the animal for his supposed mistakes until the dog begins to whine, at which point Wegman gives up insisting on explaining "his mistakes" to the dog and says, "Well, okay, I forgive you."

Craig Owens sees Wegman's failures with Man Ray, and his numerous other examples of non-mastery on the tapes, as often being "the explicit theme of Wegman's works which speak of failure more often than success, of intention thwarted rather than realized, of falling short of rather than hitting the mark."[59] This approach, of course, is the basis of most slapstick comedy. And, as if in corroboration, Wegman himself has said, "As soon as I got funny, I killed any majestic intention in the work."[60]

In 1972, Wegman, his family, and the dog moved to New York City, and that same year Wegman had his first solo exhibition at the Sonnabend Gallery in New York, where he continued to exhibit his drawings, video tapes, and photographs through 1977. By the mid-1970s, Wegman's dog, Man Ray, had himself become quite a celebrity, appearing in person and on tape on such popular television programs as the Johnny Carson show and *Saturday Night Live*. In 1978, the Polaroid Corporation invited Wegman to use its large-format camera in Cambridge, Massachusetts. At first, Wegman was reluctant, feeling he had enough to do. "I was making photographs; they took care of the need for making graphic things, composing things, dealing with formal issues. Video took care of my performance urge, my urge to be the life of the party without being at the party. The drawings let me roam around almost any topic. So I wasn't terribly excited about going to Polaroid."[61] To use its special camera required Wegman to come to the Polaroid studio to set up the shot. The studio, in turn, supplied a technician to operate the camera, a film handler, and a lighting specialist. What finally emerged from the process was a highly detailed, ultra-vivid 20 × 24" color photograph. Wegman reported he found the first shooting experience as compelling as "getting my first video deck. . . . The pictures came out like presents."[62] With the help of these glossy prints—which, according to Polaroid, have the presence and uniqueness of paintings—in 1978 Wegman began to make Man Ray into a "star image." An early 1979 picture from the series titled *Fey Ray* presents the animal with polished toenails sitting in front of a bottle of nail polish and offering a paw toward the camera. Partly because by 1980 Man Ray was becoming an old dog, Wegman began camouflaging his aging body by dressing him up in zany clothes, making a Brooke Shields, jeans-wearing Man Ray, an "elephant" [93] version of the dog wearing a trunk, and even a Man Ray "Ray Bat." In all these portraits, Man

[93] William Wegman. *Elephant.* 1981.

Ray's canine existence—his good faith, as it were—is posited over and in apposition to Wegman's human—not so good-faith—intentions. In 1982, Wegman did a portrait, entitled *Blue Period,* of the twelve-year-old Weimaraner sitting behind a small Picasso reproduction and a large guitar. Other, more serious closeup pictures focusing on Man Ray are tinted with faintly iridescent dyes in shades of blue, red, or silver and, in their way, are farewell portraits. In 1982, Harry N. Abrams, Inc., published a collection of Wegman's Man Ray photos under the title *Man's Best Friend,* and Wegman's dedication read, "To Man Ray: 1890–1976 and 1970–1982."

The dog's history from working artist model to star in the late 1970s predicted the new art-star emphasis that was about to take place. Indeed, the dog's sudden stellar status seemed to predict the 1980 celebrity status of Joseph Beuys, who served as an advance runner for the new art hero. Along with this new type of persona, Beuys brought, in the form of his 1979–80 Guggenheim Museum solo exhibition, a new cognizance of Europe and of European politics to the New York art world. The exhibition and Beuys's own trademark costume in 1980 became major media subject matter. The Beuys exhibition had been mounted and its exhibition catalog paid for in the main by the government of the Federal Republic of Germany. A feature article in the *New York Times* magazine section prior to the exhibition explained to the American public that Joseph Beuys was an artist of international stature, and that this creator of "social sculpture" was in fact one of Europe's steadiest-selling artists. At the opening, Beuys himself appeared, a tall fifty-eight-year-old man in his "trademark" felt hat and Chaplin-like baggy pants that are part of his poor affect. Beuys had come to America, in fact, the week before with a squad of uniformed assistants to set up his four-floor museum installation. Beuys's works of twenty years, from 1958 on, filled the Guggenheim, and the artist's triumphant opening on November 2, 1979, was followed by a no-less triumphant closing, when Beuys returned two months later to take down the show and field questions from a packed audience of artists and non-artists at the Great Hall of the Cooper Union School of Art and Architecture on January 4, 1980. The exhibition itself, as Beuys announced in the catalog and on an accompanying audiotape, was merely an extension of his persona, his chosen role of artist-shaman in the arena of contemporary politics. The Beuys catalog and exhibition, in fact, presented the sculptures in the form of dated events corresponding to the artist's personal history, beginning with a bathtub sculpture made to commemorate the year of Beuys's birth. The Guggenheim Museum press release offered a somewhat shortened version of the artist's early history and began: "Born in Cleves on the German Dutch border in 1921, Joseph Beuys was exposed from his early childhood to Teutonic myths and traditions. His earliest training was scientific, fostering a life-long sensitivity to natural forms and mechanical processes. In World War II, as a combat pilot in the German air force Beuys was seriously injured several times."[63] Then comes the Beuys myth, the explanation of his use of felt and fat materials, documented in the Guggenheim catalog and which also formed the chief subject matter of the *New York Times* magazine article, in the form of a story recounting how the Stuka dive-bomber pilot Joseph Beuys had to make a forced landing in the Crimea in 1943. According to the artist's report of the matter in the catalog, he was knocked unconscious by the crash and later rescued by Tartars, who discovered his half-frozen body in the snow and saved his life by wrapping him in fat and felt. Indeed, the Guggenheim catalog reprinted photographs of Beuys and a tipped-over plane, which we are led to believe belonged to the artist. Benjamin Buchloh, a critic writing in the January 1980 issue of *Artforum*, pointed out that the

existence of such photographs raised a number of interesting questions: "Who would or could pose for photographs after a plane crash when severely injured?" he asked. "And who took the photographs? The Tartars with their fat-and-felt camera?"[64]

Nevertheless, the mythical aspect is essential to Beuys's art, both for him and his audience. At Cooper Union, Beuys reiterated that he was making "Social Sculpture —Sculpture as an evolutionary process." And he has further argued, "To critics who interpret my work as having to do with the holocaust—the fat I use, with catastrophe, with death, the gray color with destruction, I say I am not interested in allusion. I am interested in Change."[65] Even this statement, though, becomes questionable in the light of the fact that a whole case of Beuys sculptures in the Guggenheim were given by the artist the title *Auschwitz*.

The overall effect of the Beuys installation was powerful, rather than pleasant or agreeable. The museum's elegant curving tiers, by the artist's direction, were kept half lit, and the building itself cold (with the temperature lowered to keep Beuys's sculptures of mammoth chunks of fat from melting). Heavy smells of rotting honey pulp pervaded the ramp by the first week after the opening, and the artist's designed heavy wood-framed glass museum cases gave the works displayed inside the look of natural history museum objects. Beuys had organized the show into "24 sections, as objects that belong together as stages or stations in a journey."[66] The exhibition was filled with drawings of crosses, and crosses were incorporated into several sculptural objects in keeping with Beuys's concept of the artist as shaman or holy man. Shamanism, for Beuys, "represents a return to richness lost from the material world." Among the magic, shamanistic objects, grouped in Station 10, were Beuys's double-handled spades (used by the artist in performance pieces), a sculpture involving hare's blood, and a pair of horns and a small bandaged knife with the label, "When you cut yourself, bandage the knife." On one of the lower ramps, a work titled *Hearth 11* consisted of twenty-nine copper rods, iron, and a pile of sixty-two felt suits, so folded and stacked as to be suggestive of prisoners of war in general, and of inmates of the German concentration camps in particular. Nearby Beuys had included a 1964 piece he titled *Fat Chair,* consisting of a wooden chair on whose seat was piled a huge triangular lump of fat. Beuys claims his initial intention in using fat was to stimulate discussion. "The flexibility of the material appealed to me, particularly in its reaction to temperature change."[67] Whether Beuys uses the fact that human fat was made to serve as a basis for soap during the Hitler war years, as a conscious or subconscious symbolism is difficult to say.

The most impressive work in the Guggenheim exhibition was a Bechstein grand piano [94], which, in an action he performed on July 7, 1977, Beuys had covered with felt and two crosses of red material to show how the sound of the piano was trapped inside the felt skin. "Such an object," Beuys stated in the catalog, "is intended as a stimulus for discussion and in no way is to be taken as an aesthetic project." The

[94] Joseph Beuys. Installation, The Solomon R. Guggenheim Museum, New York City, 1979–80.

show's most appalling works, which dominated the museum's ground floor, were the five "monumental sculptures" made out of twenty tons of tallow fat that had been originally cast into a rectilinear form in 1977 and later cut into five pieces with a heated wire. Their overall shape was Minimal, perhaps reflecting the fact that Beuys had come to New York for a stay in the mid-1960s, and the overall appearance of the exhibition seemed to refer to that earlier time. One of the exciting aspects of the Guggenheim show was that Beuys seemed to be using the visual vocabulary of Minimal and Process Art for political ends. In at least a metaphorical way, his ideas and aims in the catalog encompassed all the protest movements of the 1960s, espoused equal rights for women, and took an equal-rights stand for animals. Beuys's revolutionary manner of advocating change didn't seem at all to get in the way of either his government sponsorship or his collectors' economic practices.

In 1974, Joseph Beuys came to New York and did a performance piece titled

I Like America and America Likes Me [95]. In this work, dressed in his usual baggy clothes and felt hat and carrying a shepherd's crook, Beuys spent a week in a newspaper-littered loft on Spring Street—a loft Beuys littered with copies of the *Wall Street Journal*—living with a live coyote. One was invited to walk up to Beuys's second-floor Spring Street space to witness the spectacle of artist and animal during regular SoHo gallery hours. The event was duly noted by performance aficionados and then forgotten. But Beuys's triumphant return to New York in 1979–80 was a different matter.

In my opinion, the Guggenheim exhibition treated Americans to the feeling of the world of Germany's soldiers on the Russian front, the dark and the cold, and also suggested the world of the concentration camps as seen from the point of view of the guards. It also insisted that such a thing as a European viewpoint existed and, since the show was backed by money from the West German government, this idea was soon to make a deep impression on the New York art world. In 1981, the West

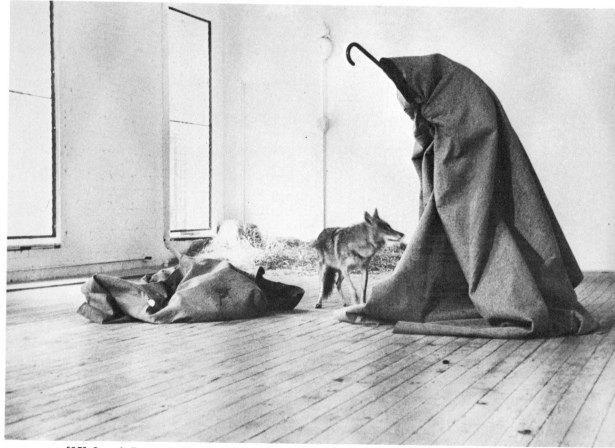

[95] Joseph Beuys. *I Like America and America Likes Me.* 1974.

German government sponsored a second show at The Guggenheim Museum, a show presenting masters of German Expressionism from 1909 to 1937, which had enormous impact. Expressionism was an art movement, like many others, that existed of and for itself, and had little patience with overly intellectual abstract art. In its emphasis on true feeling and real emotion, it was at the very opposite pole from the easy openness of Pluralism—which, in fact, may be why Pluralism began to seem unsatisfactory to many people. At a recent 1983 panel, the painter Chuck Close remarked, "The 70s was a period nobody much liked, but the artists." And the reason for this may be that 1970s art offered alternatives rather than final answers in a way that was stimulating and provocative but possibly not so satisfying in that it demanded that the audience do its own thinking and make its own choices.

NOTES:
PHOTOGRAPHY, VIDEO, AND
PERFORMANCE

1. Susan Sontag, *On Photography* (New York: Farrar, Straus and Giroux, 1977, and Delta Paperback, Dell Publishing Co., 1977).
2. Peter Plagens, "Fretting About Photos: Four Views," *Art in America,* Nov. 1979, p. 13.
3. A.D. Coleman, "The Directorial Mode: Notes Toward a Definition," *Artforum,* Sept. 1975, pp. 55–61.
4. Andy Grundberg, "Duane Michals at Light," *Art in America,* May/June 1975, p. 78.
5. Duane Michals, *Real Dreams* (Danbury, N.H.: Addison House, 1977).
6. Jonathan Crary, "Duane Michals," *Arts Magazine,* Dec. 1976, p. 25.
7. *Ibid.*
8. Michals's photograph reproduced in *Art in America,* May/June 1975, p. 79.
9. *Duane Michals,* exhibition catalog, Sidney Janis Gallery, New York, 1976, unpaged.
10. *Ibid.*
11. Lucas Samaras, "I Use the Whole Body," *New York Times,* Sunday, Oct. 31, 1976, p. 30.
12. Kim Levin, *Lucas Samaras* (New York: Harry N. Abrams, 1975), p. 91.
13. *Lucas Samaras: Photo-Transformations* (California State University and New York: E.P. Dutton, 1976).
14. Lois Greenfield, "Can Polaroids Make Art?" *Village Voice,* Nov. 10, 1975, p. 116.
15. Grace Glueck, "To Samaras the Medium is Multiplicity," *New York Times,* Monday, Nov. 24, 1975.
16. Eve Sonneman, *Real Time: 1968–1974* (New York: Printed Matter, 1976).
17. "Camera at Work: All About Eve's Success," *Life* magazine, Apr. 1982, p. 16.
18. Andy Grundberg, "Eve Sonneman's Explorations," *New York Times,* Sunday, Apr. 18, 1982, p. 29.
19. *Ibid.*
20. Nancy Foote, "Situation Esthetics: Impermanent Art and the Seventies Audience," *Artforum,* Jan. 1980; Eve Sonneman statement, p. 29.
21. David Schapiro, *Eve Sonneman's Photography: Splitting and Integrity,* exhibition catalog, Minneapolis Institute of Arts, 1980.
22. Robert Hayes, "Robert Mapplethorpe," *Interview* magazine, March 1983, p. 50.
23. Andy Grundberg, "Photography View," *New York Times,* Sunday, March 13, 1983, p. 32.
24. Mario Amaya, *Robert Mapplethorpe Photographs,* exhibition catalog, Chrysler Museum at Norfolk, Virginia, 1978, unpaged.
25. Hilton Kramer, "Robert Mapplethorpe," *New York Times,* Friday, June 5, 1981.
26. Mario Amaya, *op. cit.*
27. Kay Larson, "Art," *New York* magazine, June 1, 1981.
28. Rein von der Fuhr, "Robert Mapplethorpe," in *Robert Mapplethorpe Fotos/Photographs,* exhibition catalog, Galerie Jurka, Amsterdam, Holland, p. 5.
29. Andy Grundberg, *op. cit.,* p. 35.
30. Henry Post, "Viewpoints: Photography and Photographers," *Gentlemen's Quarterly,* Feb. 1983, p. 28.
31. Andy Grundberg, "Fish on a Line," *The SoHo News,* Jan. 13, 1981, p. 35.
32. *Photography Year,* 1981 Edition (Alexandria, Va.: Time-Life Books, 1981).
33. *Ibid.,* p. 12.
34. Chris Johnson and Ted Hedgpeth, "Interview:

Sandy Skoglund," *San Francisco Camerawork Quarterly,* Autumn 1983, p. 11.

35. *Ibid.*

36. *Ibid.*

37. Gene Thornton, "Photography View: A Mixed Bag of Exhibitions," *New York Times,* Jan. 18, 1981.

38. Nam June Paik with Charlotte Moorman, "Videa, Vidiot, Vidiology," in Gregory Battcock, *New Artists Video* (New York: Dutton, 1978), p. 130.

39. Calvin Tomkins, "Video Visionary," *The New Yorker,* May 5, 1975, p. 51.

40. Judson Rosbuch, *Nam June Paik: Videa n'Videology 1959–1973*, exhibition catalog, Everson Museum of Art, Syracuse, N.Y., 1975.

41. *Ibid.*

42. Calvin Tomkins, *op. cit.,* p. 70.

43. Gregory Battcock, *op. cit.,* p. 130.

44. *Ibid.,* p. 123.

45. Calvin Tomkins, *op. cit.*, pp. 44–79.

46. Constance de Jong, "Joan Jonas: Organic Honey's Vertical Roll," *Arts Magazine,* March 1973, p. 27.

47. Joan Jonas biography, Performing Artservices, Inc., New York, 1980.

48. Ingrid Wiegand, "Joan Jonas Unmasking: Mirage of Phantom Knot," *SoHo Weekly News,* Thursday, May 27, 1976, p. 17.

49. *Ibid.*

50. Rosalind Krauss, "Video: The Aesthetics of Nar-

cissism," in Gregory Battcock, *op. cit.,* p. 59.

51. John Howell, "Theatre/Performance" *SoHo News,* Dec. 22, 1981.

52. Ingrid Wiegand, "Vito Acconci Finally Finds Himself—Through Others," *Village Voice,* Oct. 18, 1976, p. 55.

53. *Ibid.*

54. Castelli-Sonnabend Videotapes and Films, New York, vol. 1, no. 2, Nov. 1975, p. 14.

55. Carrie Rickey, "Vito Acconci: The Body Impolitic," *Art in America,* Oct. 1980, p. 119.

56. Carrie Rickey, *op. cit.*, p. 121.

57. Lisa Lyons, *Wegman's World,* exhibition catalog, Walker Art Center, Minneapolis, 1983, p. 7.

58. Castelli-Sonnabend Videotapes and Films, 1975 Supplement, New York, p. 129.

59. Craig Owens, "William Wegman's Psychoanalytic Vaudeville," *Art in America,* March 1983, p. 101.

60. Lisa Lyons, *op. cit.*, p. 64.

61. *Ibid.,* p. 32.

62. *Ibid.,* p. 34.

63. Press release, Guggenheim Museum.

64. Benjamin Buchloh, "Beuys: The Twilight of the Idol," *Artforum,* Jan. 1980, p. 38.

65. Press release, Guggenheim Museum.

66. *Ibid.*

67. Joseph Beuys statement in press release, Guggenheim Museum.

BIBLIOGRAPHY

Minimal Art: A Critical Anthology, edited by Gregory Battcock (Dutton, 1968).
Conceptual Art, edited by Ursula Meyer (Dutton, 1972).
Postminimalism, essays by Robert Pincus-Witten (Out of London Press, 1977).
Idea Art, edited by Gregory Battcock (Dutton, 1973).
The Afro-American Artist, by Elsa Honig Fine (Holt, Rinehart and Winston, 1973).
American Women Artists, by Charlotte Streifer Rubinstein (Avon Books, 1982).
Art Talk: Conversations with 12 Women Artists by Cindy Nemser (Charles Scribner's Sons, 1975).
Feminist Collage: Educating Women in the Visual Arts, edited by Judy Loeb (Teachers College Press, 1979).
The Writings of Robert Smithson, edited by Nancy Holt (New York University Press, 1979).
Art on the Edge by Harold Rosenberg (Macmillan, 1975).
American Artists on Art, from 1948 to 1980, edited by Ellen H. Johnson (Harper & Row, 1982).
Super-Realism, edited by Gregory Battcock (Dutton, 1975).
On Photography by Susan Sontag (Dell, 1977).
Light Readings: A Photography Critic's Writings 1968–1978 by A. D. Coleman (Oxford University Press, 1979).
New Artists Video, edited by Gregory Battcock (Dutton, 1978).
Total Art by Adrian Henri (Praeger, 1974).
Performance: Live Art 1909 to the Present by RoseLee Goldberg (Harry N. Abrams, 1979).

INDEX

Numbers in *italics* refer to pages with illustrations.